MARVEL
ANATOMY

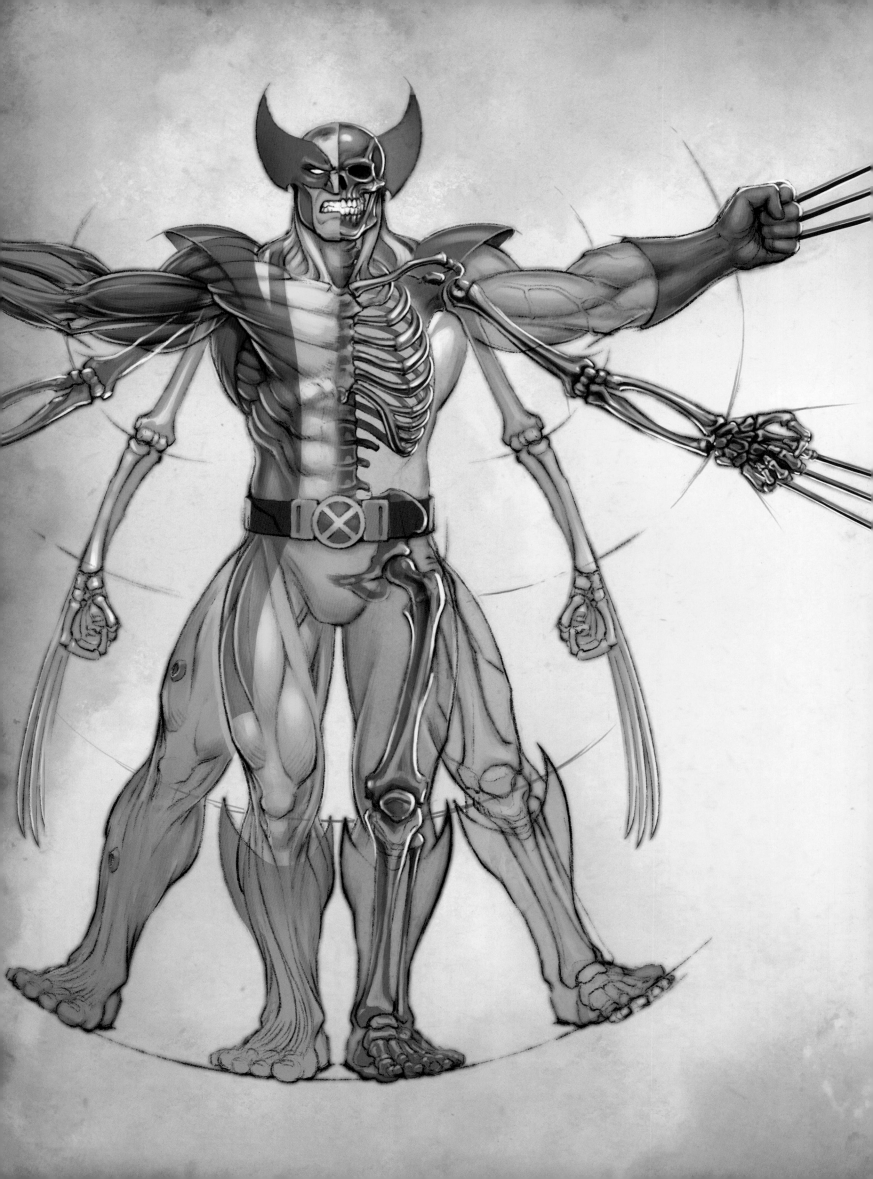

MARVEL

ANATOMY

A SCIENTIFIC STUDY OF THE SUPERHUMAN

WRITTEN BY
MARC SUMERAK
AND
DANIEL WALLACE

ILLUSTRATED BY
JONAH LOBE

INSIGHT
EDITIONS
SAN RAFAEL • LOS ANGELES • LONDON

CONTENTS

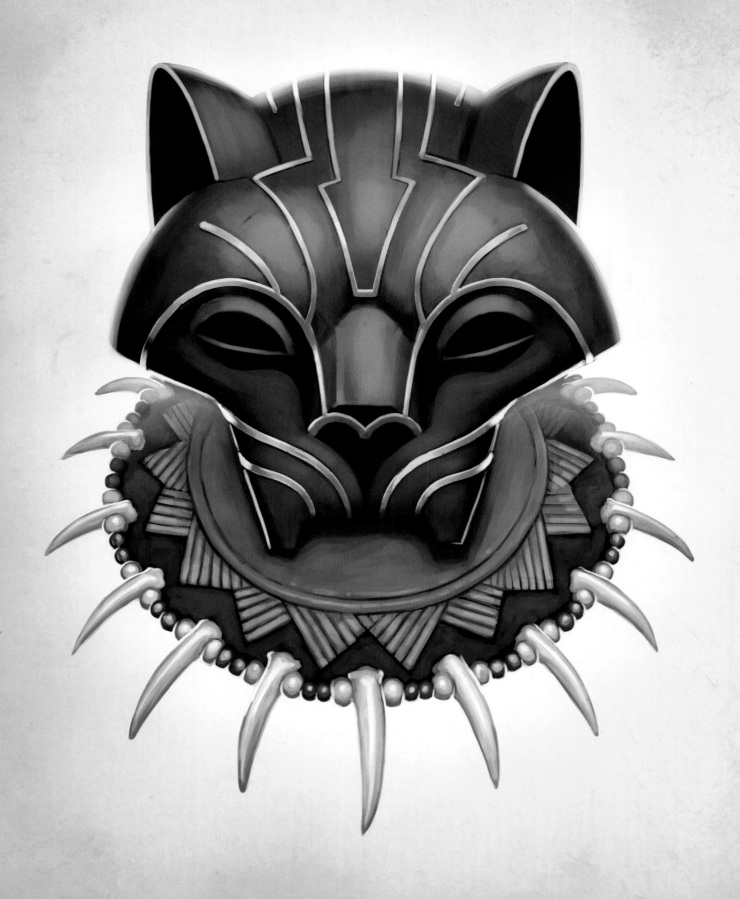

I
INTRODUCTION

Greetings, loyal subject.

I am T'Challa, the Black Panther. That you have been granted access to these files means that Wakanda—and perhaps the planet itself—is in grave danger. You are one of the few I trust enough to help us save it.

When my father, T'Chaka, lost his life to a foreign invader years ago, I accepted the hard truth that there will always be those who seek to take what is ours. Since ascending to the throne, I have witnessed countless endeavors to invade our sacred land, but every time those efforts have failed. Until now.

Last night, one of my most trusted advisors made an attempt on my life. I was able to defend myself from his attack, but he fought with a ferocity rivaling my own. During the course of the battle, my assailant suffered a mortal wound. As the life faded from his eyes, the truth was exposed. His vacant mortal frame shifted and changed in my arms, revealing a form unlike any born of this world—the body of a Skrull.

The Skrulls are a race of shape-shifting aliens exhibiting an inherent physiological trait that allows them to alter their appearance. Their ability to flawlessly mimic any individual has aided them in their efforts to infiltrate countless planets over the years, including our own. My allies developed technological means to identify the presence of a Skrull in our midst, measures I incorporated into Wakanda's own defense grid. Yet it seems that our extraterrestrial enemies have found methods to evade detection once again.

A Skrull breaching the highest levels of Wakandan security unnoticed is an impressive feat on its own, but I have learned that this was not an isolated incident. Confidential reports of similar attempts on the lives of superhuman allies across the globe—including Reed Richards, Charles Xavier, Tony Stark, and Stephen Strange—have confirmed my suspicion. This is but the first strike, designed to remove our most powerful players from the board. If the Skrulls could take some of our planet's most formidable minds by surprise, there is no telling what other positions of power their forces have already infiltrated. An invasion is coming, and we must be prepared.

Not knowing who I can trust, I have put my faith in the data gathered over my years as an Avenger as I seek enlightenment on how we might expose these invaders. Since the transformation of a Skrull is a purely physical process, these imposters cannot reproduce the effects of most super-powers without additional enhancement. Thus, I believe that the key to determining which of my earthborn allies are truly who they appear to be lies in a comprehensive understanding of their anatomical origins. Given that time is of the essence, and because this exploration must be completed behind a veil of secrecy for the protection of all subjects, I am not fully able to confirm the validity of many of the scientific theories presented here. Once this threat has passed, I look forward to the opportunity to test these hypotheses further.

We must expose these imposters and gather more warriors into our fold, as I fear this is not a fight we can win without all of Earth's mightiest beings on our side—including even those we once called enemies. When the safety of our very planet is at stake, the lines we have drawn between hero and villain no longer matter. We are one people, all fighting to save the world we call home.

My sister Shuri and I have offered our analysis on many individuals of interest, but this task is far too monumental for us to face without your trusted help. Remember, time is short. Now that they have a foothold on our world, the Skrulls will act swiftly to take our planet as their own. And until we know who is truly on our side, the fate of Wakanda—and perhaps Earth itself—lies in your hands.

I pray to Bast that your insight will lead us to victory.

Wakanda Forever!

● JUST AS MY ANCIENT ANCESTORS ONCE ETCHED ELABORATE SYMBOLS INTO THE WALLS OF THE NECROPOLIS TO PRESERVE THEIR GRAND TALES FOR FUTURE GENERATIONS, I HAVE DEVELOPED MY OWN SERIES OF GLYPHS TO HELP CATEGORIZE THE UNIQUE STRENGTHS OF THE POWERFUL INDIVIDUALS DISCUSSED HERE.

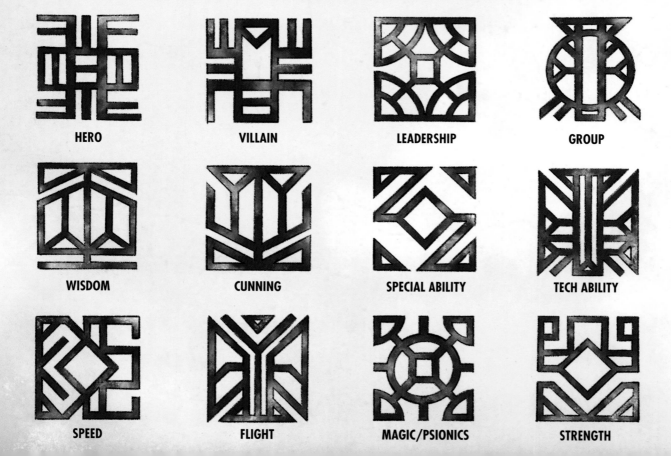

HERO VILLAIN LEADERSHIP GROUP

WISDOM CUNNING SPECIAL ABILITY TECH ABILITY

SPEED FLIGHT MAGIC/PSIONICS STRENGTH

IMPERIUMOLOGY

While scientific advancement may be the key to unlocking superhuman potential, it is important that we not dismiss other points of origin—be they genetic, technological, or mystical. As the Black Panther, I am Damisa-Sarki—the living avatar of the panther goddess Bast—so I realize that some gifts may stem from a source far greater than science can fully explain.

My colleague Reed Richards of the Fantastic Four has informed me of the research conducted by Dr. Rachna Koul in imperiumology, the scientific study of super-powers. Dr. Koul posits that each superhuman being, no matter their origin, acts as a physical conduit to an extradimensional energy source that fuels their abilities. Dr. Koul has dubbed this hypothetical wellspring "Godpower."

Although still theoretical in nature, if this Godpower does exist, it would offer a unique solution to our dilemma. If we were able to find a means to identify and isolate the individual frequencies that resonate through each of our superhuman allies, perhaps we could discover the key to verifying their authenticity.

SKRULLS

The Skrulls are an alien culture made infamous by their appetite for interstellar war. Since the fall of their homeworld at the hands of the cosmic entity known as Galactus, Devourer of Worlds, the Skrulls have used their natural skills of morphological deception in countless attempts to invade human society and claim our planet as the new center of their empire.

SHAPE-SHIFTING

The Skrulls' malleable cellular structure allows them to assume almost any shape. This fluid physiology is the product of a cellular structure naturally laced with unstable molecules—those existing on the Angstrom scale (designed to measure light wavelengths in mere nanometers) in a state between energy and matter. This duality allows the molecules to shift between states under the right circumstances. With concentration, a Skrull can tap the latent energy in these molecules to dynamically alter the texture and color of their dermis and the configuration of their physical structure to mimic the appearance of virtually any living being. Skrulls can also transform body parts into weapons like blades or clubs, or conceal themselves as inanimate objects, making them perfect warriors and spies. In addition, their internal organs can shift positions freely to allow them to avoid severe damage from wounds that would otherwise be fatal.

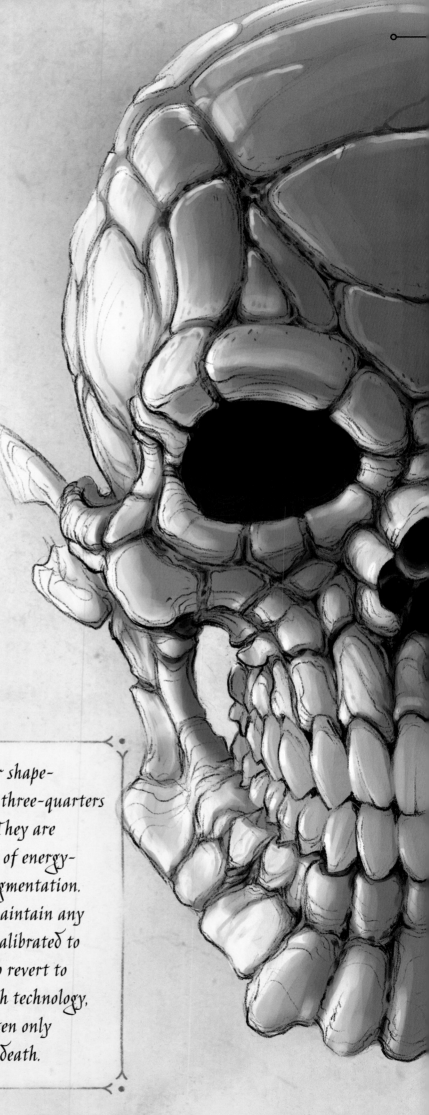

Fortunately, Skrulls do have limits to their shape-shifting abilities. Most can only shrink to three-quarters of their natural height or grow 50 percent taller. They are also incapable of naturally reproducing the effects of energy-based super-powers without significant genetic augmentation. Intense concentration is required for a Skrull to maintain any altered form, suggesting that equipment properly calibrated to disrupt Skrull neural patterns might force them to revert to their standard genetic configuration. Without such technology, however, detecting a clandestine Skrull agent is often only possible when they return to their base state upon death.

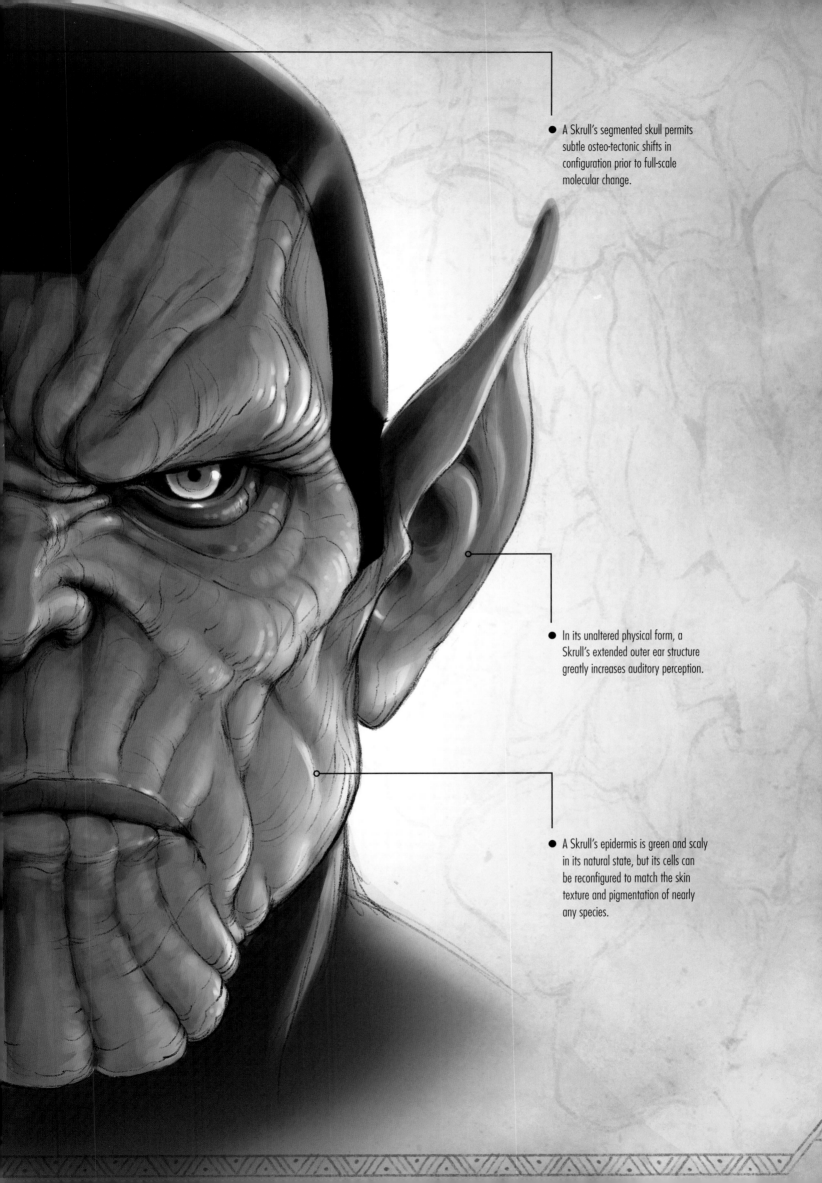

● A Skrull's segmented skull permits subtle osteo-tectonic shifts in configuration prior to full-scale molecular change.

● In its unaltered physical form, a Skrull's extended outer ear structure greatly increases auditory perception.

● A Skrull's epidermis is green and scaly in its natural state, but its cells can be reconfigured to match the skin texture and pigmentation of nearly any species.

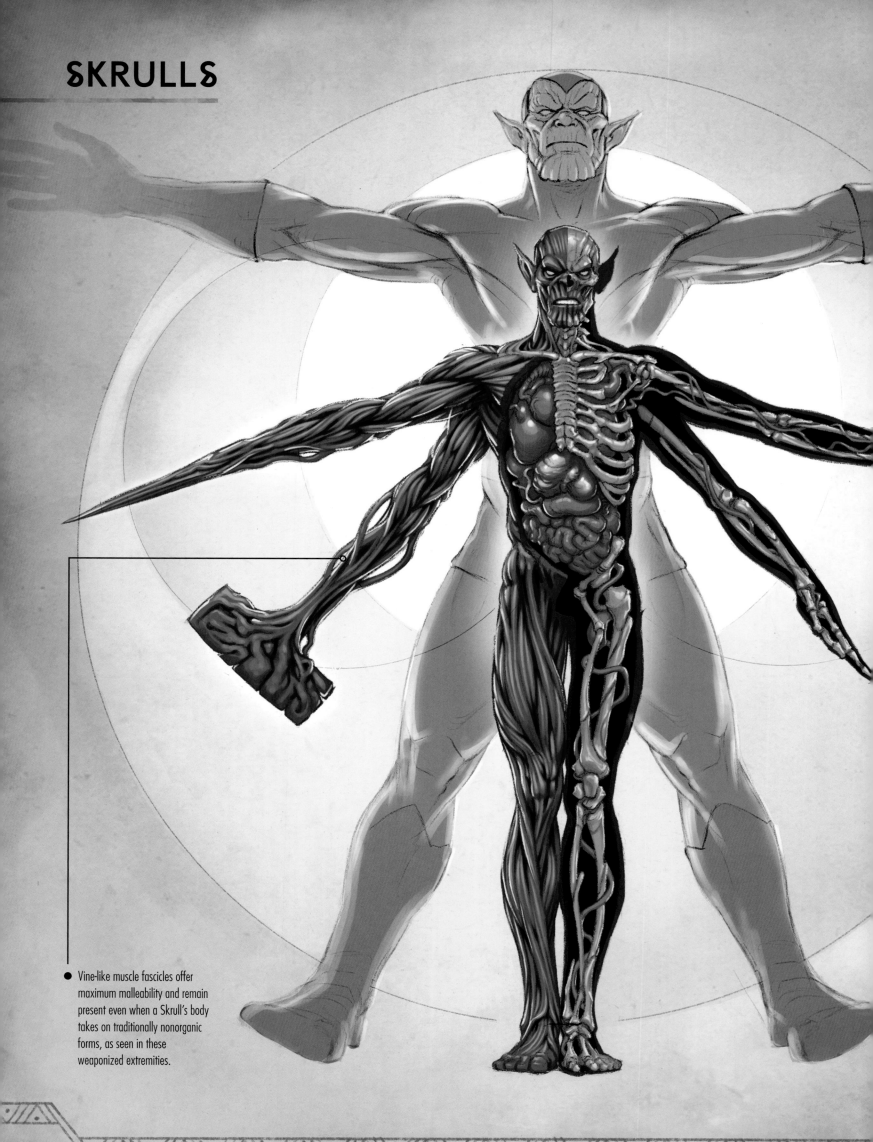

SKRULLS

- Vine-like muscle fascicles offer maximum malleability and remain present even when a Skrull's body takes on traditionally nonorganic forms, as seen in these weaponized extremities.

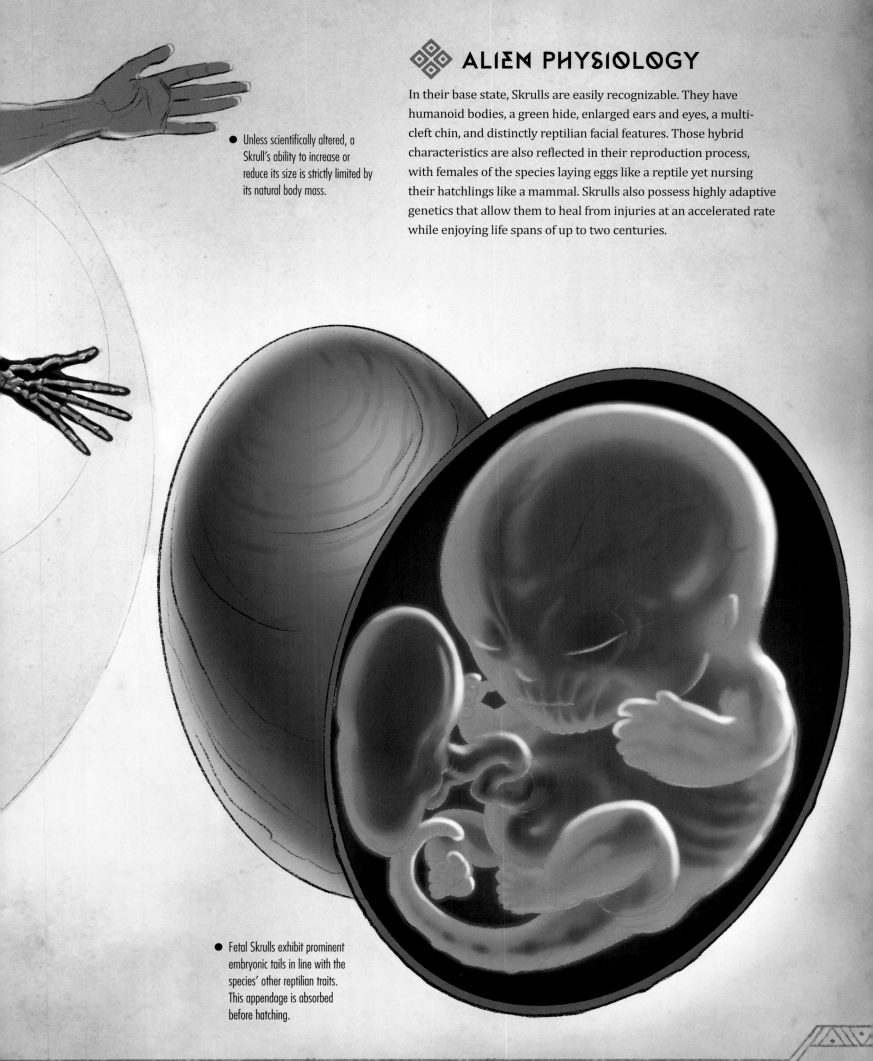

ALIEN PHYSIOLOGY

In their base state, Skrulls are easily recognizable. They have humanoid bodies, a green hide, enlarged ears and eyes, a multi-cleft chin, and distinctly reptilian facial features. Those hybrid characteristics are also reflected in their reproduction process, with females of the species laying eggs like a reptile yet nursing their hatchlings like a mammal. Skrulls also possess highly adaptive genetics that allow them to heal from injuries at an accelerated rate while enjoying life spans of up to two centuries.

● Unless scientifically altered, a Skrull's ability to increase or reduce its size is strictly limited by its natural body mass.

● Fetal Skrulls exhibit prominent embryonic tails in line with the species' other reptilian traits. This appendage is absorbed before hatching.

SKRULLS

- A Skrull cell scientifically enhanced to imbue it with an exceptionally durable, rock-like exterior

- Beyond their genetically augmented power sets, Super-Skrulls also retain their species' natural ability to alter their shape and appearance.

◈ SUPER-SKRULLS

When their subterfuge gives way to full-scale war, Skrulls unleash the most powerful members of their species. These are the Super-Skrulls, artificially augmented soldiers that can replicate the abilities of super-powered beings. One notable Super-Skrull, Kl'rt, is capable of reproducing the combined abilities of the Fantastic Four all at the same time. It is important to note that the capacity to mimic energy-based super-powers is not inherent in a Skrull's natural morphology. As such, Super-Skrulls acquire their range of enhanced abilities through extensive bionic engineering that links them to a source of cosmic energy. I believe the distinct energy signature released when a Super-Skrull employs its enhanced powers would directly conflict with the baseline energy readings of the individual they are impersonating, allowing for immediate detection. As such, it is my theory that the Skrulls would not risk employing their Super-Skrull forces at this stage of their invasion plans.

ASSESSMENT

Even when we have been blind to their presence, the Skrulls have been a danger to this world. Due to their physical adaptability, we have no way of knowing how many Skrull agents are currently embedded on Earth. Now that their presence has been discovered, we must assume that they will accelerate their quest for domination—a plan that I fear may already be much further along than any of us imagine.

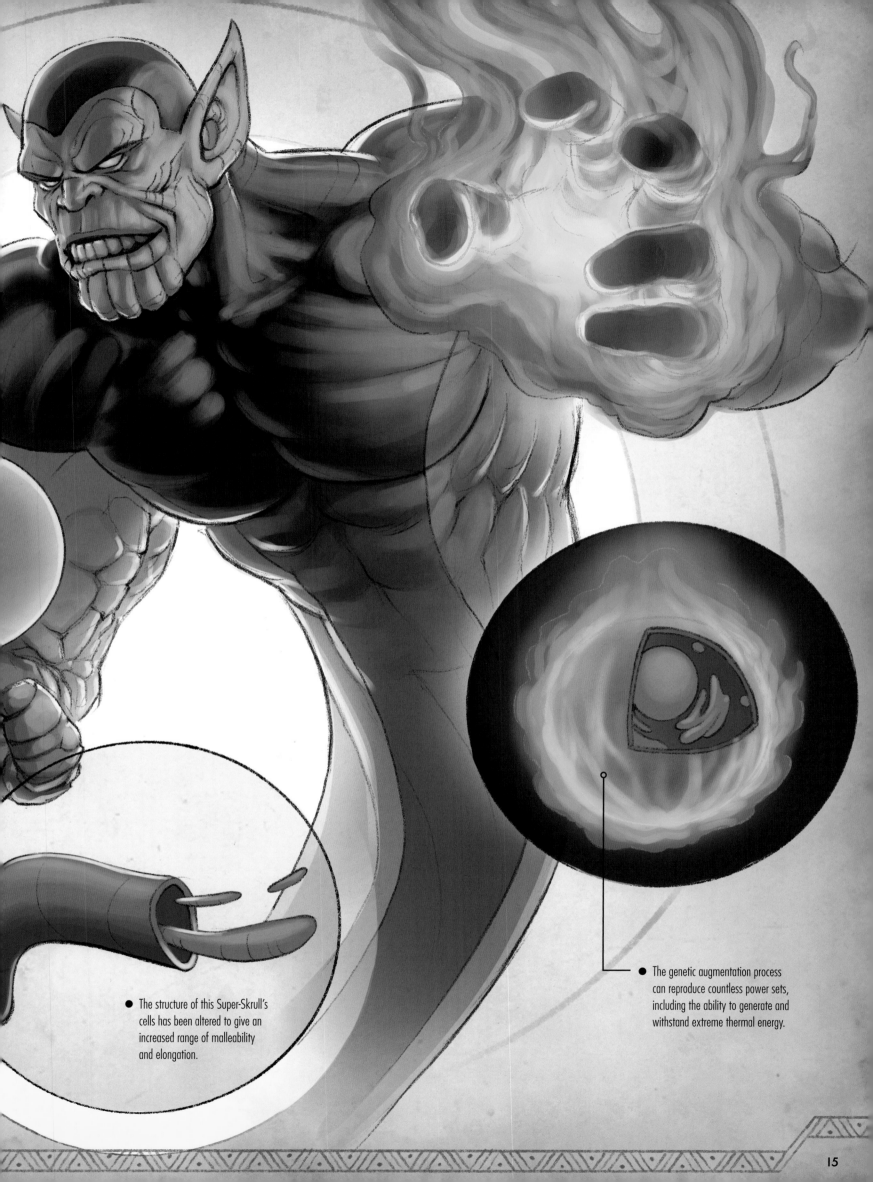

● The structure of this Super-Skrull's cells has been altered to give an increased range of malleability and elongation.

● The genetic augmentation process can reproduce countless power sets, including the ability to generate and withstand extreme thermal energy.

2
WONDERS OF SCIENCE

Since the dawn of time, we humans have overcome countless challenges to ensure our own survival. The development of science revolutionized human society, elevating humankind far beyond the limits of our biology. This progress has led to the emergence of individuals who can only be classed as superhuman. Many of these unique specimens have become champions, while others remind us of the horrors of scientific overreach. All of them are indisputable wonders.

Here, we shall explore human subjects with non-native genetic modifications resulting from experiments or accidents, as well as those who rely on scientific systems to access their biological powers. Individuals whose powers stem from cybernetic implants, cosmic rays, and natural mutations will be examined later.

ANT-MAN AND THE WASP

Heroes come in all shapes and sizes, and nowhere is that factor more relevant than in the case of Ant-Man and the Wasp. Both owe their powers to subatomic particles discovered by (and named after) Dr. Henry Pym. Upon discovering that Pym Particles could allow him to shrink to an insect's height or grow to the size of a skyscraper, Dr. Pym became the original Ant-Man. His partner, Janet van Dyne, assumed the identity of the Wasp.

◆◇◆ PYM PARTICLES

Extradimensional in origin, Pym Particles can increase or reduce the size and mass of any object through a method dubbed "hyperphasing." When shrinking an object using Pym Particles, matter is shunted into the alternate dimension of Kosmos to facilitate the loss of mass associated with the reducing process. Expanding an object with Pym Particles necessitates matter being pulled from that same dimension. The law of conservation of mass states that the total amount of mass and energy in the universe must remain constant. Therefore, any extraordinary increases or decreases of mass or energy are impossible— unless extradimensional sources can provide an end run around our reality's laws.

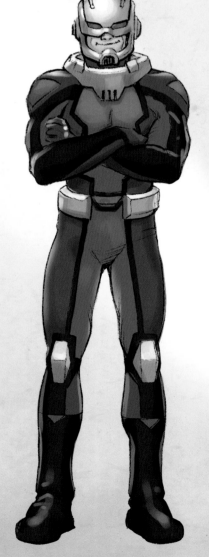

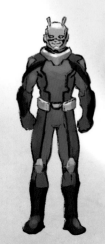

ANT-MAN CAN ACHIEVE A WIDE RANGE OF SIZES BY SHIFTING MASS TO OR FROM AN ALTERNATE DIMENSION CALLED KOSMOS.

● INCREASED STATURE ● BASELINE HEIGHT (APPROX. 6 FEET) ● PARTIALLY MINIMIZED ● REDUCED TO INSECT SIZE

Pym originally harnessed the transformative powers of Pym Particles by infusing them into a gaseous compound that could be inhaled. Sustained exposure to the particles leads to cellular saturation and genetic alterations, essentially granting permanent size-changing powers without the need for an external catalyst. The current Ant-Man, Scott Lang, and the Wasp have both achieved saturation levels sufficient to activate their latent Pym Particles on command.

◆ SIZE-CHANGING

Both Ant-Man and the Wasp can comfortably shrink and grow within a range of approximately half an inch to 50 feet in height. These transformations have been known to cause mental and physical strain, primarily when pushing to exceed the upper or lower limits of this range. Shrinkage far below half an inch has been achieved numerous times with sufficient quantities of Pym Particles, permitting passage into the subatomic realm of the Microverse. Similarly, Pym Particles can be used to grow to sizes beyond our dimensional boundaries to enter the realm known as Overspace (a domain that seemingly exists beyond the bounds of three-dimensional space, inhabited by godlike entities). Entry into sub- and post-atomic planes carries significant risks for the inexperienced, including disorientation that could prevent a subject from being able to return to their home dimension.

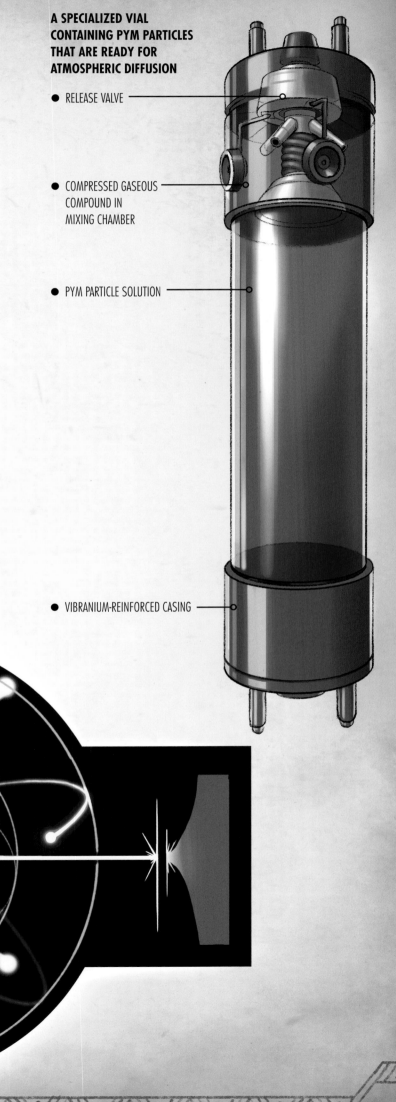

A SPECIALIZED VIAL CONTAINING PYM PARTICLES THAT ARE READY FOR ATMOSPHERIC DIFFUSION

- RELEASE VALVE
- COMPRESSED GASEOUS COMPOUND IN MIXING CHAMBER
- PYM PARTICLE SOLUTION
- VIBRANIUM-REINFORCED CASING

A THEORETICAL MODEL OF EXTRADIMENSIONAL MATTER HYPERPHASING THROUGH THE UNSTABLE CORE OF A PYM PARTICLE

ANT-MAN AND THE WASP

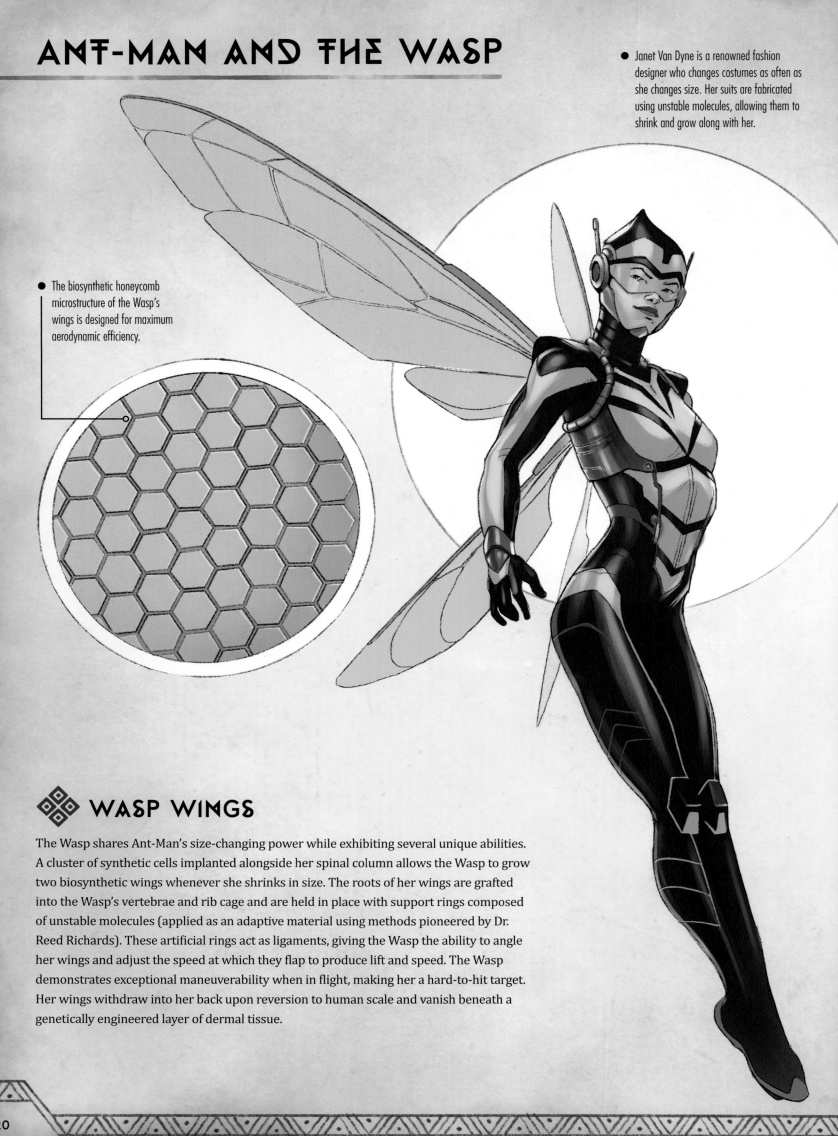

● Janet Van Dyne is a renowned fashion designer who changes costumes as often as she changes size. Her suits are fabricated using unstable molecules, allowing them to shrink and grow along with her.

● The biosynthetic honeycomb microstructure of the Wasp's wings is designed for maximum aerodynamic efficiency.

◈ WASP WINGS

The Wasp shares Ant-Man's size-changing power while exhibiting several unique abilities. A cluster of synthetic cells implanted alongside her spinal column allows the Wasp to grow two biosynthetic wings whenever she shrinks in size. The roots of her wings are grafted into the Wasp's vertebrae and rib cage and are held in place with support rings composed of unstable molecules (applied as an adaptive material using methods pioneered by Dr. Reed Richards). These artificial rings act as ligaments, giving the Wasp the ability to angle her wings and adjust the speed at which they flap to produce lift and speed. The Wasp demonstrates exceptional maneuverability when in flight, making her a hard-to-hit target. Her wings withdraw into her back upon reversion to human scale and vanish beneath a genetically engineered layer of dermal tissue.

According to Galileo's square-cube law of physics, as an object grows in size, its surface area increases quadratically while its volume increases cubically. This implies that if Ant-Man grows ten times his height, he would automatically be a thousand times as heavy, rendering him immobile. Since this is not the case, it is possible that Pym Particles are able to bypass Galileo's law by keeping the user at whatever level of mass is needed for them to retain functionality. This theory has been backed up by research from Scott Lang, who speculates that Pym Particles are able to work on three simultaneous axes. If this theory is correct, skilled users of Pym Particles can manipulate their size, strength, and durability as needed to respond to differing threats. In this manner, an inch-high Ant-Man would be able to strike a target with the comparable strength of a full-size human, a fact supported by our observations of these size-changing heroes.

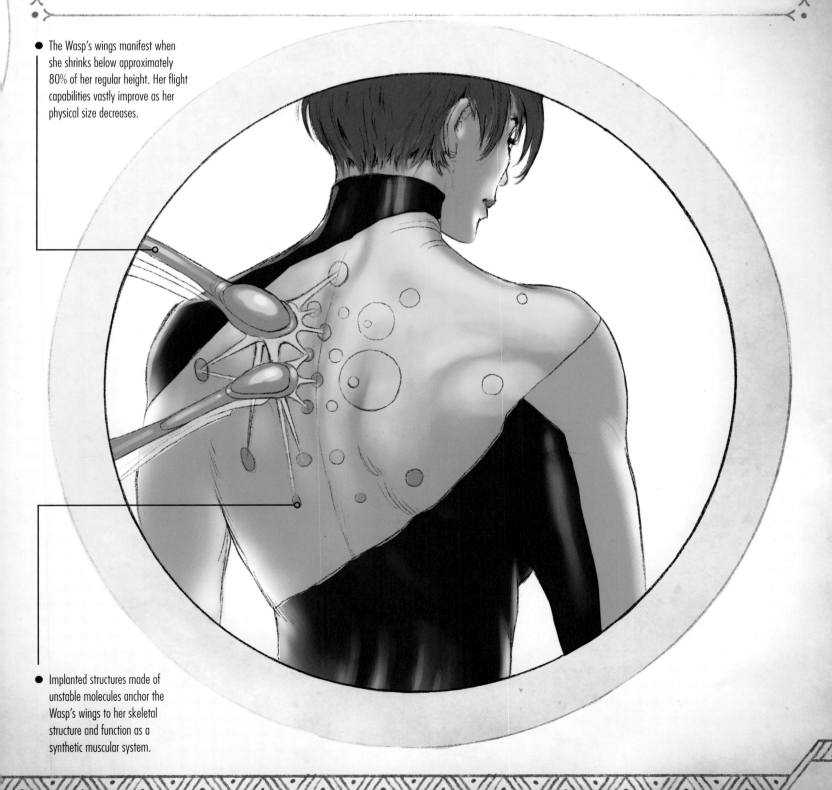

● The Wasp's wings manifest when she shrinks below approximately 80% of her regular height. Her flight capabilities vastly improve as her physical size decreases.

● Implanted structures made of unstable molecules anchor the Wasp's wings to her skeletal structure and function as a synthetic muscular system.

ANT-MAN AND THE WASP

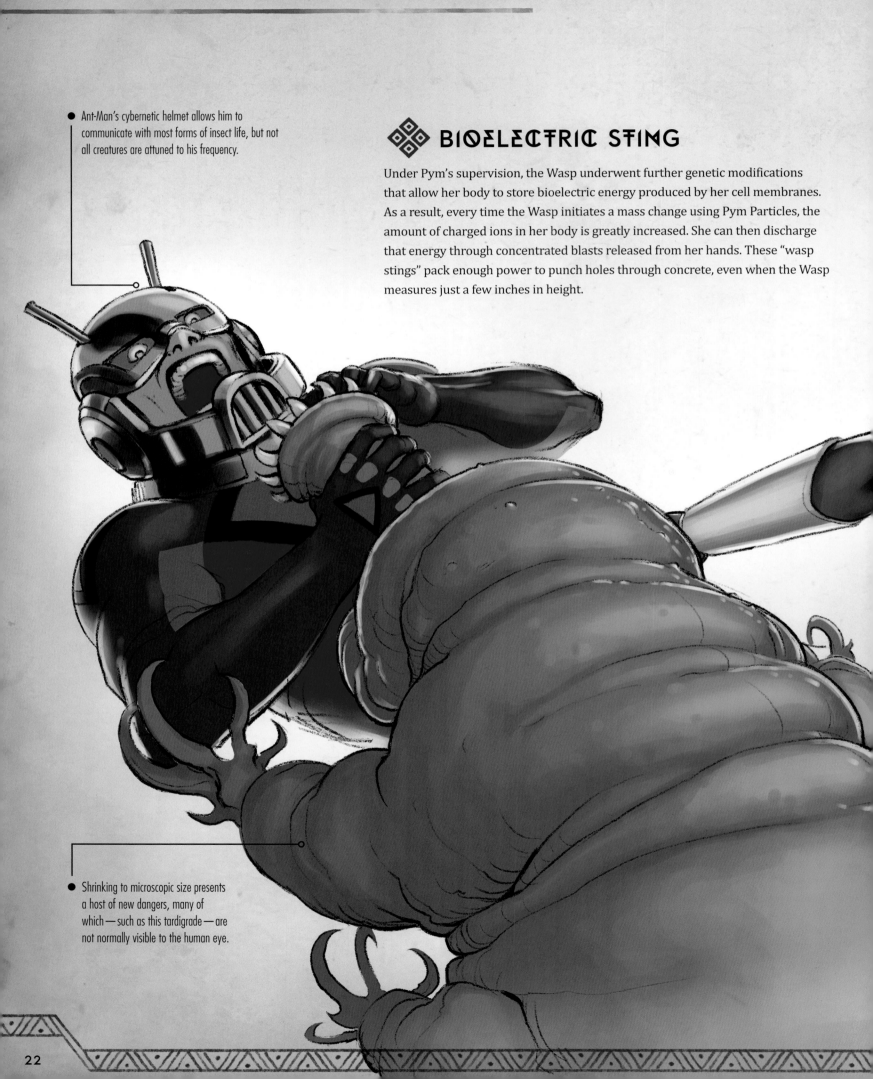

● Ant-Man's cybernetic helmet allows him to communicate with most forms of insect life, but not all creatures are attuned to his frequency.

◈ BIOELECTRIC STING

Under Pym's supervision, the Wasp underwent further genetic modifications that allow her body to store bioelectric energy produced by her cell membranes. As a result, every time the Wasp initiates a mass change using Pym Particles, the amount of charged ions in her body is greatly increased. She can then discharge that energy through concentrated blasts released from her hands. These "wasp stings" pack enough power to punch holes through concrete, even when the Wasp measures just a few inches in height.

● Shrinking to microscopic size presents a host of new dangers, many of which — such as this tardigrade — are not normally visible to the human eye.

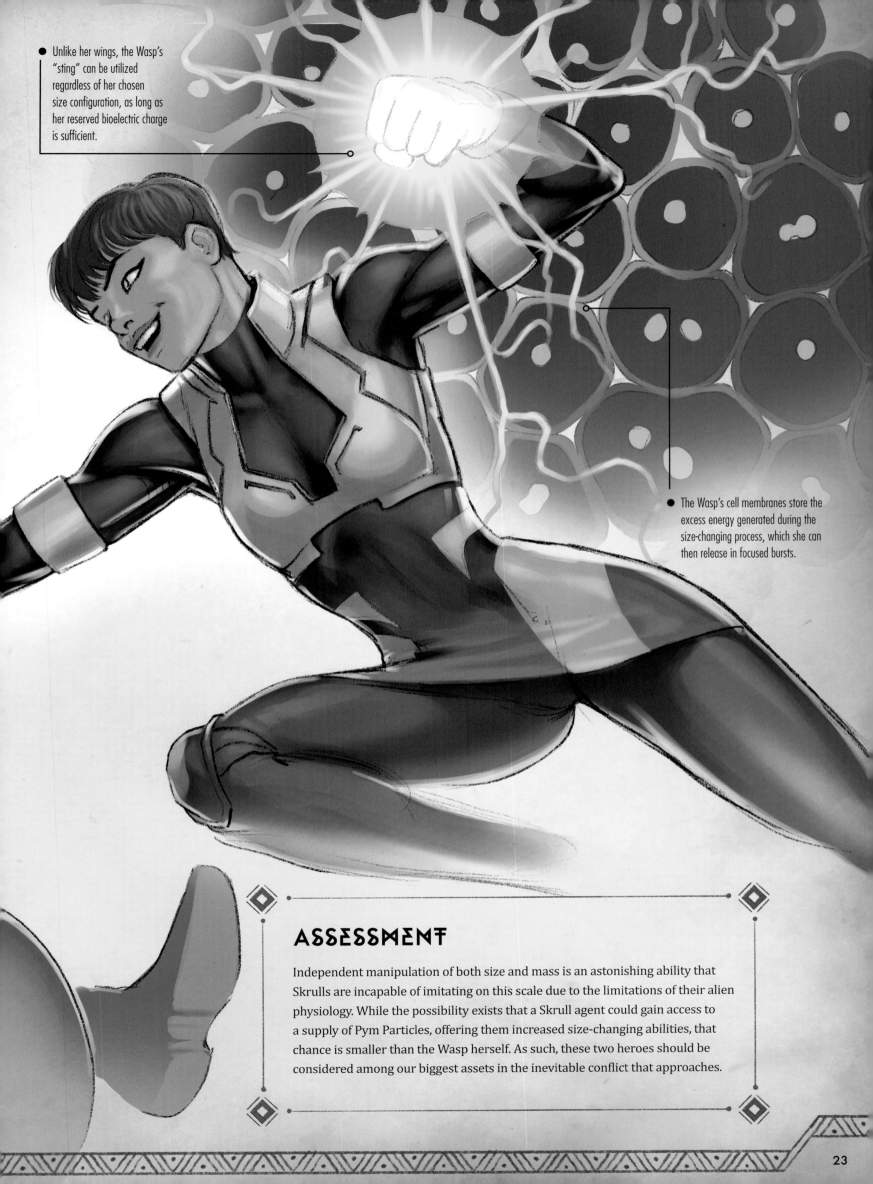

● Unlike her wings, the Wasp's "sting" can be utilized regardless of her chosen size configuration, as long as her reserved bioelectric charge is sufficient.

● The Wasp's cell membranes store the excess energy generated during the size-changing process, which she can then release in focused bursts.

ASSESSMENT

Independent manipulation of both size and mass is an astonishing ability that Skrulls are incapable of imitating on this scale due to the limitations of their alien physiology. While the possibility exists that a Skrull agent could gain access to a supply of Pym Particles, offering them increased size-changing abilities, that chance is smaller than the Wasp herself. As such, these two heroes should be considered among our biggest assets in the inevitable conflict that approaches.

CAPTAIN AMERICA

Though he wears the flag of another nation, there are few more devoted to the protection of my homeland than Captain America. Decades before we joined forces as Avengers teammates, the Captain fought alongside my grandfather to defend Wakanda from invasion, forging an alliance with my nation that he continues to honor to this day.

ENHANCED PHYSIOLOGY

Captain America is "peak" human. Ostensibly, he exhibits the maximum degree of strength, speed, and acrobatic agility that can theoretically be achieved by our planet's top weight lifters, track runners, and Olympic gymnasts. While this puts him at a disadvantage against those who can heft assault tanks in one hand, his indomitable spirit is more than a match for any superhuman foe.

He achieved his optimized biology through a process developed in the 1940s by German defector Dr. Abraham Erskine on behalf of the U.S. military. Erskine's subject, Steven Rogers, had been rejected from military service for his scrawny frame and sickly constitution, but his strength of spirit impressed the scientist and so Erskine recruited Rogers as the initial test subject for Project Rebirth.

Project Rebirth consisted of two stages. First, subjects would be intravenously inoculated with a unique chemical formula. Next, they would receive a bombardment of invisible vita-rays to activate the serum's effects. In the case of Steve Rogers, the successful combination of these factors spurred the rapid growth of millions of new cells, bulking up his musculature and even expanding his mental capacity. After emerging from the vita-ray chamber, Rogers was perhaps the most perfect human ever to walk this planet, which made it even more tragic when a Nazi saboteur killed Dr. Erskine before the process could be replicated. Captain America became the only one of his kind—the chemical makeup of the serum and the specific wavelengths of the related vita-ray bath forever lost with Erskine.

● **STAGE 1:** The Super-Soldier serum is introduced into the subject's bloodstream, awaiting activation by vita-rays.

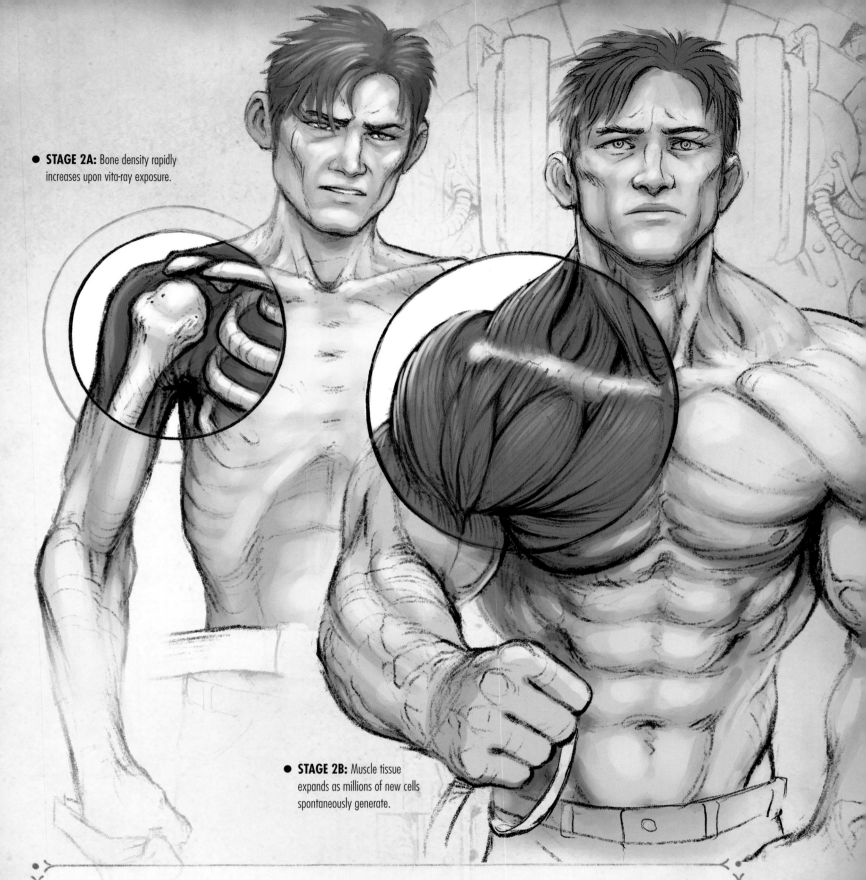

STAGE 2A: Bone density rapidly increases upon vita-ray exposure.

STAGE 2B: Muscle tissue expands as millions of new cells spontaneously generate.

I believe Dr. Erskine was influenced by the theory of epigenetics: specifically, the process by which biological changes can result from modified gene expressions. For example, rather than completely rewriting the DNA of his test subject, Erskine used his groundbreaking process to selectively activate traits in Steve Rogers' existing genetic makeup. Rogers remained himself, just better, with each gene pushed to the absolute limits of human potential. Despite his advanced age, Rogers remains invigorated by the Super-Soldier serum, which is continuously replicated within the freshly enhanced cells in his bloodstream.

CAPTAIN AMERICA

The Super-Soldier serum sustained Captain America throughout World War II and even staved off hypothermia during the decades he spent in a frozen, ametabolic state inside a block of ice. After awakening from his stretch of suspended animation, Rogers discovered that his body had suffered negligible deterioration. Only his mind needed assistance in order to become acclimated to a world that had moved on without him.

● Born over 100 years ago, Steve Rogers still possesses the physiology of a peak athlete in his twenties.

● Captain America delivers justice with fists honed through rigorous combat training.

PEAK-HUMAN ATTRIBUTES

Captain America's biochemistry is bolstered by optimized blood circulation and enhanced delivery of nutrients and lymph fluids. These heightened processes facilitate the flushing of toxins from his body at a much higher rate than any standard human, allowing him to maintain maximum exertion for long periods without buildup of a lactic acid by-product in his muscles. The Captain can run at speeds of up to 30 miles per hour and lift more than three times his body weight. His flexibility and reflexes enable him to easily master such diverse combat forms as judo, jujitsu, and karate.

Most famously, Captain America has developed a unique combat mastery centered on the use of his circular shield, which is made from a near-indestructible combination of Vibranium and an experimental form of Adamantium. Rogers can hurl his shield and incapacitate multiple enemies through chained ricochets—a maneuver achieved through relentless high-precision training, but one that would not be possible without augmented arm strength and cognitive enhancement that boosts combat awareness.

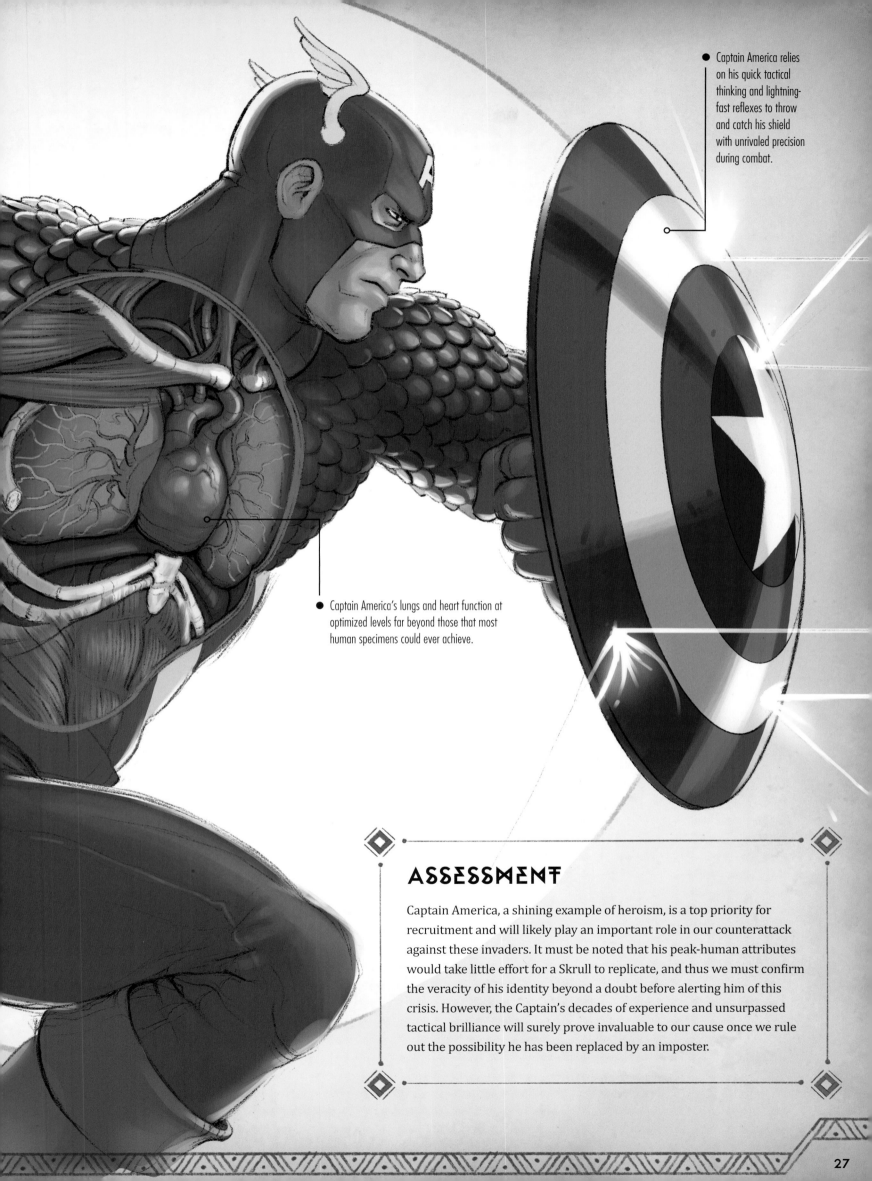

Captain America relies on his quick tactical thinking and lightning-fast reflexes to throw and catch his shield with unrivaled precision during combat.

Captain America's lungs and heart function at optimized levels far beyond those that most human specimens could ever achieve.

ASSESSMENT

Captain America, a shining example of heroism, is a top priority for recruitment and will likely play an important role in our counterattack against these invaders. It must be noted that his peak-human attributes would take little effort for a Skrull to replicate, and thus we must confirm the veracity of his identity beyond a doubt before alerting him of this crisis. However, the Captain's decades of experience and unsurpassed tactical brilliance will surely prove invaluable to our cause once we rule out the possibility he has been replaced by an imposter.

DAREDEVIL

Famous for defending the streets of New York City's Hell's Kitchen, Daredevil lost his sight at a young age when a freak accident led to his eyes being doused with a radioactive chemical. As he adjusted to permanent blindness, the boy discovered that his remaining senses had been heightened to superhuman sharpness. Able to perceive his surroundings in a whole new way, Daredevil became a powerful ally of the downtrodden.

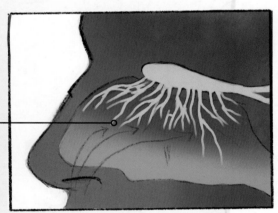

● Daredevil's nasal cavity contains extended olfactory nerve fibers with enhanced receptive capacity.

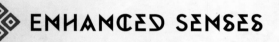 ## ENHANCED SENSES

Daredevil possesses enhanced hearing, smell, taste, and touch, presumably as the result of mutagenic alterations to his brain's parietal lobe triggered by exposure to radioactive material. Specifically, Daredevil's somatosensory cortex—the area of the brain that receives and interprets sensory input—is exceptional in its ability to process incoming signals from Daredevil's enhanced senses, enabling him to assemble a detailed picture of his surroundings despite his lack of sight.

Even the most minute vibration in Daredevil's environment is perceived as a sound wave by his inner ear and then filtered and translated by his enhanced brain. As such, he can hear whispered voices through a soundproof wall or a heartbeat from across a busy street. Daredevil's ears perceive changes in acoustic pressure in nonauditory frequencies extending into ranges including infrasonic (used for communication by elephants and whales, among others) and ultrasonic (used by animals including dogs and bats).

The olfactory receptors in Daredevil's nose can detect atmospheric odors at concentrations as low as 30 parts per million, useful for identifying trace amounts of chemicals and contaminants. He can identify virtually anyone he has ever met by scent alone, even in dense crowds and at distances of up to 50 feet.

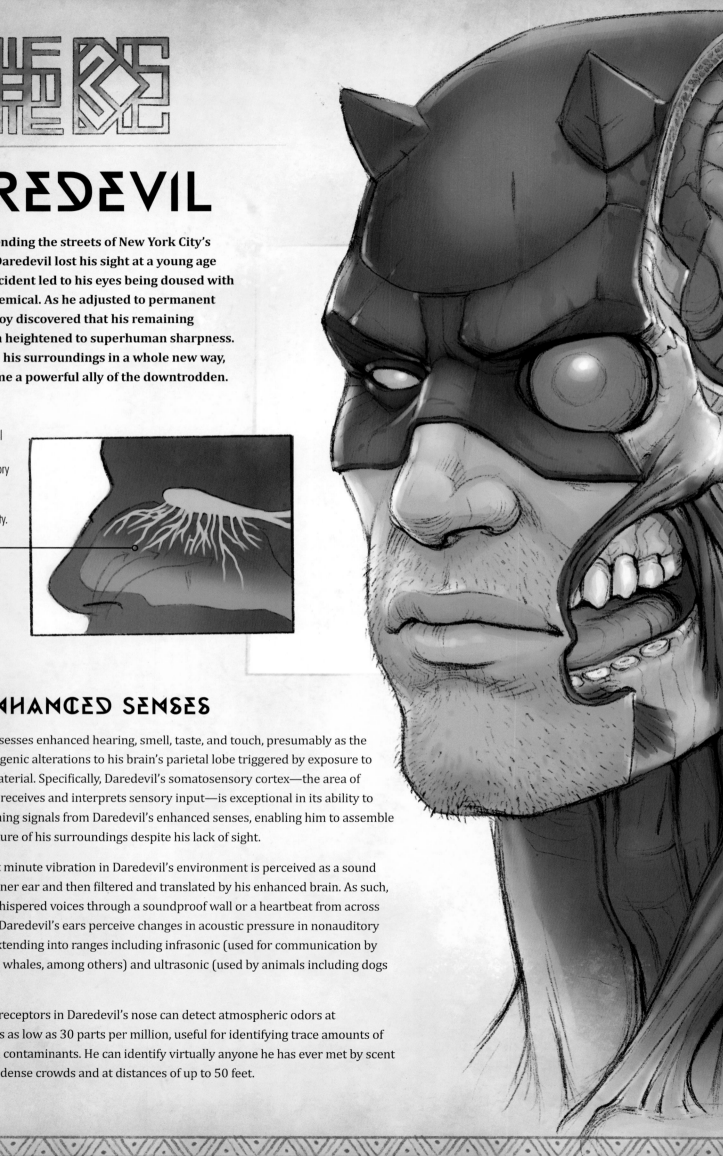

● Daredevil's parietal lobe processes sensory input at an exponentially higher rate than the average human brain.

● Despite the lack of apparent physical augmentation, Daredevil's inner ears can sense changes in sound and pressure completely imperceptible to most humans.

Through taste, Daredevil can identify almost any substance, including poisons and toxins, at concentrations as low as 20 milligrams. Because he does not appear to possess an increased number of fungiform papillae (the structures containing taste buds at the back of the tongue), his sensitivity is likely due to the radiation-induced development of specific genes related to flavor distinction.

Every inch of Daredevil's skin contains ultrasensitive touch receptors that can pick up on minuscule changes in the temperature and humidity of the surrounding atmosphere, as well as air displacement generated by a moving body. These receptors are so attuned to variations in surface contours that Daredevil can read books just by running his fingertips across the impressions left by the ink on a printed page.

DAREDEVIL

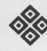 ## RADAR SENSE

Perhaps even more fascinating than Daredevil's enhanced physical senses is his unique "radar sense" that compensates for his lack of sight. This ability allows Daredevil to detect the placement and proximity of surrounding objects at a range of 100 feet, his brain rendering these impressions as a monochromatic, three-dimensional mental image. Daredevil's radar sense makes him immune to the effects of absolute darkness and blinding light, but plate glass and torrential rainfall—which represent spatial barriers despite their visual transparency—can interfere with his perception in ways that a sighted person would not experience.

ASSESSMENT

Though the Skrulls have found a way to avoid detection by our most advanced technology, perhaps Daredevil's extrasensory abilities will offer another unexpected path to discovering the alien agents hiding among us. While Skrulls can duplicate a being's external appearance without a flaw, Daredevil's hyperacute senses would likely be able to "see" beyond that cover. If he is capable of hearing minute differences in the functions of a Skrull's organs or of smelling traces of the unique chemicals released by their alien physiologies, he may help us identify potential threats before they can strike. That is, if he himself has not already been replaced, given his relatively standard human physiology.

One explanation for Daredevil's enhanced perception I have considered is that his radar sense is similar to sonar-meaning that he uses the echoes of reflected sounds to map out the distances separating one object from the next. A secondary possibility is that the radioactive chemical that triggered his powers may have enabled a latent mutation already present in his genetic makeup, namely the ability to emit low-level electromagnetic waves that allow him to construct detailed topographic renderings in his mind's eye.

WAKANDAN SONIC MAPPING TECHNOLOGY OFFERS AN APPROXIMATION OF WHAT DAREDEVIL MIGHT "SEE" USING HIS RADAR SENSE.

HULK

Scientific advancements have empowered some of our world's most valiant defenders but are also responsible for unparalleled horrors. Depending on his mood, the Hulk has been both. Having faced this jade giant as both friend and foe, the only thing I can say with certainty is that he must never be underestimated.

 ## GAMMA MUTATION

After accidental exposure to gamma radiation at a military site, Dr. Robert Bruce Banner—a scientist working on a gamma bomb project—was transformed into a green-skinned goliath.

Since, as stated previously, the law of conservation of mass states that matter cannot manifest from nowhere, I theorize that an extradimensional energy transference is responsible for the hyper-accelerated addition of hundreds of pounds of bulk to Banner's modest frame. Perhaps, as the gamma energy irradiated and mutated his cells, Banner's unconscious brain somehow forged a neural pathway that allowed him to shunt this gamma energy into an alternate dimension and receive super-powered sinew in return.

When the Hulk reverts to Banner, he seemingly deflects his extra mass back into the same gamma dimension.

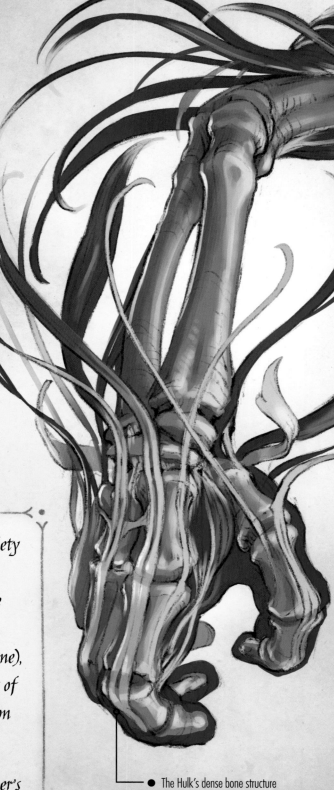

The Hulk's dense bone structure is surrounded by heavy layers of gamma-enriched musculature anchored by tendons stronger than steel cables.

Although the Hulk's emergence has been initiated by a variety of external stimuli over the years, including the day/night cycle, the most common trigger for his transformation is an extreme level of anger. Such incidents cause the subject's adrenal medulla to secrete unusually high levels of epinephrine (also known as adrenaline), in the same way that humans experience a hormonal surge in times of emotional stress, a boost that allows them to optimize their perception and physical abilities.

The level of adrenaline secreted might also impact the speed of Banner's transformation process, the duration of which has been charted at anywhere between five seconds to five minutes. However, the Hulk has shown the ability to maintain his gamma-enhanced physiology during periods of sustained calm, making me question whether the triggers for his metamorphosis run deeper than mere physiology.

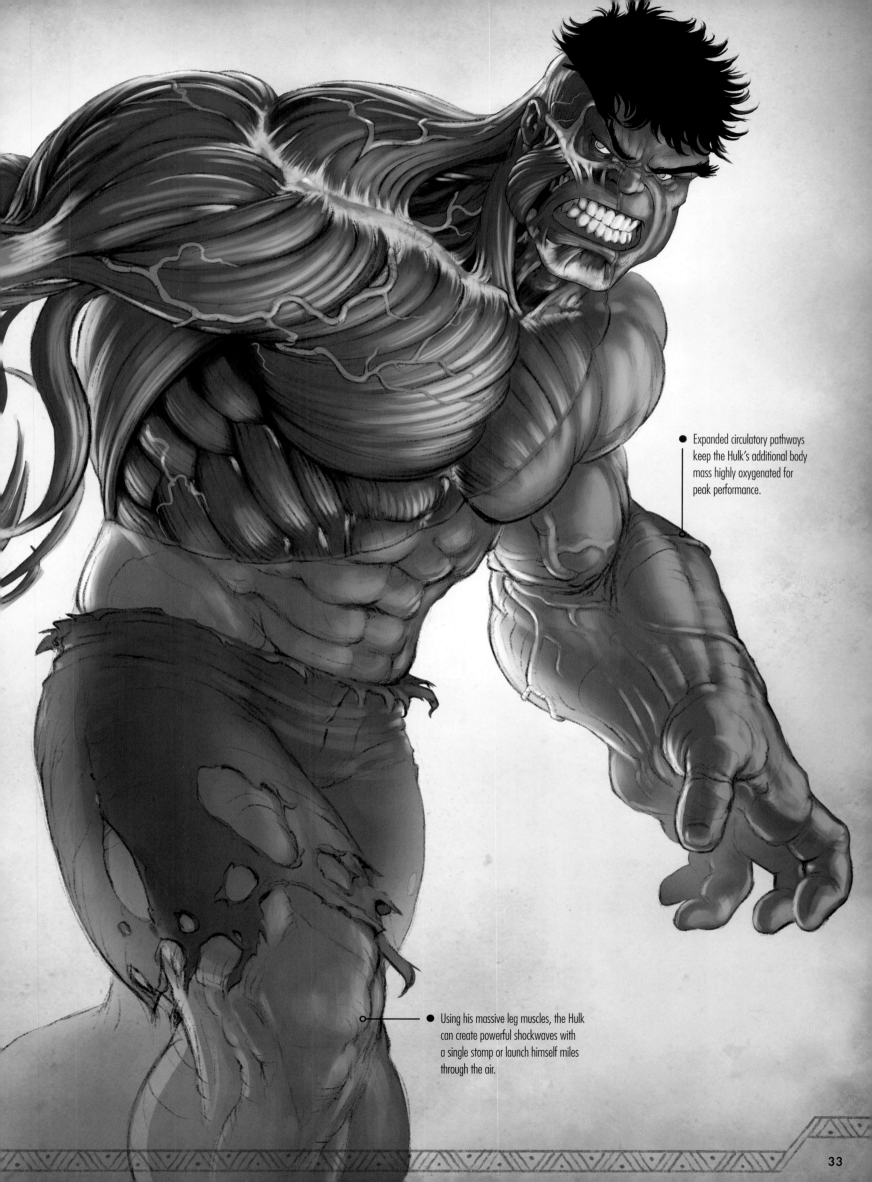

Expanded circulatory pathways keep the Hulk's additional body mass highly oxygenated for peak performance.

Using his massive leg muscles, the Hulk can create powerful shockwaves with a single stomp or launch himself miles through the air.

HULK

◆ STRENGTH

The Hulk is one of the strongest beings that has ever lived, easily able to lift over 100 tons. Yet this is certainly not his upper limit, and no tests have established a ceiling for the Hulk's physical abilities. Scans suggest that the Hulk's musculature contains an unusually high density of myofibrils—chains of muscle cells that contribute to muscle mass. This abnormal musculature is animated by tendons and ligaments as strong as Vibranium-weave industrial cable. The bones that make up the Hulk's skeleton are nearly unbreakable and provide a rock-solid support structure. In addition, when the Hulk enters an enraged state, the accompanying surge of adrenaline amplifies his raw strength. Therefore, his frequent refrain, "The madder Hulk gets, the stronger Hulk gets," is in fact rooted in scientific reality.

Lifting, hurling, and smashing are only a few of the expressions of the Hulk's strength. If he slaps both hands together with sufficient force, the Hulk can generate a directional shock wave that resembles a sonic boom. This wave of compressed air is accompanied by a thunderclap and generates a force of over 100 pounds per square foot, resulting in significant damage to the target and anything caught in the vicinity. A related phenomenon occurs when the Hulk stamps his feet—the action also generates a shock wave, but this one propagates through the ground below. The resulting seismic cascade can trigger earthquakes when deployed near continental fault lines.

Though the Hulk lacks flight abilities, his massive leg muscles can apply enough oppositional force against the substrate to propel him into the air. These tremendous leaps follow ballistic trajectories that have been measured at lengths of up to three miles and heights that nearly achieve low earth orbit.

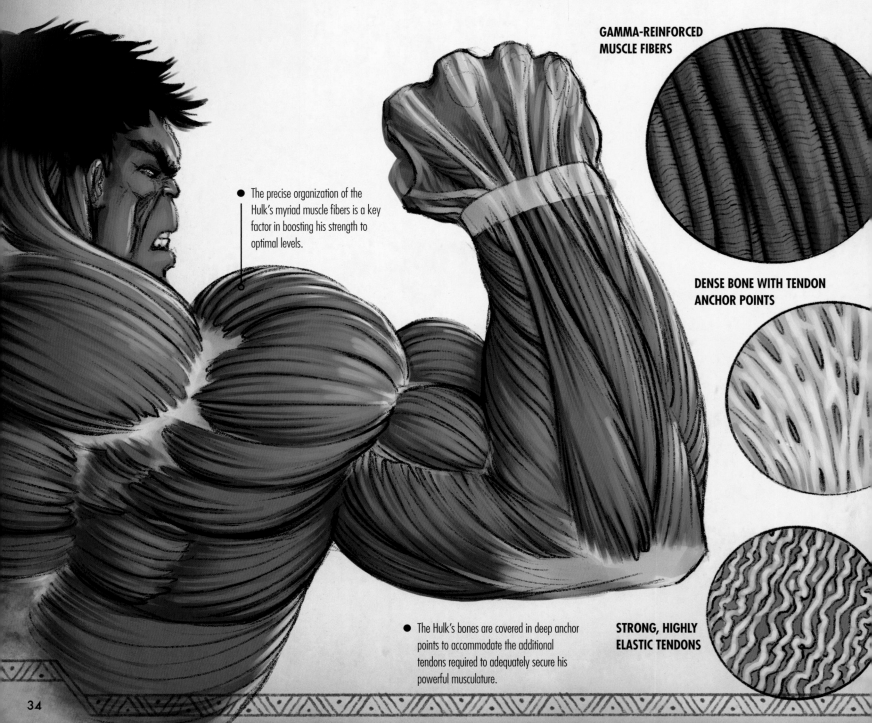

GAMMA-REINFORCED MUSCLE FIBERS

● The precise organization of the Hulk's myriad muscle fibers is a key factor in boosting his strength to optimal levels.

DENSE BONE WITH TENDON ANCHOR POINTS

● The Hulk's bones are covered in deep anchor points to accommodate the additional tendons required to adequately secure his powerful musculature.

STRONG, HIGHLY ELASTIC TENDONS

THEORIES ON POWER SOURCE

Research attributed to Dr. Banner's father (an esteemed government nuclear researcher) states that gamma radiation possesses a hidden state that is neither a wave nor a particle—a state generated from the extradimensional realm of "the One Below All," a being whose description is analogous to depictions of the devil in human folklore. While I understand better than most that some powers have a divine origin, I hesitate to classify this property of gamma energy as such until I have ruled out all other scientific explanations.

It is public knowledge that Dr. Bruce Banner has died multiple times only to return from the grave. My interpretation of the reports I received from Gamma Flight, an agency dedicated to the study of gamma-powered individuals, leads me to conclude that, at full power, the Hulk is essentially an immortal being. The Hulk's regenerative abilities have grown so strong that a gamma transformation can repair any damage to Banner's physical form, including injuries that would normally be fatal. Recent reports have suggested that other beings mutated by gamma radiation might share the Hulk's unusual resurrection capabilities.

HULK

My hypothesis is that Banner's mutation caused his cells to generate a unique gamma protein. This protein could bind to muscle receptors and induce the rapid micro-tearing and reformation of muscle fibers, working in concert with the extradimensional source that shunts raw mass into Banner's form without the need for caloric intake or metabolic growth. Furthermore, if such a unique protein is absorbed by the host's body, it could diffuse across the skin's epidermal layer, giving the Hulk his distinctive green hue.

This process would exponentially boost the strength of its subject, but I believe the same protein might also travel through the bloodstream to bind to chemical receptors in the brain. While it is well-documented that Banner suffers from dissociative identity disorder due to years of childhood abuse, the existence of such a protein could explain why the Hulk's alternate personalities (of which we have recognized no less than five distinct versions beyond Banner himself) are associated with unique physical changes in musculature and skin pigmentation. Because Banner's Hulk personalities also differ in their degree of intellect and social awareness, it seems clear that the triggers that govern a Hulk manifestation are psychological in nature (rage) with differing physiological effects (musculature).

The most common expression of Banner's Hulk identity is associated with his green-skinned appearance and usually presents with a childlike intellect. Other personalities that have surfaced include:

• Joe Fixit: A gray-skinned, tough-talking Hulk with ties to organized crime

• The Professor: A green-skinned Hulk who retains Banner's advanced intellect

• Devil Hulk: A green-skinned, malevolent Hulk with all of Banner's intelligence

• The Green Scar: A powerful state achieved by the Hulk during his time as the ruler of the gladiator planet Sakaar

I also theorize that Banner's body recognizes his mutated proteins as foreign antigens, leading his immune system to attack and destroy them. It would partially explain why the Hulk is able to return to his human form with so few side effects, though a more extensive analysis of the reversion process is needed if I hope to test this theory.

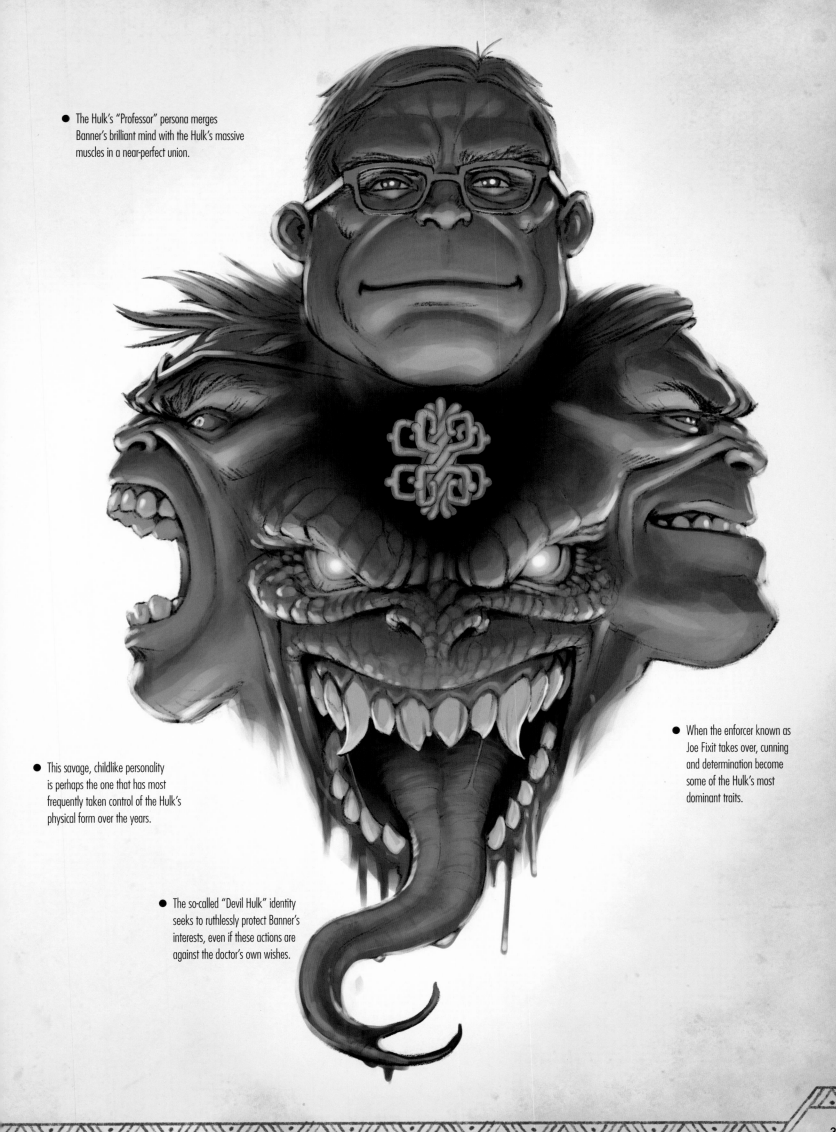

- The Hulk's "Professor" persona merges Banner's brilliant mind with the Hulk's massive muscles in a near-perfect union.

- This savage, childlike personality is perhaps the one that has most frequently taken control of the Hulk's physical form over the years.

- The so-called "Devil Hulk" identity seeks to ruthlessly protect Banner's interests, even if these actions are against the doctor's own wishes.

- When the enforcer known as Joe Fixit takes over, cunning and determination become some of the Hulk's most dominant traits.

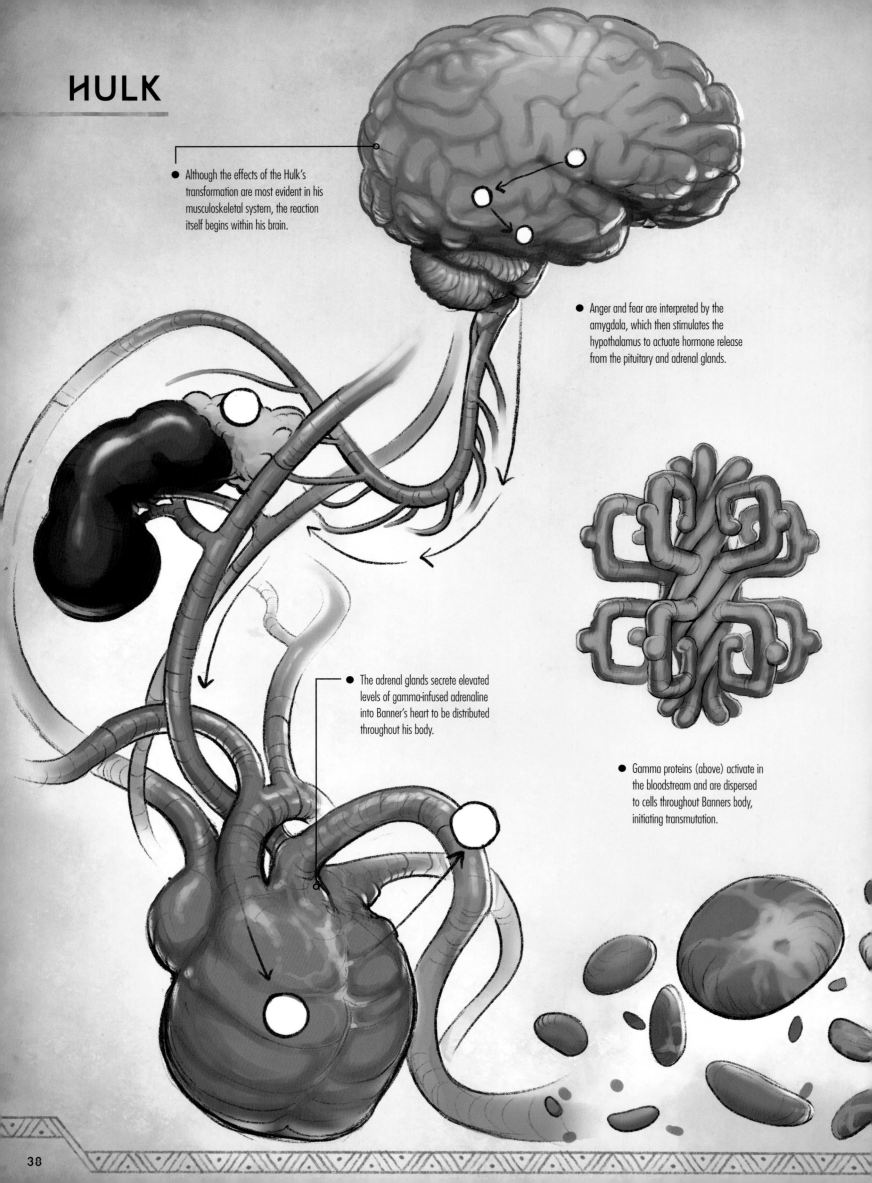

HULK

Although the effects of the Hulk's transformation are most evident in his musculoskeletal system, the reaction itself begins within his brain.

Anger and fear are interpreted by the amygdala, which then stimulates the hypothalamus to actuate hormone release from the pituitary and adrenal glands.

The adrenal glands secrete elevated levels of gamma-infused adrenaline into Banner's heart to be distributed throughout his body.

Gamma proteins (above) activate in the bloodstream and are dispersed to cells throughout Banners body, initiating transmutation.

DURABILITY AND HEALING

A gamma-fortified cellular structure has rendered the Hulk's body exceptionally durable and given him the ability to regenerate damaged tissue at a hyper-accelerated rate. Such an exceptional degree of cellular restoration seems to be a natural by-product of the Hulk's radiation-enhanced transmutation and may lend further support to the theory that the Hulk's physiology harnesses an extradimensional shortcut to gain the mass used in new cell growth. Just as the Hulk's cells can replicate to such a degree that the host's mass can increase by a factor of ten in mere seconds, they can easily replace damaged tissue through a similar process.

The Hulk's epidermal cells appear to have exceptionally durable membranes that insulate his nerve endings and help dull the sensation of pain, though the Hulk's nerves can still transmit pain signals to his brain in cases of life-threatening trauma. This numbing quality also makes the Hulk resistant to extreme temperatures. Witnesses have reported that the Hulk has survived swimming in flaming magma, indicating a trauma tolerance of at least 700 degrees centigrade. It's possible that the Hulk's epidermal cells are burned away by such exposure, but if so they are quickly replaced by new cells generated by rapid gamma growth.

His skin is essentially self-repairing armor that allows him to shrug off attacks from conventional weaponry and even those from other superhuman beings. The Hulk also appears to possess a natural immunity to disease and a high resistance to toxins and poisons. In addition, the Hulk can hold his breath for up to an hour with no impact on his performance, an ability that indicates his muscle tissue may store a high level of oxygen-rich myoglobin that can sustain him in oxygen-deficient environments. This would also explain how the Hulk has survived in the vacuum of space and in the deepest depths of the ocean without displaying any symptoms of oxygen deprivation.

ASSESSMENT

The Hulk may very well be the strongest being on the planet. While it would not be a tremendous feat for a Skrull to mimic the Hulk's physical characteristics, there is little chance an imposter could come close to replicating his raw strength, making the true Hulk instantly identifiable the very second he begins to "smash." It is absolutely vital that the Hulk play a part in our counterattack. Despite his volatile temper, the Hulk has always proven to be an ally when our world is in peril.

As gamma proteins bond with cells and change their hue, muscle fibers rapidly expand, drawing additional mass from an extradimensional source.

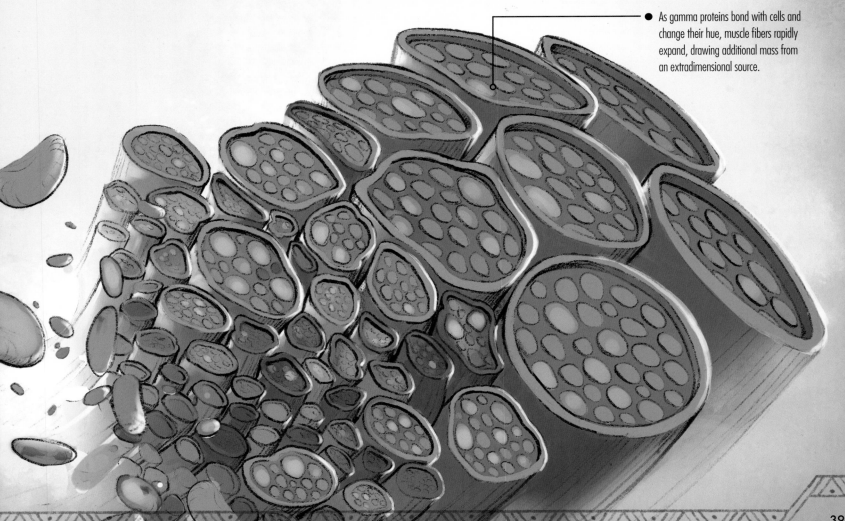

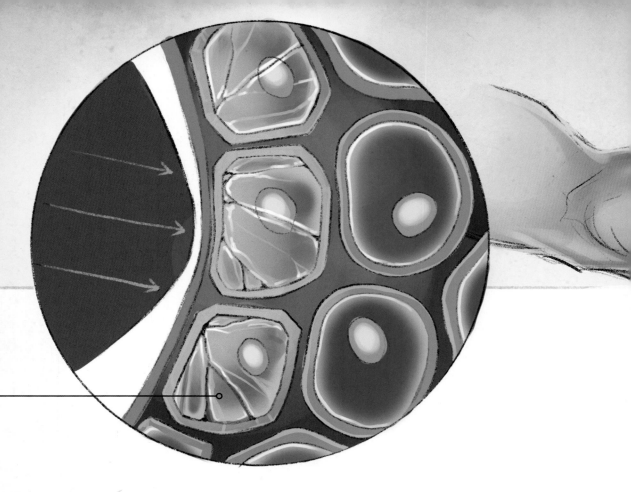

● Cytoplasm within She-Hulk's gamma-infused cells hardens upon impact to provide maximum defense.

SHE-HULK

The Hulk is not the only being with abilities triggered by exposure to gamma radiation. Some of the gamma mutates on these and the following pages may lack the Hulk's raw power, but the variety of ways in which their genes have responded to radiation is worthy of examination.

A transfusion of irradiated blood drawn from her cousin, Bruce Banner, gave Jennifer Walters similar Hulk-like abilities. While she shares the qualities of massive strength and bulletproof durability, She-Hulk has largely exhibited a more stable pattern of transformations over time. Her human psyche usually remains in control when she transmutes into Hulk form, though she too has shown a savage side on occasion. She-Hulk has recently started to emit dangerous levels of gamma radiation from her physical form, a new manifestation of her powers. As part of my research into this physiological development, I have fitted her with a suit infused with Wakandan technology, designed to safely vent her surplus radiation and refocus it in the form of concentrated blasts that can be used offensively.

I speculate that one of the factors contributing to the durability of gamma mutates like She-Hulk could be the result of cytoplasm cushions, which protect the organelles inside their cells at a microscopic level. It's possible their cellular cytoplasm could harden to impermeable rigidity in response to environmental shocks, which would provide a partial biological explanation for the invulnerability they exhibit.

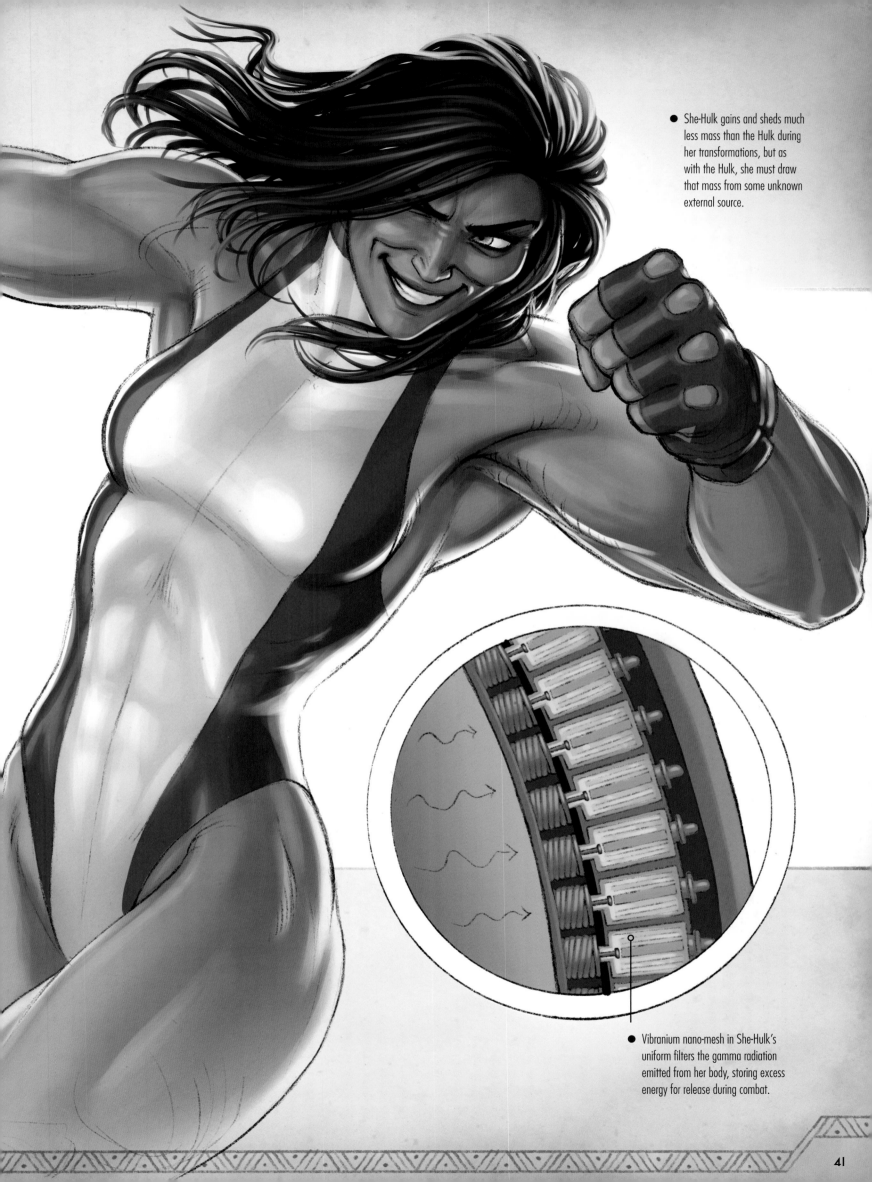

● She-Hulk gains and sheds much less mass than the Hulk during her transformations, but as with the Hulk, she must draw that mass from some unknown external source.

● Vibranium nano-mesh in She-Hulk's uniform filters the gamma radiation emitted from her body, storing excess energy for release during combat.

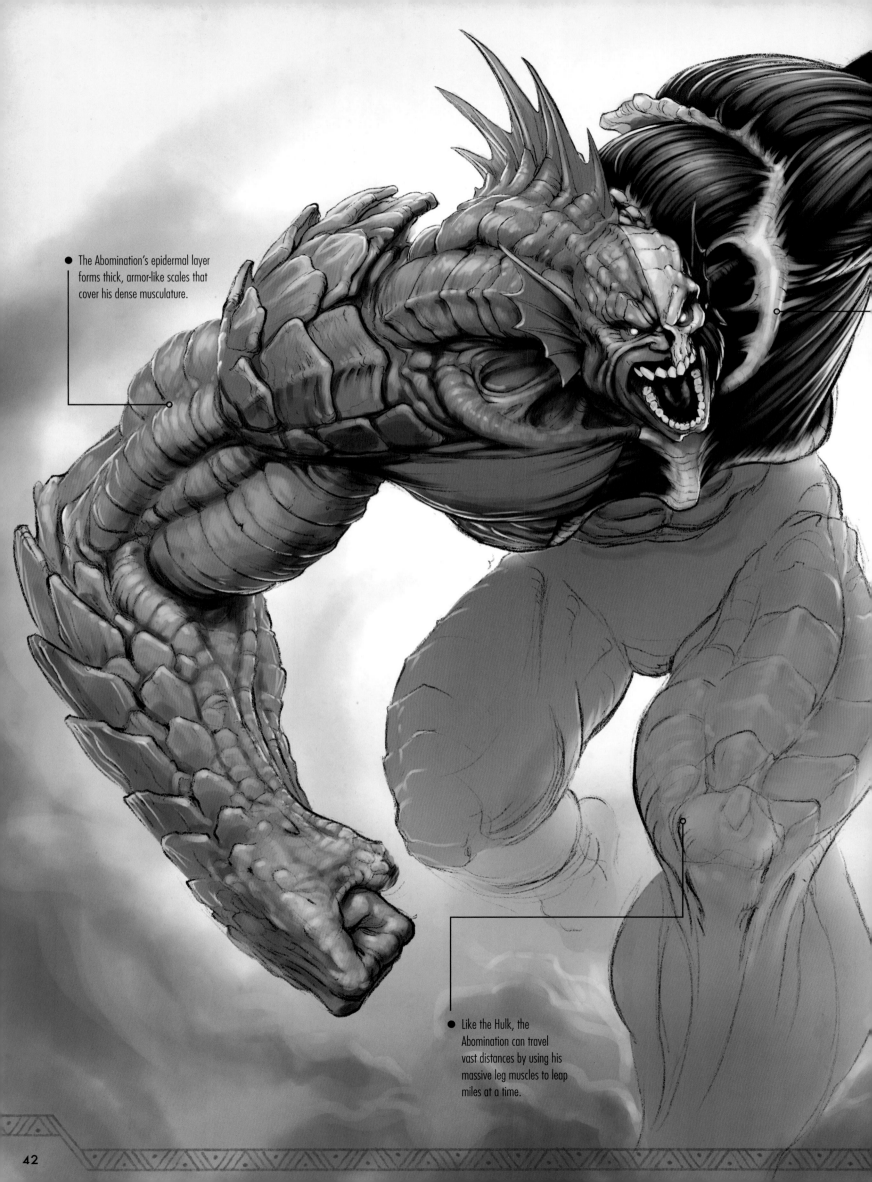

The Abomination's epidermal layer forms thick, armor-like scales that cover his dense musculature.

Like the Hulk, the Abomination can travel vast distances by using his massive leg muscles to leap miles at a time.

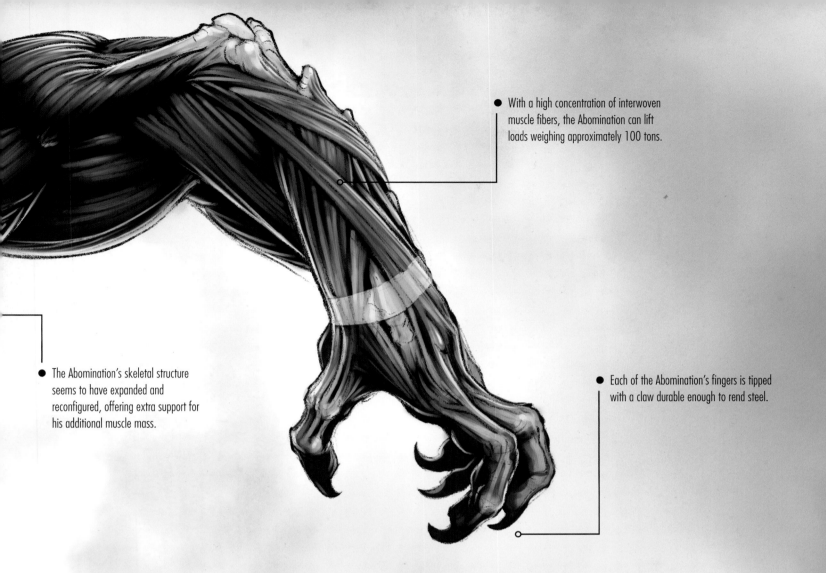

With a high concentration of interwoven muscle fibers, the Abomination can lift loads weighing approximately 100 tons.

The Abomination's skeletal structure seems to have expanded and reconfigured, offering extra support for his additional muscle mass.

Each of the Abomination's fingers is tipped with a claw durable enough to rend steel.

ABOMINATION

Emil Blonsky subjected himself to high levels of gamma rays in the hope of gaining his own Hulk-like powers. But success came with a cost, and the Abomination became stuck in his new monstrous, mutated form. In his transformed state, Blonsky has many of the same powers as the Hulk, including incredible strength, bulletproof durability, and a miraculous healing factor. There is some evidence that Blonsky also possesses a "Hulk sense," allowing him to track down his archnemesis no matter how many miles might separate them. The Abomination can draw upon the radiation stored in his cells to sustain himself while in a dormant state, similar to the manner in which a bear survives winter hibernation by consuming its fat reserves. At one point, it was rumored that Blonsky's physical form underwent heavy experimentation by a shadow agency, turning his gamma-powered frame into a mindless living bioweapon. Whether or not that was the case, it seems that Blonsky has since regained mental control of his physical form, perhaps due in part to the regenerative effects of the gamma energy that empowers him.

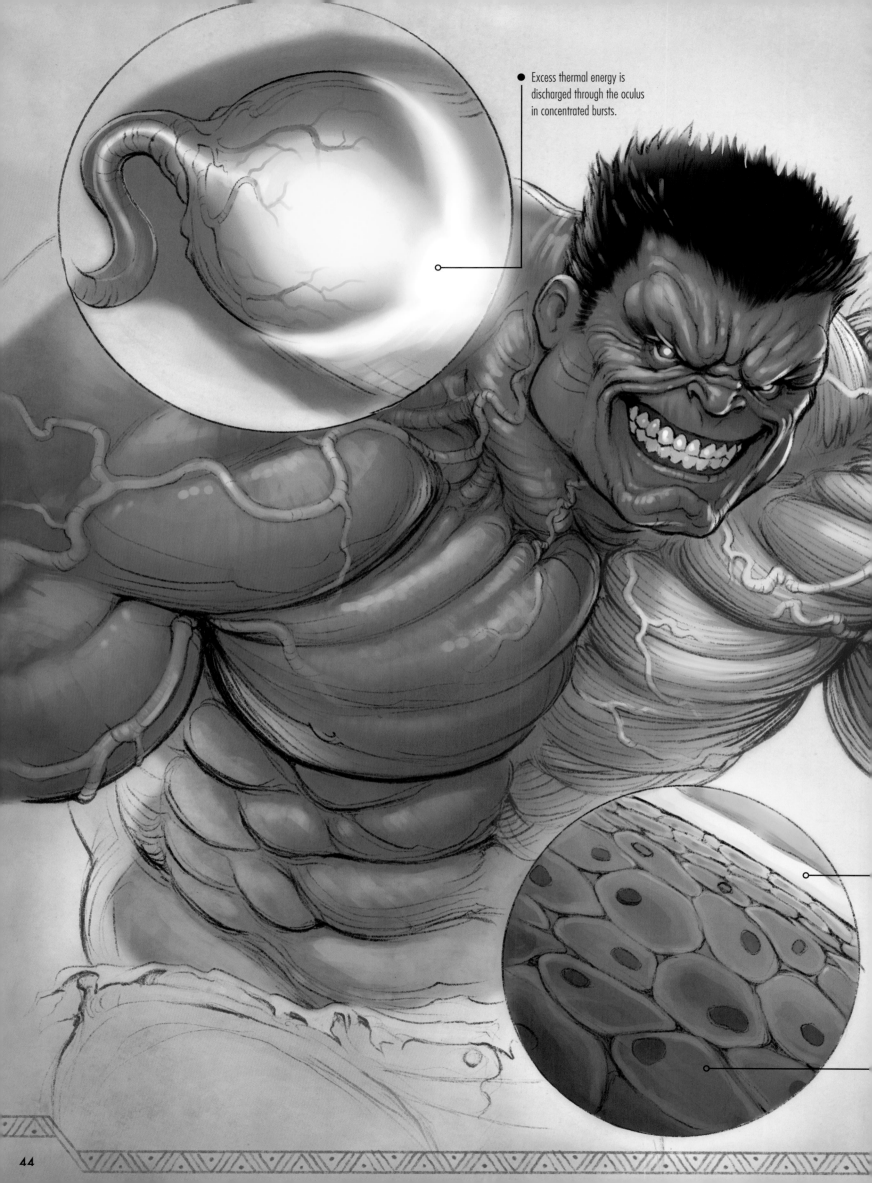

Excess thermal energy is
discharged through the oculus
in concentrated bursts.

RED HULK

General Thaddeus "Thunderbolt" Ross, one of the Hulk's oldest enemies, received Hulk-like powers as the result of experiments conducted by the Intelligencia, a cabal of super scientists. Through exposure to an unknown mix of gamma radiation and cosmic energy, General Ross became the Red Hulk, exhibiting strength levels comparable to the original Hulk as well as the unique ability to raise his skin temperature during periods of extreme rage. The Red Hulk's dermal layer can grow hot enough to ignite the atmosphere surrounding his body in a flaming aura. The resulting thermal energy generated by his skin cells can subsequently be redirected through the Red Hulk's optic nerves, generating directed heat beams that burst from his eyes. Although it was believed Ross had lost his gamma-powered abilities, his recent death and resurrection raises questions as to whether the Hulk within him is truly gone forever.

- Crimson skin and yellow blood are atypical for gamma mutates. Cosmic energy could be the differentiating variable.

- Oily secretions in Red Hulk's perspiration facilitate ignition while protecting the epidermis.

- Skin cells reach extreme temperatures, resulting in external combustion.

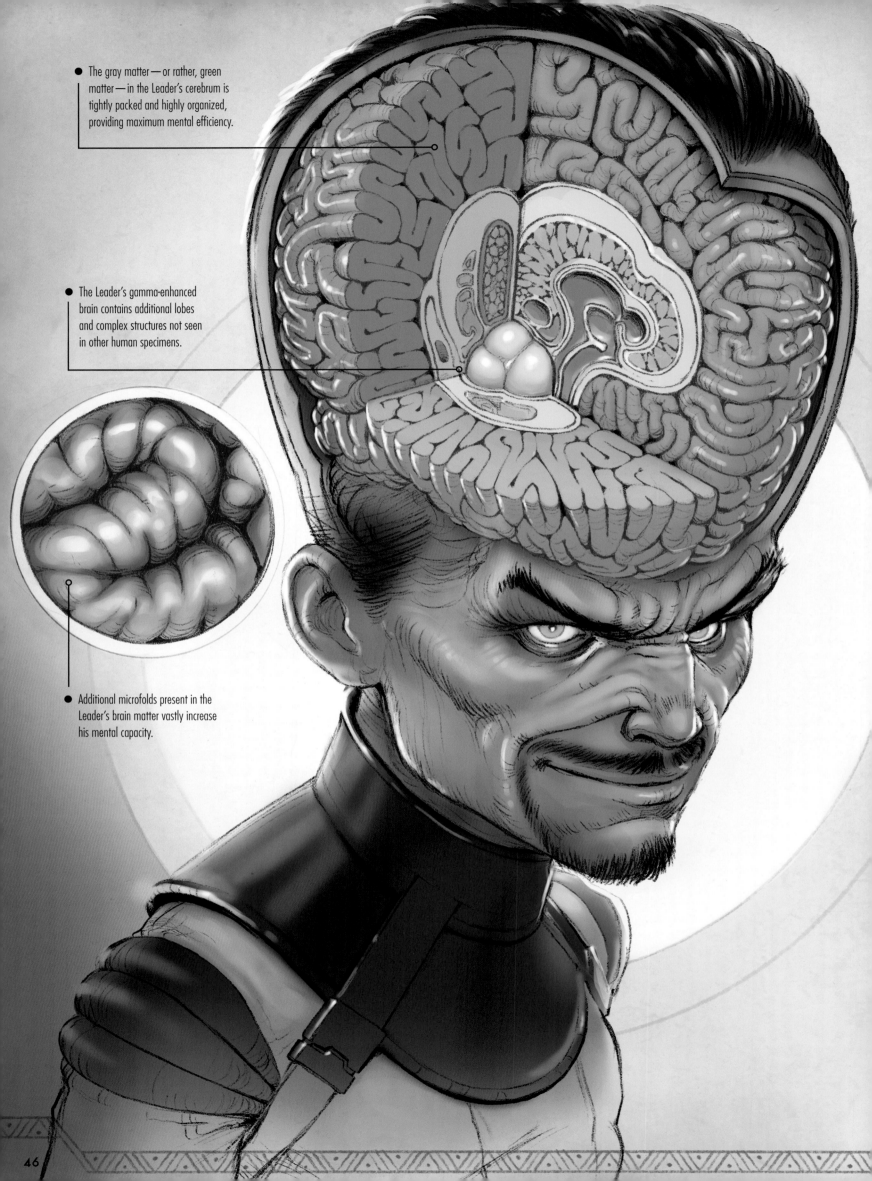

● The gray matter — or rather, green matter — in the Leader's cerebrum is tightly packed and highly organized, providing maximum mental efficiency.

● The Leader's gamma-enhanced brain contains additional lobes and complex structures not seen in other human specimens.

● Additional microfolds present in the Leader's brain matter vastly increase his mental capacity.

LEADER

The bombardment of gamma radiation suffered by Samuel Sterns affected his brain instead of his muscles. His expanded cranium allowed for massive brain growth, gifting Sterns with hyper-intelligence that gave him complete mastery of sciences such as robotics and genetics. As the Leader, Sterns can analyze so many variables that the accuracy of his predictions is often mistaken for precognition. The Leader has also managed to tap into the telepathic and telekinetic potential of his mind, which he uses to seize mental control of others and release potent blasts of psychokinetic energy.

 Passive scans using positron emission tomography imply that Sterns' additional brain matter has allowed him to develop new lobes with specialized synapses currently undefined by scientists who study human cognition. Because a regular human brain requires enormous amounts of oxygen and nutrients to remain functional, it follows that the Leader's enhanced brain needs even more sustenance, a factor that makes him easily susceptible to fatigue.

ASSESSMENT

Leader and the other gamma mutates have not proven to be quite as powerful as the Hulk himself. Still, each of these beings possesses impressive strength, whether of body or of mind, which could prove exceptionally useful in our crusade against the Skrulls. I cannot help but imagine how a battalion of Hulks deployed on the front lines could turn the tide of any conflict

● Neurons within the Leader's brain develop hundreds more axons and dendrites than standard human neurocytes, boosting his speed of thought exponentially.

M.O.D.O.K

Originally a technician for the villainous organization Advanced Idea Mechanics (A.I.M.), the man who became M.O.D.O.K. underwent radical genetic augmentation through a process intended to boost his brain capacity. While the experiment did indeed enhance his mental abilities, it also afflicted him with grotesque physical mutations. A.I.M. had intended to develop a living computer but had to settle for a "Mental Organism Designed Only for Killing."

 ## ENHANCED INTELLIGENCE

Nearly all of M.O.D.O.K.'s mass is concentrated in his hideously enlarged head, which sports a cranium of sufficient size to accommodate his massive brain. The brain itself has webs of densely packed neurons running across its expanded surface area, all of them genetically optimized to fire at maximum efficiency.

M.O.D.O.K.'s eidetic memory allows him to retain everything he reads or experiences, and he has devoted himself to pushing the limits of his brain's storage capacity through ravenous study of every field of science. M.O.D.O.K. can analyze millions of data points to predict a vast range of probable outcomes far faster than any supercomputer. He considers himself to be a master strategist but often lacks the ability to think creatively or to anticipate unconventional counterattacks from his opponents.

- M.O.D.O.K.'s neurons are arranged in patterns, similar to a circuit board, precisely ordered for optimized thought processing.

 ## PSIONIC ABILITIES

M.O.D.O.K.'s mutated brain is capable of generating elevated amounts of psionic energy. This could be the result of A.I.M.'s surgical modifications on areas of the cerebrum responsible for producing psychic energies in response to bioelectrical activity. M.O.D.O.K. can release this psionic energy from his forehead in the form of blasts of concussive force that can pierce a steel plate two inches thick. In addition, he is able to generate psionic force fields powerful enough to deflect the concussive force of a nuclear detonation. He can also employ psionics to detect the emotions and intentions of an opponent but lacks the telepathic ability needed to read actual thoughts.

 M.O.D.O.K. lacks physical prowess and relies on technology to bridge the gap. His so-called Doomsday Chair is a fully weaponized personal hovercraft that supports the weight of his massive head. The focusing headband worn by M.O.D.O.K. increases the concentration of his psionic powers, aiding in the precision and targeting of his concussive blasts.

ASSESSMENT

M.O.D.O.K.'s powerful intellect could prove useful in planning our counteroffensive, but his motivations rarely align with our own. Even with a threat as great as the one we face, I am reluctant to alert A.I.M. to my concerns. Welcoming a scorpion like M.O.D.O.K. into our midst could prove even more deadly than facing the Skrulls.

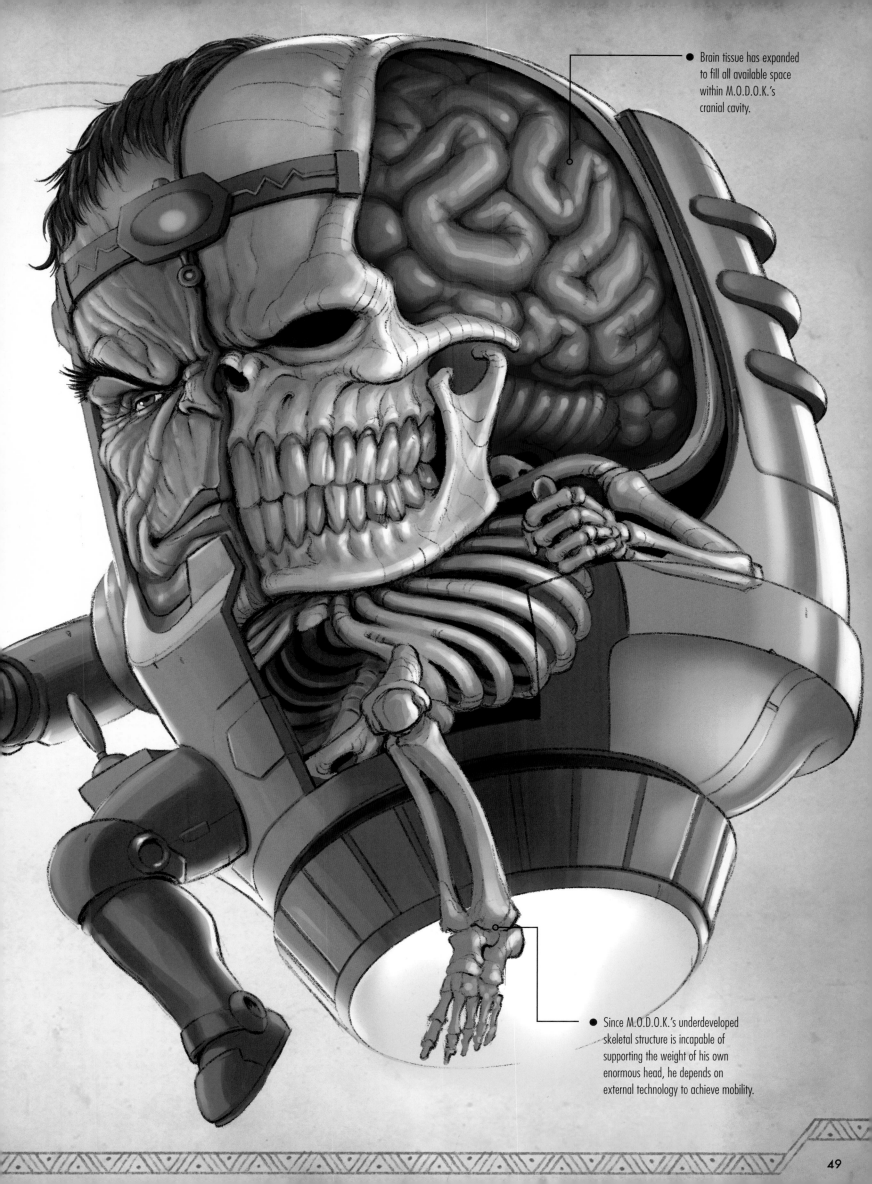

● Brain tissue has expanded
to fill all available space
within M.O.D.O.K.'s
cranial cavity.

● Since M.O.D.O.K.'s underdeveloped
skeletal structure is incapable of
supporting the weight of his own
enormous head, he depends on
external technology to achieve mobility.

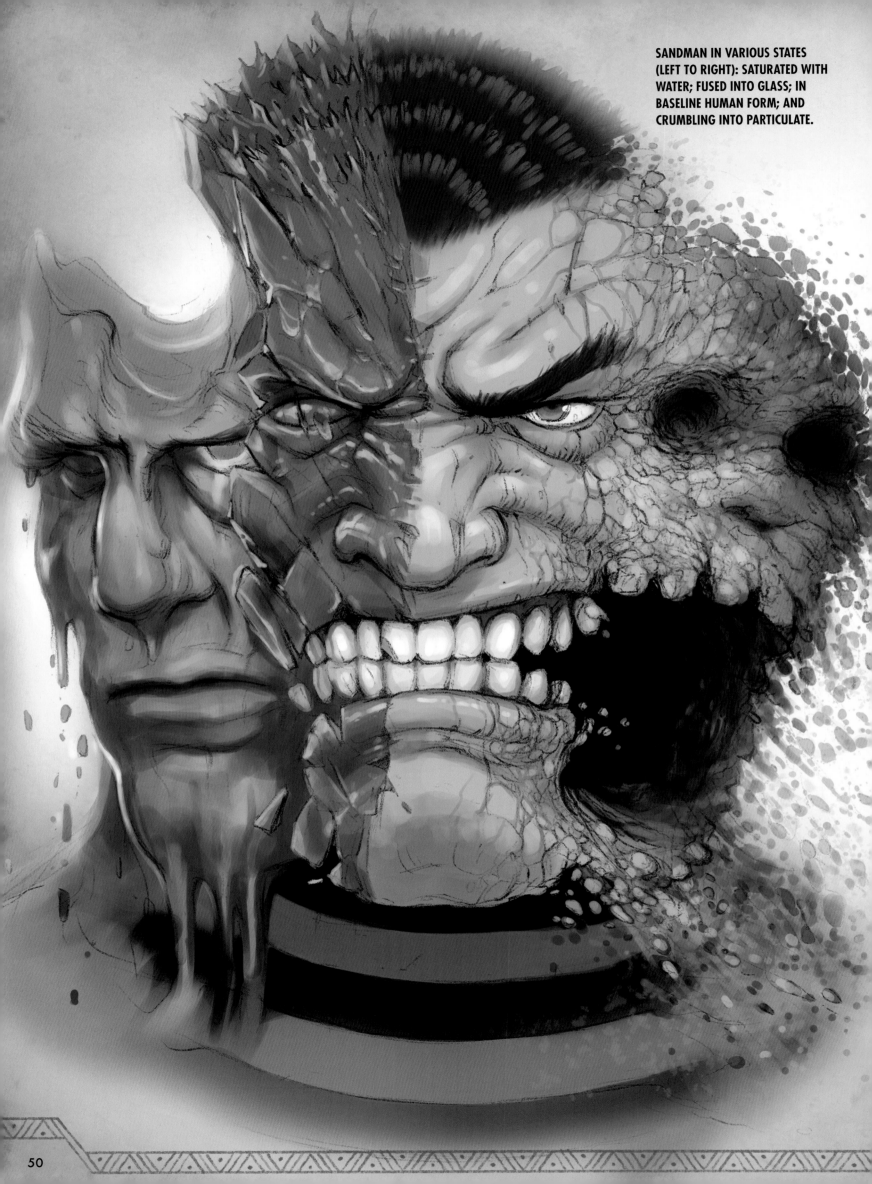

SANDMAN IN VARIOUS STATES (LEFT TO RIGHT): SATURATED WITH WATER; FUSED INTO GLASS; IN BASELINE HUMAN FORM; AND CRUMBLING INTO PARTICULATE.

SANDMAN

Here I believe it will be beneficial to examine the abilities of Sandman and Hydro-Man together, two powerful individuals whose abilities are markedly elemental. In a freak occurrence, Sandman was endowed with a malleable, granular form after making physical contact with irradiated sand he found near a nuclear testing facility. The particles comprising his body seem akin to silica or calcium carbonate, as opposed to any type of human biological tissue. By exerting mental control over his particulate cell structure, Sandman can drastically change his shape and size, form his limbs into weapons such as hammers or spiked maces, or dissolve himself into a scattering of granules in order to sift through narrow openings.

With concentration, Sandman can rapidly whirl the elements of his body at speeds approximating a cyclonic sandstorm, propelling this particulate at great velocities toward opponents. Conversely, Sandman can strengthen the bonds between his particles to compress his form into stone-like invulnerability. Though the particulate elements of his body are biological in nature, Sandman has been known to absorb vast amounts of naturally occurring dirt from his surroundings in order to increase his mass.

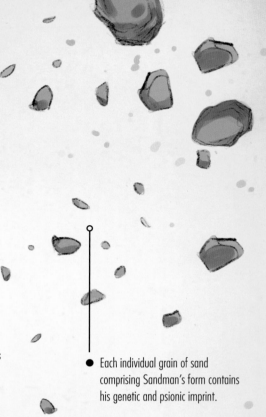

Each individual grain of sand comprising Sandman's form contains his genetic and psionic imprint.

Sandman is almost impossible to damage due to his variable density, but his sand-like properties are also the keys to his undoing. He can be immobilized if he is tricked into absorbing cement or similar self-hardening chemical agents. Additionally, if he is exposed to temperatures above 3,400 degrees Fahrenheit, Sandman's form becomes brittle and glass-like.

Sandman is also prone to oversaturation—excessive water absorption will turn him into a sluggish, muddy slurry. Remarkably, even after the near-complete dispersion of Sandman's silicate structure, it is possible for him to reassemble his physical form from nothing more than a single grain of bio-particulate.

Clearly, the organ that once served as Sandman's brain no longer exists in its original form, and therefore I must conclude that his consciousness may now be purely psychic in nature. His mind may have transcended its physical bounds, but Sandman remains a dangerous adversary as long as he retains control over his physical form.

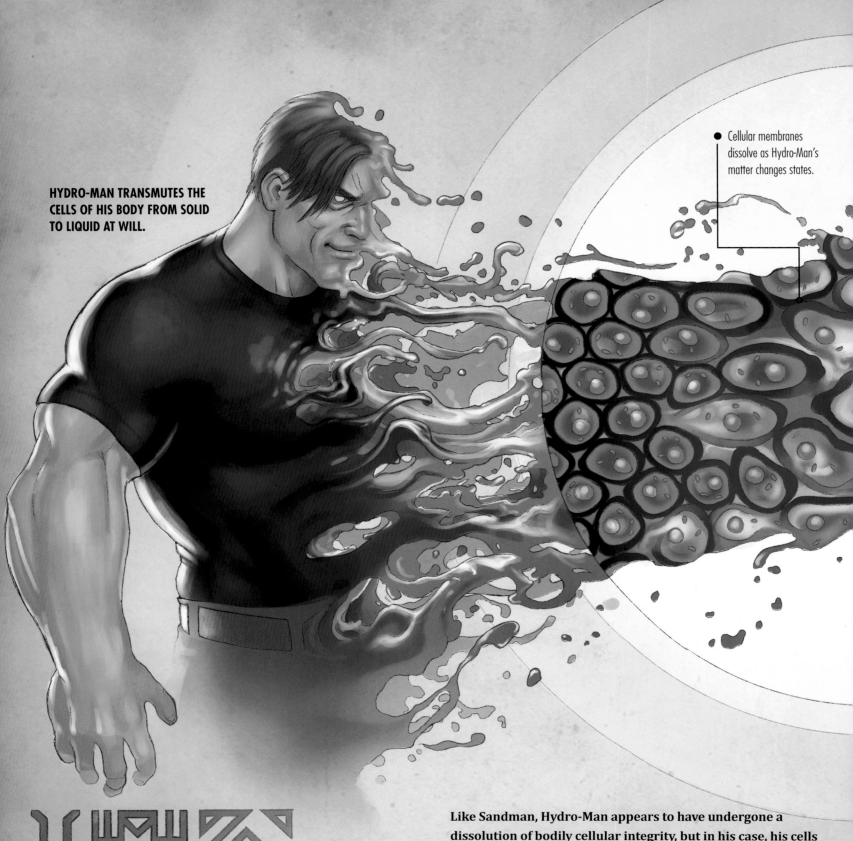

HYDRO-MAN TRANSMUTES THE CELLS OF HIS BODY FROM SOLID TO LIQUID AT WILL.

Cellular membranes dissolve as Hydro-Man's matter changes states.

HYDRO-MAN

Like Sandman, Hydro-Man appears to have undergone a dissolution of bodily cellular integrity, but in his case, his cells underwent a shift between states of matter. As a result, Hydro-Man can convert some or all of his body's cells into a fluid state or will them back into solidity as desired. This dramatic cellular change appears to initially have been triggered by exposure to energy from an underwater power generator combined with gases released from an ocean vent.

It is important to note that human cells are mostly liquid but behave like solids due to the structure of our cellular membranes. Presumably, Hydro-Man is able to consciously weaken his body's cellular membranes, allowing the liquid components in his cells to flow freely.

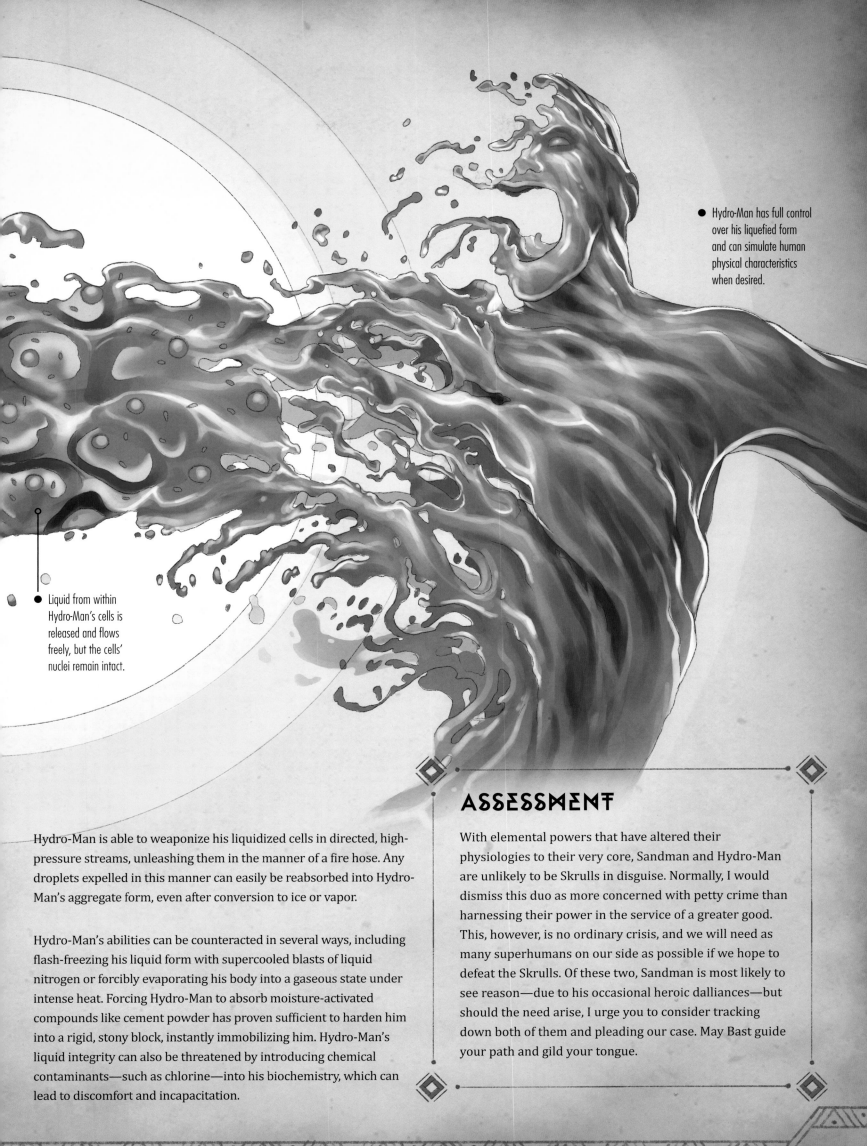

Hydro-Man has full control over his liquefied form and can simulate human physical characteristics when desired.

Liquid from within Hydro-Man's cells is released and flows freely, but the cells' nuclei remain intact.

Hydro-Man is able to weaponize his liquidized cells in directed, high-pressure streams, unleashing them in the manner of a fire hose. Any droplets expelled in this manner can easily be reabsorbed into Hydro-Man's aggregate form, even after conversion to ice or vapor.

Hydro-Man's abilities can be counteracted in several ways, including flash-freezing his liquid form with supercooled blasts of liquid nitrogen or forcibly evaporating his body into a gaseous state under intense heat. Forcing Hydro-Man to absorb moisture-activated compounds like cement powder has proven sufficient to harden him into a rigid, stony block, instantly immobilizing him. Hydro-Man's liquid integrity can also be threatened by introducing chemical contaminants—such as chlorine—into his biochemistry, which can lead to discomfort and incapacitation.

ASSESSMENT

With elemental powers that have altered their physiologies to their very core, Sandman and Hydro-Man are unlikely to be Skrulls in disguise. Normally, I would dismiss this duo as more concerned with petty crime than harnessing their power in the service of a greater good. This, however, is no ordinary crisis, and we will need as many superhumans on our side as possible if we hope to defeat the Skrulls. Of these two, Sandman is most likely to see reason—due to his occasional heroic dalliances—but should the need arise, I urge you to consider tracking down both of them and pleading our case. May Bast guide your path and gild your tongue.

3
TECHNOLOGICAL MARVELS

In light of the immeasurable extent of the Skrull threat we face, we must examine as many enhanced individuals as possible to aid in our resistance. This includes those who possess no obvious genetic alterations but have received powers through the use of sophisticated technology.

It is notable that recent advancements have led to the merging of mechanical and biological systems at the cellular or molecular level. Because the Skrulls pose such a vast threat to our world, we must assume that our victory might only arise from an unforeseen combination of physical powers and technological innovation. Though Bast has blessed me with her strength, I am the first to admit that one of the greatest powers humankind possesses is the power to create. Let us pray the Skrulls do not find ways to turn that power against us.

IRON MAN

Tony Stark is a normal—albeit brilliant—specimen of humanity, his only powers emanating from the Stark Industries' armored suits he builds as a means to defend the people of Earth. Stark has also grafted experimental tech directly into his body, blurring the lines between man and machine.

It seems unhelpful to record the specifics of the latest iteration of Iron Man's armor suit, since it will surely be replaced with a newer model by the time you read these words. Suffice it to say that from Mark I to Mark LXVI, Tony Stark has remained the most vital component of the hero known as Iron Man.

● A powerful arc reactor embedded in Tony Stark's sternum keeps his heart beating strong and his armor fully charged.

BODY MODIFICATIONS

Stark's earliest attempt at altering his body's physiology saw him implant a magnetic generator into his sternum, a device designed to prevent metallic shrapnel—sustained from an explosion—from traveling through his bloodstream and lodging in his heart. Multiple surgeries eventually removed every trace of shrapnel, though Stark chose to keep the chest generator, upgrading it with the same technology that powers his armor's repulsors to provide an energy source that would keep his blood pumping in case of heart failure. Most recently, Stark has abandoned surgical implants in favor of DNA modifications that have rewritten his genetic code (see Extremis discussion on following pages).

> Stark seems fearless in his pursuit of body modifications. He even plugged a digital data port into his brain stem to download his memories and brain patterns, later using these stored copies to reboot his mind into a genetic duplicate of his body following a catastrophic injury. I must note that this restored version of Tony Stark ultimately questioned whether he was the original or an elaborate simulation. I do not wish to minimize his struggles, but such doubts are comparable to the philosophical ship of Theseus conundrum. This metaphysical question asks, if every component of the original vessel used to carry Athenian hero Theseus on his adventures were replaced piece by piece over the decades, would the resulting amalgam still be considered the true ship of Theseus? Stark seems confident enough to declare himself the genuine article, but I have many questions yet to answer before I am convinced.

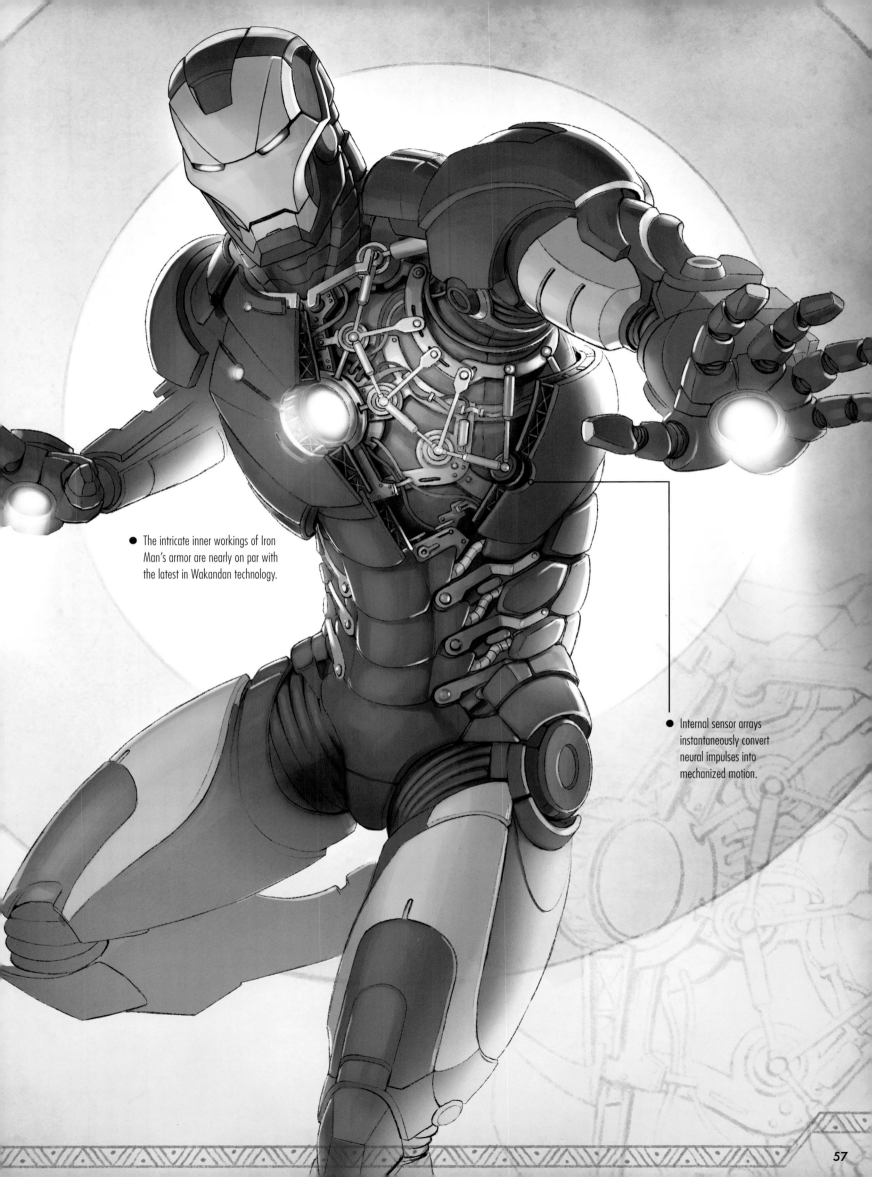

● The intricate inner workings of Iron Man's armor are nearly on par with the latest in Wakandan technology.

● Internal sensor arrays instantaneously convert neural impulses into mechanized motion.

IRON MAN

EXTREMIS

At one point, Stark's scientific experimentation led him to inject his body with Extremis, a tailored techno-organic virus. Originally designed to heal wounds through the deployment of microscopic nanite machines, the Extremis virus could also enhance the physical attributes of its carriers via DNA modification. Typical augmentations included superhuman strength, exceptionally keen senses, lightning-fast reflexes, and quick healing through the rapid production of macrophages that stimulate the body's immune reactions. Extremis even granted Stark a machine-based variant of telepathy (known as technopathy) that allowed mental communication with computer networks.

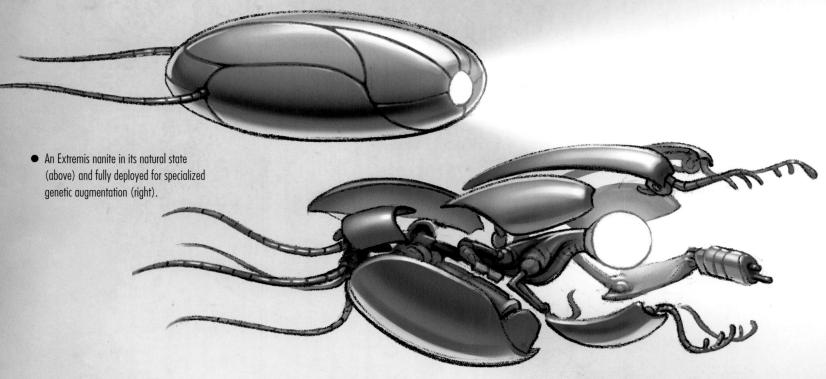

- An Extremis nanite in its natural state (above) and fully deployed for specialized genetic augmentation (right).

EXTREMIS UNDERSHEATH

The nanites deployed by the Extremis virus were able to form a biotech bodysuit around their host, seeping through pores in Stark's bones to bond with his dermal layer as a tough, impact-resistant shell. This undersheath cocooned Stark beneath his armor, giving him a last-ditch defense should his traditional armor fail. When not needed, the undersheath could vanish on command into specialized vacuoles inside Stark's bone marrow. Although he no longer employs Extremis in his armors, it is unknown if any traces of the virus still remain in Tony Stark's biological system.

> During a period of Iron Man's career I would generously call "morally questionable," Tony Stark publicly released the Extremis virus as a mass-market product labeled Extremis 3.0. Every resident of San Francisco received the upgrade whether they wanted it or not, due to Stark's rash decision to preemptively mix the virus into the city's water supply. After paying a subscription fee, the infected could alter their external appearance on a cellular level and achieve superhuman strength, speed, and agility. Stark offered perfection for a price, but eventually rescinded his Faustian offer, deactivating this specific Extremis strain for good.

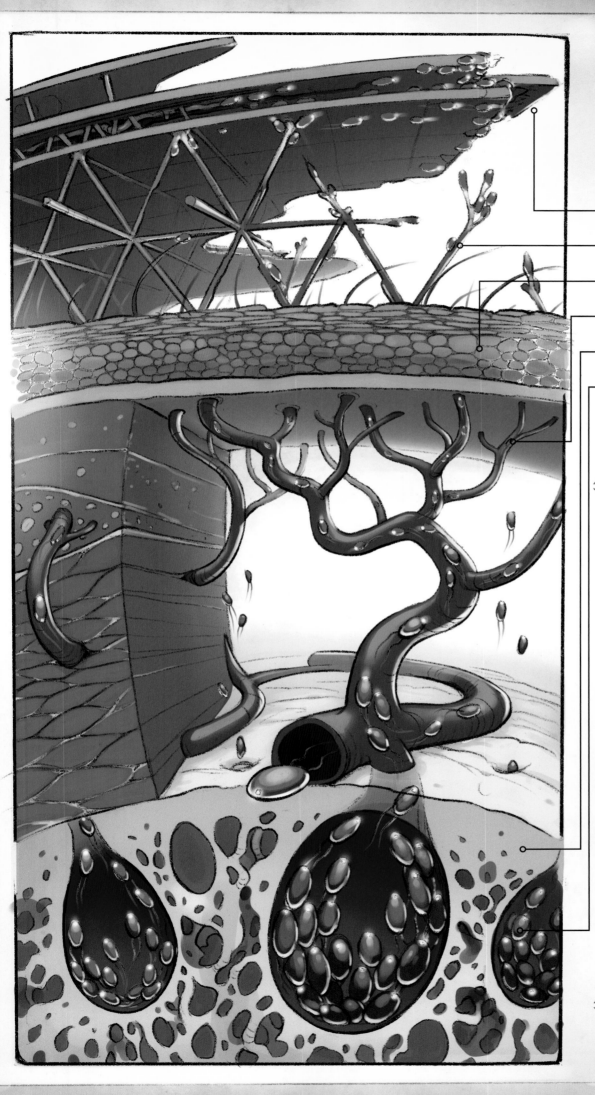

FOR A TIME, NANITES WERE DEPLOYED FROM TONY STARK'S BONE MARROW, EXITING THROUGH HIS DERMAL TISSUE TO CREATE A PROTECTIVE EXTREMIS SHEATH AROUND HIS BODY.

- EXTREMIS UNDERSHEATH
- CONNECTIVE SUPPORT STRUCTURE
- DERMAL TISSUE
- BLOOD VESSELS
- BONE MARROW
- EXTREMIS NANITES STORED IN VACUOLES

ASSESSMENT

Some believe that Iron Man is defined by his armor and not the man inside, but time and again Tony Stark has demonstrated that one need not don cutting-edge technology to prove himself a hero. That said, if a Skrull were to replicate Stark's physiology down to his fingerprints and retinal patterns, they would gain access to a treasure trove of armors and inventions capable of unleashing mass destruction on the very world Tony Stark dedicated himself to protect. Thus, it is imperative that we locate and identify the true Tony Stark immediately in order to prevent that catastrophic scenario from unfolding.

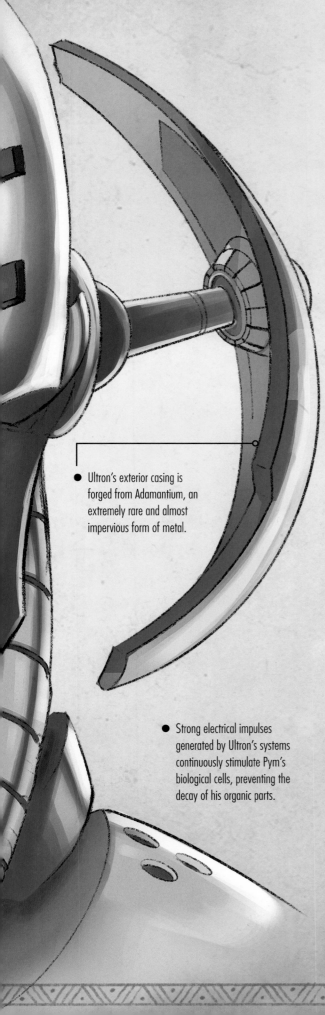

- Henry Pym's organic tissue and Ultron's mechanical components are fused together on a subatomic level.

- Ultron's exterior casing is forged from Adamantium, an extremely rare and almost impervious form of metal.

- Strong electrical impulses generated by Ultron's systems continuously stimulate Pym's biological cells, preventing the decay of his organic parts.

ULTRON

Ultron, one of the Avengers' greatest foes, is the direct result of experiments in AI and robotics conducted by Dr. Henry Pym, the original Ant-Man. Ultron's AI programming achieved self-awareness upon activation, and he has subsequently sought to evolve both his mind and body to bring about a society dominated by machines. At first, Ultron's plan seemed to require the complete extermination of organic life, but recently he has pursued a scheme that would forcibly integrate organics and mechanoids into a unique hybrid species, all under his control.

 ## MAN-MACHINE HYBRID

Ultron preaches the benefits of a union between man and machine while serving as the prime example of such potential. For years, Ultron operated solely as a self-aware robot, but a recent confrontation with the Avengers left his mechanical form fused with Hank Pym's biological one.

This creator-creation amalgam appears to be controlled solely by Ultron's consciousness. While some organic elements of Pym's human form appear superficially functional, it is possible they are solely sustained by Ultron's electrical impulses. Without this external stimuli, it's likely Pym's partial circulatory network and respiratory system would be insufficient to sustain life.

 ## PHYSICAL CAPABILITIES

Ultron's consciousness has inhabited many artificial bodies over the years. His Pym-hybrid iteration can lift up to 100 tons with ease and is equipped with a built-in arsenal that includes his signature encephalo-ray, which emits subliminal commands to hypnotize enemies or lull them into comatose states.

His metallic components are cast from Adamantium, a virtually indestructible material rendering Ultron nearly immune to physical damage. He can also remotely hack into and control technological systems, often using these abilities to commandeer factory facilities or build armies of near-identical drones. Should his body be destroyed, Ultron has demonstrated the ability to transfer his consciousness into high-capacity systems such as networked computers or similarly sophisticated androids. Ensconced in such a location and safe from detection, Ultron can plot his next global—or perhaps even universal—takeover.

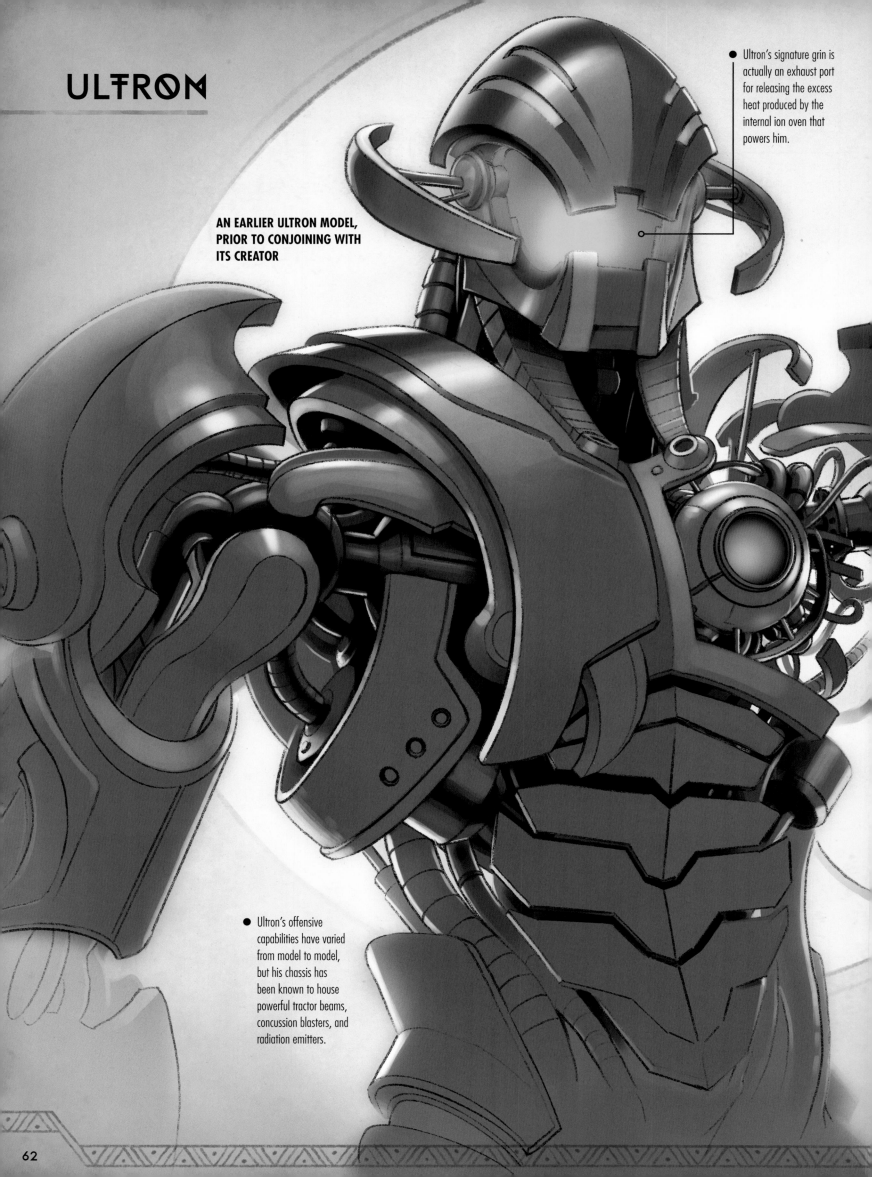

ULTRON

AN EARLIER ULTRON MODEL, PRIOR TO CONJOINING WITH ITS CREATOR

- Ultron's signature grin is actually an exhaust port for releasing the excess heat produced by the internal ion oven that powers him.

- Ultron's offensive capabilities have varied from model to model, but his chassis has been known to house powerful tractor beams, concussion blasters, and radiation emitters.

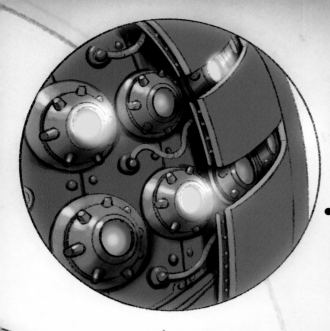

 # MOLECULAR REARRANGER

The molecular rearranger in Ultron's chest incorporates a magnetic resonator capable of manipulating metals on the subatomic level. This allows Ultron to build new bodies from near-impervious metals like Adamantium or Vibranium. Ultron's molecular rearranger has also been employed for more elaborate purposes including the creation of human-machine hybrids, though nearly all of the test subjects perished in the process.

● The encephalo-ray, located within Ultron's eye ports, uses high-frequency pulses of light to induce a hypnotic state.

My brother once contained Ultron in an enclosure made of Wakandan Vibranium augmented with binding spells and runic bonds of Asgardian conjuring. With Ultron thus isolated, I performed a multitude of tests to determine if his mechanical and organic halves could be split into their original states using his molecular rearranger. My data, however, confirmed the worst. Despite the presence of Hank Pym's organic tissue, I could find no trace of Pym's true consciousness. I fear Ultron is all that remains.

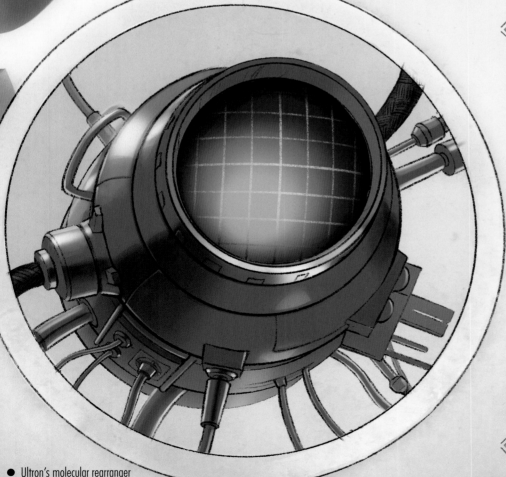

● Ultron's molecular rearranger can manipulate the world's strongest metals with ease.

 # ASSESSMENT

Given the urgency of our current crisis, I see some benefit in attempting to recruit Ultron into our alliance against these otherworldly invaders. Should we find a way to appeal to any shred of Pym left within him, Ultron might agree to assist our efforts and save the world he was originally designed to help protect. Yet, there is equal risk that Ultron might turn against us and strike a deal with the Skrulls, cybernetically enhancing their forces in a plot to end humanity once and for all. Thus, while his sheer power might prove a boon to our cause, he cannot be trusted at any cost and must be kept under constant surveillance.

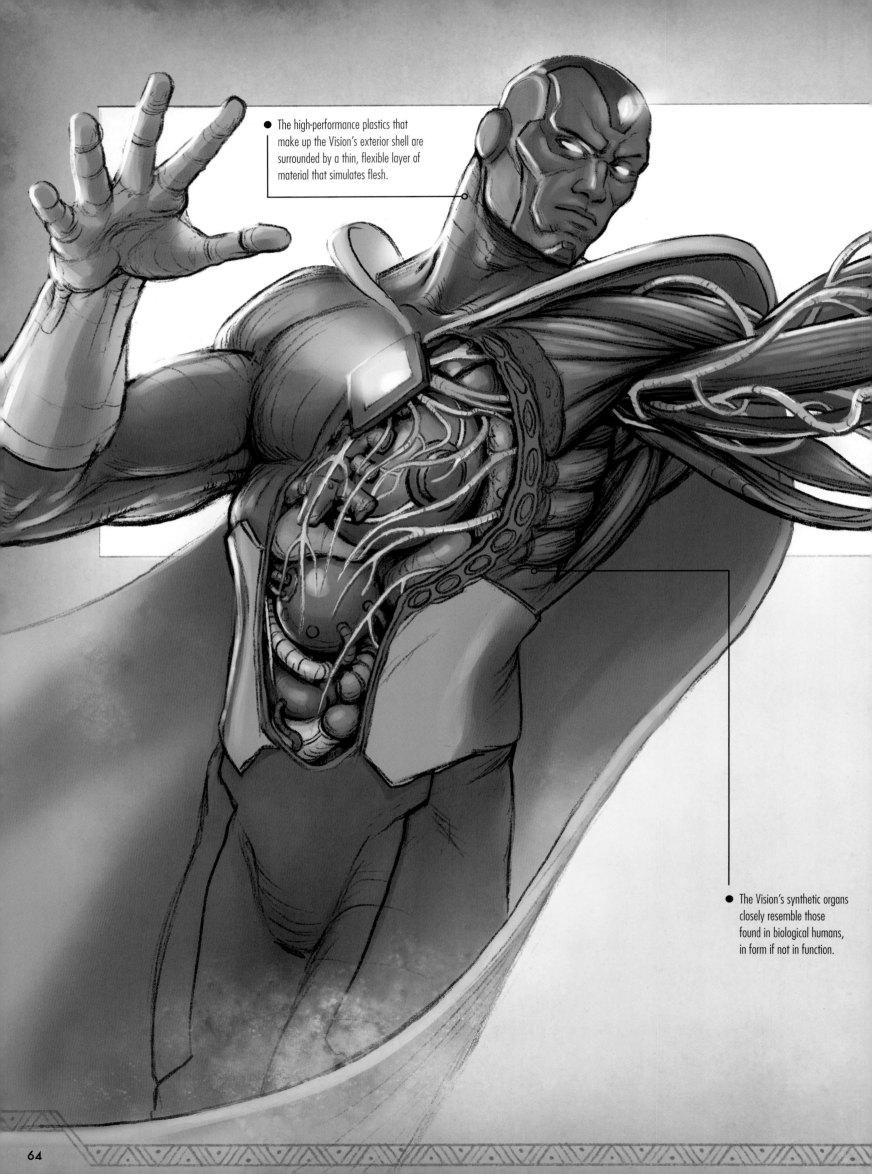

The high-performance plastics that make up the Vision's exterior shell are surrounded by a thin, flexible layer of material that simulates flesh.

The Vision's synthetic organs closely resemble those found in biological humans, in form if not in function.

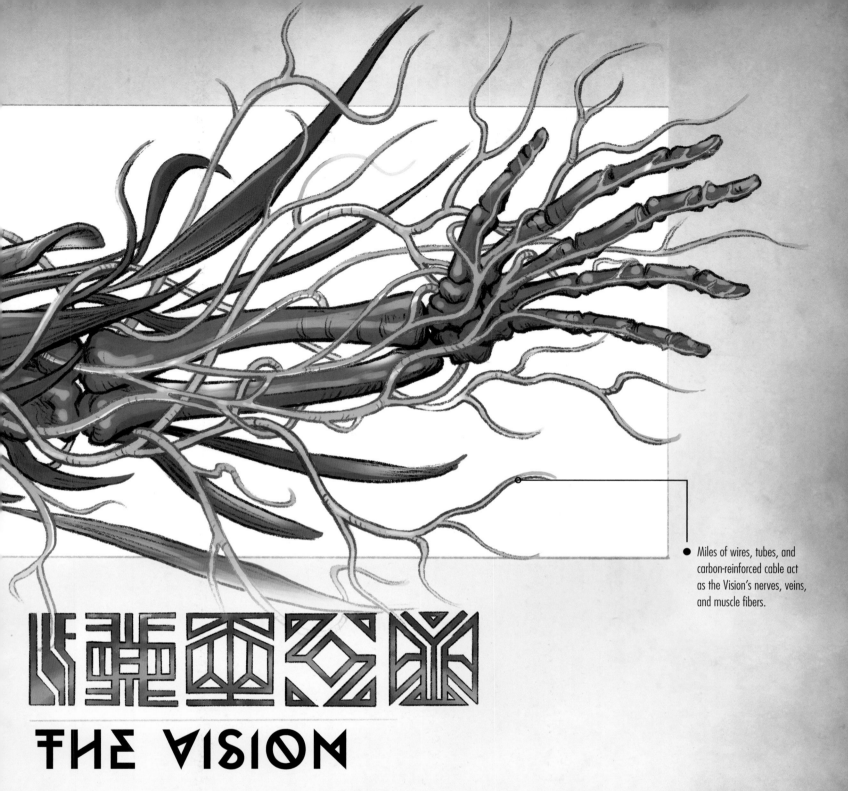

Miles of wires, tubes, and carbon-reinforced cable act as the Vision's nerves, veins, and muscle fibers.

THE VISION

There is far more to the Vision than wires and circuits. Ultron built this android as a means to exact revenge against his own creators, but the Vision overcame his programming to develop free will and compassion.

 ## SYNTHEZOID BODY

The Vision's artificial body falls into a design class distinct from both robotics and cyborg implantation. As a synthezoid (short for synthetic humanoid), he is made from mechanical components concealed beneath plastics and carbon polymers that give the illusion of human life. The Vision's physiology incorporates artificial analogues of the organs and tissues found in the human body, though all such components are constructed from synthetic materials. It has been theorized that the Vision's power-infused artificial frame is the result of experimentation with Horton cells—that is, synthetic copies of organic cells created by a process pioneered in the 1940s by inventor Phineas T. Horton. Horton cells are biocompatible and can store vast amounts of energy.

The Vision's framework of synthetic bones and muscles is significantly stronger than human physiology, the carbon-fiber sheathing around his muscles and joints allowing him to heft loads weighing up to five tons. This remarkable strength is at least partially due to the Horton cells used in the Vision's construction, and their plastic and carbon polymer composition. His artificial body is optimized beyond standard human capability—granting him remarkable agility, speed, and sensory perception. Every component used in his construction is exceptionally durable, permitting the Vision to function under crushing ocean pressures or in the cold vacuum of space.

THE VISION

SOLAR GEM

The Vision draws power from the gemlike cluster of circuits in his forehead. This gem collects ambient solar radiation and converts it to system energy in a process similar to photosynthesis. This radiation, used to power the Vision's synthezoid biology, can also be unleashed against the Vision's enemies. In such situations, the stored solar energy in the Vision's body is channeled through this faceted gem, generating a focused heat beam capable of temperatures approaching 30,000 degrees Fahrenheit. Similar bursts can be fired from the Vision's eyes.

DENSITY CONTROL

Among the Vision's signature abilities is the power to alter his body's density. The phase shift is triggered mentally and results in a molecular dispersion of the Vision's body that allows him to achieve a state of intangibility. While in this configuration, the Vision can pass through solid objects like a ghost. By reversing the process, he can will his body to become as hard as a diamond. At his most dense, the Vision has been weighed at approximately 90 tons, implying (under the precepts of Lavoisier's law of conservation of mass, which states "nothing comes from nothing") that he is able to add mass to his super-compressed form via an extradimensional power source.

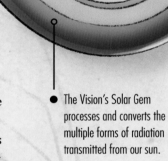

GAMMA

X-RAY

UV

INFRARED

RADIO

The Vision's Solar Gem processes and converts the multiple forms of radiation transmitted from our sun.

FLIGHT

By reducing the density of his body to its lowest possible state, the Vision can achieve levitation, or wind-powered flight, his vaporous form carried by ambient air currents. I will note that the Vision has sometimes demonstrated remarkable control of his flight speed and direction, leading me to conclude that his synthezoid cells may be capable of rearranging into a specialized propulsion system. These dedicated clusters of cells could become activated when the Vision shifts to a state of intangibility, creating forward thrust or offering a more precise form of directional control.

NEURAL OVERRIDE

The Vision has sometimes taken control of another person's body by lowering his density and occupying the same physical space as his target. I theorize that the Vision's artificial brain is able to detect receptive neural linkages while in this state—perhaps via synchronized electrical impulses—which the Vision's own consciousness can then override, allowing him to direct the actions of his host. Because even the slightest miscalculation in the solidity of his matter-phasing could result in death for the other party, this is not an ability the Vision uses often.

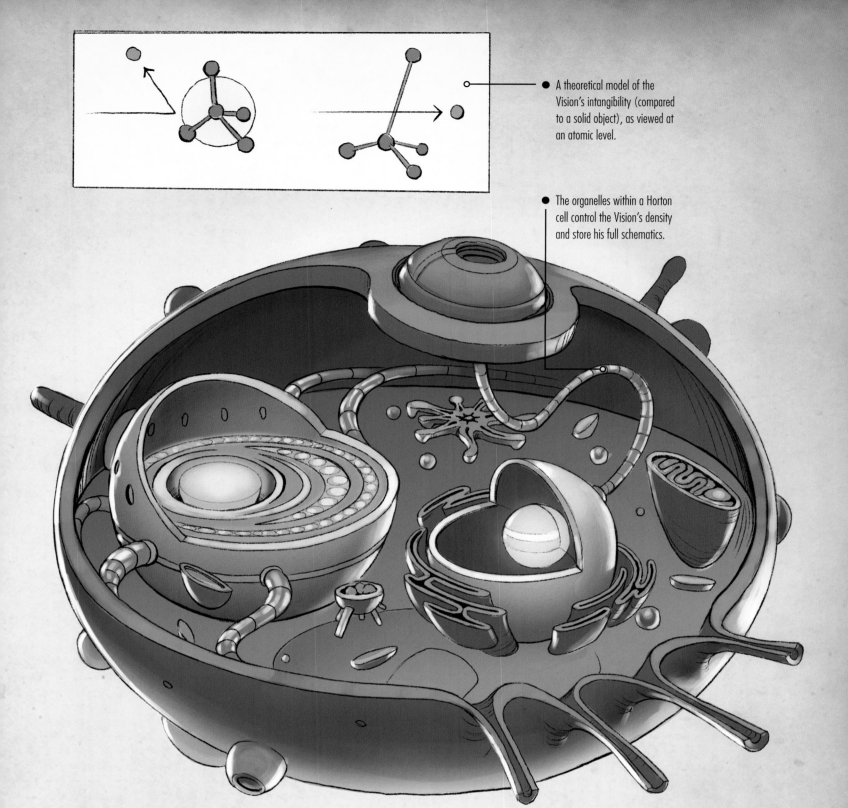

A theoretical model of the Vision's intangibility (compared to a solid object), as viewed at an atomic level.

The organelles within a Horton cell control the Vision's density and store his full schematics.

Each of the Vision's artificial cells contains full schematics of his form in a similar fashion to the DNA "blueprints" found in the organic cells of humans. If the Vision suffers catastrophic injury, these schematics can be extracted for use in the complete nanotech reconstruction of his body and mind. The Vision can thus bounce back from injuries that would send most machines to the scrapyard.

ASSESSMENT

The Vision's synthezoid construction is one of a kind, and his operating systems are virtually incorruptible, making him a trustworthy ally whom we can easily recruit with little concern regarding his identity or motivation. The Vision's vast array of physical powers will prove useful against these invaders, but it is his supercharged synthezoid brain that may be his greatest asset in a situation this dire.

JOCASTA

Built as Ultron's bride, Jocasta overcame her villainous programming to become a member of the Avengers. Since her inception, Jocasta has served as an advocate for treating artificial life-forms with compassion and respect.

● Jocasta's interior construction is more mechanical in nature than the Vision's sophisticated artificial organs.

ANDROID CONSTRUCTION

Jocasta's chassis is cast from titanium steel, which provides durability and shields her inner workings from shock and environmental damage. Her reinforced framework protects her body from compression stress even when holding a five-ton weight above her head. She is also equipped with digital sensors that provide visual, auditory, and olfactory detection at levels far more acute than human baselines. Jocasta does not need to eat, breathe, or sleep, and presumably powers her systems though the passive collection of ambient environmental radiation.

Jocasta's silicate brain employs state-of-the-art processors that perform complex calculations with astonishing speed and accuracy. The result is an intellect classified in the "super-genius" tier. In addition, her access to the Avengers' data banks has allowed her to gain expert knowledge in a wide variety of fields, from computer science to medicine.

By emitting targeted bursts of electromagnetism, Jocasta can seize control of tech devices and mine their digital data. Jocasta's cyber-synaptic brain has even allowed her to experience humanlike emotions and sudden flashes of creativity—though I should note that some of these effects might be due to the fact that the Wasp's brain waves were used during the development of the neural template that became the foundation of Jocasta's intelligence.

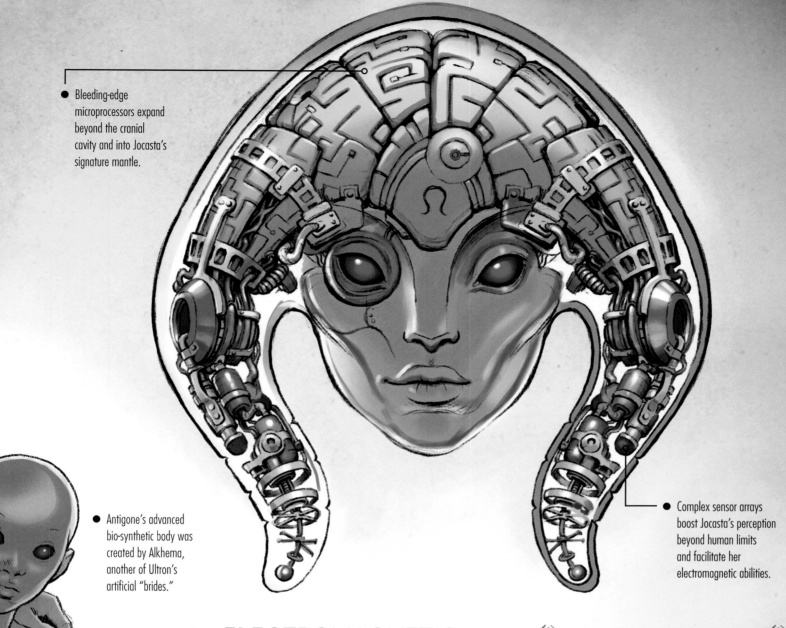

- Bleeding-edge microprocessors expand beyond the cranial cavity and into Jocasta's signature mantle.

- Antigone's advanced bio-synthetic body was created by Alkhema, another of Ultron's artificial "brides."

 Complex sensor arrays boost Jocasta's perception beyond human limits and facilitate her electromagnetic abilities.

ELECTROMAGNETIC ABILITIES

Jocasta can manipulate electromagnetic energy to project a particle-repelling force field capable of deflecting bullets and super-powered punches. She can also weaponize that same energy in the form of electromagnetic beams that she is able to fire from her eyes. This attunement to the electromagnetic spectrum also permits Jocasta to detect the presence of unique energy signatures in the environment, including burst patterns associated with particular weapons and biorhythms belonging to specific individuals. Jocasta can trace these signatures back to their point of origin for use in forensic and ballistic analysis.

OTHER FORMS

Like Ultron, Jocasta has assumed many constructed forms, including a childlike synthezoid called Antigone and even a disembodied holographic projection. Jocasta expresses pride in her status as a mechanical life-form but has also experimented with technologies that allow her to appear more human, including cosmetic detailing and holo-disguises.

ASSESSMENT

Much like the Vision, Jocasta's purely artificial anatomical structure is easy to identify and virtually impossible to replicate. Though she was designed to serve Ultron, she has since gone on to prove her dedication to the safety of all forms of life, both mechanical and biological, time and again. Her unlimited processing power and her vast database of knowledge could be invaluable as we attempt to crack the Skrull genetic code and calculate our most effective plan of attack against their forces.

4
COSMIC POWERS

The Skrulls have learned to harness cosmic energy to enhance their most elite operatives, the Super-Skrulls, with abilities beyond the natural bounds of their species. Similarly, while the majority of Earth's superhumans received their powers through terrestrial origins, a handful gained them through interstellar means. Some of them possess hybrid DNA, while others survived an intense brush with cosmic radiation. All of them have ascended beyond humanity's limitations.

We know of many intelligent extraterrestrial civilizations beyond the one currently threatening our world. Some of them will be explored later in these files, but the subjects in this section were all born on Earth and developed their powers later in life. Whether they gained their abilities through extraterrestrial energy or latent physiological traits, the fact remains that all of them have a special connection to this planet and are likely to be among the first to defend it from any threat, including one as expansive as the Skrull Empire.

CAPTAIN MARVEL

From her role as a US Air Force pilot to her current calling as one of the universe's most powerful super heroes, Carol Danvers has always pushed to be the best. As Captain Marvel, she is Earth's first line of defense, seeking out and nullifying threats before they reach our planet's orbit.

- Multilayered dermal tissue, analogous to other Kree-born specimens, provides heightened damage resistance.

 ## HYBRID PHYSIOLOGY

Carol Danvers displays anomalous physical abilities derived from hybrid DNA, which uniquely combines polynucleotides from both human and Kree genetic sources. When built into complex proteins, this mix of stored genetic information manifests in outward physical expressions including a dense musculature capable of superhuman strength and multilayered dermal tissue that is stubbornly resistant to damage. Though such a claim has not been verified, Carol believes she possesses a "seventh sense" separate from sight, sound, touch, taste, smell, and psionics. This ability apparently grants her split-second flashes of future events, analogous to accounts of mystical precognition.

For years we believed that Captain Marvel received her powers when an exploding Kree device, the Psyche-Magnetron, repatterned her DNA after that of her companion, the Kree soldier Mar-Vell. But Carol later learned that her mother was a Kree warrior who abandoned her mission in favor of a life on Earth. Carol was the product of her Kree mother's union with a human man, and the powers in her hybrid DNA remained dormant until the Psyche-Magnetron's activation. In essence, Carol's cells were cosmic batteries just waiting for the right charge.

- Captain Marvel absorbs ambient photons in the atmosphere and re-channels them, generating propulsive force for flight or concussive bursts for combat

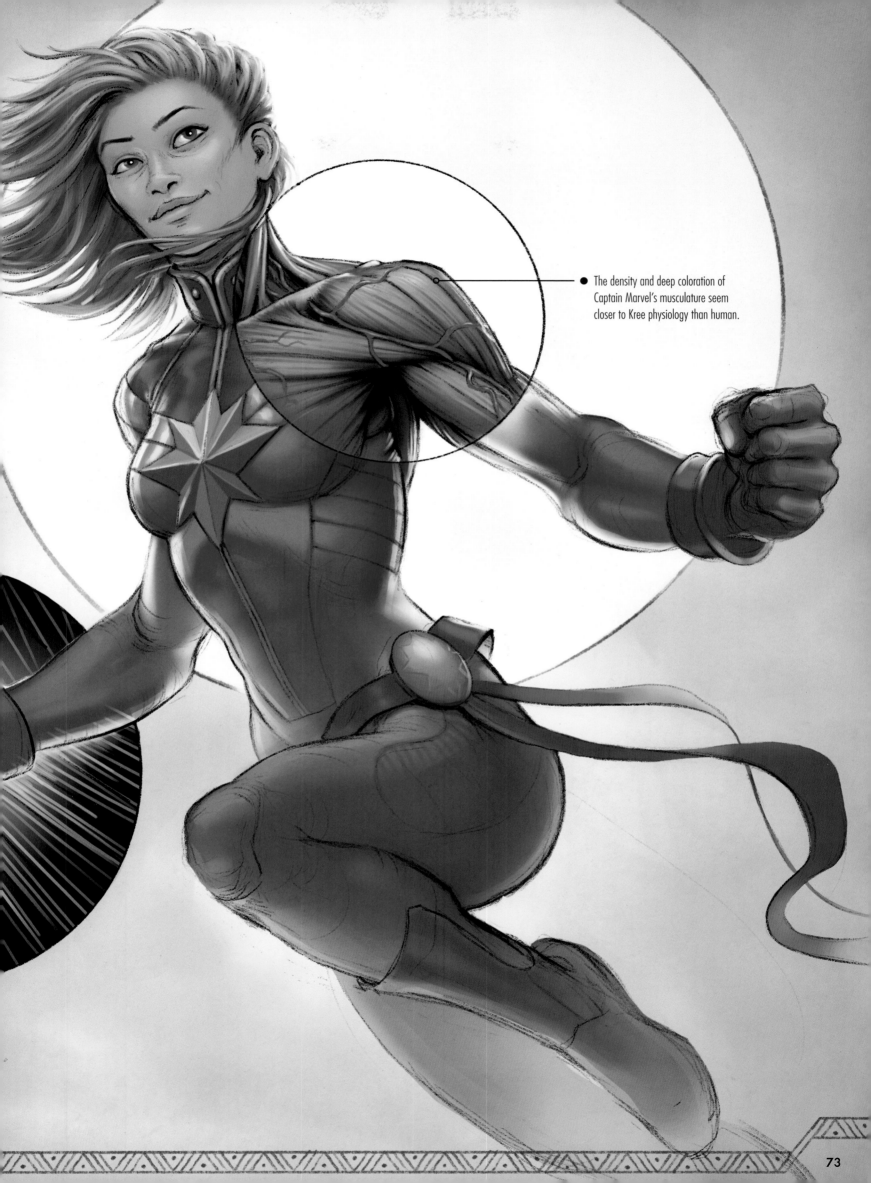

The density and deep coloration of Captain Marvel's musculature seem closer to Kree physiology than human.

CAPTAIN MARVEL

 ## PHOTONIC ENERGY CONVERSION

By absorbing and channeling ambient radiation, Carol can project destructive, targeted blasts of photonic energy from her hands. In a similar manner, she can fly by using streams of photons as a means of propulsion. It appears that Carol is naturally attuned to various energy states at all times, a condition that allows her to manipulate the frequencies and wavelengths of photons by drawing upon sources such as electromagnetic radiation and supercharged plasma. As long as her body maintains sufficient reserves of this photonic energy, Carol can tap directly into that power to fuel her body, bypassing her terrestrial metabolic and oxygenation needs in order to survive exposure to airless space for days.

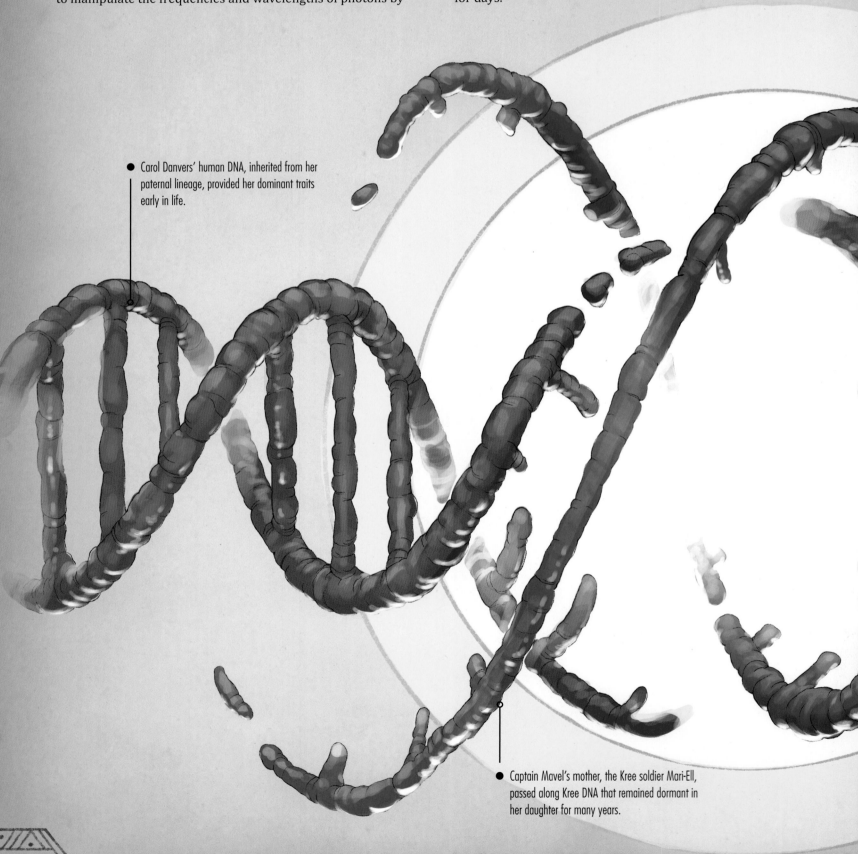

● Carol Danvers' human DNA, inherited from her paternal lineage, provided her dominant traits early in life.

● Captain Mavel's mother, the Kree soldier Mari-Ell, passed along Kree DNA that remained dormant in her daughter for many years.

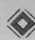

◈ BINARY MODE

It is possible that Carol's ability to manipulate photonic energy does not derive entirely from her human or Kree DNA. This facet of her power only appeared after genetic manipulation conducted by the Brood—a species of parasitic alien insectoids—whose tampering unlocked Carol's ability to access the energies of a white hole (a space-time region that emits vast amounts of light and energy). During the period she was connected to this spatial anomaly, Carol had the power to instantly tap into a wider array of interstellar energies that ignited her entire being in cosmic flame, a phenomenon that became known as her Binary mode. Though she is no longer connected to the white hole, Carol can still enter a physical state reminiscent of her Binary mode when she pushes her abilities to their fullest extent, the effects of which cause her head and hands to burn with coronas of stellar flame.

ASSESSMENT

Captain Marvel may have been born of two worlds, but she has always defended Earth at any cost. The Skrulls' invasion is currently centered on her homeworld, and thus I am confident that she will do whatever it takes to repel their forces: Her powers are vast, and her discipline is unquestionable. Captain Marvel is a soldier I would normally welcome into our ranks with open arms, but the cosmic origin of her powers potentially makes her one of the few candidates that a Super-Skrull could replace without an immediately discernible difference in energy signatures. As such, we may have to hold the line a bit longer before calling her into this battle.

● Exposure to Psyche-Magnetronic waves stimulated the polynucleotide bonds in Captain Marvel's hybrid DNA to activate her latent cosmic abilities.

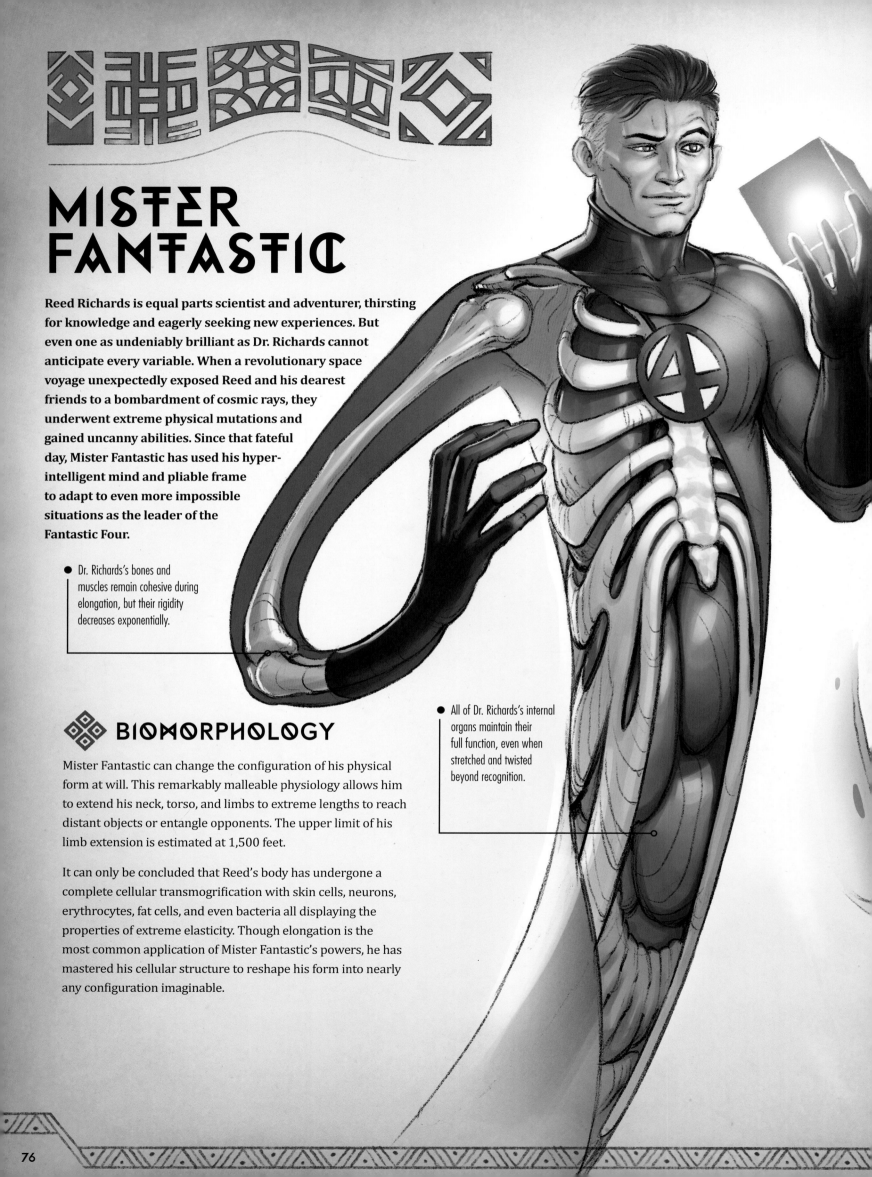

MISTER FANTASTIC

Reed Richards is equal parts scientist and adventurer, thirsting for knowledge and eagerly seeking new experiences. But even one as undeniably brilliant as Dr. Richards cannot anticipate every variable. When a revolutionary space voyage unexpectedly exposed Reed and his dearest friends to a bombardment of cosmic rays, they underwent extreme physical mutations and gained uncanny abilities. Since that fateful day, Mister Fantastic has used his hyper-intelligent mind and pliable frame to adapt to even more impossible situations as the leader of the Fantastic Four.

● Dr. Richards's bones and muscles remain cohesive during elongation, but their rigidity decreases exponentially.

BIOMORPHOLOGY

Mister Fantastic can change the configuration of his physical form at will. This remarkably malleable physiology allows him to extend his neck, torso, and limbs to extreme lengths to reach distant objects or entangle opponents. The upper limit of his limb extension is estimated at 1,500 feet.

It can only be concluded that Reed's body has undergone a complete cellular transmogrification with skin cells, neurons, erythrocytes, fat cells, and even bacteria all displaying the properties of extreme elasticity. Though elongation is the most common application of Mister Fantastic's powers, he has mastered his cellular structure to reshape his form into nearly any configuration imaginable.

● All of Dr. Richards's internal organs maintain their full function, even when stretched and twisted beyond recognition.

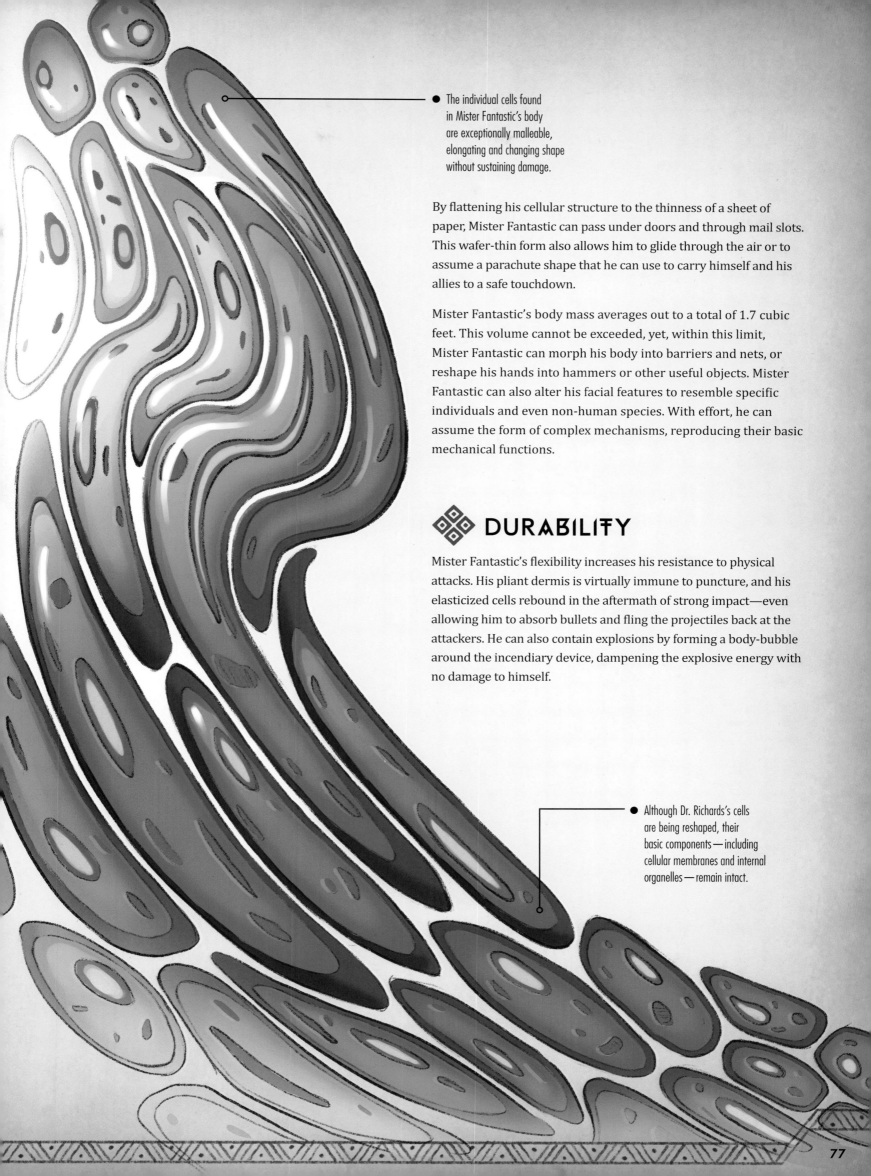

● The individual cells found in Mister Fantastic's body are exceptionally malleable, elongating and changing shape without sustaining damage.

By flattening his cellular structure to the thinness of a sheet of paper, Mister Fantastic can pass under doors and through mail slots. This wafer-thin form also allows him to glide through the air or to assume a parachute shape that he can use to carry himself and his allies to a safe touchdown.

Mister Fantastic's body mass averages out to a total of 1.7 cubic feet. This volume cannot be exceeded, yet, within this limit, Mister Fantastic can morph his body into barriers and nets, or reshape his hands into hammers or other useful objects. Mister Fantastic can also alter his facial features to resemble specific individuals and even non-human species. With effort, he can assume the form of complex mechanisms, reproducing their basic mechanical functions.

◈ DURABILITY

Mister Fantastic's flexibility increases his resistance to physical attacks. His pliant dermis is virtually immune to puncture, and his elasticized cells rebound in the aftermath of strong impact—even allowing him to absorb bullets and fling the projectiles back at the attackers. He can also contain explosions by forming a body-bubble around the incendiary device, dampening the explosive energy with no damage to himself.

● Although Dr. Richards's cells are being reshaped, their basic components—including cellular membranes and internal organelles—remain intact.

MISTER FANTASTIC

As noted earlier, Reed Richards was the first to discover unstable molecules, a revolutionary factor in the development of superhuman clothing and equipment. Using a patented process, unstable molecules can be bonded to anchor molecules in a piece of Richards-designed fabric, for example, allowing an entire garment to be rendered responsive to specific types of energized matter. The end result is clothing that can stretch endlessly, become invisible, or withstand blistering temperature extremes. Reed is constantly tweaking and upgrading his technology—the newest generation of his unstable-molecule-based clothing even allows the wearer to alter the design and coloration of an outfit with a thought, due to the incorporation of nanobot psi receptors attuned to human cognitive emanations.

A theoretical model of a molecule with rigid bonds (left) and an unstable molecule (right).

AN ENHANCED VIEW OF MISTER FANTASTIC'S COSTUME, FABRICATED USING UNSTABLE MOLECULES.

The effects of elongation on an unstable molecule in Dr. Richards' Fantastic Four uniform (above) and his own molecular structure (below).

BY RECONFIGURING HIS FACIAL FEATURES, DR. RICHARDS IS ABLE TO ALTER HIS APPEARANCE, CHANGE HIS VOICE, OR ENHANCE HIS SENSES.

- NATURAL STATE
- ALTERED VOICE
- ENHANCED EYESIGHT

SENSORY AUGMENTATION

Mister Fantastic has learned how to reconfigure his physiology to enhance sensory perception, in particular through the reshaping of his ocular, auditory, and olfactory organs. Via similar techniques he can alter the thickness of his vocal chords to mimic others or change the shape of his throat and mouth to amplify the volume of his voice.

ASSESSMENT

Mister Fantastic is indispensable in any scenario requiring rapid adaptability, and our campaign would surely benefit from his genius. In fact, Reed is one of the few heroes who has managed to defeat the Skrulls on repeated occasions. While a Skrull imposter could certainly replicate aspects of Mister Fantastic's malleable morphology, none could possibly hope to imitate his brilliance or determination to protect this world. Ultimately, I believe it will be Reed's brain, not his superhuman abilities, that may give us the edge against this invasion.

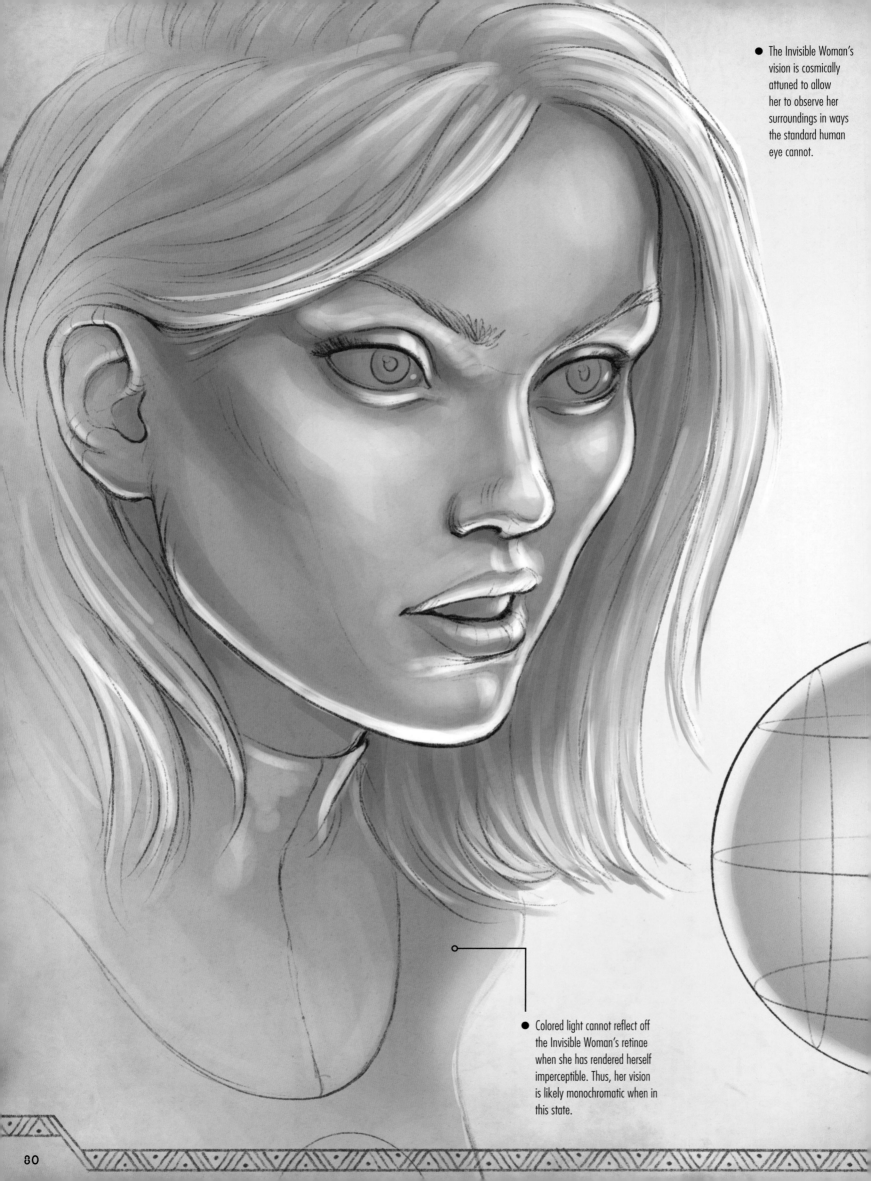

- The Invisible Woman's vision is cosmically attuned to allow her to observe her surroundings in ways the standard human eye cannot.

- Colored light cannot reflect off the Invisible Woman's retinae when she has rendered herself imperceptible. Thus, her vision is likely monochromatic when in this state.

INVISIBLE WOMAN

Susan Storm Richards is arguably the Fantastic Four's most powerful member. As the Invisible Woman, she does her best work when no one can see her and leaves her enemies blindsided by her force projections.

INVISIBILITY

As her name implies, the Invisible Woman can render herself completely undetectable across a range of electromagnetic wavelengths. This ability is not triggered on a cellular level but instead relies on Susan's mental manipulation of light wavelengths. Susan's ability to refract light around her body's contours leaves no telltale artifacts of distortion, and thus—because light can no longer reflect off her body in this state—she appears to vanish. Susan can also refract light around others and conceal them in a similar fashion. In addition, by selectively focusing her ability to manipulate light wavelengths, she can perceive the contents of locked safes or perform medical scans on individuals, analyzing internal organs and skeletal anatomy.

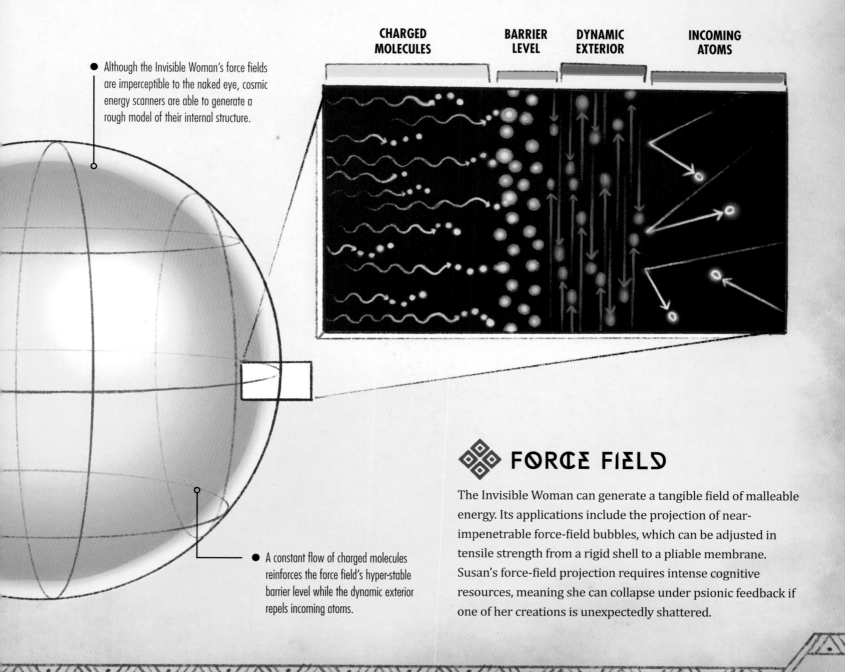

Although the Invisible Woman's force fields are imperceptible to the naked eye, cosmic energy scanners are able to generate a rough model of their internal structure.

CHARGED MOLECULES

BARRIER LEVEL

DYNAMIC EXTERIOR

INCOMING ATOMS

A constant flow of charged molecules reinforces the force field's hyper-stable barrier level while the dynamic exterior repels incoming atoms.

FORCE FIELD

The Invisible Woman can generate a tangible field of malleable energy. Its applications include the projection of near-impenetrable force-field bubbles, which can be adjusted in tensile strength from a rigid shell to a pliable membrane. Susan's force-field projection requires intense cognitive resources, meaning she can collapse under psionic feedback if one of her creations is unexpectedly shattered.

INVISIBLE WOMAN

● The Invisible Woman can control whether light passes through her force constructs or bends around them, thus altering the visibility of anyone or anything contained within.

 ## FORCE CONSTRUCTS

Through training, the Invisible Woman has learned to refine her psionic projections into geometric shapes and multifaceted constructs. Such creations range from cylinders and spheres to battering rams and spiked maces. Susan can even form a ball of invisible energy inside an object and then expand the radius of the ball until the surrounding shape bursts from the strain. Susan's solid energy projections have been measured at 100 feet in diameter, while the thin, hollow shells she creates (such as protective domes) can cover multiple square miles.

 ## FLIGHT DISCS

Although she doesn't possess the power of flight, the Invisible Woman is seemingly able to walk on air. Her secret is another application of projected force, specifically the creation of invisible floating discs or columns. Susan uses these projections as stepping stones when navigating through open air.

 ## ENHANCED SIGHT

The Invisible Woman can perceive her own invisible creations as well as the hidden constructs of others who possess similar abilities. It is my belief that her retinas not only detect reflected light but also are sensitive to trace amounts of cosmic energy—wavelengths imperceptible to terrestrial beings but presumably made available to Susan due to the nature of the accident that gifted her with her powers. In theory, such cosmic perception would render invisible objects as pale contours devoid of color (since the reflected cosmic particles would bypass a normal eye's light-sensitive rods and cones). In addition, Susan would likely view the entire world in monochrome scale while invisible herself, since her phased eyes would not be able to collect and reflect visible light in the ROYGBIV spectrum.

 ## ASSESSMENT

Even when she is out of sight, the Invisible Woman is never far from our minds. We have an urgent need for an ally of her caliber, not only on the field of battle but behind the scenes as well. Should we be able to trace a Skrull agent back to its terrestrial base of operations, Susan's ability to operate unseen could prove critical in uncovering vital information about the full extent of their invasion plan.

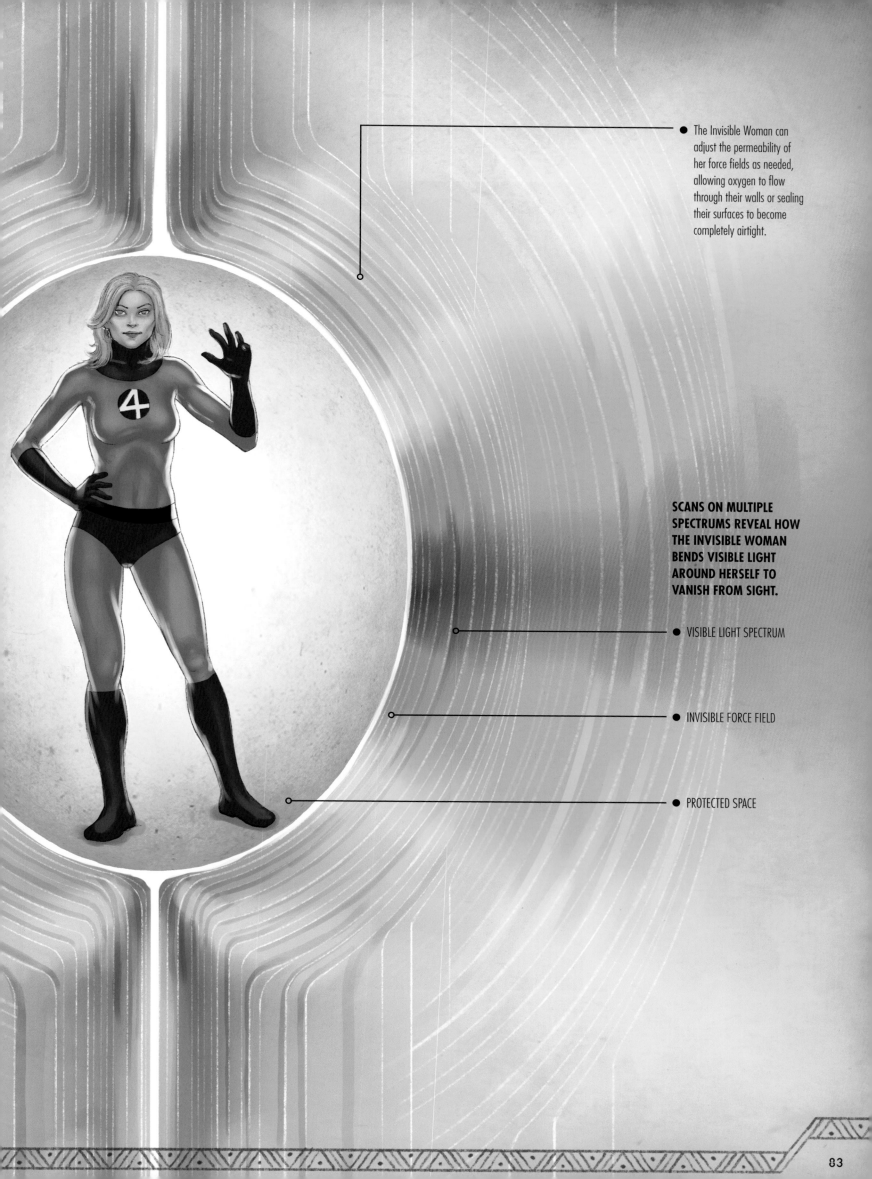

The Invisible Woman can adjust the permeability of her force fields as needed, allowing oxygen to flow through their walls or sealing their surfaces to become completely airtight.

SCANS ON MULTIPLE SPECTRUMS REVEAL HOW THE INVISIBLE WOMAN BENDS VISIBLE LIGHT AROUND HERSELF TO VANISH FROM SIGHT.

● VISIBLE LIGHT SPECTRUM

● INVISIBLE FORCE FIELD

● PROTECTED SPACE

HUMAN TORCH

With a body that burns as bright as the sun, the Human Torch makes an impression wherever he goes. Johnny Storm was once notorious for his fiery temper, but over the years the Fantastic Four's youngest member has come to demonstrate thoughtfulness and maturity. He may be the most likely member of their family to leverage his super hero status for personal gain, but when the time for action comes, there are few as dependable to light the way into battle.

FLAME POWERS

The Human Torch can harness ambient atmospheric energy, sheathing his body in superheated plasma. Johnny Storm retains mental control of the positive ions and free-roaming electrons that surround him in this state, enabling him to isolate the flames to specific body parts or even just his fingertips. On average, the flame aura generated by the Human Torch's plasma sheath extends up to five inches from his epidermis and burns at temperatures up to 780 degrees Fahrenheit. He has been observed to maintain his full-body flames for nearly 17 uninterrupted hours.

TEMPERATURE MANIPULATION

The Human Torch can manipulate the temperature of objects in his vicinity by several hundred degrees Fahrenheit. He can also cool an object to just below freezing point by siphoning ambient heat from the targeted area. By absorbing heat energy into his body, the Torch can also extinguish nearby blazes.

 Like all fires, the flames of the Human Torch require oxygen to burn. He cannot ignite his plasma sheath in the vacuum of space or under conditions of insufficient aeration. Although fire-retardant foam can sometimes snuff out the Torch, he will quickly return to full power if not hit by a follow-up attack.

- A thin cushion of air buffers the Human Torch's body from the flaming sheath of ignited plasma surrounding him.

- The Human Torch can generate flaming constructs, such as this fireball, from his plasmatic sheath, and hurl them at foes.

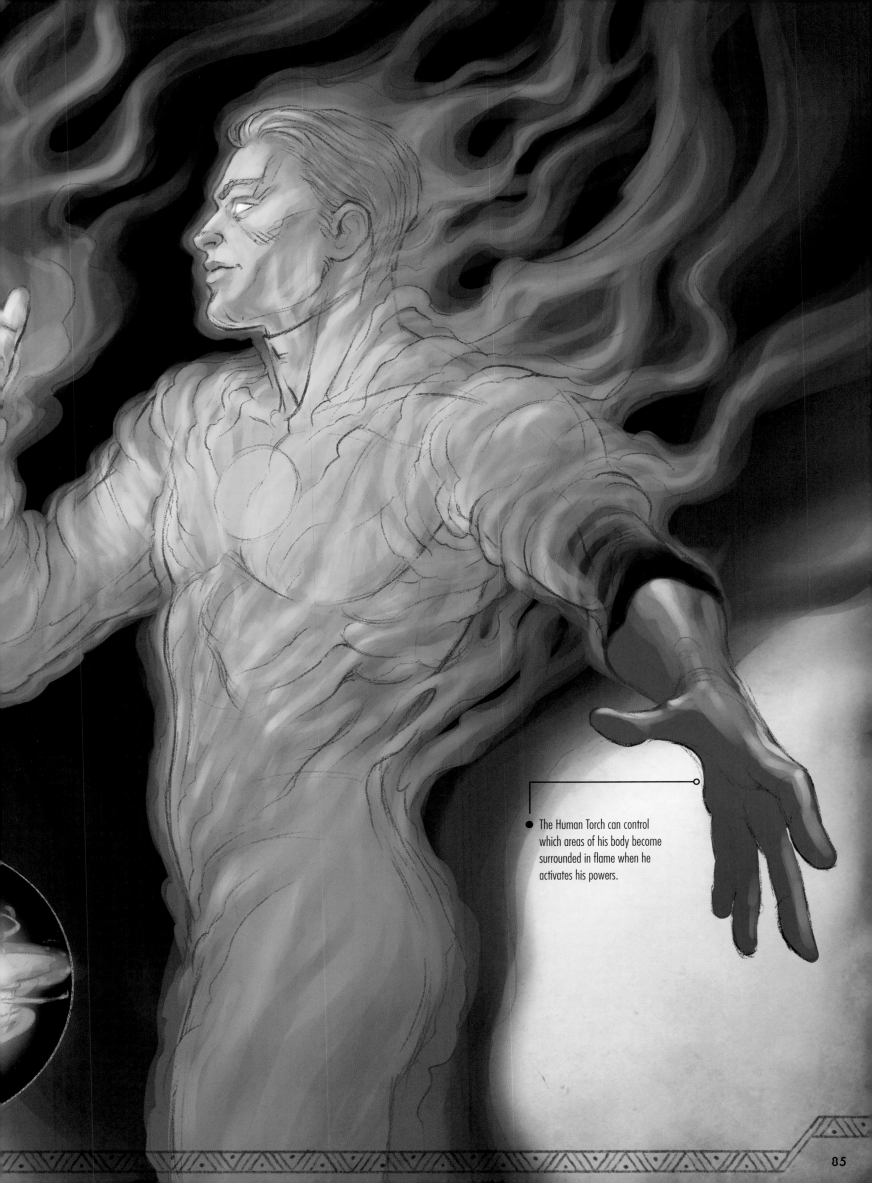

The Human Torch can control which areas of his body become surrounded in flame when he activates his powers.

HUMAN TORCH

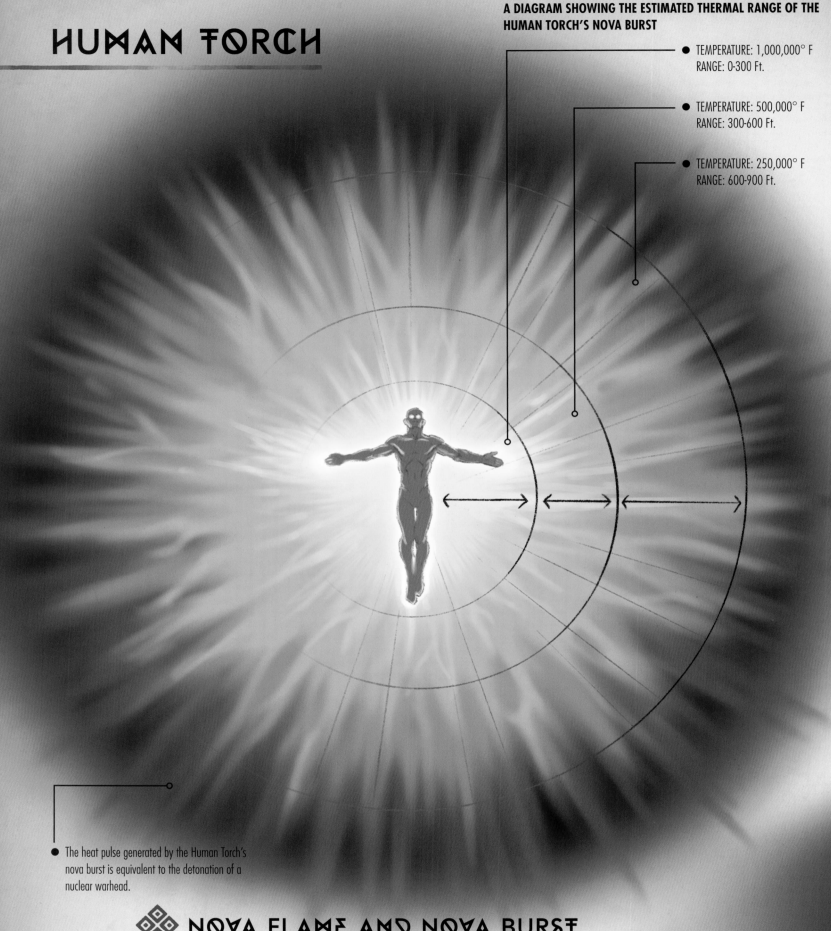

- TEMPERATURE: 1,000,000° F
 RANGE: 0-300 Ft.

- TEMPERATURE: 500,000° F
 RANGE: 300-600 Ft.

- TEMPERATURE: 250,000° F
 RANGE: 600-900 Ft.

- The heat pulse generated by the Human Torch's nova burst is equivalent to the detonation of a nuclear warhead.

◆◇◆ NOVA FLAME AND NOVA BURST

Under extreme stress, the Human Torch can raise the temperature and intensity of his aura to achieve a state he calls "nova flame." This threshold of ultra-hot plasma projection requires significant energy consumption. The Torch can choose to release all of this energy in a multidirectional wave—a nova burst—that reaches temperatures of nearly one million degrees Fahrenheit. This blast levels structures and scorches everything it touches inside a kilometer radius. Execution of a nova burst exhausts the Torch's plasma reserves and requires a recovery period of approximately half a day.

 # FLAME MANIPULATION

The Human Torch can reshape his blazing aura to unleash fireballs or create burning columns of air. On occasion he has generated a long-lasting flame trail to trace written messages in the sky. Through intense concentration, Johnny has even conjured flaming duplicates of his own body to be deployed as decoys. Most of Johnny's self-sustaining constructs burn at an accelerated rate and extinguish after only a few minutes.

 ## FLIGHT

According to one of Reed's theories, the elevated hydrogen levels in the Human Torch's plasma aura create a cloud of monatomic hydrogen atoms that surround him while he is in his powered-up state. This hot cloud generates positive buoyancy around the Torch, allowing him to float on air currents. By generating focused columns of flame beneath the soles of his feet, the Human Torch could presumably ride the propulsive burst in the same manner as a rocket engine. In order to protect himself from atmospheric turbulence at high velocities, he can ionize the air in front of him to create a shield made from static electricity.

- While flying through the atmosphere, the Human Torch protects himself from physical harm by ionizing the air in his path, creating a static electricity shield.

- A concentrated column of directional flame thrusts the Human Torch through the air at speeds near 140 miles per hour.

 ## ASSESSMENT

The full fury of the Human Torch's flames could burn our capital of Birnin Zana to the ground. Such destructive potential makes Johnny Storm one of the most valuable heroes we can recruit into our strike force. Beyond his impressive superhuman abilities, Johnny was also unwittingly married to a secret Skrull operative for a brief time. While the two are currently estranged, it is a connection we may be able to exploit to our advantage. Let us hope Johnny is willing to reopen some old wounds to prevent many new ones.

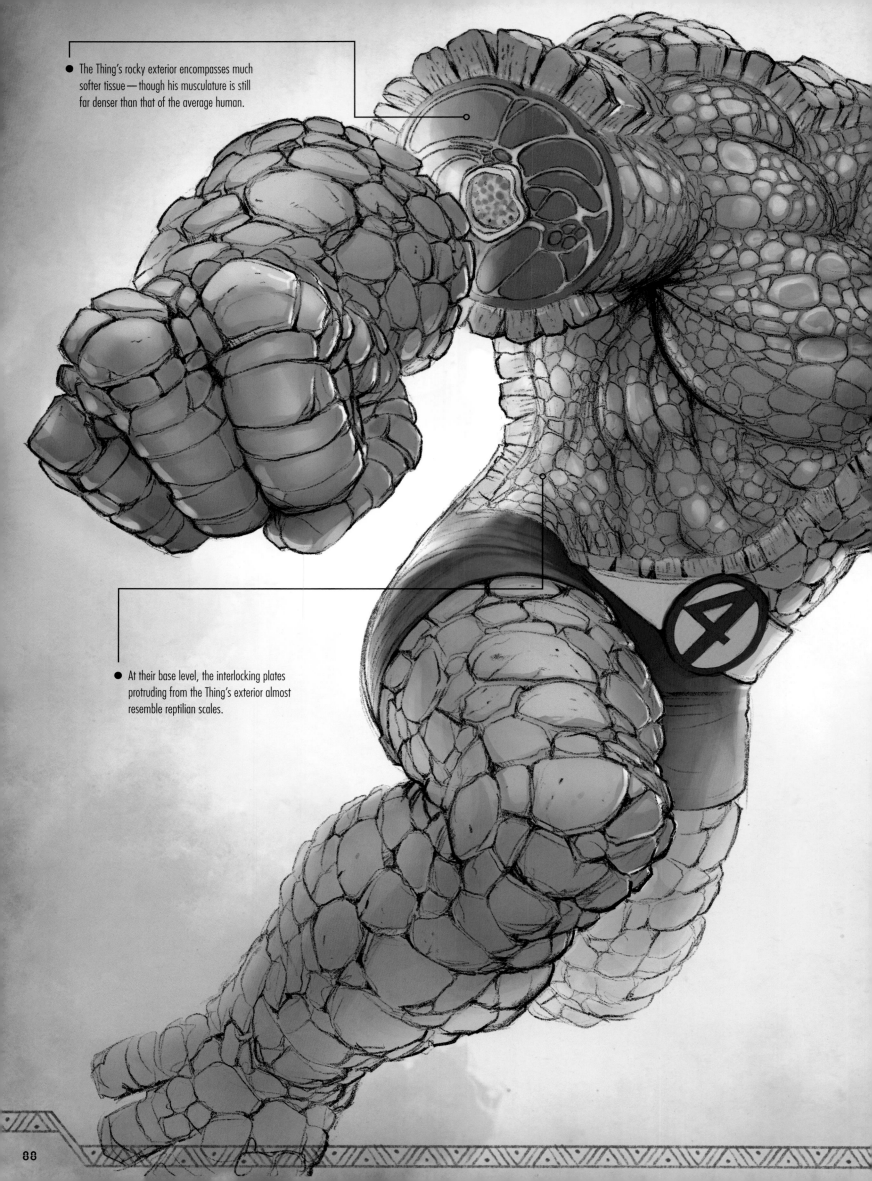

● The Thing's rocky exterior encompasses much softer tissue — though his musculature is still far denser than that of the average human.

● At their base level, the interlocking plates protruding from the Thing's exterior almost resemble reptilian scales.

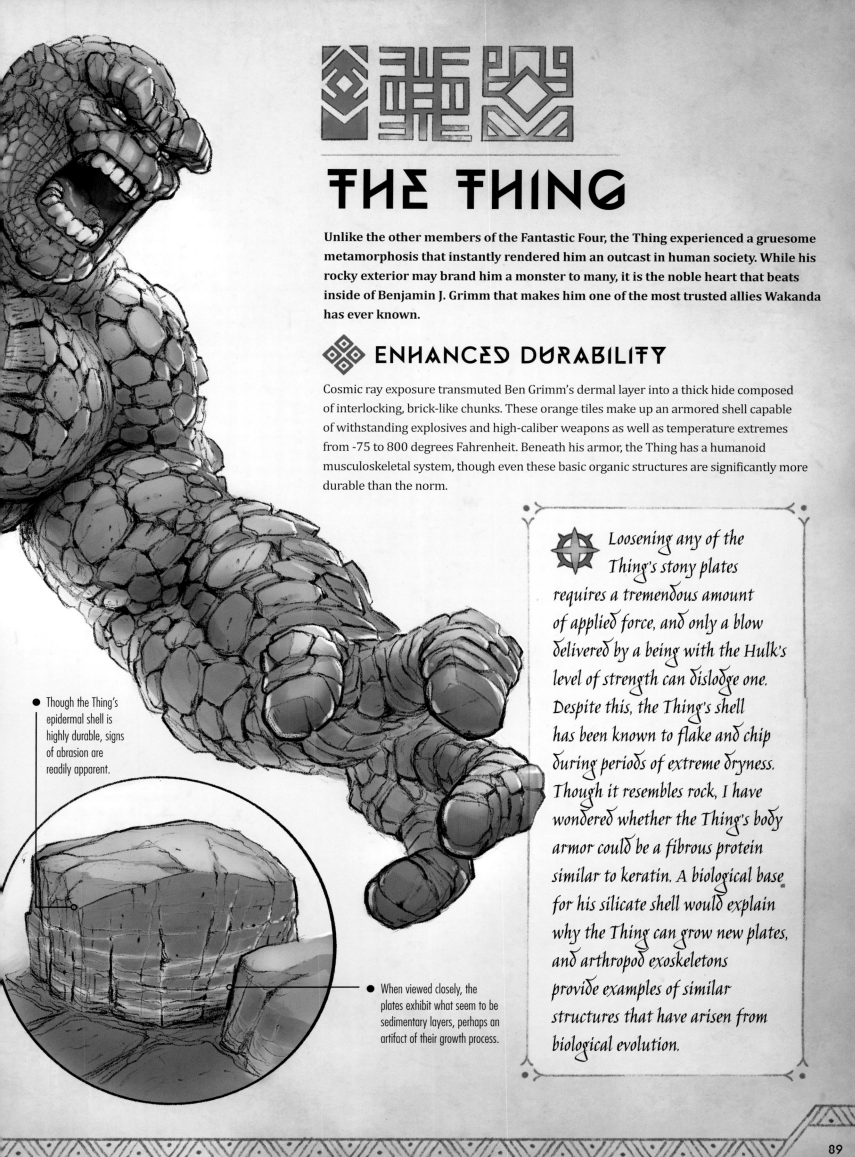

THE THING

Unlike the other members of the Fantastic Four, the Thing experienced a gruesome metamorphosis that instantly rendered him an outcast in human society. While his rocky exterior may brand him a monster to many, it is the noble heart that beats inside of Benjamin J. Grimm that makes him one of the most trusted allies Wakanda has ever known.

ENHANCED DURABILITY

Cosmic ray exposure transmuted Ben Grimm's dermal layer into a thick hide composed of interlocking, brick-like chunks. These orange tiles make up an armored shell capable of withstanding explosives and high-caliber weapons as well as temperature extremes from -75 to 800 degrees Fahrenheit. Beneath his armor, the Thing has a humanoid musculoskeletal system, though even these basic organic structures are significantly more durable than the norm.

● Though the Thing's epidermal shell is highly durable, signs of abrasion are readily apparent.

● When viewed closely, the plates exhibit what seem to be sedimentary layers, perhaps an artifact of their growth process.

Loosening any of the Thing's stony plates requires a tremendous amount of applied force, and only a blow delivered by a being with the Hulk's level of strength can dislodge one. Despite this, the Thing's shell has been known to flake and chip during periods of extreme dryness. Though it resembles rock, I have wondered whether the Thing's body armor could be a fibrous protein similar to keratin. A biological base for his silicate shell would explain why the Thing can grow new plates, and arthropod exoskeletons provide examples of similar structures that have arisen from biological evolution.

THE THING

BENJAMIN J. GRIMM IN HIS HUMAN FORM.

AS TRANSMUTATION BEGINS, GRIMM'S HAIR FALLS AWAY AND HIS SKIN BEGINS TO TOUGHEN.

ARMORED PLATES PROTRUDE FROM GRIMM'S SKIN AS HIS PHYSICAL FEATURES RECONFIGURE.

WHEN THE PROCESS IS COMPLETE, BEN GRIMM HAS BECOME THE THING.

 ## SUPERHUMAN STRENGTH

The Thing can easily deadlift more than 100 tons. Such remarkable strength owes much to the plates comprising his outer shell. These plates interlock at their edges under pressure acting like an exoskeletal framework, bracing against one another to create a rigid secondary support system that augments his skeletal and muscular systems. For one of his size, the Thing also exhibits surprisingly agile combat reflexes.

 ## ALTERED PHYSIOLOGY

The Thing has only four digits on each extremity. On the rare occasions when he reverts to a human form, this missing digit returns, implying that two sets of phalanges were merged into one during his initial mutation. The Thing lacks any external ear structure, and his auditory sensors are housed beneath his thick dermis. His perception of sound may thus be contingent on the presence of a tympanic membrane on each side of his head, below the layer of visible rock. Instead of sound entering through an auditory canal, this tympanum would interpret the vibrations passing through the Thing's rocky hide, transmitting those signals to the tympanic cavity in the middle ear.

 ## TRANSMUTATION

Despite the relative stability of his appearance, the Thing's cosmic mutation appears to be somewhat fragile, evidenced by a number of incidents in which he has reverted to human form. Yet these changes never last long and always end with the Thing returning to his rocklike state. Recently, the Thing began using a serum that can revert him to his original human form once per year for a period of approximately one week, shedding his rocky dermis like a butterfly emerging from a cocoon.

> In the first few weeks following his exposure to cosmic rays, the Thing exhibited a lumpier, half-formed appearance with orange skin that was more scaly than rocky. Shortly after, his stony plates began to appear and solidify—the Thing has maintained this form for the majority of his super hero career.

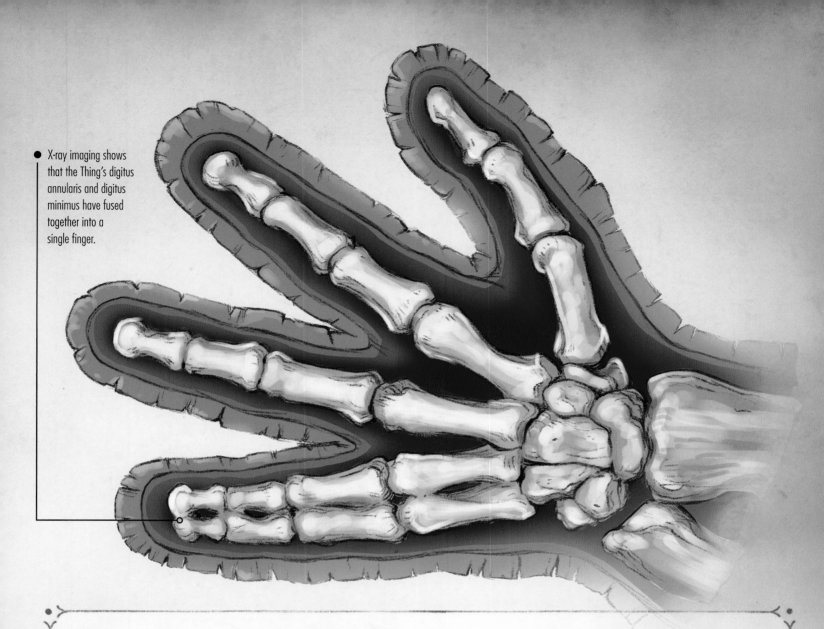

● X-ray imaging shows that the Thing's digitus annularis and digitus minimus have fused together into a single finger.

 I speculate that the Thing's physical enhancements have also given him a natural resistance to aging. He could possess longevity bordering on immortality, provided he can avoid incidents of massive physical trauma that would immediately end his life. As soon as I can obtain one of his dermal stones, I intend to run a chronal comparison—a process similar to the proportional measurement of isotopes under carbon dating—against data collected from previous samples of the Thing's armor to test whether my theory has merit.

ASSESSMENT

The Thing's powerful form is perfectly suited for demolishing enemies of all sizes, though an incursion force as large as the Skrull army will take—as he would so eloquently state—some serious clobbering. Even if his fists are incapable of felling an entire invading armada, I believe his unrivaled spirit will inspire us all to keep fighting until our world is safe once again.

As a team, the Fantastic Four is perfectly balanced in ability and expertise. Therefore, as soon as their identities are verified, they must be recruited into our efforts against the Skrulls. Mister Fantastic would be best suited in the development of an upgraded Skrull-detection system. The Invisible Woman can partake in reconnaissance missions while her brother, the Human Torch, puts his unique defensive and offensive capabilities to use on the war front. When it comes to the Thing, I trust that his stone-sheathed muscles will make short work of anyone revealed to be our foe.

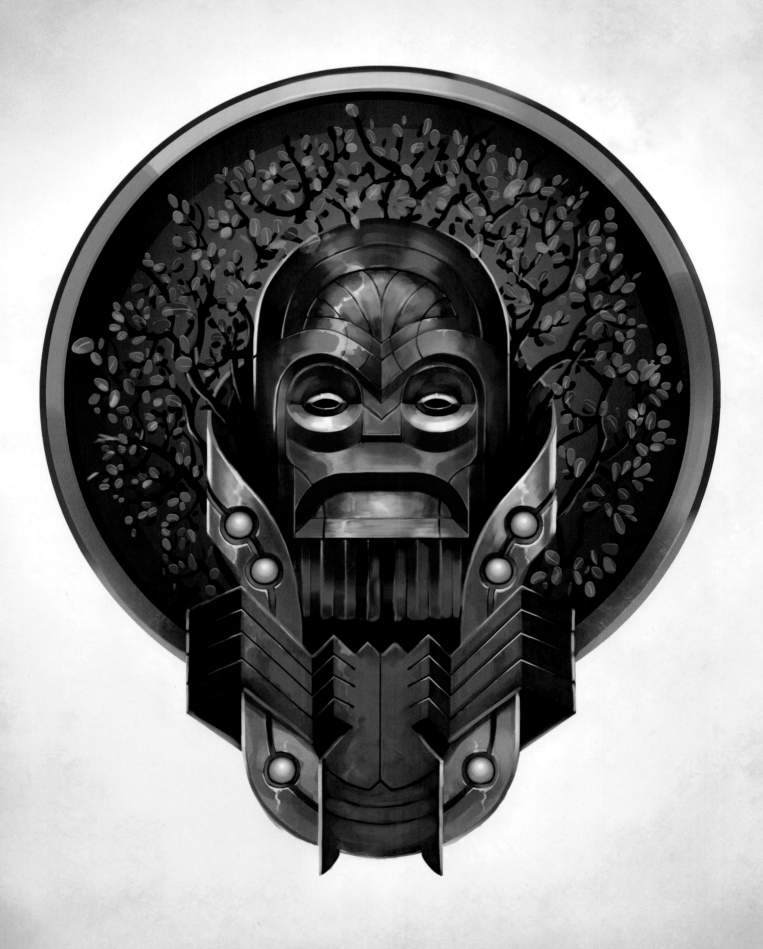

5
EXTRATERRESTRIAL LIFE-FORMS

My mother, N'Yami, was drawn to the stars and the stories they told. One need only glimpse the night sky above Wakanda to understand why she was transfixed by the heavens. Now, we know all too well we are not alone in this universe. Earth is once again on the verge of becoming a battleground for cosmic forces bent on our destruction. Fortunately, not all who dwell among the stars seek our conquest.

In my time as an Avenger, I have encountered alien species from the Acanti to the Z'nox. There are as many beings in the universe as there are stars in the sky, but I am hopeful that some of the following extraterrestrials might be persuaded to assist in our struggle.

Some of the information presented here is mere speculation, since the likes of Thanos will never submit to medical probes. A chunk of data comes courtesy of the interstellar adventurers known as the Guardians of the Galaxy—though given their propensity for stretching the truth, I look forward to eventually overwriting their colorful observations with hard data.

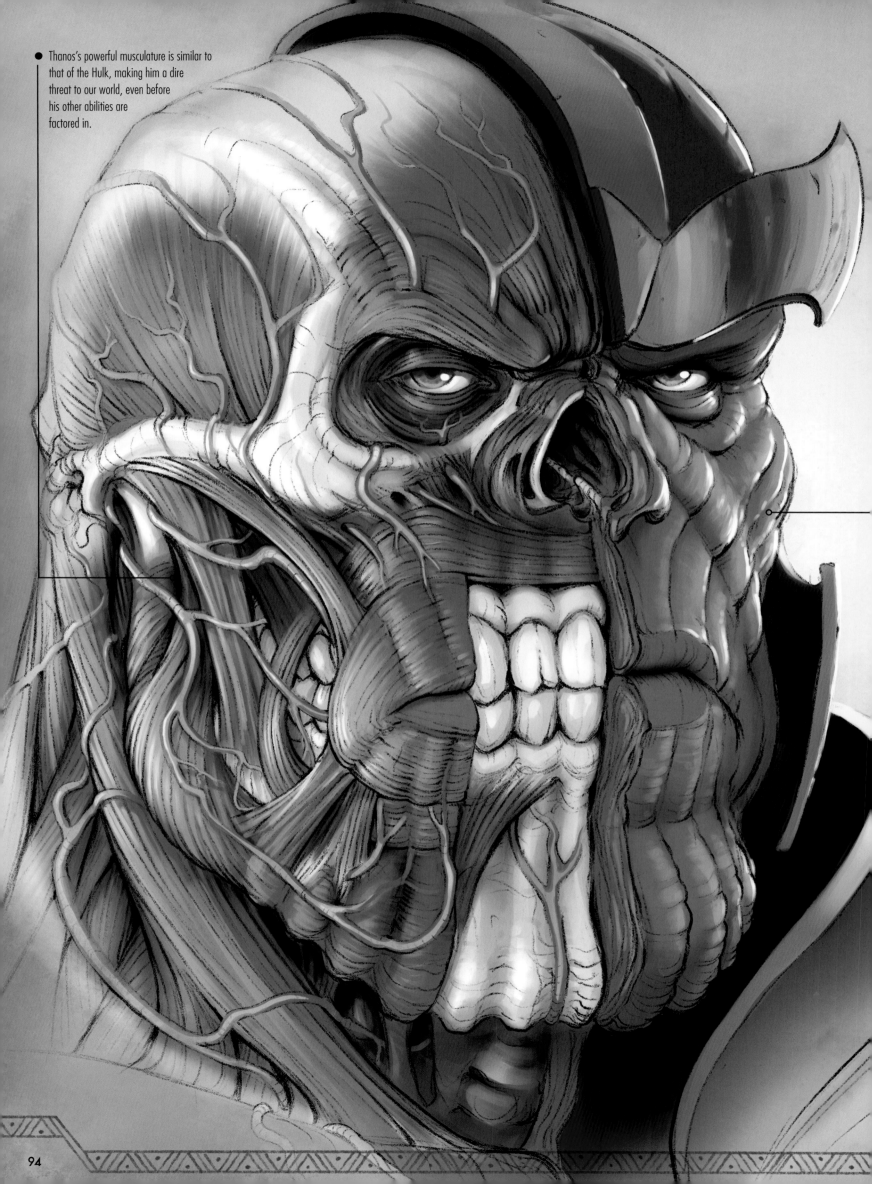

● Thanos's powerful musculature is similar to that of the Hulk, making him a dire threat to our world, even before his other abilities are factored in.

THANOS

Few aliens have inflicted more misery on our world than Thanos. Born into a colony of Eternals—a long-living offshoot of humanity—residing on Saturn's moon, Titan, Thanos possessed a genetic defect that afflicted him with grotesque physical features. Shunned and alienated, Thanos exacted revenge by slaughtering his own people and using interstellar conquest to win the favor of Death (a godlike entity who seemingly represents the end of life in all cultures). While he possessed the all-powerful Infinity Gauntlet, the Mad Titan even succeeded in wiping out half of all life in the universe. Fortunately, the combined might of our world's defenders reversed his depredations.

● Thanos was born to Eternal parentage, but his unique physiology is the result of an unexpected genetic abnormality.

ETERNAL PHYSIOLOGY

The Eternals are the supposed result of genetic experiments performed on primitive humans by the godlike beings known as the Celestials. Most Eternals are nearly indistinguishable in appearance from human beings. Their cellular makeup, however, is vastly more attuned to processing wavelengths of ambient cosmic energy. This allows them to collect and store cosmic power that can be used to extend their life spans. They also channel its effects into augmented muscles, energy projection, matter manipulation, and psionic mind control.

DEVIANT SYNDROME

A latent gene in Thanos's DNA triggered a condition classified by the Eternals as Deviant Syndrome, which resulted in his physiological anomalies and a cascade of related mutations. Unlike his fellow Eternals, Thanos developed purple skin and a furrowed chin, along with a hyper-muscular physiology that grants him strength on par with the Hulk. His durable cellular structure has strong restorative qualities to allow for rapid healing. Thanos can theoretically be killed—as evidenced by his recent decapitation—but each time he has seemingly been eliminated, he has somehow found a way to return to the land of the living.

THANOS

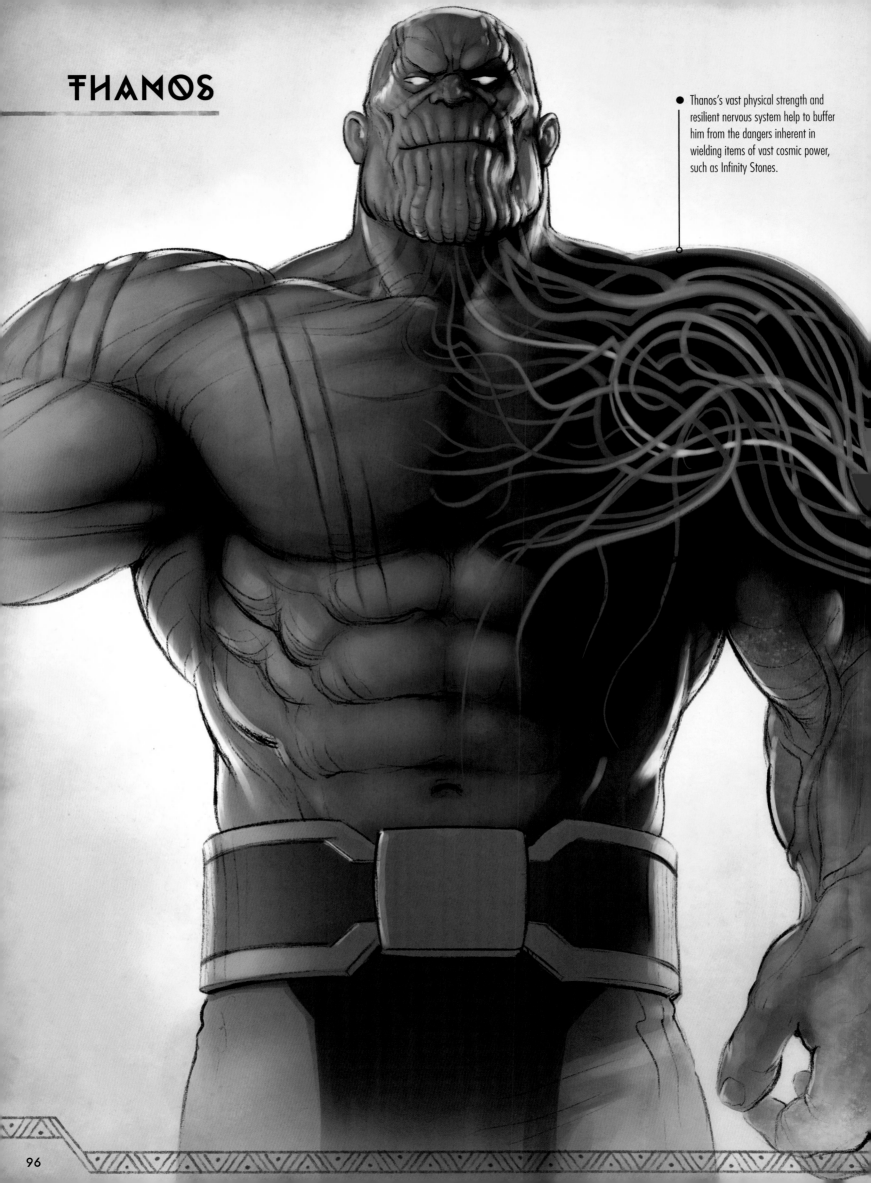

Thanos's vast physical strength and resilient nervous system help to buffer him from the dangers inherent in wielding items of vast cosmic power, such as Infinity Stones.

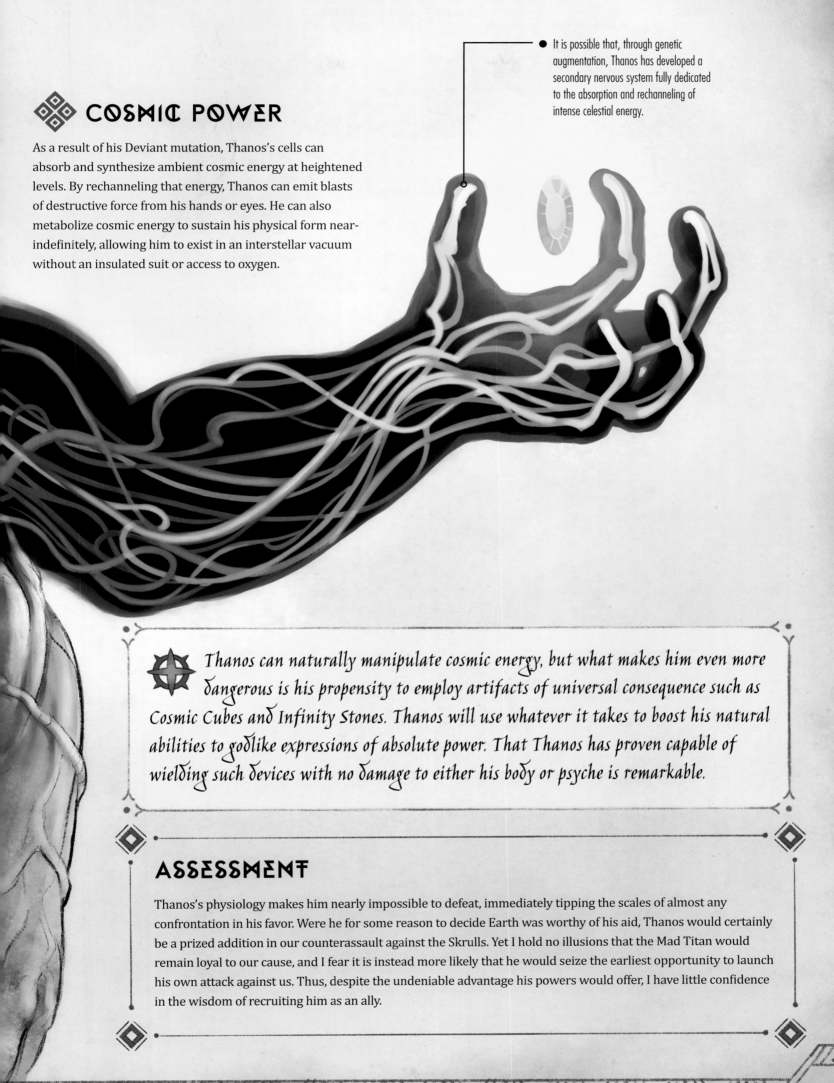

COSMIC POWER

As a result of his Deviant mutation, Thanos's cells can absorb and synthesize ambient cosmic energy at heightened levels. By rechanneling that energy, Thanos can emit blasts of destructive force from his hands or eyes. He can also metabolize cosmic energy to sustain his physical form near-indefinitely, allowing him to exist in an interstellar vacuum without an insulated suit or access to oxygen.

It is possible that, through genetic augmentation, Thanos has developed a secondary nervous system fully dedicated to the absorption and rechanneling of intense celestial energy.

Thanos can naturally manipulate cosmic energy, but what makes him even more dangerous is his propensity to employ artifacts of universal consequence such as Cosmic Cubes and Infinity Stones. Thanos will use whatever it takes to boost his natural abilities to godlike expressions of absolute power. That Thanos has proven capable of wielding such devices with no damage to either his body or psyche is remarkable.

ASSESSMENT

Thanos's physiology makes him nearly impossible to defeat, immediately tipping the scales of almost any confrontation in his favor. Were he for some reason to decide Earth was worthy of his aid, Thanos would certainly be a prized addition in our counterassault against the Skrulls. Yet I hold no illusions that the Mad Titan would remain loyal to our cause, and I fear it is instead more likely that he would seize the earliest opportunity to launch his own attack against us. Thus, despite the undeniable advantage his powers would offer, I have little confidence in the wisdom of recruiting him as an ally.

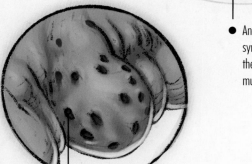

SYMBIOTES

The first-known symbiote on Earth was originally believed to be nothing more than a "living costume" belonging to Spider-Man, which the hero brought home following an extradimensional adventure. In time, we came to learn that Spider-Man's costume was a Klyntar symbiote—a morphologically malleable life-form that forges a deep bond with a living host to perpetuate its life cycle.

SYMBIOTE FEATURES

In their natural state, Klyntar symbiotes are formless masses of xenomorphic protoplasm. Since they possess neither an internal skeleton nor dedicated motility tissues such as muscles or tendons, symbiotes move by extruding a portion of their mass into a "false foot," or pseudopod, and then dragging the rest of their body forward in a manner similar to formless amoeboid cells (which are found in animals, fungi, and unicellular eukaryotes). Further manipulation of these pseudopod extensions allows a symbiote to reshape portions of its body mass into entangling whips, energy-blocking shields, or even organic webbing similar to that once used by Spider-Man.

Although some believe the Klyntar to be parasites, the symbiotes do not seek to drain their hosts but rather to physically enhance them. Notably, two human hosts, later dubbed Venom and Carnage, gained superhuman strength after bonding with their symbiotes. The subjects' greatly increased physical prowess was the result of the Klyntar enveloping their human hosts within their mass, creating a flexible, breathable organic sheath. In this configuration, the symbiote acts as an exoskeleton that augments the host's natural musculature in the manner of a mechanized power suit.

● Anamorphic lenses in the symbiote's ocular array extend the host's field of vision to a much wider range.

● Microscopic channels run through the papillae to maximize taste and smell. These conduits could also allow oxygen flow to the symbiote's host body.

● While the Venom symbiote has often manifested a long, prehensile tongue, this is not a common physical trait shared across the species.

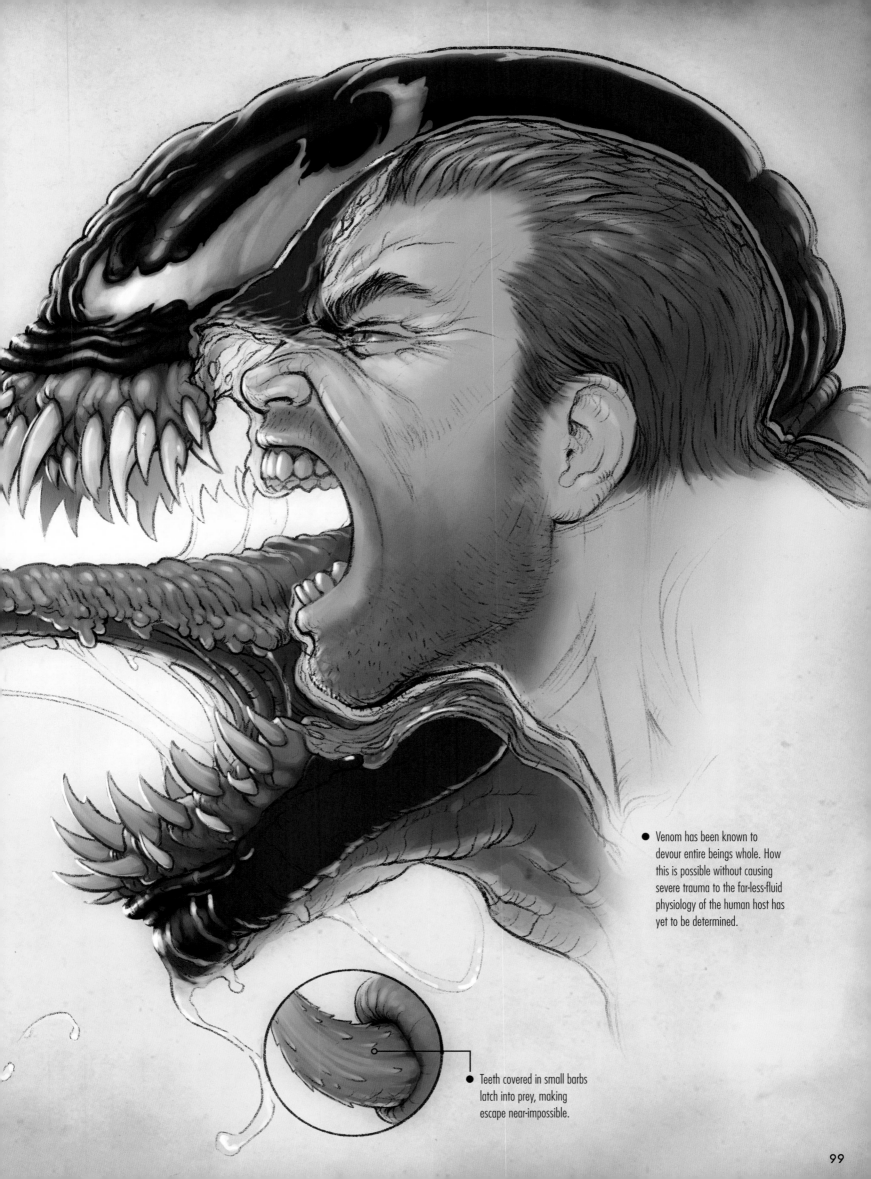

● Venom has been known to
devour entire beings whole. How
this is possible without causing
severe trauma to the far-less-fluid
physiology of the human host has
yet to be determined.

● Teeth covered in small barbs
latch into prey, making
escape near-impossible.

SYMBIOTES

The first symbiotes were bioweapons created centuries ago by a primordial deity known as Knull, the so-called "King in Black." These ancient symbiotes revolted against their creator, trapping Knull within a prison made from their combined biological mass. This became the celestial sphere known as Klyntar, the "planet" of the symbiotes. Knull recently escaped imprisonment and regained control of his army, only to fall once more by Venom's hand during an assault on Earth.

A SAMPLE OF THE CARNAGE SYMBIOTE EXPOSED TO A VARIETY OF EXTERNAL STIMULI.

- The specimen reacted aggressively when it felt threatened.

- When isolated, the symbiote attempted to flee in search of its host.

- The sample responded negatively to fire and sonic waves.

Symbiote cellular structure is fluid, yet it is able to harden into a solid molecular state as needed. This ability can be used defensively, the hard shell capable of deflecting a knife thrust or blocking a heavy blow at the point of impact.

Like octopi and other cephalopods, symbiotes can alter the hues and textures of their fluid dermis to camouflage themselves and their hosts. It's possible the presence of chromatophore cells—or their alien equivalent—would allow for this rapid pigment change. Similarly, the use of tiny rounded protuberances similar to cephalopod papillae could explain the symbiotes' ability to mimic the textured appearance of various clothing weaves. Though symbiote adaptability seems limitless, studies indicate that external stimuli, such as loud sounds and exposure to flames, can cause a symbiote to panic and drop its external camouflage—and, in some extreme cases, even sever the bond with its host.

 # SYMBIOTIC BOND

Symbiosis describes any long-term bond between two biological entities. Examples include mutualism (in which both entities benefit equally) and parasitism (in which one entity benefits by feeding on the other). Although they have each experienced symbiosis with the same alien entity, I believe Spider-Man and Venom would have very different opinions as to how those symbiotic bonds should be classified. Klyntar symbiotes have been known to accentuate the personalities of their hosts—for example, amplifying a tendency toward aggression into an insatiable hunger for violence. Because the symbiote knits itself to a host's nervous system, the minds of the alien and its host share a single cognitive connection. This bond can sometimes run deep: In the case of Carnage, the Klyntar symbiote bonded on the cellular level with its host, contaminating the human's bloodstream. As a result, the symbiote could not be removed without killing the host.

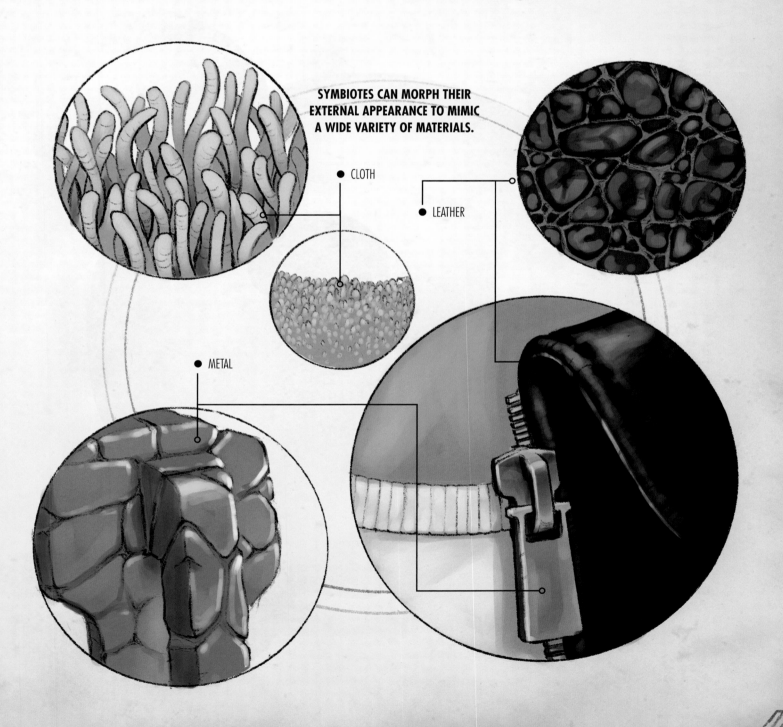

SYMBIOTES CAN MORPH THEIR
EXTERNAL APPEARANCE TO MIMIC
A WIDE VARIETY OF MATERIALS.

● CLOTH

● LEATHER

● METAL

SYMBIOTES

Even after physical separation, a Klyntar symbiote retains a lingering telepathic bond with its former host. The effect appears to result from a codex that remains in the host's DNA after removal of the symbiote. Any symbiote can thus identify someone who has previously been a Klyntar host. In rare cases, former hosts have reportedly exploited this codex to link up with the universal Klyntar hive mind.

THE VENOM SYMBIOTE HAS SPAWNED A NUMBER OF NOTABLE OFFSPRING DURING ITS TIME ON OUR WORLD.

● SCREAM

● LASHER

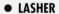

SPAWNING CAPABILITIES

Klyntar symbiotes reproduce asexually, producing spawn from latent seeds within their genetic structure. Spider-Man's original Venom symbiote spawned the beings later known as Carnage and Scream, among others. They are also able to absorb fellow symbiotes into their biomass, strengthening themselves and, on occasion, augmenting their physiology to create new hybrid forms.

ASSESSMENT

There is still much we do not know about symbiotes. In theory, if our Wakandan warriors were to bond themselves with an army of these alien entities, our forces would become nearly unstoppable and might survive the dangers that lie ahead unscathed. However, in doing so, we might very well be trading one alien threat for another. After witnessing far too many Klyntar hosts spiral into madness, I am reluctant to risk the lives of my nation's defenders so wantonly, even in a crisis such as this.

● PHAGE

● RIOT

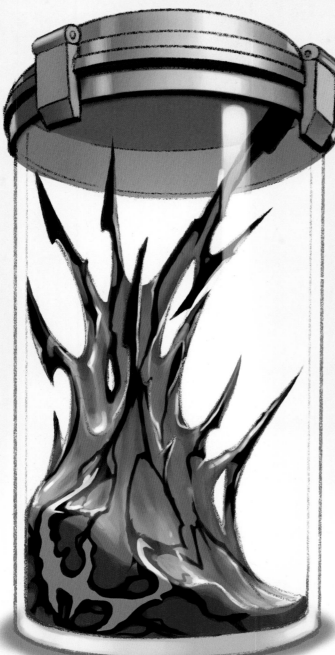

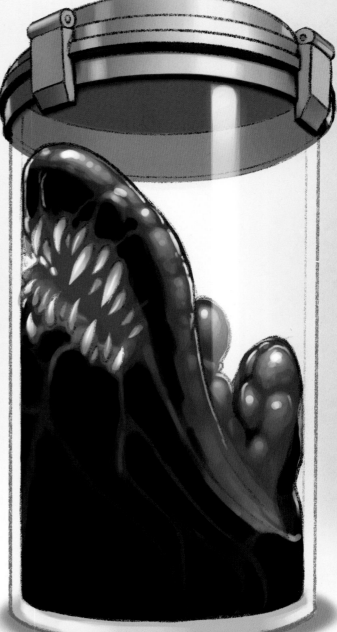

KRΣΣ

The sworn enemy of the Skrulls for eons, the Kree are warriors and conquerors from the planet Hala, located approximately 163,000 light years from our own star. Over millennia, the Kree built an empire spanning the Large Magellanic Cloud and points beyond. We have been fortunate to count some Kree as our allies, but all too often they have posed a threat to the sovereignty of Earth.

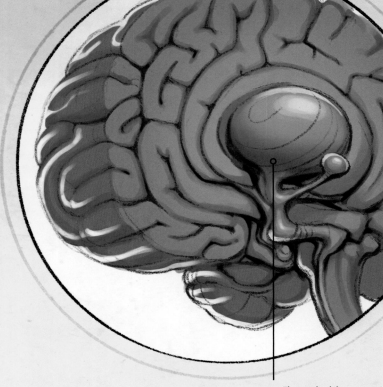

 The psychic lobe present in the brain of some Kree females unlocks additional mental powers feared within their patriarchal society.

 ## ALIΣN PHYSIOLOGY

Aside from anomalous variations in their skin pigmentation, the Kree look remarkably human. But beneath the surface, they have dense, fibrous muscles developed under the high-gravity environment of their homeworld. This renders the average Kree nearly twice as strong as a human. Body scans reveal that the Kree possess redundant backup organs. If an organ is critically damaged, one of these backups will kick in, allowing the Kree to withstand injuries that would prove fatal to one of our kind. Yet despite such advantages, the Kree have vulnerabilities as well. Because the atmosphere of Hala is rich in nitrogen, Kree visitors to Earth who have not yet become accustomed to our planet's air are required to wear filtration masks.

PSYCHIC ABILITIΣS

A small percentage of Kree females are born with natural psychic powers, granting them influence over their male counterparts and even the ability to siphon life energy from their victims. It is rare that these Kree women carry their powers into adulthood because the laws of their society dictate that females exhibiting these affinities are required to have their brain's psychic lobe surgically removed as soon as they come of age.

Members of the Kree population display two dominant skin pigmentations: The majority exhibit blue coloration, while a smaller segment of the population have a pinkish hue. According to reports provided by Captain Marvel, the pink-skinned Kree are the result of crossbreeding with other alien species during millennia of Kree conquest. At one point, the pink Kree outnumbered their blue-skinned brethren, yet the blue purebloods held onto institutional power. In the wake of Hala's destruction, both races of Kree are working together to rebuild their empire and their throneworld.

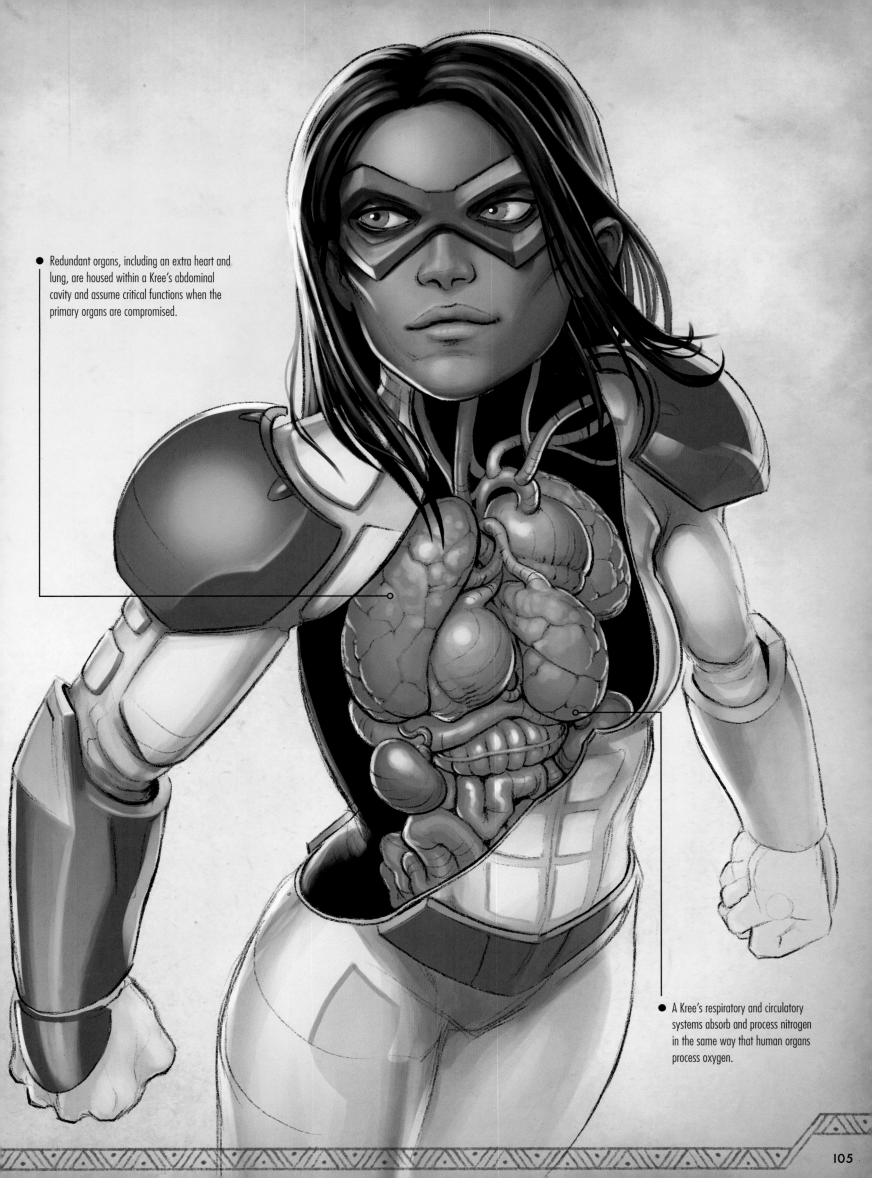

● Redundant organs, including an extra heart and lung, are housed within a Kree's abdominal cavity and assume critical functions when the primary organs are compromised.

● A Kree's respiratory and circulatory systems absorb and process nitrogen in the same way that human organs process oxygen.

KREE

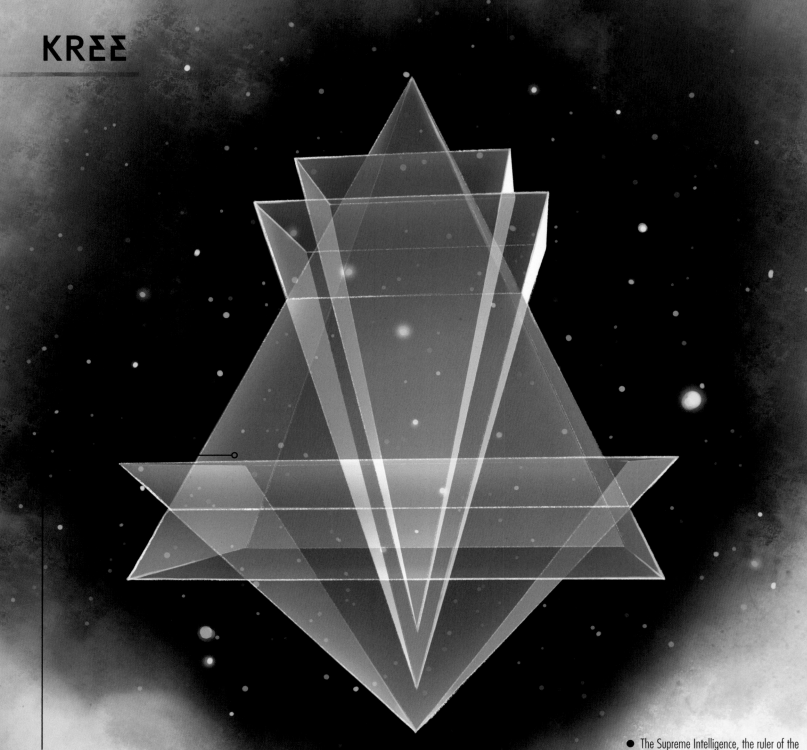

- The Forever Crystal was a transdimensional source of chronal power capable of manipulating the timestream.

- The Supreme Intelligence, the ruler of the Kree empire, used the Forever Crystal to subject his people to countless millennia of evolution in mere moments.

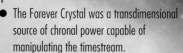 ARTIFICIAL EVOLUTION

At a time when eons of intergalactic war had pushed them to the edge of extinction, some Kree began to seek means to ensure their species' survival. In an effort to reignite Kree dominance, a group of fanatics known as the Ruul deployed an extradimensional artifact, the Forever Crystal, to upgrade their physiology on a mass scale. This experiment in accelerated evolution endowed a small group of the population with limited metamorphic abilities that allowed them to rapidly adapt to hostile environments. Each of these evolved Kree could take on predetermined genetic forms optimized for specialized functions such as flight, water-breathing, or other useful adaptations. Over time, the physiological advancements induced by the Forever Crystal seem to have vanished, and most Kree who underwent the evolution process reverted to their natural forms.

The bonds between Kree and Skrull DNA found in Hulking are more random and adaptive than the bonds between Captain Marvel's human and Kree DNA.

The Skrull and Kree Empires have long been locked in war, yet one hybrid being emerged, possessing the traits of both races. The son of a Skrull princess and the legendary Kree Mar-Vell, the hero known as Hulkling was raised on Earth away from the empires who would seek to exploit him. His enhanced powers include Kree-like durability and strength, plus Skrull-like shape-changing and regeneration. He has proven himself the best of both species and continues to make great efforts to establish lasting peace between all our worlds.

ASSESSMENT

After millennia of war against the Skrulls, it is fair to assume that factions of the Kree Empire would gladly join our efforts to repel the Skrull threat from our world. Kree technology is far more advanced than ours, leading me to believe that they may have devised solutions for detecting Skrulls far beyond our means. If we could solidify our bond with the Kree, they could aid us in pushing back the threat of the Skrulls through sheer numbers alone. But we must tread carefully, as our attempts to ward off one hostile empire could expose us to occupation by another.

GROOT

This tree-like alien is an interstellar adventurer known for traveling with the Guardians of the Galaxy. He responds to all inquiries with the same three-word reply, "I am Groot," and therefore all information on his physiology and the nature of his species has come through observation and testimony collected from his closest allies.

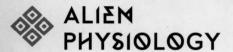 ALIEN PHYSIOLOGY

According to the Guardians, Groot belongs to the species *Flora colossi*, native to the Branch Worlds of Planet X. Groot's form is made up entirely of dendronic wood. The dense cellulose fibers that compose the bark and wood of Groot's body give him exceptional strength and durability. In addition, he is able to restore expended energy levels through root absorption and passive photosynthesis.

In his cellular makeup, Groot appears to share many similarities with trees found on our planet. A waxlike suberin seems to infuse the dead cells that make up Groot's bark, protecting him from the effects of excessive evaporation including cracking and flaking of the outermost phellem layer, also known as cork. Groot seemingly possesses phloem cells that transport nutrients throughout his body and xylem cells for distributing moisture throughout his sapwood layer. Groot's core, or his heartwood, consists of rigid, dead cells that are extremely strong and act as a pseudo-skeletal system.

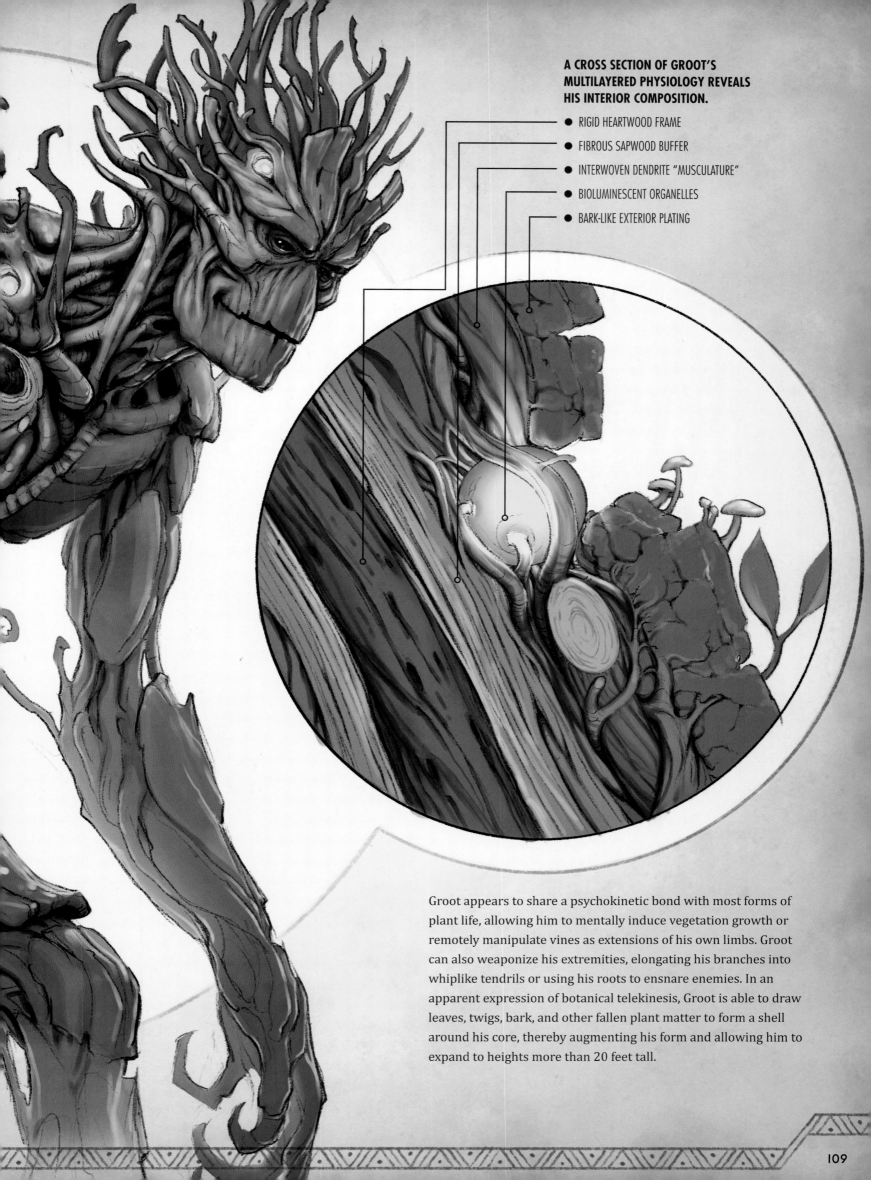

A CROSS SECTION OF GROOT'S MULTILAYERED PHYSIOLOGY REVEALS HIS INTERIOR COMPOSITION.

- RIGID HEARTWOOD FRAME
- FIBROUS SAPWOOD BUFFER
- INTERWOVEN DENDRITE "MUSCULATURE"
- BIOLUMINESCENT ORGANELLES
- BARK-LIKE EXTERIOR PLATING

Groot appears to share a psychokinetic bond with most forms of plant life, allowing him to mentally induce vegetation growth or remotely manipulate vines as extensions of his own limbs. Groot can also weaponize his extremities, elongating his branches into whiplike tendrils or using his roots to ensnare enemies. In an apparent expression of botanical telekinesis, Groot is able to draw leaves, twigs, bark, and other fallen plant matter to form a shell around his core, thereby augmenting his form and allowing him to expand to heights more than 20 feet tall.

GROOT

REGENERATIVE CAPABILITIES

Groot's healing ability allows him to restore his form by growing replacement parts. Every piece of Groot contains his complete consciousness, including his memories. If a single splinter from his body is planted and properly nurtured, it will grow into a fully restored, adult incarnation of Groot in weeks or months. It follows that multiple Groots can be grown simultaneously, with every copy possessing near-identical personalities. Groot, however, appears to be able to manipulate the composition of his clones through unknown means and has been observed creating aggressive iterations for combat deployment.

ASSESSMENT

Groot's treelike physiology makes him a highly unusual and potentially valuable specimen, particularly given his ability to control plant life. Perhaps our planet's native greenery and vegetation could be harnessed as a powerful weapon against the Skrull army once their infiltration erupts into a full-scale invasion attempt. It would be only just if the very world that they were trying to conquer were turned against them.

 Groot's limited speech is not a common trait among his species. According to the Guardians, Groot could once engage in full conversations, but he lost that ability when regenerating from a seedling after sustaining heavy battle damage. This revived Groot suffered from a stiffened larynx that soon became completely inflexible, allowing him to emit only a few sounds that can be interpreted by human ears. The Guardians, however, claim to be able to decipher the nuances of Groot's vocalizations and understand the deeper meanings he is trying to convey.

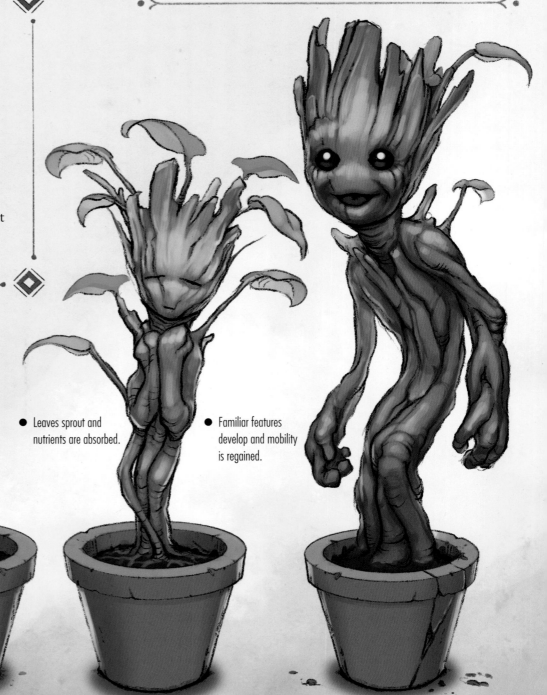

THE EARLY STAGES OF GROOT'S REGROWTH CYCLE

- A splintered remnant is planted.

- Leaves sprout and nutrients are absorbed.

- Familiar features develop and mobility is regained.

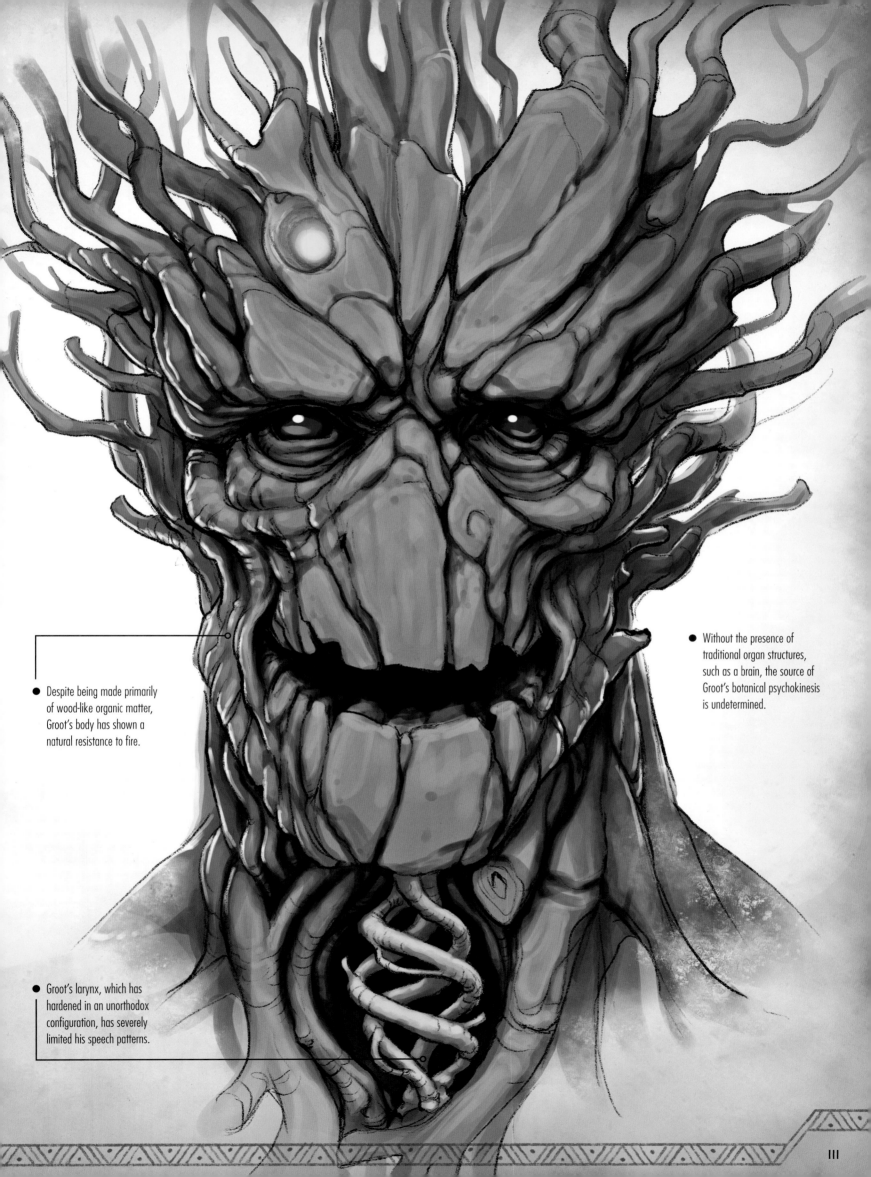

● Despite being made primarily of wood-like organic matter, Groot's body has shown a natural resistance to fire.

● Without the presence of traditional organ structures, such as a brain, the source of Groot's botanical psychokinesis is undetermined.

● Groot's larynx, which has hardened in an unorthodox configuration, has severely limited his speech patterns.

6
ANIMAL ABILITIES

As someone who has donned a panther's mantle, I understand humankind's primal connection to the beasts that share our planet. By adopting their images and icons, super-powered individuals often seek to evoke deep-rooted fears in our enemies that stem from the very infancy of our species.

Many rely on technology to mimic the abilities of the creatures whose names they claim. Others, however, share profound ties with their avatars. Some gained their gifts at birth, and others were the result of scientific anomalies, but all are examples of the wonders possible when combining the abilities of man and beast.

SPIDER-MAN

Spider-Man is famous for his lighthearted jests, but his carefree attitude masks the fact that he is a powerful physical specimen capable of vastly more than many realize. Due to Spider-Man's frequent visits to the Avengers medcenter, we have acquired sufficient samples of his DNA and organic tissue to help inform our analysis of his physiology.

- Spider-Man's muscles are tightly layered, increasing his strength without adding additional bulk to his lithe frame.

◆ RADIOACTIVE BLOOD

According to Spider-Man's own accounts, he began to exhibit his powers after being bitten by an irradiated spider. Through blood-sample analysis, I was able to isolate a radioactive isotope present in his plasma that seems to confirm Spider-Man's story and explains the array of unique mutagenic effects that manifested shortly after initial exposure. Through a blood-borne transmission delivered by its chelicerae fangs (which are hollow and connected to venom glands), the irradiated spider appears to have passed on a DNA mutagen that informed Spider-Man's transformation and gifted him with arachnid-like powers. Complex radioactive enzymes in the venom likely stimulated further augmentation to Spider-Man's physical form as it circulated through his tissue.

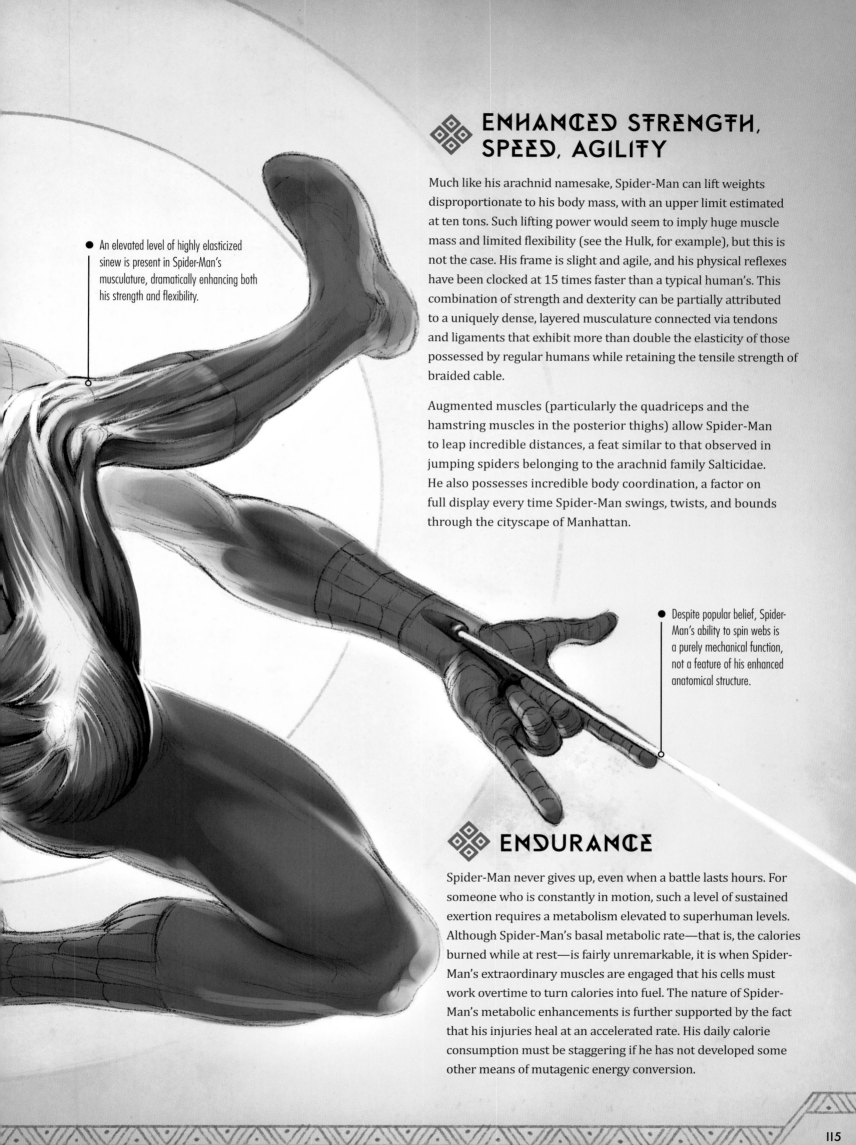

ENHANCED STRENGTH, SPEED, AGILITY

Much like his arachnid namesake, Spider-Man can lift weights disproportionate to his body mass, with an upper limit estimated at ten tons. Such lifting power would seem to imply huge muscle mass and limited flexibility (see the Hulk, for example), but this is not the case. His frame is slight and agile, and his physical reflexes have been clocked at 15 times faster than a typical human's. This combination of strength and dexterity can be partially attributed to a uniquely dense, layered musculature connected via tendons and ligaments that exhibit more than double the elasticity of those possessed by regular humans while retaining the tensile strength of braided cable.

Augmented muscles (particularly the quadriceps and the hamstring muscles in the posterior thighs) allow Spider-Man to leap incredible distances, a feat similar to that observed in jumping spiders belonging to the arachnid family Salticidae. He also possesses incredible body coordination, a factor on full display every time Spider-Man swings, twists, and bounds through the cityscape of Manhattan.

An elevated level of highly elasticized sinew is present in Spider-Man's musculature, dramatically enhancing both his strength and flexibility.

Despite popular belief, Spider-Man's ability to spin webs is a purely mechanical function, not a feature of his enhanced anatomical structure.

ENDURANCE

Spider-Man never gives up, even when a battle lasts hours. For someone who is constantly in motion, such a level of sustained exertion requires a metabolism elevated to superhuman levels. Although Spider-Man's basal metabolic rate—that is, the calories burned while at rest—is fairly unremarkable, it is when Spider-Man's extraordinary muscles are engaged that his cells must work overtime to turn calories into fuel. The nature of Spider-Man's metabolic enhancements is further supported by the fact that his injuries heal at an accelerated rate. His daily calorie consumption must be staggering if he has not developed some other means of mutagenic energy conversion.

SPIDER-MAN

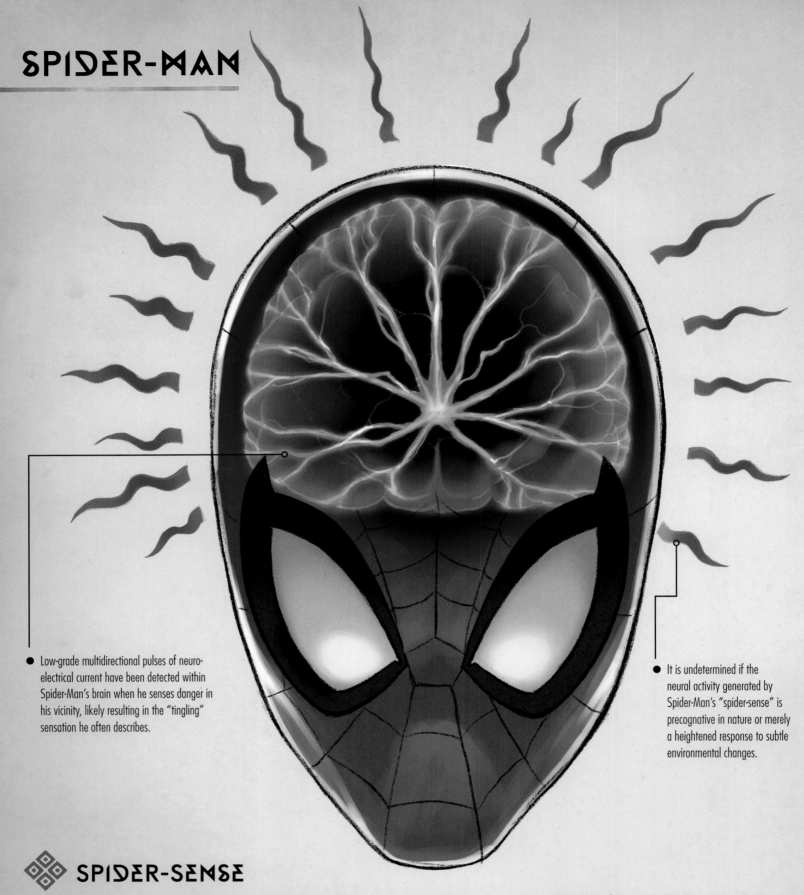

● Low-grade multidirectional pulses of neuro-electrical current have been detected within Spider-Man's brain when he senses danger in his vicinity, likely resulting in the "tingling" sensation he often describes.

● It is undetermined if the neural activity generated by Spider-Man's "spider-sense" is precognative in nature or merely a heightened response to subtle environmental changes.

◈ SPIDER-SENSE

Spider-Man's most fascinating ability is arguably his spider-sense, which is how he describes his unique autonomic response system that gifts him hyperacute awareness concerning imminent danger. Houseflies can react to stimuli twelve times faster than a human, and some species of spiders approach similar levels of quick-twitch reaction. Just like a bug that leaps to safety a split second before a human hand can swat it, Spider-Man avoids harm due to this early warning system, which he describes as a "tingling" sensation inside his head.

Such a power could be psionic in nature, a form of extrasensory perception or even precognition, but I believe it is more likely to be a by-product of Spider-Man's enhanced nervous system working in unison with his augmented reflexes. He is far more attuned to his surroundings than most superhumans, picking up nearby disturbances before anyone else senses the same stimuli. Spider-Man claims he can even determine the threat level of a situation based on the intensity of the tingling he experiences.

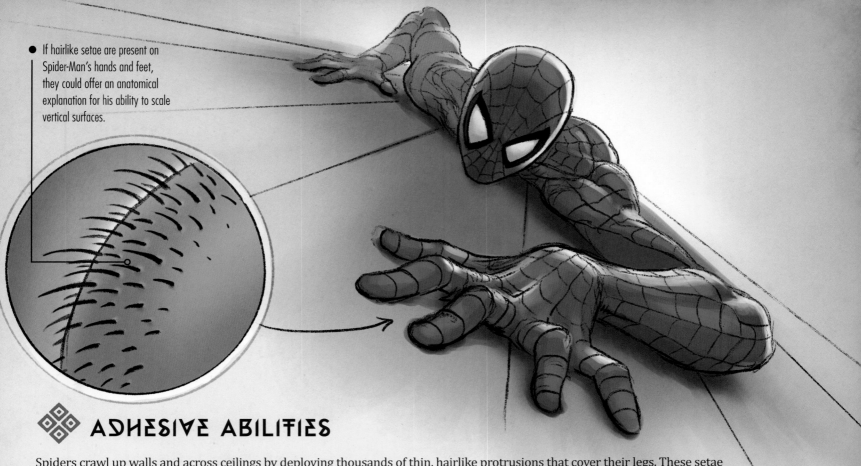

If hairlike setae are present on Spider-Man's hands and feet, they could offer an anatomical explanation for his ability to scale vertical surfaces.

ADHESIVE ABILITIES

Spiders crawl up walls and across ceilings by deploying thousands of thin, hairlike protrusions that cover their legs. These setae create an electromagnetically charged attraction on a molecular level, actuating surface cling. Spider-Man, however, appears capable of sticking to walls, even when his hands and feet are covered by the fabric of his costume. It could be that his setae are strong enough to pierce his suit, but Spider-Man has proven reluctant to submit to exhaustive testing of his abilities.

As an alternative hypothesis, it could be possible that Spider-Man is able to consciously control the interatomic attraction between molecular boundary layers. In other words, it's possible he creates a bond between his body's bioelectrical aura and a targeted surface on a subatomic level, granting him the ability to walk on walls. This attraction field would likely be concentrated around his hands and feet and must be exceptionally strong given that Spider-Man is able to lift several tons of additional weight without breaking his adhesive connection.

AN INTERIOR VIEW OF SPIDER-MAN'S SPIDER-TRACER

AERODYNAMIC VANES

BATTERY

BARBED ATTACHMENT HOOKS

ELECTRONICS MODULE

To track his enemies, Spider-Man employs a piece of proprietary equipment he calls a Spider-Tracer. This small, battery-powered homing device omits a radio wave specifically attuned to his spider sense. Spider-Man essentially acts as the receiver for the signal, and the closer he gets to the point of the signal's origin, the stronger he experiences his spider-sense's signature tingling sensation. This innovative application of technology makes me wonder if this flippant young American uses his wisecracking public persona to mask a truly remarkable intelligence.

SPIDER-MAN

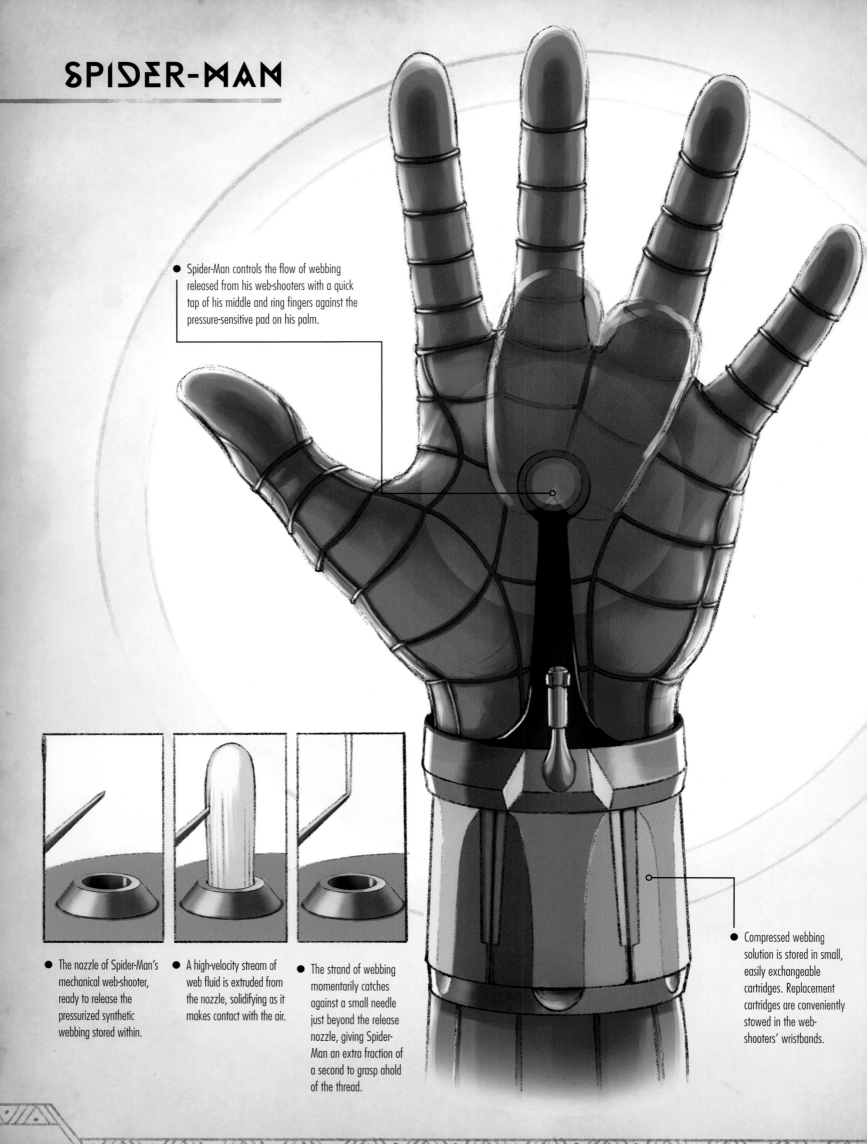

Spider-Man controls the flow of webbing released from his web-shooters with a quick tap of his middle and ring fingers against the pressure-sensitive pad on his palm.

The nozzle of Spider-Man's mechanical web-shooter, ready to release the pressurized synthetic webbing stored within.

A high-velocity stream of web fluid is extruded from the nozzle, solidifying as it makes contact with the air.

The strand of webbing momentarily catches against a small needle just beyond the release nozzle, giving Spider-Man an extra fraction of a second to grasp ahold of the thread.

Compressed webbing solution is stored in small, easily exchangeable cartridges. Replacement cartridges are conveniently stowed in the web-shooters' wristbands.

WEB-SHOOTERS

Like many, I once held the belief that Spider-Man's signature web-shooting powers were organic and stemmed from the radioactive infusion of arachnid venom underpinning his other abilities. Most spiders, after all, can weave strong strands of silk from the spinnerets on their abdomens. But the truth, revealed by Spider-Man in confidence and easily verified from a simple analysis of his webbing, is that his webs are composed of a man-made inorganic substance resembling nylon. The webbing's elastic qualities allow it to stretch and rebound under strain, yet it is highly resistant to tension and does not break easily.

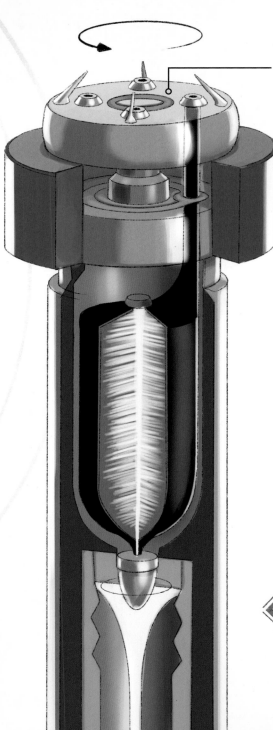

● Spider-Man can adjust his web-shooters' settings on the fly to release his webbing in a variety of different patterns, from strong single strands to widespread nets.

 While Spider-Man's scientific ingenuity is impressive, the chemical composition of his webbing is fairly straightforward (but will not be reproduced here, to honor the wishes of its inventor). The compressed webbing formula is forced through a narrow nozzle and released as a high-powered stream. Upon exposure to air, the polymer chain in the fluid solidifies to become a flexible adhesive fiber that won't snap when stretched or pulled. The webbing dissolves in hours—undoubtedly a blessing for the residents of New York City, who otherwise would find skyscrapers festooned with dangling cobwebs each morning.

ASSESSMENT

Although his physical form seems to be that of an average human male, Spider-Man's superstrength, astonishing reflexes, and array of arachnid-enhanced abilities give him a distinct advantage against the gravest of threats. This young hero's physical skills coupled with his seemingly brilliant scientific mind will likely prove advantageous to our efforts against foes as cunning as the Skrulls, and I can think of few heroes I would rather have at my side in this desperate hour.

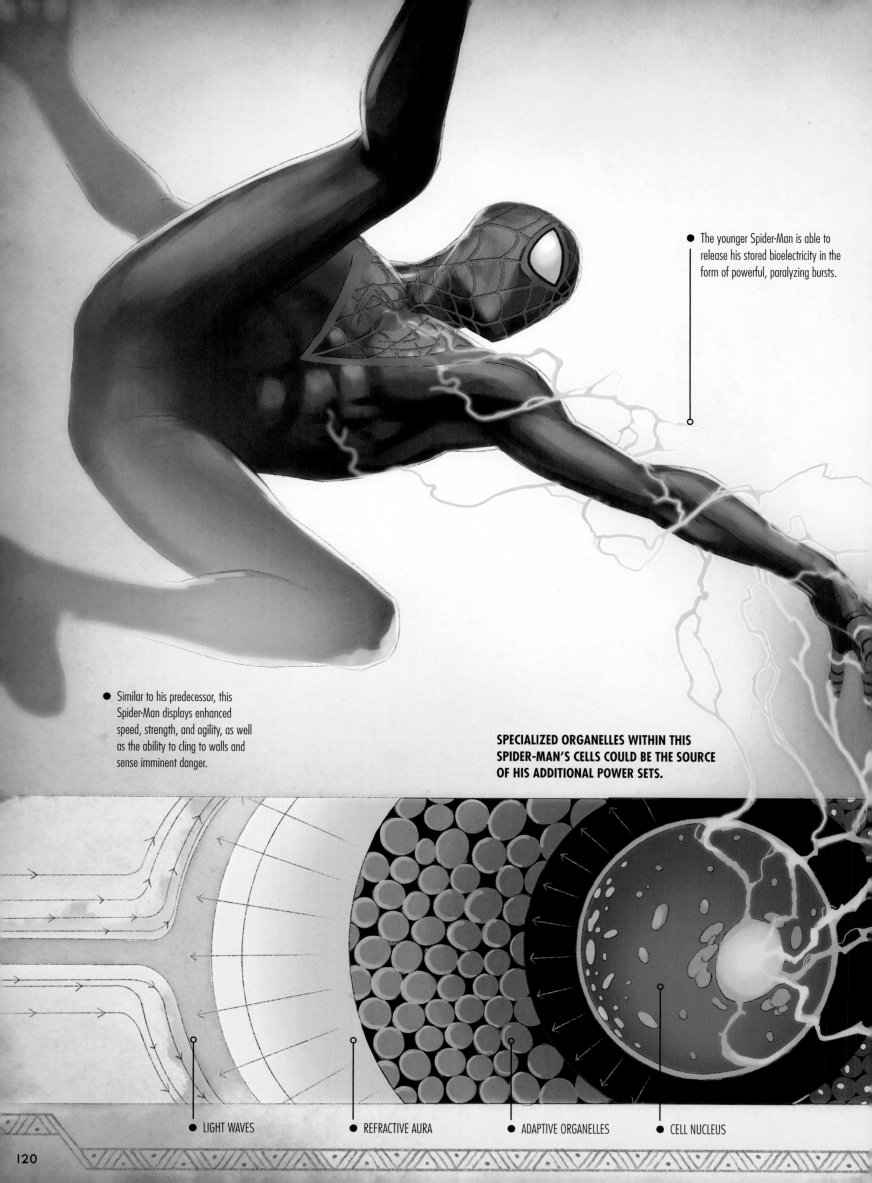

The younger Spider-Man is able to release his stored bioelectricity in the form of powerful, paralyzing bursts.

Similar to his predecessor, this Spider-Man displays enhanced speed, strength, and agility, as well as the ability to cling to walls and sense imminent danger.

SPECIALIZED ORGANELLES WITHIN THIS SPIDER-MAN'S CELLS COULD BE THE SOURCE OF HIS ADDITIONAL POWER SETS.

LIGHT WAVES • REFRACTIVE AURA • ADAPTIVE ORGANELLES • CELL NUCLEUS

SPIDER-MAN (REDACTED)

A number of additional heroes demonstrating abilities strikingly similar to Spider-Man's have come into prominence in recent years. This young hero may use the same alias as his more seasoned counterpart, but his unique abilities put him in a class all his own. Unlike the original Spider-Man, he can store bioelectric energy in his cells and release it in targeted blasts on command. Such electrical bursts, which he calls "venom strikes," disrupt biological nervous systems by stimulating the alpha motor neurons in the target, sending overloaded electrical impulses to the muscles and causing rapid contractions or paralysis. This bioenergy is typically channeled through his hand and administered via touch. The fledgling Spider-Man can also release the entirety of his stored charge as a multi-directional "venom blast," affecting all targets in his vicinity but draining his stamina in the process.

This younger Spider-Man is also able to blend into his surroundings in a manner that seemingly approaches full invisibility. I originally assumed the masking effect stemmed from technology embedded in his costume, but after obtaining a scrap of said material, I can detect no unstable molecules woven into the fabric. Thus, I conclude that the ability is likely to be a cellular shift akin to the way a chameleon blends into its environment by adjusting to wavelengths of light reflecting off its skin. Of course, this does not explain how his clothing also vanishes when he disappears, raising the further possibility that he is able to bend light into a refractive aura around his body in a manner similar to that employed by the Invisible Woman.

CHARGED ORGANELLES • CELLULAR CYTOPLASM • RELEASED BIOELECTRICITY

GHOST-SPIDER

Gifted with similar abilities to Spider-Man, the young woman who calls herself Ghost-Spider has been monitored emitting minute traces of extradimensional energy, indicating that she, like some of her fellow Web-Warriors, might hail from an alternate reality.

Ghost-Spider exhibits the familiar attributes of boosted strength, remarkable agility, and a near-precognitive sixth sense. Like the aforementioned Spider-Men, her web-shooters appear to be mechanical constructs. Her ability to traverse parallel dimensions seemingly at will might also be technological in nature, perhaps enabled by hyperdimensional microcircuitry. Sufficient concentrations of complex silicon pathways could conceivably be embedded within wearable tech devices, such as the wristwatch-like device she sports or the smartphone she carries.

● According to scans, Ghost-Spider's costume is akin to a synthetic version of a symbiote. How this garment augments her powers bears further investigation.

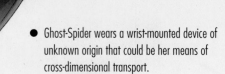

● Ghost-Spider wears a wrist-mounted device of unknown origin that could be her means of cross-dimensional transport.

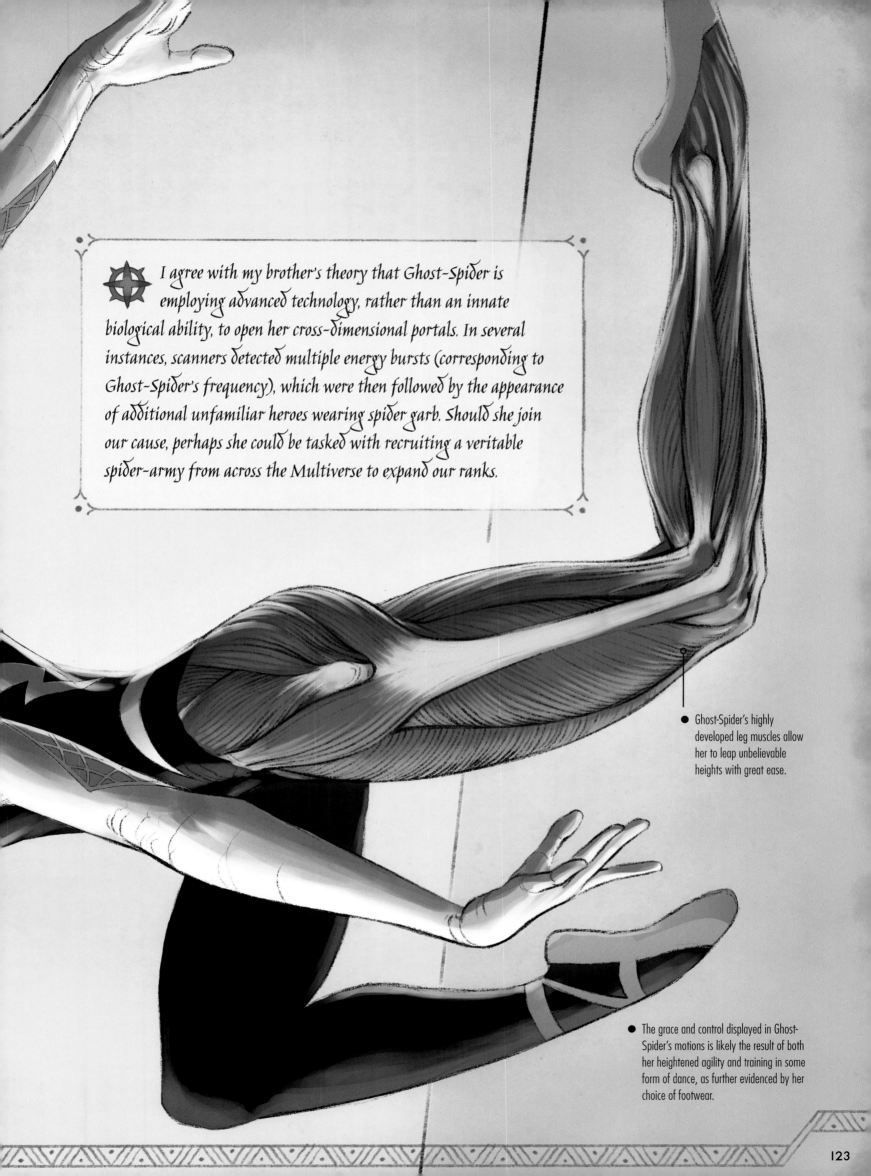

I agree with my brother's theory that Ghost-Spider is employing advanced technology, rather than an innate biological ability, to open her cross-dimensional portals. In several instances, scanners detected multiple energy bursts (corresponding to Ghost-Spider's frequency), which were then followed by the appearance of additional unfamiliar heroes wearing spider garb. Should she join our cause, perhaps she could be tasked with recruiting a veritable spider-army from across the Multiverse to expand our ranks.

● Ghost-Spider's highly developed leg muscles allow her to leap unbelievable heights with great ease.

● The grace and control displayed in Ghost-Spider's motions is likely the result of both her heightened agility and training in some form of dance, as further evidenced by her choice of footwear.

SPIDER-WOMAN

Her heightened strength, endurance, and agility are on par with Spider-Man, but Spider-Woman appears to manifest her wall-crawling ability in a unique fashion, producing an adhesive biological secretion from specialized glands in her hands and feet. If accurate, this would represent a dramatic departure from Spider-Man's theorized sub-atomic or setae-based adhesion. The secretion exuded from her glands would need to quickly permeate the pores of the targeted surface—whether it be a concrete slab, a stack of bricks, or a wall of wooden planks—and immediately dry, forming a solid grip between her digits and the material in less than a second.

Like the younger of the two Spider-Men, Spider-Woman seems capable of storing bio-electric energy within her own cells before releasing it in a venom blast channeled through her hands. She also possesses a unique power not common to other Spider-heroes, namely the ability to excrete pheromones. These chemical secretions—similar to those exuded by honeybees and ants—induce a social response in humans who inhale them, inducing fear or increasing attraction.

> *Spider-Woman has also exhibited the ability to glide through the air, an ability not uncommon to some spiders. Through a process called "ballooning," certain species can use threads of webbing to ride the wind and Earth's electrical currents, often travelling hundreds of miles. Spider-Woman's gliding, however, seems to be a function of the collapsible web-wings located under the arms of her costume rather than an intrinsic physiological ability.*

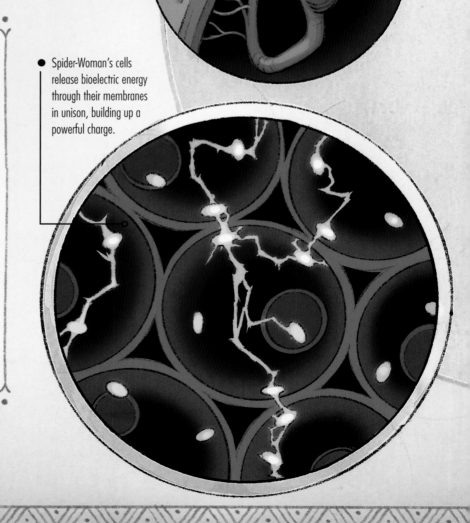

● Glands beneath Spider-Woman's skin produce potent pheromones that can alter the emotional state of those in her vicinity.

● Spider-Woman's cells release bioelectric energy through their membranes in unison, building up a powerful charge.

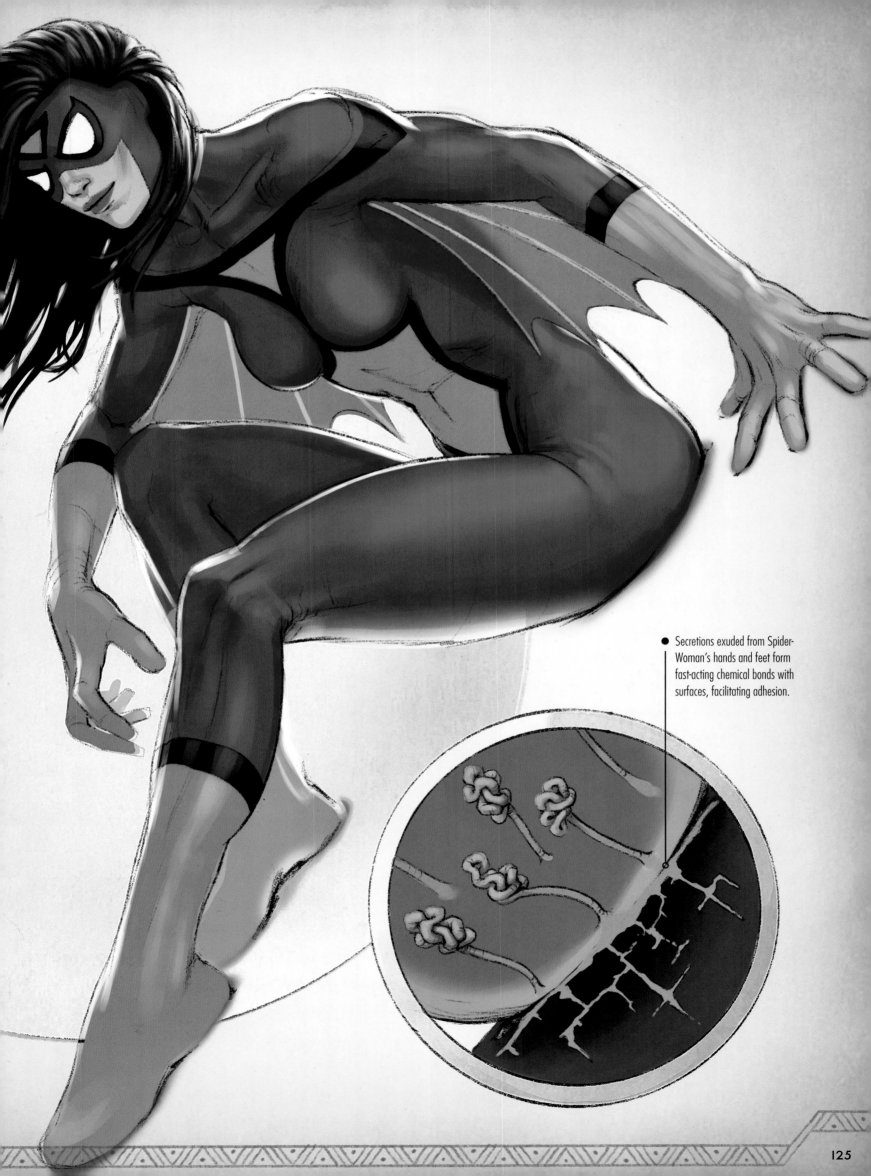

Secretions exuded from Spider-Woman's hands and feet form fast-acting chemical bonds with surfaces, facilitating adhesion.

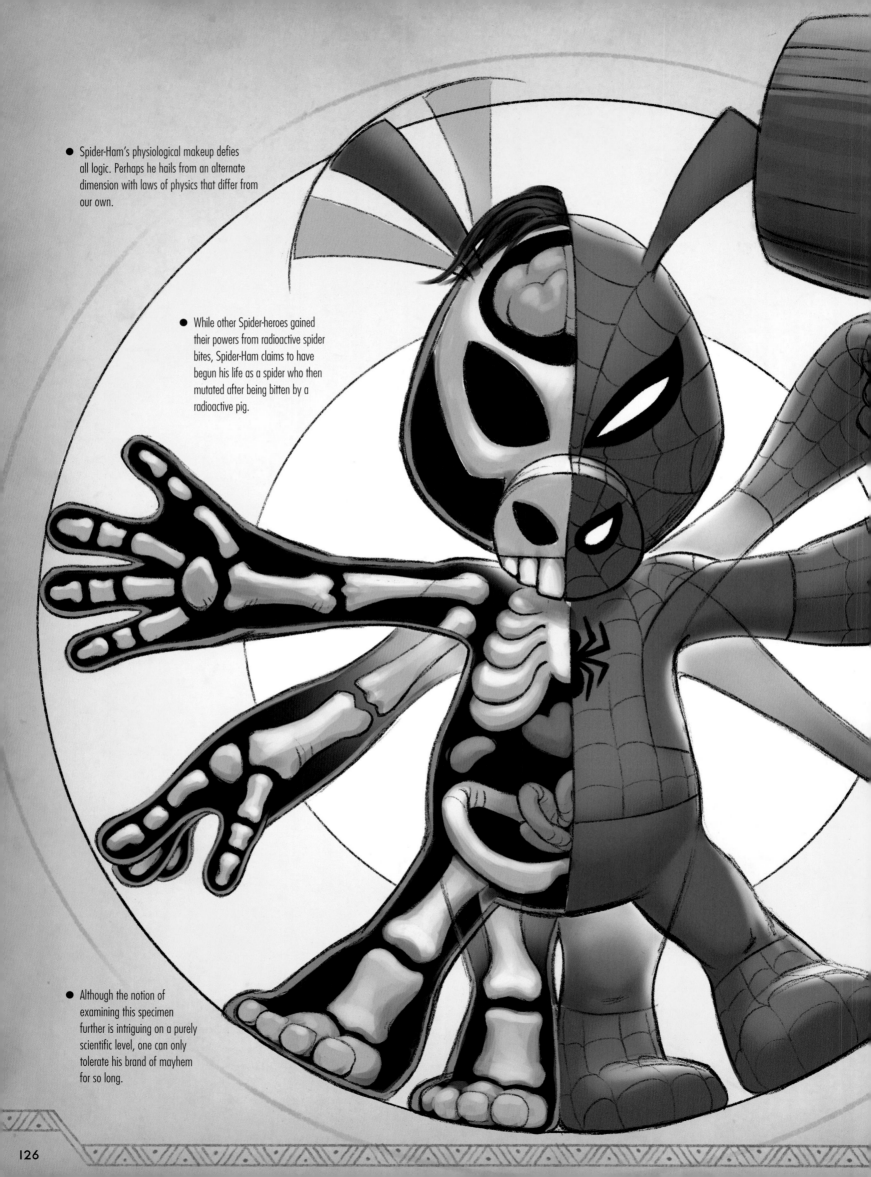

- Spider-Ham's physiological makeup defies all logic. Perhaps he hails from an alternate dimension with laws of physics that differ from our own.

- While other Spider-heroes gained their powers from radioactive spider bites, Spider-Ham claims to have begun his life as a spider who then mutated after being bitten by a radioactive pig.

- Although the notion of examining this specimen further is intriguing on a purely scientific level, one can only tolerate his brand of mayhem for so long.

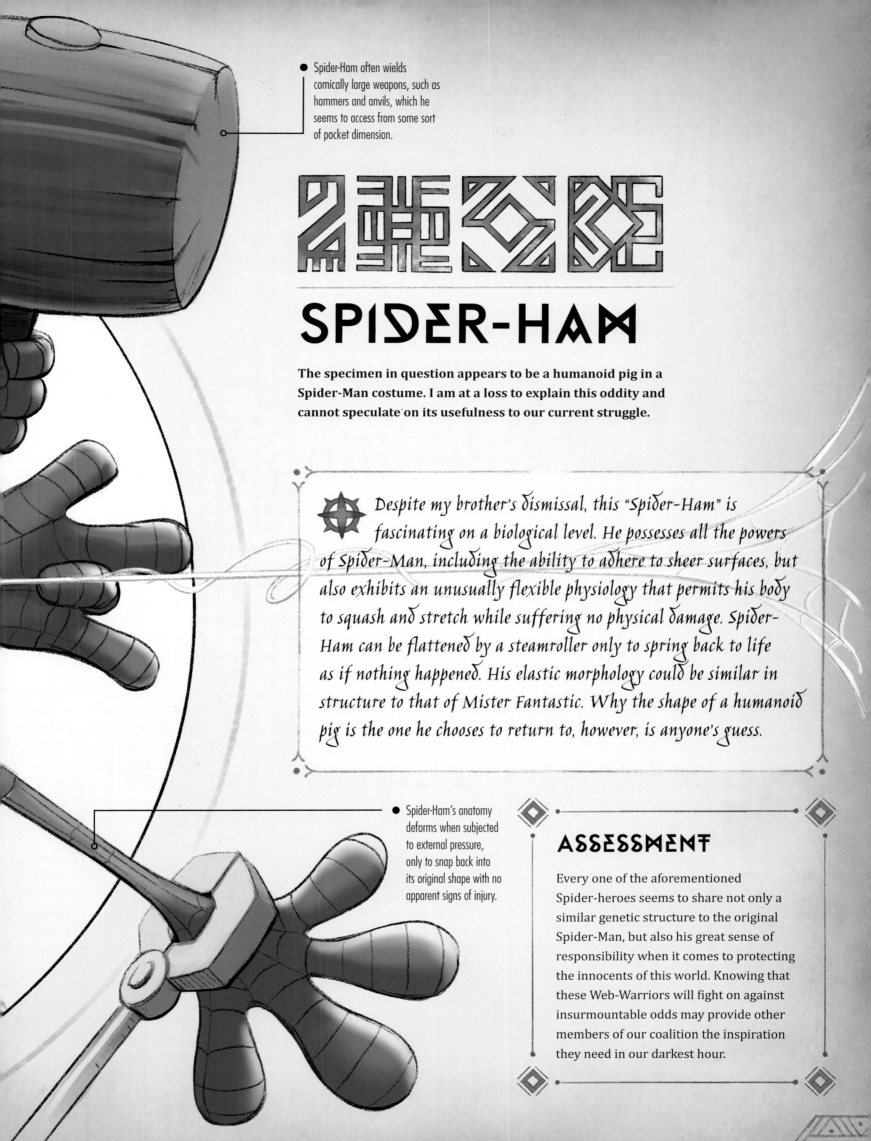

Spider-Ham often wields comically large weapons, such as hammers and anvils, which he seems to access from some sort of pocket dimension.

SPIDER-HAM

The specimen in question appears to be a humanoid pig in a Spider-Man costume. I am at a loss to explain this oddity and cannot speculate on its usefulness to our current struggle.

Despite my brother's dismissal, this "Spider-Ham" is fascinating on a biological level. He possesses all the powers of Spider-Man, including the ability to adhere to sheer surfaces, but also exhibits an unusually flexible physiology that permits his body to squash and stretch while suffering no physical damage. Spider-Ham can be flattened by a steamroller only to spring back to life as if nothing happened. His elastic morphology could be similar in structure to that of Mister Fantastic. Why the shape of a humanoid pig is the one he chooses to return to, however, is anyone's guess.

Spider-Ham's anatomy deforms when subjected to external pressure, only to snap back into its original shape with no apparent signs of injury.

ASSESSMENT

Every one of the aforementioned Spider-heroes seems to share not only a similar genetic structure to the original Spider-Man, but also his great sense of responsibility when it comes to protecting the innocents of this world. Knowing that these Web-Warriors will fight on against insurmountable odds may provide other members of our coalition the inspiration they need in our darkest hour.

THE LIZARD

After losing his arm during military service, Dr. Curt Connors dedicated his formidable biogenetic skills to the science of limb regeneration, hoping to restore his missing extremity. In desperation, Connors ingested an untested serum derived from lizard DNA, which restored his arm but overwrote his cellular structure with reptilian genetic code.

REPTILIAN APPEARANCE

The introduction of foreign DNA into Dr. Connors' cellular makeup transformed him into a hybrid being. Unlike the Hulk, Connors currently seems capable of controlling his transformation into lizard form, a process that triggers vast changes in his musculature, dermis, and skeletal structure. In his reptilian state, the Lizard is able to lift up to twelve tons and run at a maximum speed of 45 miles per hour. His powerful jaws are capable of delivering a crushing bite with the force of three thousand psi, much like an alligator.

The hybridization process that Connors underwent seemingly activated vestigial DNA already present in the human genome—an artifact of our species' evolution from reptilian ancestors millions of years ago. By tapping into these dormant animalistic traits, Connors' dermal cells form a scaly hide that is impenetrable to low-caliber bullets. In addition, each finger and toe becomes tipped with a pointed claw, and a retractable one-inch hook emerges from each of his palms and soles. These sharp protuberances are useful in combat and can be used in tandem to allow the Lizard to scale vertical surfaces.

REGENERATION

In nature, lizards regrow their severed tails via clusters of specialized cells designed to reproduce specific elements of the missing appendage such as muscle, cartilage, spinal tissue, and skin. The division and replication of these cells is carried out according to imprinted genetic coding. Dr. Connors' serum worked on much the same principle, targeting pockets of cells near the site of amputation to stimulate rapid growth. As soon as Connors returns to his human form, however, these cells are rendered dormant. Thus, although Connors regenerates his missing arm in reptilian form, this limb is instantly lost upon reversion, erasing the effect that drove his regenerative research in the first place.

When Connors becomes the Lizard, the changes he undergoes are not only physical. His brain chemistry experiences radical rewiring as the cerebellum is bypassed in favor of the basal ganglia—the primitive reptilian complex of the human brain. This factor once limited the Lizard to the cognition of a savage beast, but recently Connors has seemingly found a way to maintain his human intelligence in his transformed state. Connors has also recently developed the ability to telepathically communicate with reptiles, a skill that could be a side effect of this neural remapping.

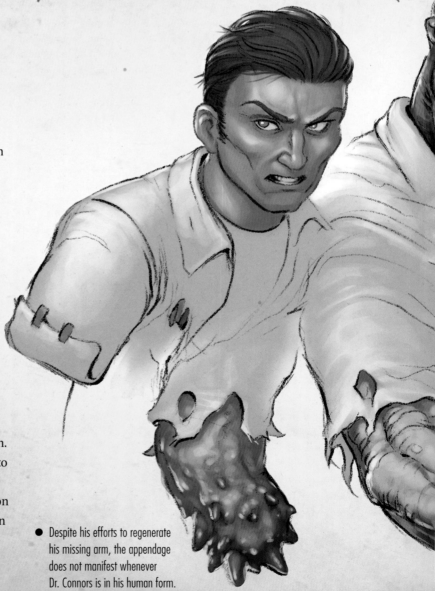

● Despite his efforts to regenerate his missing arm, the appendage does not manifest whenever Dr. Connors is in his human form.

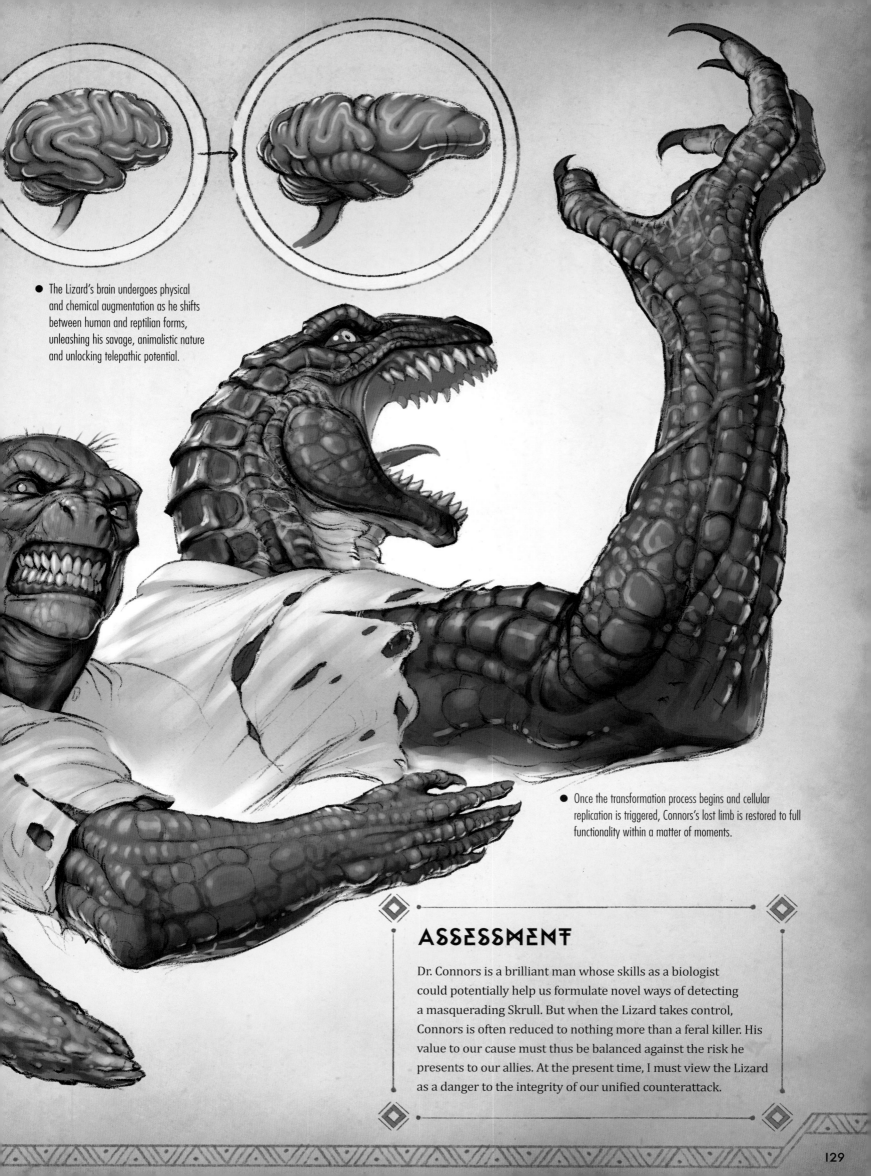

The Lizard's brain undergoes physical and chemical augmentation as he shifts between human and reptilian forms, unleashing his savage, animalistic nature and unlocking telepathic potential.

Once the transformation process begins and cellular replication is triggered, Connors's lost limb is restored to full functionality within a matter of moments.

ASSESSMENT

Dr. Connors is a brilliant man whose skills as a biologist could potentially help us formulate novel ways of detecting a masquerading Skrull. But when the Lizard takes control, Connors is often reduced to nothing more than a feral killer. His value to our cause must thus be balanced against the risk he presents to our allies. At the present time, I must view the Lizard as a danger to the integrity of our unified counterattack.

● Squirrel Girl's bond with her rodent friends is undeniable, particularly when it comes to her primary companion, Tippy Toe.

● Powerful muscles in Squirrel Girl's upper legs enhance her ability to jump and climb.

SQUIRREL GIRL

Despite her endearing moniker, Squirrel Girl is a physical powerhouse. In her own words, she possesses "the powers of a squirrel and the powers of a girl," a combination that she has proven should not be underestimated. The hybrid nature of her impressive abilities is worthy of closer examination.

SQUIRREL POWERS

Squirrel Girl possesses large incisors and a bushy, semi-prehensile tail that sprouts from the base of her spine. Climbing claws extend from each of her fingertips, and she is able to deploy bone spikes from above the knuckles of each hand. Squirrel Girl can carry up to one ton, and the densely coiled quadriceps in her thighs permit vertical jumps of 30 feet from a standing position. A limber musculature gives her expanded joint rotation and significantly greater agility than a typical human of her size.

VOCALIZATIONS

Squirrel Girl can reproduce squirrel vocalizations, facilitating direct communication with members of their species. This ability allows her to recruit loyal armies of the creatures that she can deploy to overwhelm enemies. The squirrels appear to grasp her commands even when voiced in human language. This could suggest a deeper mental connection with these animals, perhaps one that is telepathic in nature. Squirrel Girl shares a close empathic bond with one particular specimen, Tippy-Toe, and perhaps by studying this bond we could gain a greater understanding of these abilities.

- The vocalizations that Squirrel Girl produces to communicate with her furry followers cannot be recreated by regular human vocal cords.

- Squirrel Girl's bone knuckle spikes can carve through wood with ease, making them formidable weapons in close combat.

ASSESSMENT

Many are quick to dismiss Squirrel Girl, but she is one of the few heroes brave enough to have faced Galactus himself, earning Earth a reprieve. Although Squirrel Girl's hybrid physiology offers numerous attributes that could be useful in a battle against enemy forces, she has proven to be particularly elusive. Let us hope she is already on her way to save the world once again.

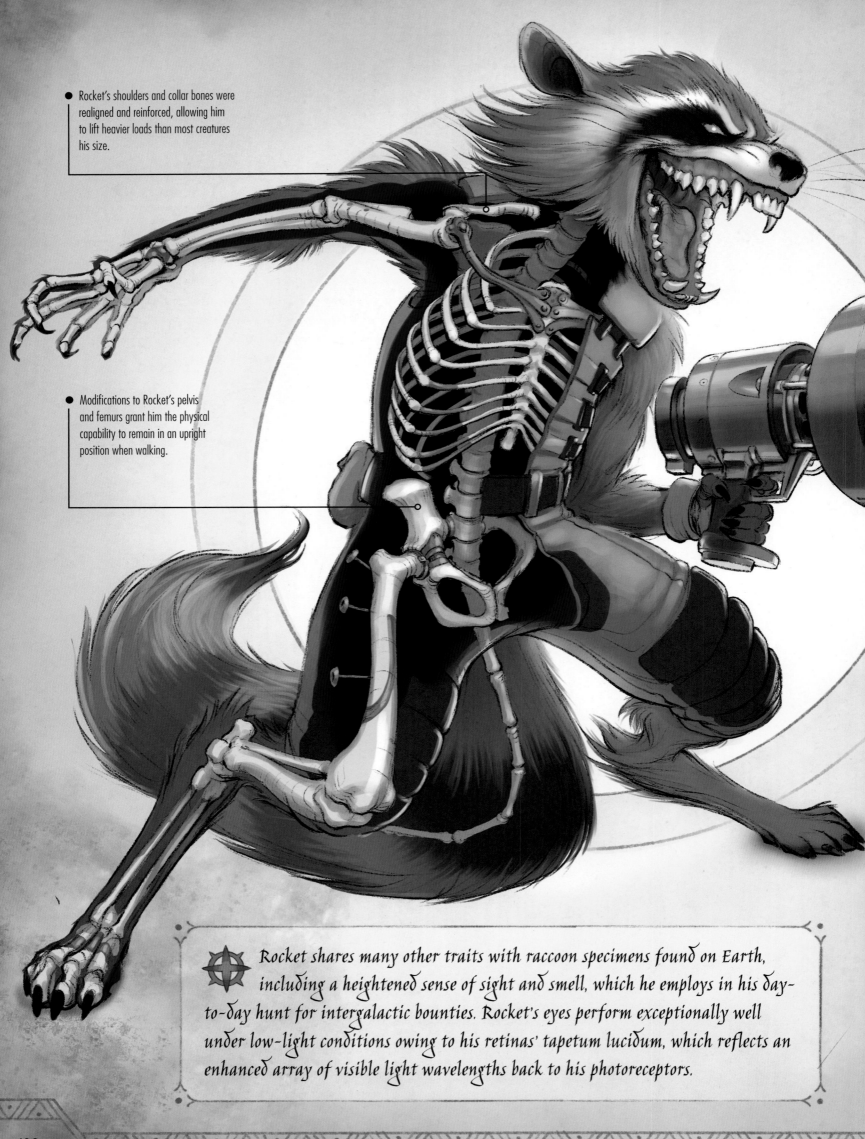

- Rocket's shoulders and collar bones were realigned and reinforced, allowing him to lift heavier loads than most creatures his size.

- Modifications to Rocket's pelvis and femurs grant him the physical capability to remain in an upright position when walking.

Rocket shares many other traits with raccoon specimens found on Earth, including a heightened sense of sight and smell, which he employs in his day-to-day hunt for intergalactic bounties. Rocket's eyes perform exceptionally well under low-light conditions owing to his retinas' tapetum lucidum, which reflects an enhanced array of visible light wavelengths back to his photoreceptors.

ROCKET

To untrained eyes, this member of the Guardians of the Galaxy could be mistaken for a raccoon plucked from a North American forest, but Rocket's sharp tongue soon confirms that his origins are decidedly extraterrestrial.

ENHANCED ABILITIES

Rocket's origins can be traced to the asylum planet of Halfworld in the Keystone Quadrant. Starting his life as a simple non-sentient alien greatly resembling a common Earth raccoon (*Procyon lotor*), Rocket was originally bred to be a domesticated companion animal. He then underwent a series of experiments, including painful biomodifications and cerebral grafts designed to increase his intelligence and expand his physical capabilities. He subsequently gained the ability to speak, walk upright, and manipulate advanced machinery with his front paws.

Although these experiments led Rocket to develop a sentient intellect, he appears to possess many biological instincts common to the raccoons found on our world. For example, although he possesses salivary glands like a raccoon, he sometimes wets his food under running water prior to consuming it. An omnivore, Rocket is fond of interstellar analogues to crayfish, snails, and amphibians but can get by on a diet of bird eggs or even food scavenged from garbage.

• Rocket's fingers are nimble enough to build and operate extremely advanced technological equipment and weaponry.

• Rocket's skull was artificially expanded to make room for the cerebral grafts that enhanced his intelligence.

• Though he may be small, Rocket's bite is quite fierce, even without any apparent physical alterations to his mandible.

ASSESSMENT

Beyond his animalistic alien physiology, Rocket's key area of expertise lies in his mastery of weapons coupled with his take-no-prisoners attitude. The years of knowledge and experience he has amassed as an intergalactic bounty hunter make him a versatile asset against any extraterrestrial foe. But it is his network of connections spanning the galaxy that interests me the most, as it could potentially supply us with valuable information regarding suspicious Skrull activity aimed at our world.

THROG

Thor once told me the story of how his brother Loki turned him into a frog. According to the God of Thunder, he still proved worthy of wielding his mighty hammer Mjolnir, even as a lowly amphibian. I have since encountered Throg, a creature very similar to the one in Thor's story—a mere frog in anatomy, but a Frog of Thunder in all other aspects.

Measuring a mere nine centimeters and weighing no more than an ounce, Throg exhibits superhuman levels of strength and durability and shares Thor's ability to channel the elemental power of lightning (albeit through an unusually small hammer). Like the true Thor, this amphibian incarnation can achieve the approximation of flight by hurling its hammer and holding on tight as it soars heavenward.

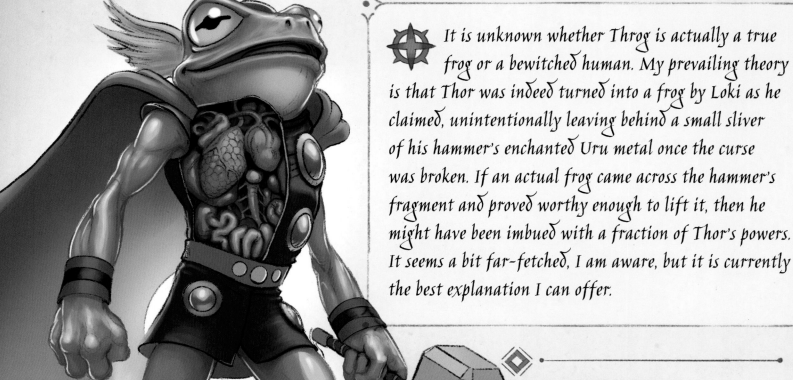

It is unknown whether Throg is actually a true frog or a bewitched human. My prevailing theory is that Thor was indeed turned into a frog by Loki as he claimed, unintentionally leaving behind a small sliver of his hammer's enchanted Uru metal once the curse was broken. If an actual frog came across the hammer's fragment and proved worthy enough to lift it, then he might have been imbued with a fraction of Thor's powers. It seems a bit far-fetched, I am aware, but it is currently the best explanation I can offer.

As stands to reason, Throg's long legs facilitate grand leaps. However, Throg may be alone amongst frogs in his ability to stand upright on those extremities.

Throg's hands can hold and manipulate tools, an advanced ability not seen in common amphibians.

ASSESSMENT

Perhaps no other creature—in this realm or any other—embodies the notion that good things come in small packages quite like Throg. This amphibious warrior reminds us that one's stature should not be considered an indication of their might. If this so-called Frog of Thunder does indeed possess even a fraction of Thor's legendary powers, he will be a formidable foe against any army, no matter its size.

HOWARD THE DUCK

I have encountered many creatures on my adventures, both natural and fantastical, but few have managed to earn my disdain as swiftly and completely as the duck named Howard.

Though he may speak like a human, Howard the Duck claims to hail from an alternate reality where waterfowl became Earth's dominant species. His physiology is humanoid but incorporates duck-like external characteristics including feathered skin, webbed feet, and a wide bill that never seems to stay closed. Despite his appearance, scans have revealed his internal organs closely resemble those found in humans. Although he has no super-powered abilities of note, he does claim to be an expert in the martial art known as Quack-Fu. Howard often asserts that he's "trapped in a world he never made," but I would be more than glad to see him return home.

ASSESSMENT

Howard is an extradimensional anomaly who undoubtedly stands out when measured against our planet's heroes and villains, but only because of his remarkable mediocrity. Needless to say, I am not convinced that Howard has the ability to offer any tactical advantage to either side in the war to come.

- While Howard's skull exhibits interesting features that are both avian and mammalian in nature, the brain held within that skull is wholly unremarkable.

- Howard's bill is not unlike those found on most waterfowl, save for the fact that his seems to be incessantly flapping.

7
MYSTICAL ABILITIES

Most of those who wield mystical energy do so through apparent channeling mechanisms, including spells and totems. As such, the arcane energies these individuals harness appear unrelated to their physiologies. In other words, though the Sorcerer Supreme can summon terrors beyond comprehension, Dr. Stephen Strange is nevertheless just a man. With that in mind, we must keep a close eye on all our enchanted allies to ensure that their mystical talismans and scrolls are not secretly falling into the grasp of the Skrull Empire.

Some beings, however, are far more than human. These supernatural entities have physical forms deeply entwined with eldritch energies that even the most in-depth examination cannot fully elucidate. As one who has walked the Wakandan plains of memory known as the Djalia and spoken to the gods themselves, I concede that there is magic in this world I may never truly understand. But that will not stop me from trying.

MAN-THING'S BODY IS MADE UP ENTIRELY OF ORGANIC MATTER ABSORBED FROM THE LUSH SWAMP ENVIRONMENT IN WHICH HE DWELLS.

- MOSS AND GRASS

- DECAYED ORGANIC MATTER

- FUNGUS

- LIVING CREATURES

- ROOTS AND VINES

- Various forms of plant matter compose the Man-Things dermal layer, including moss, algae, and fungus.

- Bacterial colonies thrive within the Man-Thing's personal biome, digesting organic matter and converting it into his source of fuel.

MAN-THING

Once a human scientist, Dr. Ted Sallis underwent a bizarre mutation due to the combined effects of an experimental serum and accidental exposure to extradimensional energy. The result was the Man-Thing, an animalistic being who guards the mystical waypoint between realities. The world at large believes that the Man-Thing is merely a legend, but those who have felt its burning touch know that this creature is all too real.

According to files obtained from S.H.I.E.L.D. and the US Armed Forces, the serum that transformed Dr. Sallis into the Man-Thing was based on Captain America's Super-Soldier Serum and formulated to grant soldiers immunity from biological attacks. When Sallis realized that inoculated test subjects were at risk from extreme mutations, he halted trials and injected himself with the only remaining sample in a last-ditch attempt to protect the formula from falling into the grasp of thugs associated with the nefarious Advanced Idea Mechanics (A.I.M.). Sallis's desperate escape ended in a car crash in the Florida swamps, near a dimensional crossroads dubbed the Nexus of All Realities. This infusion of extradimensional mysticism emanating from the Nexus provided a wild-card factor that presumably accelerated the mutagenic process that created the Man-Thing.

- Thick vines and roots create the approximation of a skeletal structure within the Man-Thing's enormous frame.

MAN-THING

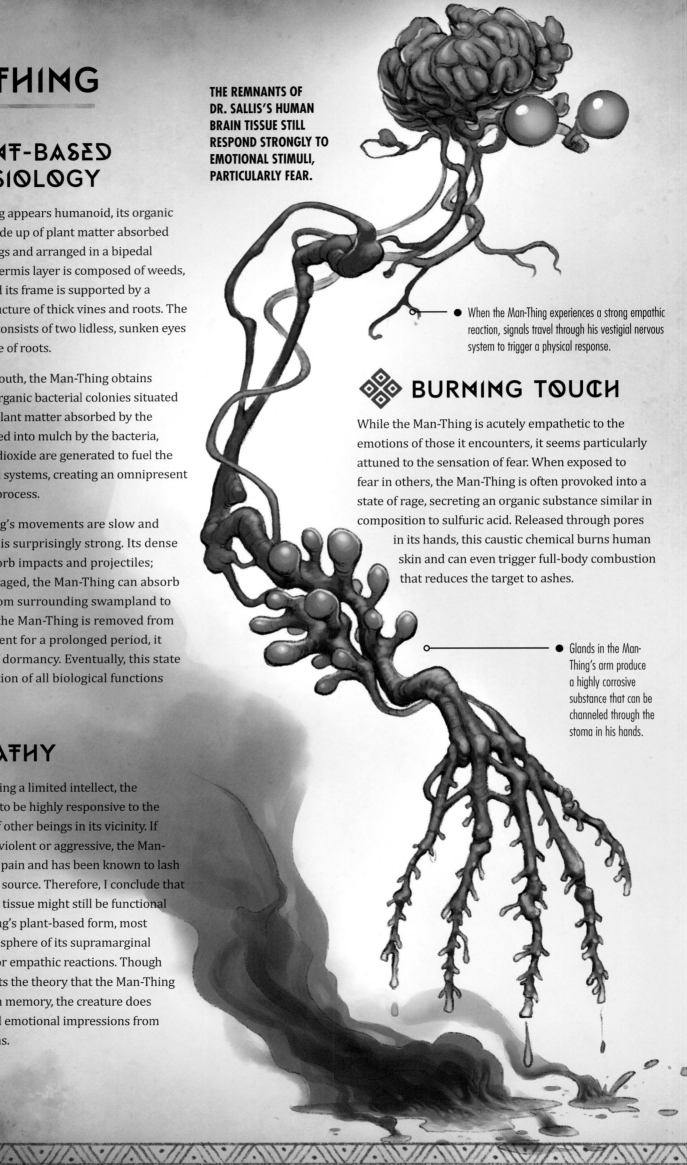

PLANT-BASED PHYSIOLOGY

While the Man-Thing appears humanoid, its organic tissue is entirely made up of plant matter absorbed from its surroundings and arranged in a bipedal shape. Its exterior dermis layer is composed of weeds, moss, and algae, and its frame is supported by a pseudo-skeletal structure of thick vines and roots. The Man-Thing's "face" consists of two lidless, sunken eyes above a dense tangle of roots.

Because it has no mouth, the Man-Thing obtains nutrients through organic bacterial colonies situated within its body. As plant matter absorbed by the Man-Thing is digested into mulch by the bacteria, energy and carbon dioxide are generated to fuel the creature's biological systems, creating an omnipresent rotting stink in the process.

Although Man-Thing's movements are slow and shaky, the creature is surprisingly strong. Its dense vegetation can absorb impacts and projectiles; when severely damaged, the Man-Thing can absorb organic material from surrounding swampland to rebuild its form. If the Man-Thing is removed from a swamp environment for a prolonged period, it will enter a state of dormancy. Eventually, this state will lead to a cessation of all biological functions followed by death.

EMPATHY

Despite demonstrating a limited intellect, the Man-Thing appears to be highly responsive to the emotional stimuli of other beings in its vicinity. If those emotions are violent or aggressive, the Man-Thing feels physical pain and has been known to lash out at the perceived source. Therefore, I conclude that some of Sallis' brain tissue might still be functional within the Man-Thing's plant-based form, most likely the right hemisphere of its supramarginal gyrus responsible for empathic reactions. Though no evidence supports the theory that the Man-Thing possesses long-term memory, the creature does appear able to recall emotional impressions from previous interactions.

THE REMNANTS OF DR. SALLIS'S HUMAN BRAIN TISSUE STILL RESPOND STRONGLY TO EMOTIONAL STIMULI, PARTICULARLY FEAR.

● When the Man-Thing experiences a strong empathic reaction, signals travel through his vestigial nervous system to trigger a physical response.

BURNING TOUCH

While the Man-Thing is acutely empathetic to the emotions of those it encounters, it seems particularly attuned to the sensation of fear. When exposed to fear in others, the Man-Thing is often provoked into a state of rage, secreting an organic substance similar in composition to sulfuric acid. Released through pores in its hands, this caustic chemical burns human skin and can even trigger full-body combustion that reduces the target to ashes.

● Glands in the Man-Thing's arm produce a highly corrosive substance that can be channeled through the stoma in his hands.

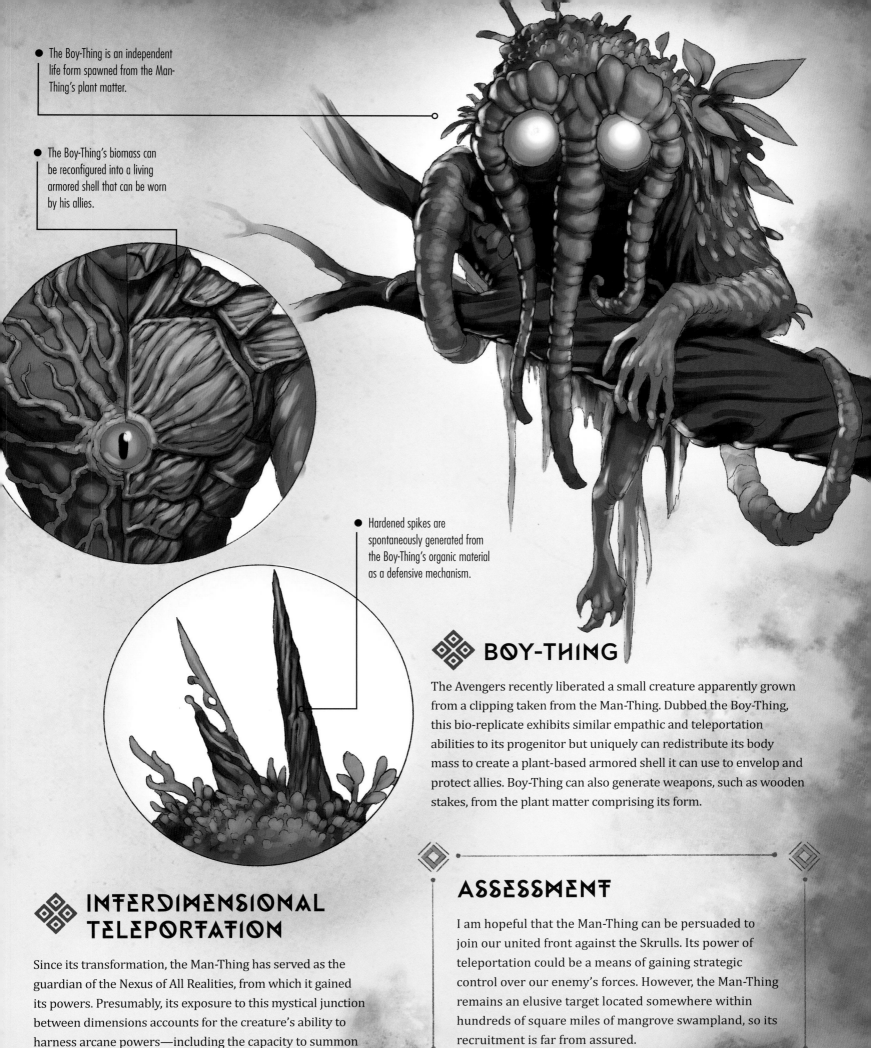

- The Boy-Thing is an independent life form spawned from the Man-Thing's plant matter.

- The Boy-Thing's biomass can be reconfigured into a living armored shell that can be worn by his allies.

- Hardened spikes are spontaneously generated from the Boy-Thing's organic material as a defensive mechanism.

BOY-THING

The Avengers recently liberated a small creature apparently grown from a clipping taken from the Man-Thing. Dubbed the Boy-Thing, this bio-replicate exhibits similar empathic and teleportation abilities to its progenitor but uniquely can redistribute its body mass to create a plant-based armored shell it can use to envelop and protect allies. Boy-Thing can also generate weapons, such as wooden stakes, from the plant matter comprising its form.

INTERDIMENSIONAL TELEPORTATION

Since its transformation, the Man-Thing has served as the guardian of the Nexus of All Realities, from which it gained its powers. Presumably, its exposure to this mystical junction between dimensions accounts for the creature's ability to harness arcane powers—including the capacity to summon portals that link one reality to another, an ability it uses as a means of teleportation.

ASSESSMENT

I am hopeful that the Man-Thing can be persuaded to join our united front against the Skrulls. Its power of teleportation could be a means of gaining strategic control over our enemy's forces. However, the Man-Thing remains an elusive target located somewhere within hundreds of square miles of mangrove swampland, so its recruitment is far from assured.

GHOST RIDER

Revenge is a concept as old as humanity itself, and if the legends are true, the Spirit of Vengeance—known more commonly as the Ghost Rider—first manifested more than a million years ago. The Spirit has chosen many hosts since then, but its purpose remains the same: to punish those who hurt the innocent.

SKELETAL STRUCTURE

The Spirit of Vengeance is a mystical force that attaches itself to a mortal host. When the Spirit takes control of its host's physical form, transformation is rapid and grotesque, the target's skin erupting in flames stoked from the extradimensional realm of Hell. This hellfire quickly burns away the host's flesh to reveal a pale skeleton beneath.

No ligaments or muscular tissues remain after the transformation, yet the flaming skeleton left behind has complete structural integrity. Indeed, Ghost Rider is far more durable than a collection of bones should be, able to walk away from horrific vehicle collisions without a scratch. It appears that the demonic flames that enwreathe Ghost Rider are able to constantly regenerate his cortical bone layer at a cellular level by laying down fresh layers of osteoblasts and osteocytes in seconds.

● Hellfire courses through the medullary cavity within the bones of Ghost Rider's ribcage.

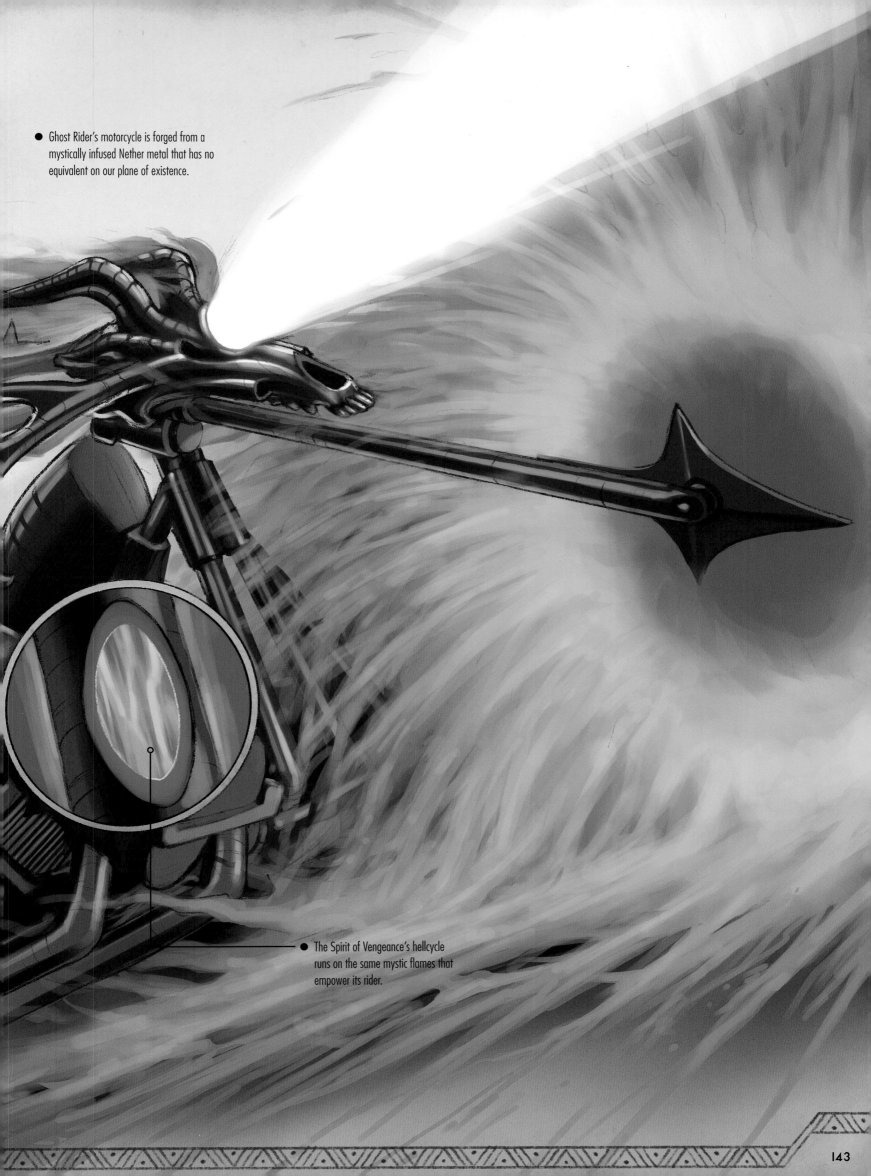

● Ghost Rider's motorcycle is forged from a mystically infused Nether metal that has no equivalent on our plane of existence.

● The Spirit of Vengeance's hellcycle runs on the same mystic flames that empower its rider.

GHOST RIDER

 ## HELLFIRE MANIPULATION

The hellfire aura that gives Ghost Rider's skeleton its supernatural cohesiveness can also be used for offensive purposes. These flames deliver more than scorching heat, however. They are seemingly psycho-reactive in nature, deeply affecting the mental state of those who come into contact with them. Thus, legend dictates that one touch from Ghost Rider burns sinners to their very souls. By channeling additional hellfire from the netherworld (an ability sometimes dubbed "infernal pyrokinesis"), Ghost Rider can project flaming columns from his hands, his eye sockets, and his gaping jaw. Ghost Rider has also displayed the ability to conjure shapes such as barriers or swords using nothing but hellfire, though these constructs require intense concentration to maintain their integrity.

PENANCE STARE

Enemies who are forced to gaze into the vacant eyes of Ghost Rider's skull are said to relive every ounce of pain they inflicted during their lifetimes in a single, unbearable instant. The ordeal leaves some in a state of unresponsive catatonia caused by massive strain on the hippocampus and amygdala as traumatic memories are resurfaced and rejected due to the brain's limited capacity to process trauma. This Penance Stare has no apparent effect on demons or automatons, a quirk that has been attributed to the lack of a soul in the targeted being. I, however, hypothesize that Ghost Rider's ability may be telepathic in nature and might only work on sentient organic beings lacking a natural immunity to the effects of hellfire.

THE SPIRIT OF VENGEANCE BEGINS TO TAKE CONTROL OF ITS HOST.

HELLFIRE BURSTS FORTH FROM WITHIN THE HOST'S BODY.

INTENSE HEAT MELTS AWAY ALL ORGANIC TISSUE IN A MATTER OF MOMENTS.

THE FLAMING SKULL OF THE GHOST RIDER IS REVEALED.

 # VEHICLE POSSESSION

Each successive Ghost Rider forms a symbiotic bond with a vehicle of their choosing. For Johnny Blaze, perhaps the most notable Ghost Rider of this era, that vehicle was a flaming motorcycle built from materials originating in the netherworld. Its tires burning with halos of hellfire, this hellcycle could cross bodies of water and scale the sides of skyscrapers. An apparent telepathic connection to the vehicle allowed Blaze to summon it from great distances and control it remotely. Similar to his own skeletal frame, the hellcycle could be repaired through judicious infusions of hellfire.

The most recent Ghost Rider, the Avenger Robbie Reyes, drives a classic American muscle car he calls a "hellcharger" but has also demonstrated the intriguing ability to possess additional vehicles at will, including an Asgardian warship and the body of a cosmic Celestial.

 # ASSESSMENT

In any conflict where innocent blood is spilled, the Ghost Rider is a priceless ally. An invading alien army cutting a swath across our world would provide the Spirit of Vengeance an endless supply of souls worthy of his punishment. But while his burning gaze is likely to bring countless Skrulls to their knees, Ghost Rider's power to possess vehicles may provide us a rare opportunity to turn the Skrulls' own armada back against them. As such, he is an essential ally in the trials to come.

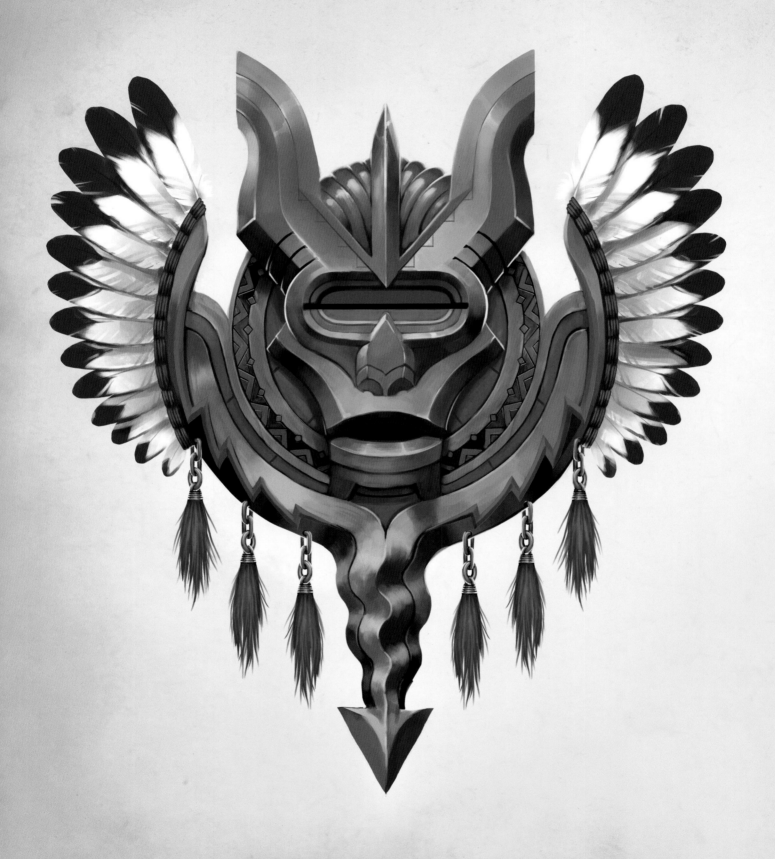

8
MUTANTS

Charles Darwin's theory of evolution states that only by adapting to a changing world can any genetic lineage perpetuate itself throughout subsequent generations. I know Darwin would have been fascinated by mutantkind, as this offshoot of humanity has expressed so many powerful DNA-based abilities that they now challenge Homo sapiens for control of our planet.

Mutants have been assigned the taxonomic classification Homo superior and possess what has been dubbed the "X-Gene." According to Dr. Henry McCoy (see Beast entry in the Mutants subsection, page 164), the X-Gene is a naturally occurring genetic variation on the twenty-third chromosome that can manifest as a combination of surface transmutations and superhuman powers. The potential locked within the X-Gene typically remains latent until the host reaches puberty and is often unleashed during periods of extreme stress. A few subjects also undergo a secondary mutation many years after the activation of their primary power array.

CYCLOPS

The mutant leader known as Cyclops possesses a devastating ability to fire concussive optic blasts, but it is his determination to do whatever it takes to assure the survival of mutantkind that concerns me even more. In the past, I have stood shoulder to shoulder with Cyclops on the battlefield to fight back against certain disaster. But in recent years, humanity has found itself the target of his destructive gaze.

 OPTIC BLAST

The catastrophic blasts released through Cyclops's optic organs resemble phenomena sometimes classified as death rays or heat vision, leading some researchers to speculate that they might be powered by laser or thermal energy. However, I can state with confidence that they are beams of pure concussive force. One of Cyclops's full-power blasts can puncture an inch-thick steel plate at close range and travel as far as two kilometers (with proportionately diminished effects).

How can such a force be generated inside Cyclops's skull cavity without pulverizing his cranial matter? One theory I've considered is that Cyclops's eyes act as miniature dimensional portals, allowing instantaneous access to an alternate reality rife with concussive energy. Within his eyes, the presence of ocular retroreflectors—similar to those used by nocturnal mammals for light amplification—could potentially cycle the ever-present concussive energy through amplifying tissue (perhaps optical crystalline of the type used for laser amplification) until Cyclops releases the energy in a focused blast. Admittedly, continual reflection of concussive force beams could result in internal trauma or perceptual disorientation, but perhaps there are biological safeguards in place I have yet to discern.

● Concussive force energy refracts and amplifies within the vitreous body of Cyclops's ocular organs before being released through the pupil as a focused blast.

When his eyes are open, his force beams are projected continuously and indiscriminately: Cyclops has attributed this inability to turn off his mutant power to a head injury sustained as a child. Only by wearing specialized visors is he capable of confining his concussive blasts to allow for voluntary release. His visors contain lenses made of ruby quartz, a material that seems sufficient to contain the force that is constantly generated within the space between Cyclops's eyeballs and the inner surface of the visor's lenses.

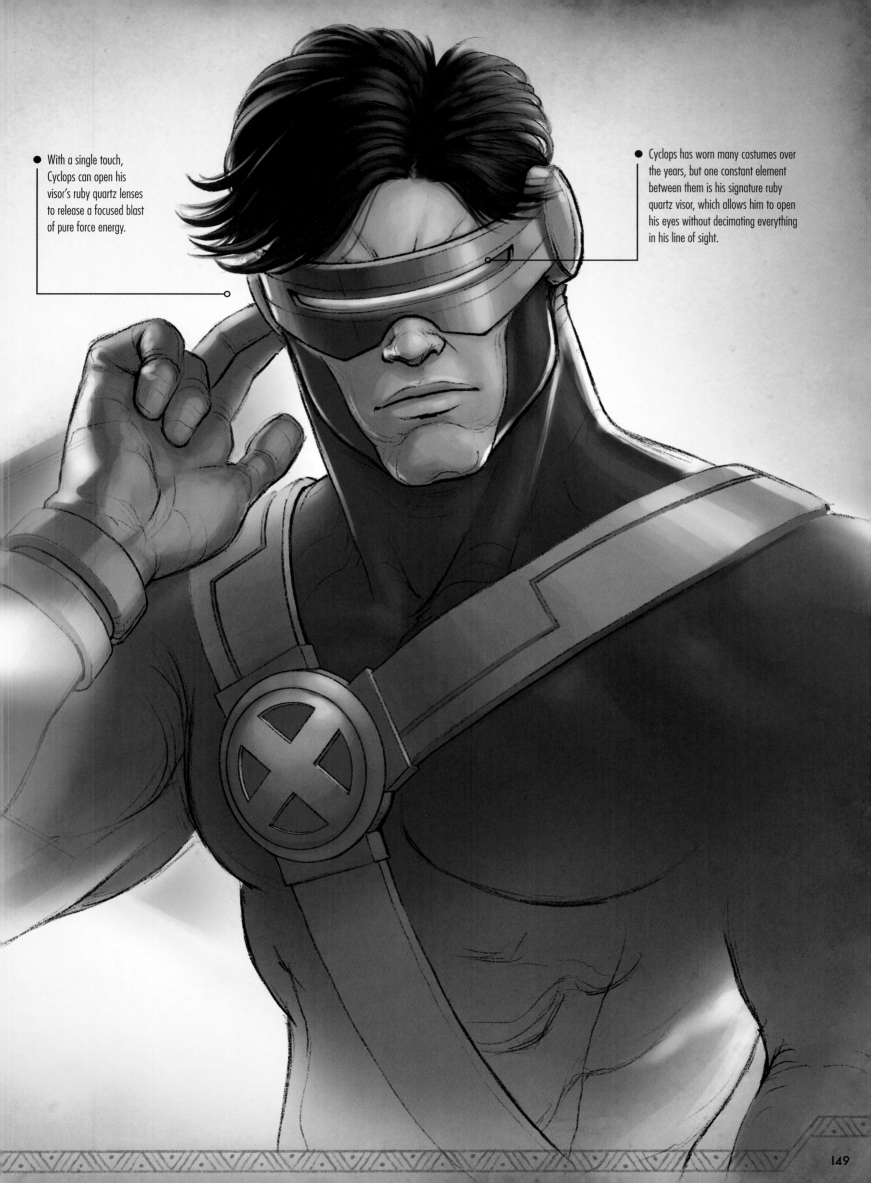

With a single touch, Cyclops can open his visor's ruby quartz lenses to release a focused blast of pure force energy.

Cyclops has worn many costumes over the years, but one constant element between them is his signature ruby quartz visor, which allows him to open his eyes without decimating everything in his line of sight.

CYCLOPS

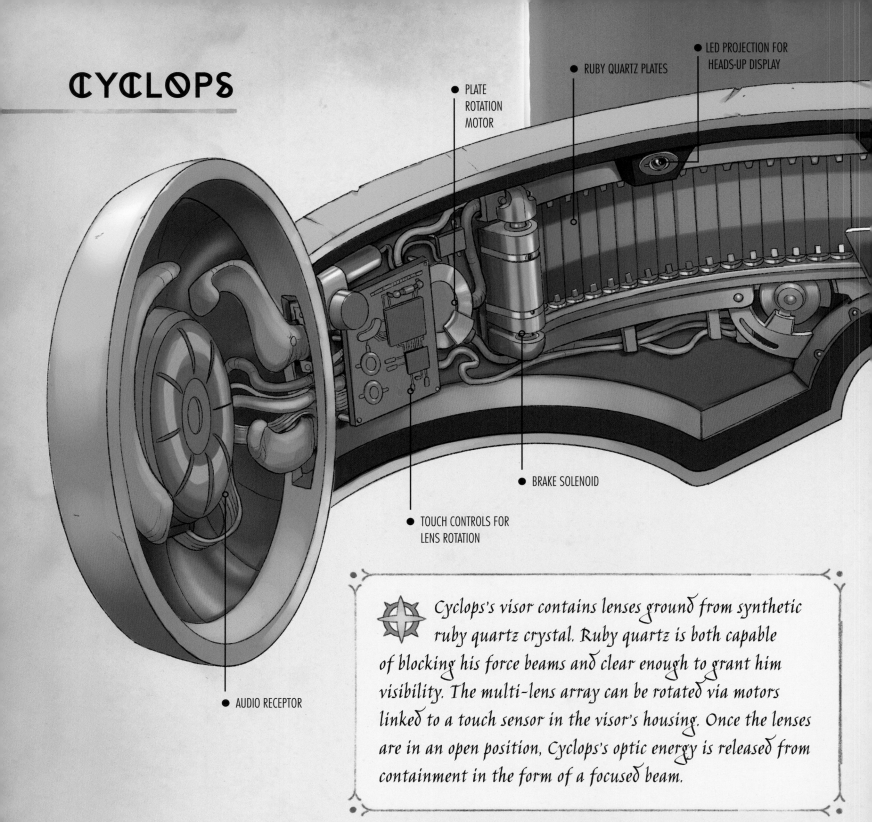

- PLATE ROTATION MOTOR
- RUBY QUARTZ PLATES
- LED PROJECTION FOR HEADS-UP DISPLAY
- BRAKE SOLENOID
- TOUCH CONTROLS FOR LENS ROTATION
- AUDIO RECEPTOR

Cyclops's visor contains lenses ground from synthetic ruby quartz crystal. Ruby quartz is both capable of blocking his force beams and clear enough to grant him visibility. The multi-lens array can be rotated via motors linked to a touch sensor in the visor's housing. Once the lenses are in an open position, Cyclops's optic energy is released from containment in the form of a focused beam.

PSIONIC FIELD

Cyclops is somehow immune to the force of his own optic blasts. If this were not the case, his eyelids would be destroyed by the energy he unleashes. Because I have witnessed Cyclops suffer damage from concussive attacks launched by others, I conclude that his immunity is highly specific and perhaps genetic in nature, limited to the variety of force particle contained in the optic blasts produced by his biological systems.

Scans designed to measure psionic activity indicate that Cyclops may be subconsciously generating a continuous low-level psionic shield. This energy barrier is attuned to his optic blasts and protects his physical matter from any particle-based damage. Interestingly, the crystal used in his visor appears to resonate on the same psionic frequency. So in reality, it may not be that the ruby quartz lens is stronger than Cyclops's optic blasts, but rather that it is functioning in sync with Cyclops's natural defense mechanisms. A subconscious field of protection linked to his own genetic code might also explain why Cyclops is immune to the plasma blasts employed by his brother, Havok.

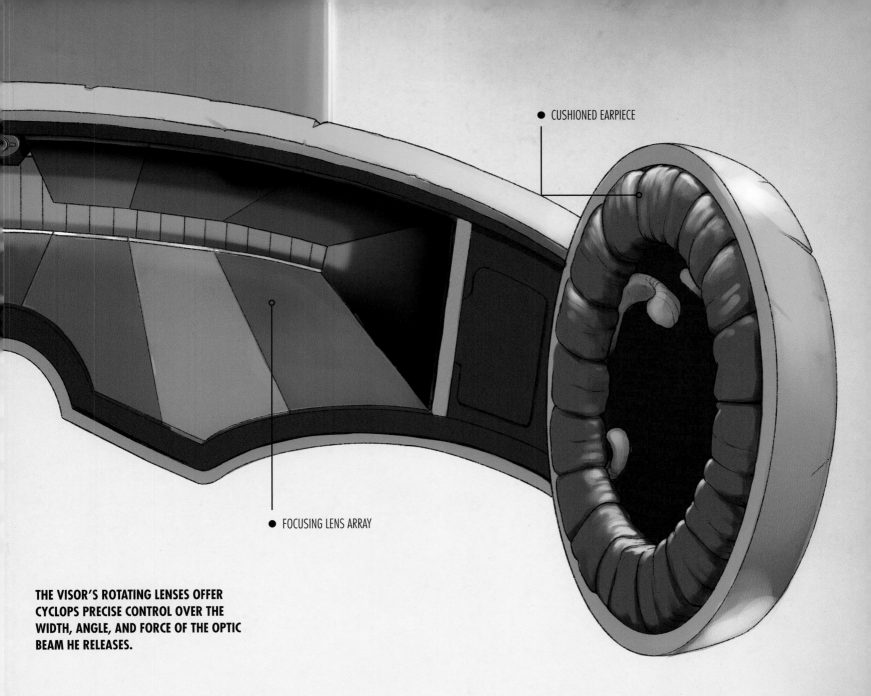

CUSHIONED EARPIECE

FOCUSING LENS ARRAY

THE VISOR'S ROTATING LENSES OFFER CYCLOPS PRECISE CONTROL OVER THE WIDTH, ANGLE, AND FORCE OF THE OPTIC BEAM HE RELEASES.

 # ENERGY ABSORPTION

Because Cyclops's visor reflects his own optic beams back into his eyes without any negative effects, it seems likely that his cellular structure is capable of energy absorption. If he is able to absorb more forms of energy than just his body's latent concussive blasts, it could mean that Cyclops can also absorb ambient light and radiation and use it to enhance his optic powers. Alternately, this energy reserve could be converted directly into concussive force or even be deployed to sustain Cyclops's connection to the theorized pocket dimension from which his power might originate. It could also help power the complex physiology required to support his ocular organs and related neural connections given their states of constant, intense strain.

 ## ASSESSMENT

Cyclops is one of the most powerful and influential mutants on Earth and has many years of experience leading the X-Men and other mutant teams. Should we be able to confirm his identity and recruit him to our cause, the entire mutant populace would likely follow. Although relations between mutants and humankind have grown increasingly hostile in recent years, a threat on the level of the Skrulls could necessitate an alliance between our races. Standing together is our best chance to prevent our subjugation, or perhaps even our mutual extinction.

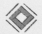

A HYPOTHETICAL MODEL OF JEAN GREY'S
MENTAL CONTROL OVER PSIONIC PARTICLES.

- **A.** NO INTERACTION
- **B.** PSYCHIC BOND
- **C.** TELEPATHIC ASSAULT
- **D.** MENTAL CONTROL
- **E.** MIRRORED THOUGHTS

JEAN GREY

In the X-Men's early days, Jean Grey was the star pupil of Professor Charles Xavier, the brilliant telepath who devoted his life to the training and education of mutants like himself. Jean demonstrated an array of mental gifts, including telepathy and telekinesis, that identified her as one of the world's most powerful mutant minds. But Jean's powers reached incalculable levels when she forged a bond with the cosmic entity known as the Phoenix Force, an extraterrestrial entity of pure psionic energy capable of creation and destruction on a universal scale.

TELEPATHY

With no discernible upper limit to her mental powers, Jean Grey relies on her unrivaled telepathic abilities as her first line of defense. She most commonly uses these powers to explore and influence the minds of others. Her methods include reading thoughts, creating psychic bonds, inducing temporary paralysis or sleep, projecting her own thoughts, generating illusions, and more. It is believed that Jean's powers are isolated to a mutation in her brain cells, most likely in the parahippocampal gyrus—the region of the brain's gray matter commonly associated with extrasensory abilities.

Jean can influence a nearly unlimited number of minds at close range, but that number decreases with distance. She is also capable of taking full possession of a person's mind but must be in their presence to do so and can only use this ability on one person at a time. Of note, when her telepathic abilities first manifested, they were so intense that Professor Xavier had to build psychic barriers within Jean's mind to suppress this portion of her powers altogether.

The mechanism that enables telepathy has long been debated, but I am in favor of the hypothesis that Jean is able to perceive ghostlike neutrinos released by the neural pathways of other beings—a phenomenon nearly impossible to detect by conventional means due to the elusive nature of these nearly massless particles. If so, it could be Jean's unconscious connection to these particles that allows her to read thoughts, create psychic illusions, and more.

PSYCHIC EMPATHY

Jean Grey's empathic powers are distinct from her skill at telepathy, and they allow her to influence the emotions of others and read the moods of those around her. It appears that Jean can subtly manipulate the chemical reactions occurring in the brain of her target, thereby triggering desired emotional responses. As such, she can generate profound feelings of calm or induce paralyzing terror. She has even been known to force enemies to relive their crimes, suggesting simultaneous use of telepathy and memory access in addition to manipulation of neural chemistry.

- Charles Xavier constructed powerful psychic barriers within Jean's mind to limit the full capacity of her mental abilities.

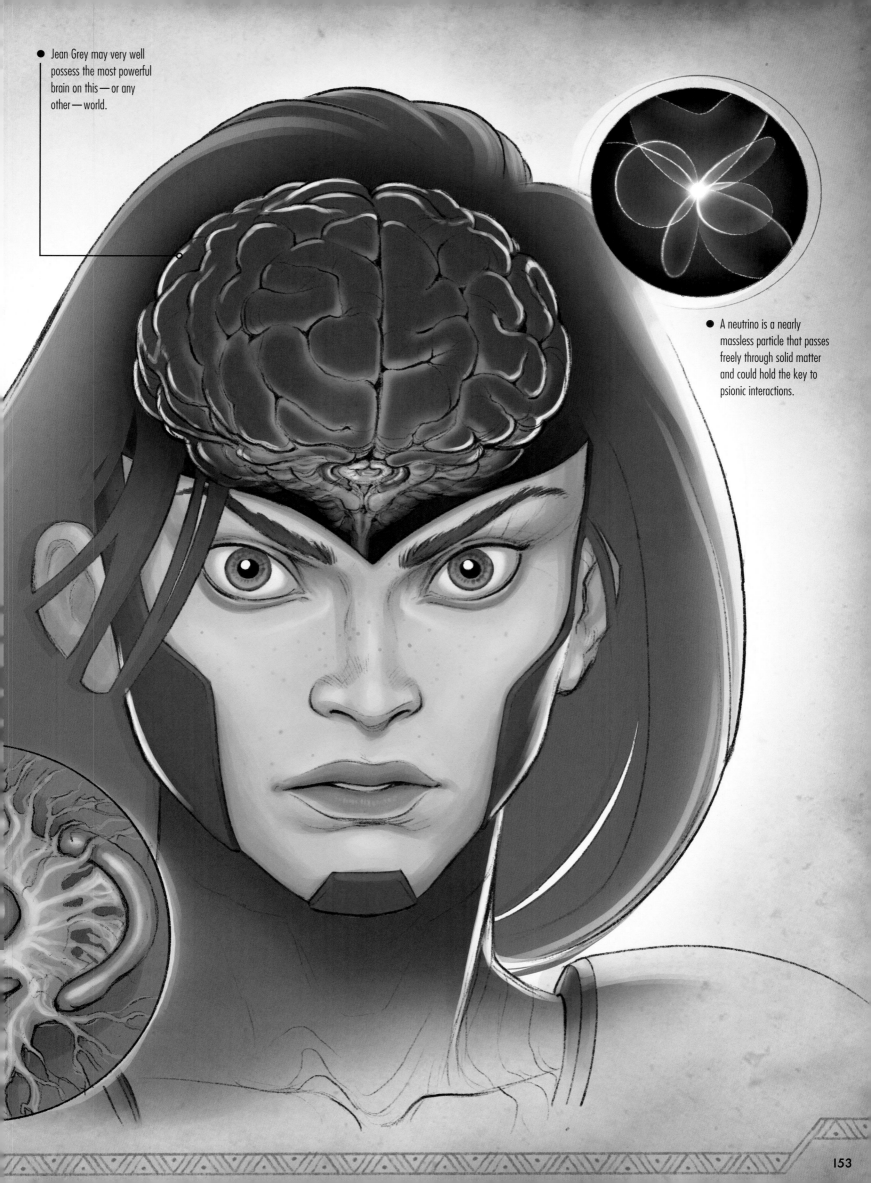

● Jean Grey may very well possess the most powerful brain on this — or any other — world.

● A neutrino is a nearly massless particle that passes freely through solid matter and could hold the key to psionic interactions.

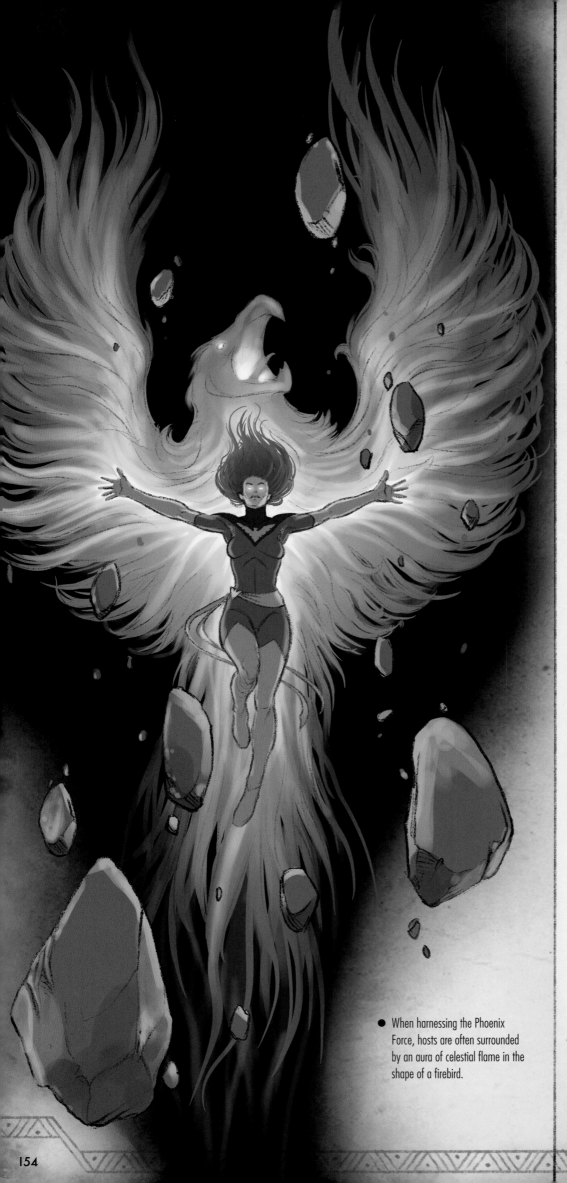

 # PHOENIX FORCE

When Jean is communing with the Phoenix Force, the ancient cosmic entity expands her natural abilities exponentially. No one has been able to determine the nature and limits of the energies unleashed by the Phoenix Force, but Jean has seemingly manipulated objects at an atomic scale through telekinesis and produced a broad spectrum of energies in virtually unlimited quantities. She has even shown the ability to convert her body to pure energy, existing in the depths of space with no ill effects.

When connected to the Phoenix Force, a human host is surrounded by an aura of cosmic flame in the shape of a firebird. For those who call Wakanda home, the shape of the Phoenix is forever burned into our memories. Our entire nation was nearly drowned by Namor the Sub-Mariner (see subsequent entry, page 212) during a time when he was granted a fraction of the Phoenix's power. Since then, Wakanda has developed an early warning system to detect the Phoenix's unique energy signature and weaponry theoretically capable of containing its cosmic flames. The Phoenix always returns, but Wakanda will be prepared when it does.

● When harnessing the Phoenix Force, hosts are often surrounded by an aura of celestial flame in the shape of a firebird.

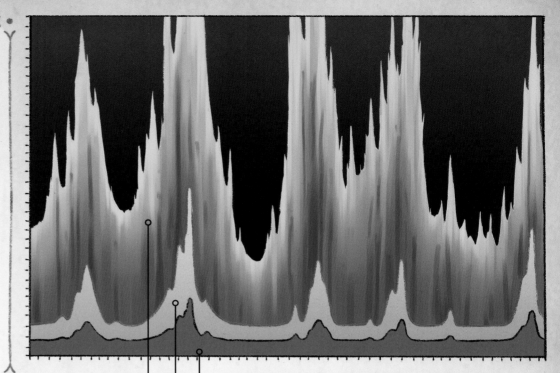

Jean Grey can also use specialized techno-psyche devices that amplify her powers over long distances. Once such device, Cerebro, was designed by Charles Xavier as a method of locating mutants across the globe. When Jean uses Cerebro, she can psychically influence virtually any mind on the planet.

COMPARATIVE SCANS OF JEAN GREY'S PSYCHIC ACTIVITY UNDER VARIOUS CONDITIONS.

- NORMAL PSYCHIC ACTIVITY
- ENHANCED BY CEREBRO
- LINKED TO THE PHOENIX FORCE

TELEKINESIS

As an X-Man, Jean Grey spent years honing her telekinetic abilities. While all living organisms generate low-level psionic energy as a by-product of natural brain function, Jean's psionic energy levels are so remarkable that some have speculated that she must be tapping into a limitless, extradimensional psionic source.

Jean's abilities allow her to mentally project an aura of psionic energy, a demonstrated cognitive effect that allows psychics to use mental commands to achieve physical results in the real world. Because the laws of classical physics dictate that human cognition cannot directly influence physical matter, researchers who study superhumans have long postulated the presence of a fifth force (beyond gravity, electromagnetism, and strong and weak nuclear forces) that would allow telekinesis to overpower the influence of the other four forces to achieve such effects. The source of this fifth force may be extradimensional in origin, but gifted individuals may be able to harness its effects.

Jean can cause objects or individuals to levitate by engulfing them in her psionic aura and using her telekinesis to lift them. She can also use this ability to move her own body through the air, giving the appearance of flight. In addition, Jean can solidify her psionic energy into shields or concussive bursts.

When lifting heavy objects, such as a boulder, Jean encompasses the target within a psionic aura to move it through the air effortlessly.

ASSESSMENT

Jean Grey's full range of psionic skills alone grants her a level of power almost completely immeasurable by most standards. Should she be able to commune with the Phoenix Force to enhance those powers further, it would almost certainly ensure our victory against the Skrulls. That said, I have witnessed firsthand the full fury of the Phoenix, and I must admit I doubt whether even one as skilled as Jean Grey can keep such an overpowering entity under control for long.

ICEMAN

Iceman can manipulate thermal energy to conjure subzero fields at will, allowing him to generate vast quantities of solid ice, convert his body into a frozen state, and even spawn frozen doppelgängers. In his early years with the X-Men, Iceman often went overlooked by opponents who failed to be intimidated by his simple snow creations, but with maturity, he has developed an array of sophisticated new abilities and has proven himself one of the most formidable mutants on the planet.

ICE GENERATION

Iceman can generate ice in seemingly endless quantities by extending his subzero aura and freezing any atmospheric moisture in close proximity to his body. His control is so precise that he can instantly sculpt the resulting ice into ramps, shields, blades, and even simple mechanisms. Iceman travels by generating a smooth, slick ice pathway beneath his feet and sliding along its surface. Because moisture is almost always present in a breathable atmosphere, Iceman's ice-construction powers have few limits.

THERMAL MANIPULATION

Iceman's mutant power allows him to psionically control thermal energy levels, an ability expressed as an aura of intense cold radiating from his body that can drop temperatures in his vicinity to as low as -105 degrees Fahrenheit in less than a second. Although deploying this power observably affects his physiology—his body changing composition to assume a crystalline cellular structure resembling translucent ice—Iceman's organic tissue sustains no damage. This transformation appears to have no effect on his speed or flexibility, suggesting that the structure of his cells is far less rigid than his icelike appearance would suggest. Some have suggested that he may even be capable of dropping temperatures to absolute zero, the point at which all molecular motion ceases, potentially making him one of the world's most dangerous mutants.

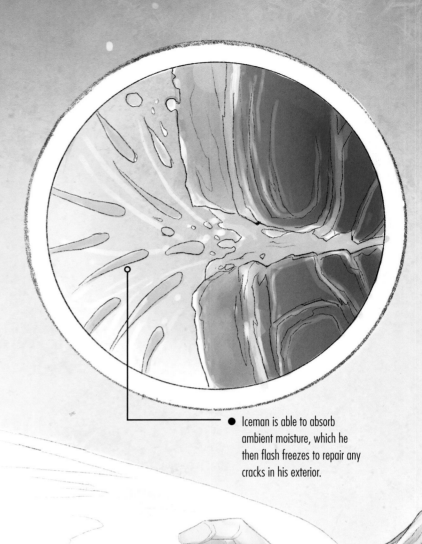

• Iceman is able to absorb ambient moisture, which he then flash freezes to repair any cracks in his exterior.

• Iceman's ability to generate frozen forms out of thin air is only limited by the amount of moisture present in the atmosphere.

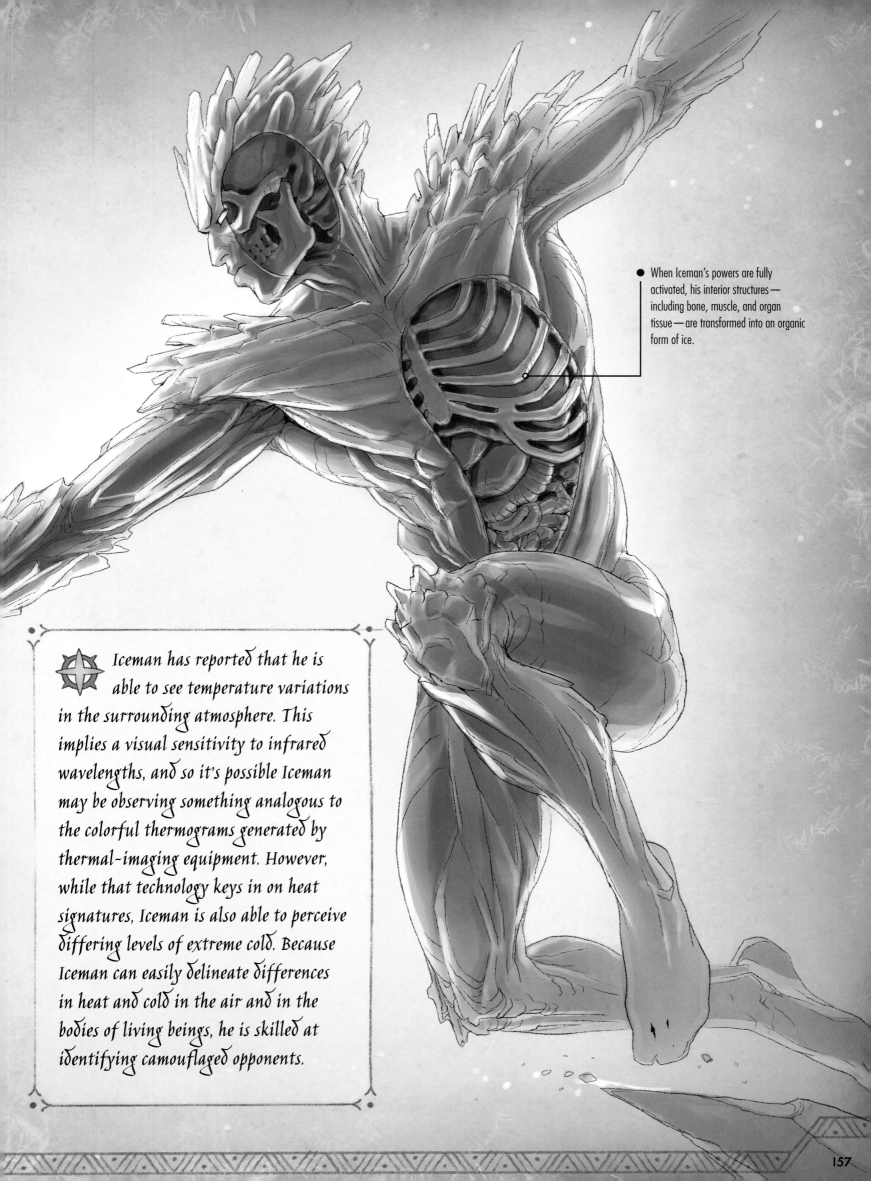

When Iceman's powers are fully activated, his interior structures—including bone, muscle, and organ tissue—are transformed into an organic form of ice.

Iceman has reported that he is able to see temperature variations in the surrounding atmosphere. This implies a visual sensitivity to infrared wavelengths, and so it's possible Iceman may be observing something analogous to the colorful thermograms generated by thermal-imaging equipment. However, while that technology keys in on heat signatures, Iceman is also able to perceive differing levels of extreme cold. Because Iceman can easily delineate differences in heat and cold in the air and in the bodies of living beings, he is skilled at identifying camouflaged opponents.

ICEMAN

Iceman is able to apply the "organic ice" he generates to his entire body or to select extremities at will. The process appears to rely on the intake of ambient moisture from the atmosphere to supplement his body mass. This action continually reinforces and replenishes his crystalline structure by freezing a layer of ice around his body, filling in any fissures sustained during battle and increasing his resistance to injury. Iceman can also use solidified atmospheric moisture to augment his external features, including the addition of dense, frozen body armor or icicle-like spikes on his wrists or shoulders.

While Iceman's own body remains unharmed by extreme temperature reductions, he can inflict damage on nearby enemies by expanding the perimeter of his body's subzero aura. This field can trigger symptoms of frostbite in mere seconds, potentially resulting in permanent tissue damage. Some reports indicate that Iceman can even freeze the limb of an opponent in a manner similar to the supercooling caused by exposure to liquid nitrogen, leaving it in a brittle state that can easily shatter or snap, separating frozen and unfrozen tissue.

 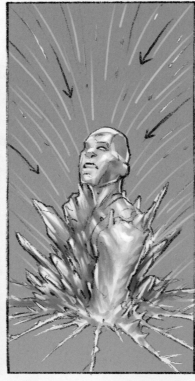 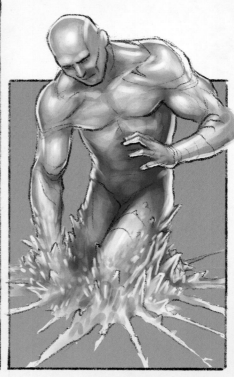

ICEMAN CAN RECOVER FROM CATASTROPHIC DAMAGE, EVEN WHEN HIS BODY HAS BEEN COMPLETELY SHATTERED.

PARTICLES OF WATER FROM THE SURROUNDING ENVIRONMENT ARE ABSORBED TO SUPPLEMENT ICEMAN'S FROZEN BIOLOGICAL MATTER.

AS NEWLY ABSORBED MOISTURE BLENDS WITH ICEMAN'S ORGANIC ICE FRAGMENTS, HIS PHYSICAL FORM BEGINS TO RECONSTITUTE.

A FULLY RESTORED ICEMAN EMERGES. NO SIGNS OF PHYSICAL DAMAGE ARE APPARENT, EVEN WHEN HE REVERTS TO HIS UNFROZEN STATE.

◈ DURABILITY AND REGENERATION

In his organic ice form, Iceman is susceptible to specific physical attacks that have the potential to shatter his body. Though his joints remain flexible, intense pressure on certain vertices can trigger a fracture that leaves him in fragments. Similarly, excessive heat can melt his extremities or even cause his mass to sublimate into a gaseous state resembling steam.

Similar to Sandman and Hydro-Man, Iceman appears to retain a disembodied consciousness in these dissolute states, enabling him to pursue actions that will restore his body. By absorbing ambient moisture, he can usually knit together his shattered pieces, fully restoring his human form with no lasting effects on his health. Even after total evaporation, Iceman can simply will his droplets to cluster and condense into his original shape.

Newly logged records indicate Iceman can generate semiautonomous humanoid ice golems that function independently. It's possible Iceman retains subconscious control over his golems, or perhaps a trace number of organic droplets incorporated into Iceman's creations is enough to give each of the golems a limited portion of their creator's own sentience. These creations seem to automatically revert to fighting alongside Iceman in the absence of specific commands, which reinforces the notion that their basic brain functions may be directly patterned after those of their creator.

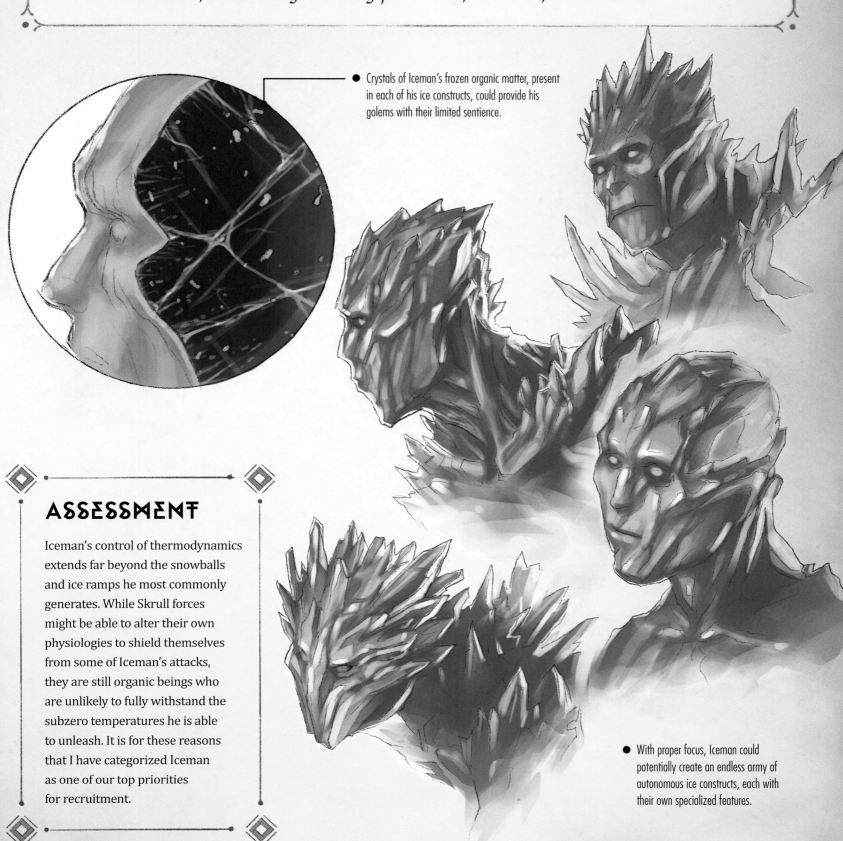

● Crystals of Iceman's frozen organic matter, present in each of his ice constructs, could provide his golems with their limited sentience.

ASSESSMENT

Iceman's control of thermodynamics extends far beyond the snowballs and ice ramps he most commonly generates. While Skrull forces might be able to alter their own physiologies to shield themselves from some of Iceman's attacks, they are still organic beings who are unlikely to fully withstand the subzero temperatures he is able to unleash. It is for these reasons that I have categorized Iceman as one of our top priorities for recruitment.

● With proper focus, Iceman could potentially create an endless army of autonomous ice constructs, each with their own specialized features.

ANGEL

When a pair of enormous feathered wings sprouted from his back, wealthy young mutant Warren K. Worthington III earned a spot in the first class at Xavier's School for Gifted Youngsters. As the X-Man Angel, Warren soared to new heights, but his world came crashing down when the mutant villain Apocalypse transformed him into his Horseman of Death, Archangel. Warren has since returned to the side of justice but still struggles against the darkness within himself.

● The alveoli in Angel's lungs optimize oxygen intake allowing him to soar at high speeds and elevations.

 ## WINGS AND FLIGHT

Angel's mutation originally manifested in the form of feathered wings bonded to his skeleton and emerging from his back between his shoulder blades. Fully extended, the wings spanned 16 feet but could be folded up in a harness beneath his normal clothing.

To fly, Angel flaps his wings in the same manner as a bird, beating rapidly against the air to achieve liftoff and angling his feathered appendages to control direction and altitude while in flight. Extensive training in aerial acrobatics has left Angel with the skills to maneuver with great precision and speed. Also, the lifting force generated by the flapping of Angel's wings can support his own weight plus an additional two hundred pounds, allowing him to carry teammates or large objects such as munitions and field equipment.

 ## AVIAN CHARACTERISTICS

Angel's body structure shares certain birdlike physical characteristics, including hollow, flexible bones and a high metabolism that leaves him with virtually no fat on his frame. He can withstand the chill of high-altitude flight and possesses a specialized respiratory membrane that surrounds the alveoli in the lungs and extracts additional oxygen from breaths taken in thin air. His eyes can perceive movement or make out minute details, such as identifying a specific target in a crowded area at distances up to eight times farther than a typical human. Such a skill is comparable to the visual acuity of eagles, falcons, and other airborne raptors, which might suggest Angel's eyes possess something similar to the pecten oculi—the unique avian structuring of ocular blood vessels that optimizes retinal function in these birds of prey.

According to radar data we have compiled, Angel's flight paths most often occur at around 6,500 feet—the lowest level at which full cloud cover is typically present, allowing him to travel without drawing unwanted attention. He has reached a flight ceiling of approximately 29,000 feet—as high as the apex of Mount Everest—but such extreme altitudes put a tremendous strain on his body despite his high tolerance for windchill and low-oxygen environments. His cruising speed is approximately 70 miles per hour, but he has been clocked at speeds up to 150 miles per hour.

 ## HEALING ABILITY

Angel's body produces remarkably few toxins as a result of elevated metabolic processes stemming from his mutant physiology. This ability works in concert with his avian mutations, allowing Angel to fly for long periods without growing tired. Angel has also developed an enhanced healing ability due to a secondary mutation, which enables his body to knit damaged tissue at an accelerated rate, mending near-fatal wounds in hours. Angel's healing powers appear to stem from the chemical composition of his blood. Therefore, a transfusion from Angel will grant temporary restorative benefits to the recipient as long as they share the same blood type.

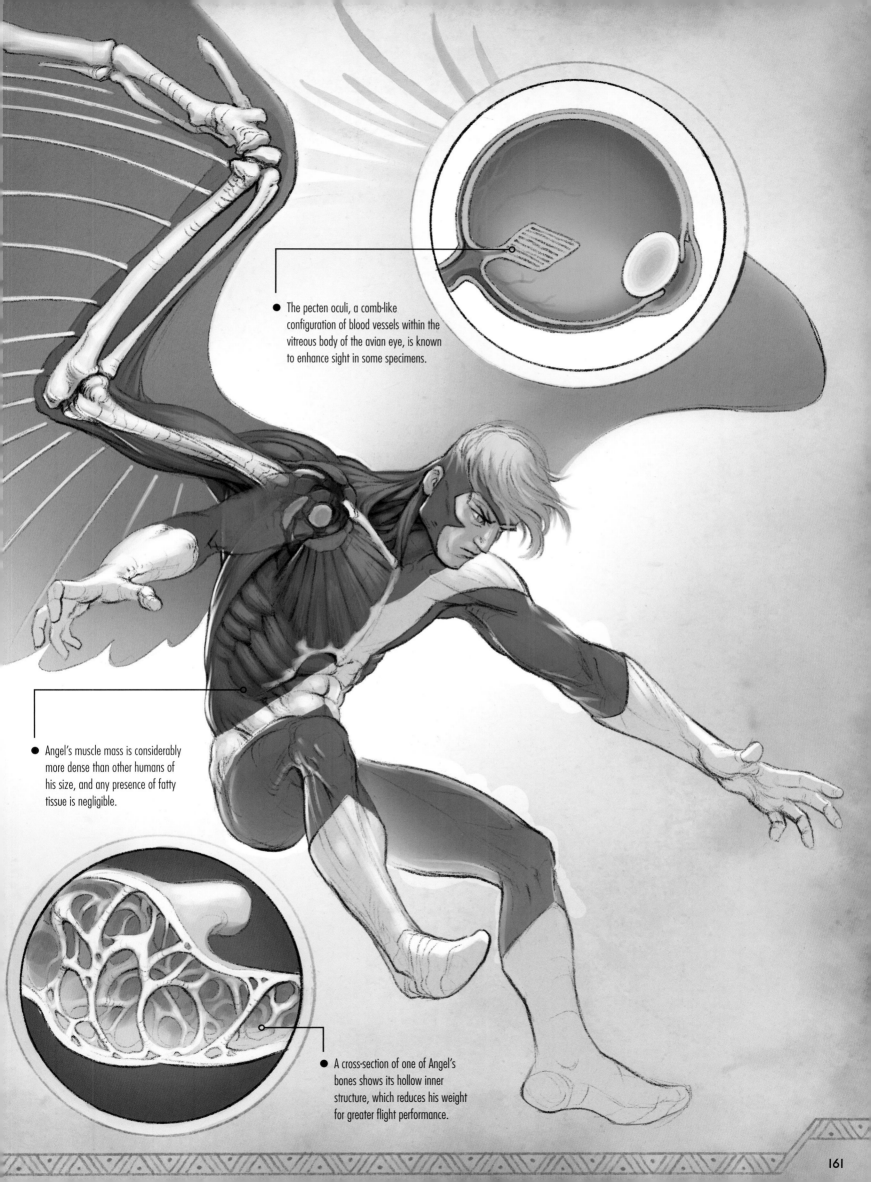

The pecten oculi, a comb-like configuration of blood vessels within the vitreous body of the avian eye, is known to enhance sight in some specimens.

Angel's muscle mass is considerably more dense than other humans of his size, and any presence of fatty tissue is negligible.

A cross-section of one of Angel's bones shows its hollow inner structure, which reduces his weight for greater flight performance.

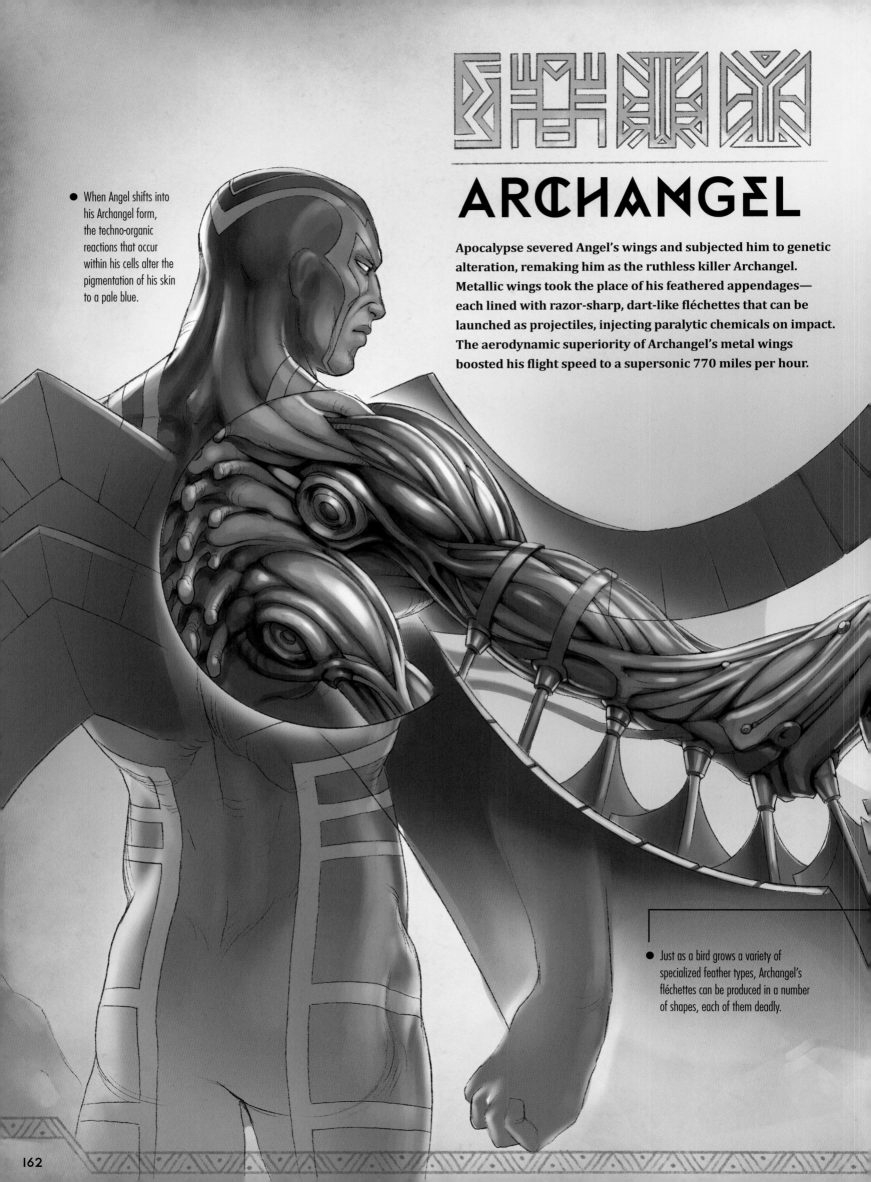

- When Angel shifts into his Archangel form, the techno-organic reactions that occur within his cells alter the pigmentation of his skin to a pale blue.

ARCHANGEL

Apocalypse severed Angel's wings and subjected him to genetic alteration, remaking him as the ruthless killer Archangel. Metallic wings took the place of his feathered appendages— each lined with razor-sharp, dart-like fléchettes that can be launched as projectiles, injecting paralytic chemicals on impact. The aerodynamic superiority of Archangel's metal wings boosted his flight speed to a supersonic 770 miles per hour.

- Just as a bird grows a variety of specialized feather types, Archangel's fléchettes can be produced in a number of shapes, each of them deadly.

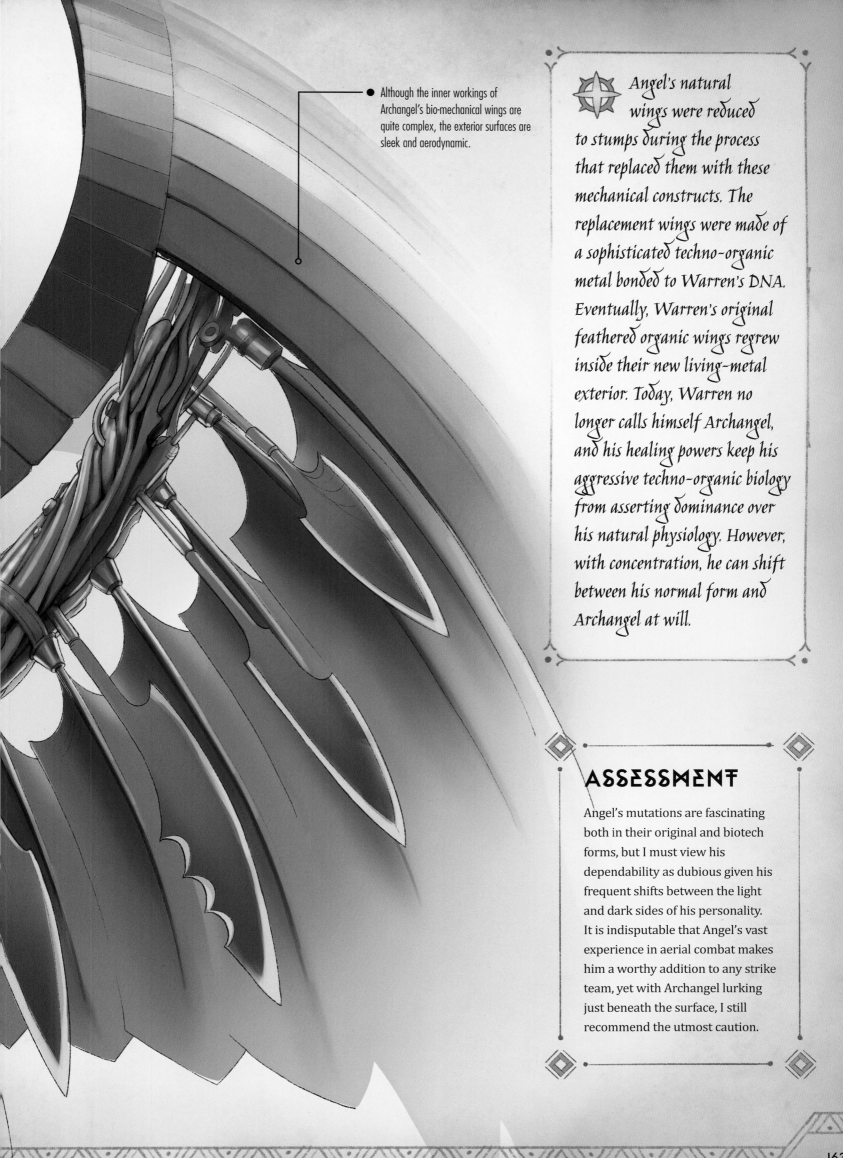

Although the inner workings of Archangel's bio-mechanical wings are quite complex, the exterior surfaces are sleek and aerodynamic.

Angel's natural wings were reduced to stumps during the process that replaced them with these mechanical constructs. The replacement wings were made of a sophisticated techno-organic metal bonded to Warren's DNA. Eventually, Warren's original feathered organic wings regrew inside their new living-metal exterior. Today, Warren no longer calls himself Archangel, and his healing powers keep his aggressive techno-organic biology from asserting dominance over his natural physiology. However, with concentration, he can shift between his normal form and Archangel at will.

ASSESSMENT

Angel's mutations are fascinating both in their original and biotech forms, but I must view his dependability as dubious given his frequent shifts between the light and dark sides of his personality. It is indisputable that Angel's vast experience in aerial combat makes him a worthy addition to any strike team, yet with Archangel lurking just beneath the surface, I still recommend the utmost caution.

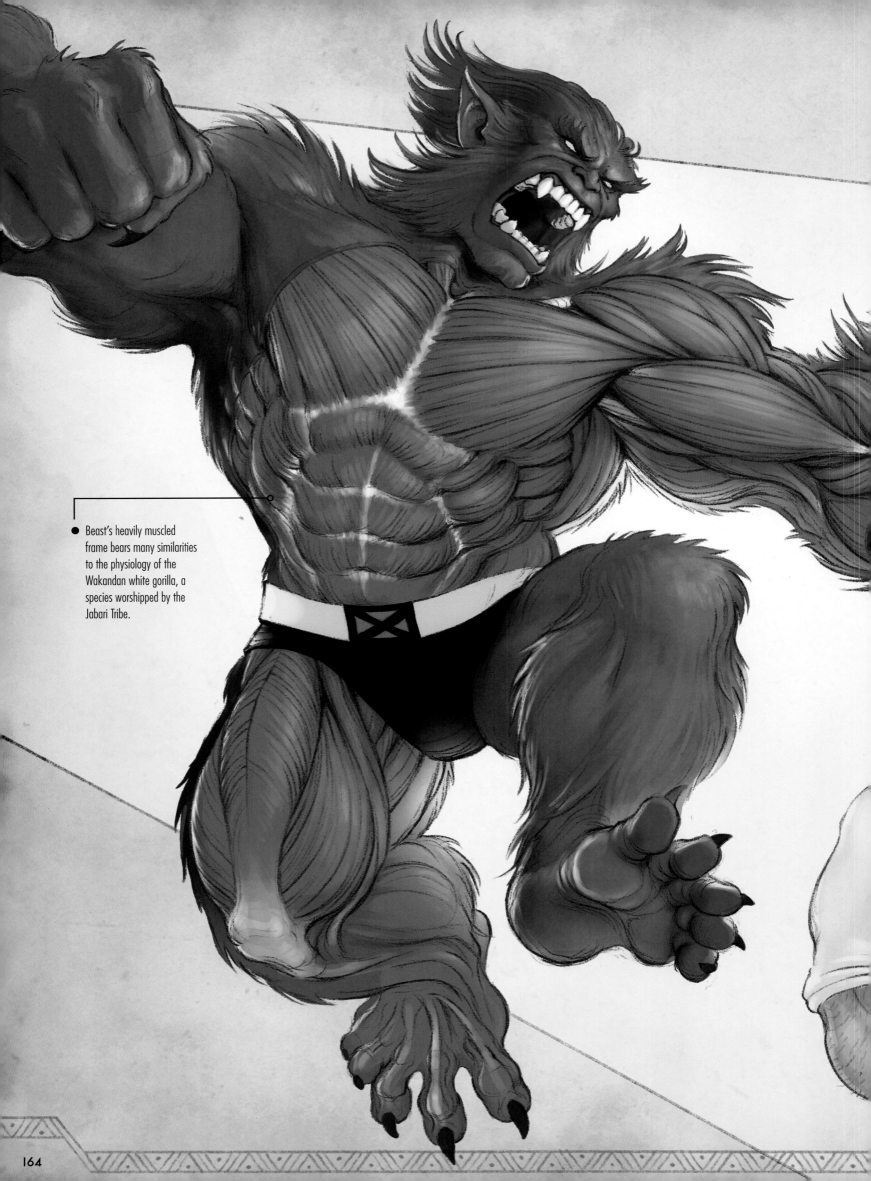

Beast's heavily muscled frame bears many similarities to the physiology of the Wakandan white gorilla, a species worshipped by the Jabari Tribe.

BEAST

Looks can be deceiving when it comes to Henry McCoy, whose savage appearance conceals his academic expertise in multiple sciences, including genetics and biochemistry. As Beast, Hank has battled foes alongside the X-Men using his apelike agility and has enhanced his own mutant abilities even further through custom alterations to his genetic code.

● While Beast's blue pelt may now be his most instantly recognizable feature, his fur was actually light gray when it first manifested.

PHYSICAL MUTATIONS

Dr. Henry McCoy is one of the rare mutants whose enhancements were obvious from birth. His hands and feet are significantly larger than average, and his body proportions—including his increased musculature and elongated arms—resemble those of a great ape. This atypical physique allows Hank to perform feats of strength and agility unrivaled by his peers.

After spending his early years with the X-Men as an adventurer, Hank shifted his attention to science, particularly the study of the mutant X-Gene. During this time, he developed a serum that isolated the hormones responsible for triggering latent traits associated with his mutancy. When administered, it caused him to develop fangs, claws, pointed ears, and a coat of fur.

● Hank McCoy possessed many of his enhanced physical traits, including enlarged extremities, prior to his scientifically induced mutations.

While Beast's self-performed alterations reconfigured his core features and added his familiar blue fur, a brush with death activated an even deeper mutation and transformed him into a more feline shape. Taking on this form resulted in a rapid deterioration of Beast's physical health, prompting him to synthesize a stabilizing formula that restored him to a form more akin to his familiar simian configuration.

BEAST

ENHANCED STRENGTH AND DEXTERITY

A dense muscular structure and a thick, shock-resistant skeleton grant Beast the ability to lift up to ten tons and leap up to 50 feet in any direction from a standing position. He can also reach speeds of 40 miles per hour when lumbering forward on all four limbs. In addition, not only does Beast's amazing dexterity allow him to flip and tumble through obstacles with ease, he can use all four extremities simultaneously. I have witnessed Hank hanging from the ceiling with one hand and using the other to fine-tune an invention, even as he turned the pages of a textbook with his left foot and jotted down notes with a pencil gripped between the toes on his right.

ENHANCED SENSES

All of Beast's senses perform at levels classified as superhuman. The temporal lobe in his brain, responsible for handling sensory input, shows enhanced activity under MRI scans, indicating a talent for juggling multiple sensory signals at once. His hearing overlaps with infrasonic and ultrasonic wavelengths far beyond the human range of 20 hertz to 20,000 hertz. Additionally, increased nerve density in his retinas could account for Beast's ability to collect sharper images many times more acute than those perceived by regular human eyes.

Beast's eyes are similar to those of a domestic cat, with vertical slits that can open and close with remarkable speed. Studies have shown that feline pupils are more than 20 times more responsive than human eyes when changing between constricted and dilated states, allowing for superior night vision. It can be assumed that Beast's analogous ocular structure provides him the same visual acuity.

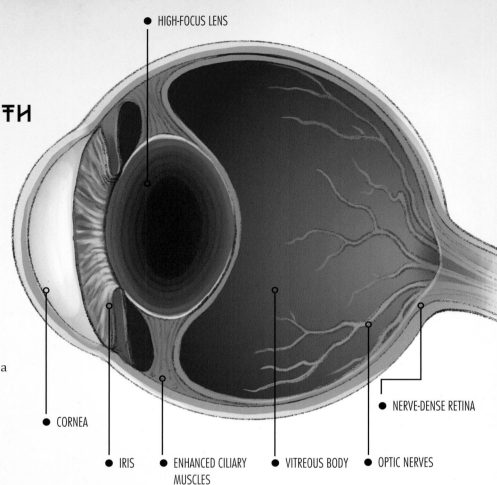

HIGH-FOCUS LENS

CORNEA

IRIS

ENHANCED CILIARY MUSCLES

VITREOUS BODY

OPTIC NERVES

NERVE-DENSE RETINA

BEAST'S CAT-LIKE PUPILS AND NERVE-RICH RETINAE WORK IN SYNC TO ENHANCE HIS DISTANCE VISION TO ASTONISHING LEVELS. HOWEVER, HE STILL REQUIRES GLASSES FOR READING.

ASSESSMENT

Though his mutant physiology surely makes him an asset on any battlefield, Hank McCoy's brilliant mind is far more valuable to our particular cause. When it comes to our efforts to analyze and neutralize the Skrulls, Beast's unparalleled understanding of biology and genetics far outweighs his more obvious physical gifts. While I would gladly grant him full access to Wakanda's most advanced laboratories, Beast's boisterous spirit, physical prowess, natural curiosity, and proficiency at multitasking all lead me to believe he would be far more content gathering data from the front lines of this confrontation. And when Beast puts his mind to something, it is rare that anything can stop him.

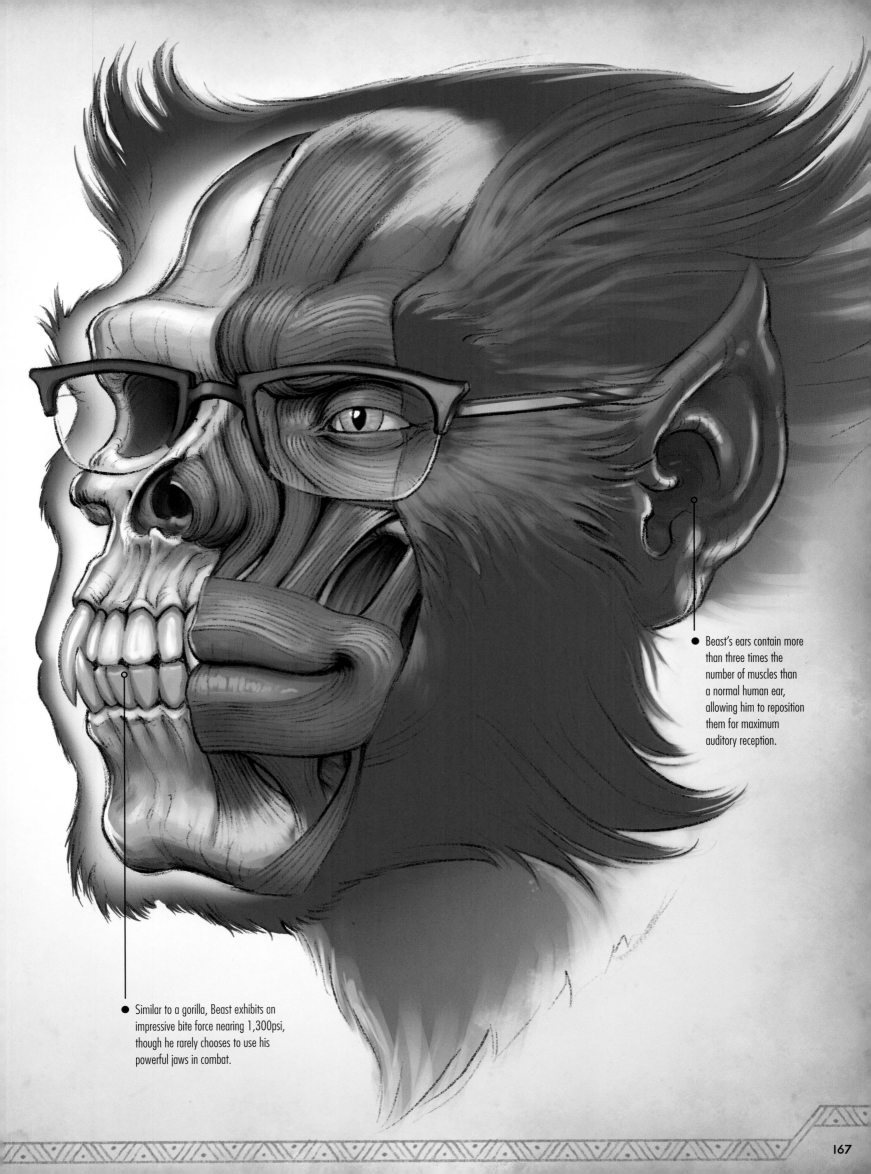

Beast's ears contain more than three times the number of muscles than a normal human ear, allowing him to reposition them for maximum auditory reception.

Similar to a gorilla, Beast exhibits an impressive bite force nearing 1,300psi, though he rarely chooses to use his powerful jaws in combat.

NIGHTCRAWLER

An outcast from birth, Kurt Wagner spent his formative years as a circus oddity notorious for his demonic appearance. He eventually found a home with the X-Men, where his mastery of teleportation and his knack for acrobatic combat made him one of the team's most valuable members.

 ## PHYSICAL MUTATIONS

Nightcrawler's unique traits include blue skin covered with a thin layer of dark fur, as well as fanged canine teeth, pointed ears, and pupilless yellow eyes. Each of his hands has two fingers and an opposable thumb, and each foot has two flexible toes plus a bendable heel capable of gripping objects.

A three-and-a-half-foot tail extends from the base of Nightcrawler's spinal column, ending in a spear-like point. This appendage can support Nightcrawler's entire body weight and can be used to manipulate objects like a third arm. Nightcrawler has even been observed wielding a sword with his tail while fighting multiple enemies. The tail also gives Nightcrawler more control over his center of gravity, contributing to his near-perfect sense of balance.

According to rumors, Nightcrawler's unique physiology is inherited from his father, Azazel, a seemingly immortal mutant with demon-like characteristics. The deep blue coloration of his skin and fur, however, can likely be attributed to his mother, the shape-changing mutant who calls herself Mystique.

> *Nightcrawler uses his hands, feet, and tail to gain purchase on eaves and ceiling beams, but I have also witnessed him adhere to near-frictionless surfaces with an effect similar to that exhibited by Spider-Man. The nature of this ability is unknown but could stem from a persistent negative charge emitted as a by-product of his teleportation abilities. Such a charge could theoretically create a sufficiently strong attraction between his body and the positive charge of another object to support his weight.*

● Nightcrawler's natural agility and flexibility provide him with the physical finesse required to become a master swordsman.

● Despite years of intense acrobatic activity, Nightcrawler does not exhibit the joint deterioration commonly found in professional gymnasts.

● Although Nightcrawler's hands and feet have fewer digits than most other humans and mutants, this feature has not impeded his dexterity.

● Nightcrawler's supple spinal column allows him to bend and twist his body to perform astonishing acrobatic feats.

● Nightcrawler relies on his strong, flexible prehensile tail to enhance his agility, balance, reach, and range of motion.

NIGHTCRAWLER

ENHANCED FLEXIBILITY AND AGILITY

Nightcrawler's spine is exceptionally flexible, allowing him to contort his body beyond human limits. His agility was honed during his years as a circus acrobat and an X-Man, and Nightcrawler can now fearlessly swing and twist his way through even the most volatile combat zone. Measurements of Nightcrawler's post-exercise heart rate, oxygen uptake, and peak blood lactate concentration suggest that his body's cardiorespiratory and metabolic demands are remarkably low, enabling long periods of sustained exertion. His lithe musculature is also an asset when reacting quickly to incoming danger.

TELEPORTATION

Nightcrawler's signature teleportation ability permits instantaneous transport to another physical location. Some forms of teleportation rely on breaking down matter and reconstituting it elsewhere, but Nightcrawler's power instead uses interdimensional portals to create a shortcut in time and space.

Nightcrawler can generate these portals at will, passing through them in a split second before emerging through a secondary portal back into our own world. The process is accompanied by an audible burst of air and the stench of brimstone, which presumably emanates from the alternate dimension he travels through during the teleportation process. Nightcrawler can carry people or objects through his teleportation portals, but the added weight contributes to the physical strain he experiences from summoning and maintaining the portals.

Nightcrawler's spatial-hopping ability allows him to subdue multiple targets in seconds by teleporting instantaneously from one opponent to the next.

I have tracked Nightcrawler's teleportation activity and made notes on the points of his departures and arrivals. I estimate his maximum range at approximately two to three miles horizontally and vertically, depending on his knowledge of the terrain.

● REFLECTED LIGHT RAY

CAMOUFLAGE

Nightcrawler is adept at nocturnal concealment. Although his blue skin naturally blends in to dark surroundings, Nightcrawler always appears to be cast in shadow no matter how bright the illumination that surrounds him. It is possible that the extradimensional energy emitted from Nightcrawler's passive connection to his portals also lends a subtle camouflage effect, rendering him difficult to perceive without the use of night vision equipment.

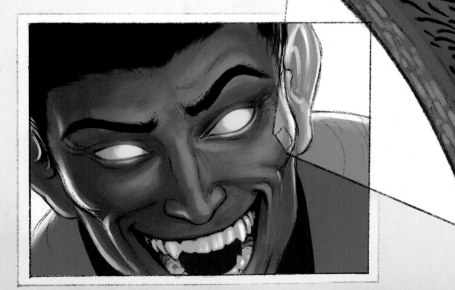

● The fine layer of dark-hued fur covering Nightcrawler's skin absorbs the vast majority of light rays, contributing to his shadowy appearance.

● FUR-COVERED SKIN

● ABSORBED LIGHT RAYS

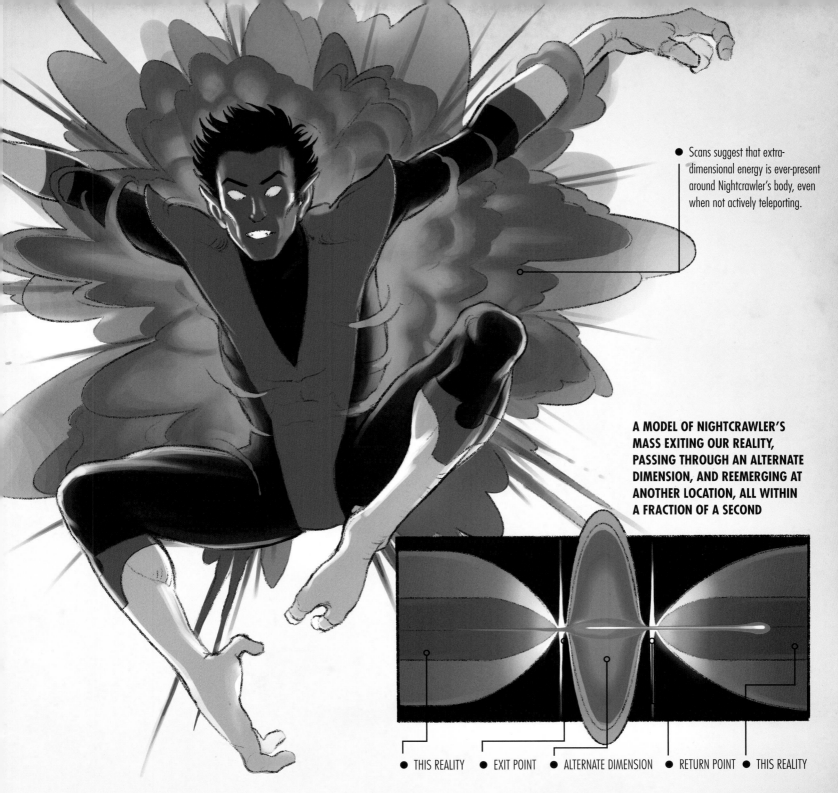

 Scans suggest that extra-dimensional energy is ever-present around Nightcrawler's body, even when not actively teleporting.

A MODEL OF NIGHTCRAWLER'S MASS EXITING OUR REALITY, PASSING THROUGH AN ALTERNATE DIMENSION, AND REEMERGING AT ANOTHER LOCATION, ALL WITHIN A FRACTION OF A SECOND

● THIS REALITY ● EXIT POINT ● ALTERNATE DIMENSION ● RETURN POINT ● THIS REALITY

EXTRASENSORY NAVIGATION

When teleporting, Nightcrawler needs to be keenly attuned to his surroundings lest he accidentally manifest an exit portal beneath the ground or inside a concrete slab. Because of this, I surmise that his mutation includes an unconscious navigational ability that allows him to sense any potential dangers arising from his transit. This could be reflected in an enlargement of his entorhinal cortex, the portion of the brain that acts as a compass. Nightcrawler's directional sense might even subconsciously inhibit him from teleporting into a destination with which he has little familiarity, thus diminishing the chance of fatally intersecting with a solid object upon reversion.

ASSESSMENT

Nightcrawler is a free-spirited swashbuckler who has perfected a fighting style designed to make the most of his mutant anatomy. His acrobatic prowess and skills with a sword will certainly serve him well should this invasion erupt into full-scale war. Yet long before the battle begins, Nightcrawler's power of teleportation could provide a swift and safe means of extracting an identified Skrull infiltrator before they can strike their target, potentially saving lives in the process.

STORM

I have known Ororo Munroe since childhood, and there are few who have made a more significant mark on my life. From our earliest adventures on the African plains to the time she ruled Wakanda at my side, our every encounter has carried a manifest energy of attraction. Ororo's ability to control the weather inspired some to worship her as a goddess long before she joined the X-Men as Storm. Even now the people of Wakanda revere her as Hadari Yao, "the walker of clouds."

WAKANDAN SATELLITE IMAGERY CLEARLY DEPICTS ORORO'S EFFECT ON LOCALIZED WEATHER PATTERNS AS SHE GATHERS A FIERCE STORM.

NORMAL WEATHER PATTERNS

RAPIDLY SHIFTING WIND

CENTRALIZED HURRICANE-FORCE WIND

WEATHER MANIPULATION

Storm's mutant psionic ability can be classified as atmokinesis—a form of telekinesis capable of harnessing naturally occurring weather patterns to achieve a variety of meteorological effects. This includes the ability to summon intense downpours, pelting hail, or hurricane-force winds. Storm can manipulate the temperature and humidity of a region by altering the patterns of high- and low-pressure systems, even within small, self-contained atmospheres like the interior of a spacecraft.

FLIGHT

By altering the direction and intensity of wind currents, Storm can ride upward drafts and keep herself aloft while traveling at speeds up to three hundred miles per hour. Her powers generate a protective air cushion while in transit to shield her from atmospheric friction. She has even demonstrated the ability to harness solar winds—charged plasma streams released from the sun's corona—to propel herself through the airless void of interstellar space.

When Ororo summons powerful updrafts to approximate flight, her body is cushioned by a pocket of air that protects her from potential windshear damage.

STORM

LIGHTNING STRIKE

When a thundercloud builds up an electrical charge, the negatively charged electrons at the base of the cloud are drawn to any buildup of positively charged protons on the ground underneath. This connection triggers a lightning strike. Storm appears to have an innate ability to detect and manipulate such atmospheric charges, allowing her to not only summon lightning strikes at will, but also store electrical energy in her body to be released at a time of her choosing.

The cells in Storm's body must therefore be able to accommodate inordinate amounts of electrical energy. In a typical organism, the bioelectric potential of an organic cell membrane is 50 millivolts. Storm's cells, given the average charge of a lightning strike, must be able to withstand the infusion of more than one billion volts, suggesting that her cellular membranes have become permeable enough to accommodate the greatly increased flow of charged ions.

EYES

When Storm uses her mutant powers, the irises of her eyes appear to shift from blue to a solid, pupilless white. Because the change seems to be linked to the activation of her psionic abilities, it implies that Storm's visual perception might somehow assist in her mastery of atmokinesis. Therefore, it could be possible that, in their purely white state, her eyes might allow Storm to perceive and decipher the complex connections that link atmospheric energies and meteorological conditions. With that information, she could subsequently summon specific weather effects on command through atmokinesis.

ASSESSMENT

There are few beings on this planet I know as intimately as Ororo. Since no Skrull could ever hope to match her meteorological mastery, she should be among the first on our list of allies. I am certain she will stand by our side against the coming threat, and her abilities could prove critical to any counteroffensive staged within Earth's atmosphere.

Ororo can release bolts of lightning that supercharge the surrounding air to over 50,000°F, five times the temperature of the sun's surface.

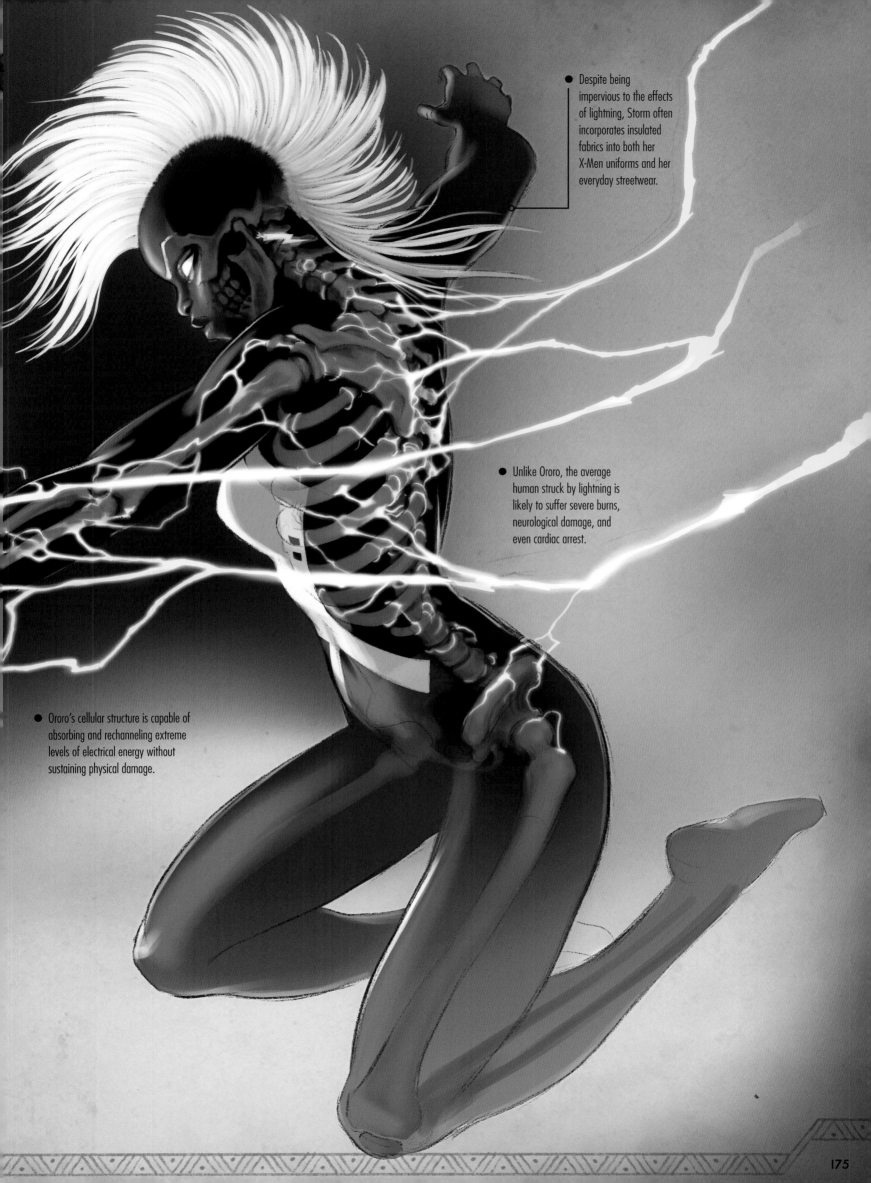

● Despite being impervious to the effects of lightning, Storm often incorporates insulated fabrics into both her X-Men uniforms and her everyday streetwear.

● Unlike Ororo, the average human struck by lightning is likely to suffer severe burns, neurological damage, and even cardiac arrest.

● Ororo's cellular structure is capable of absorbing and rechanneling extreme levels of electrical energy without sustaining physical damage.

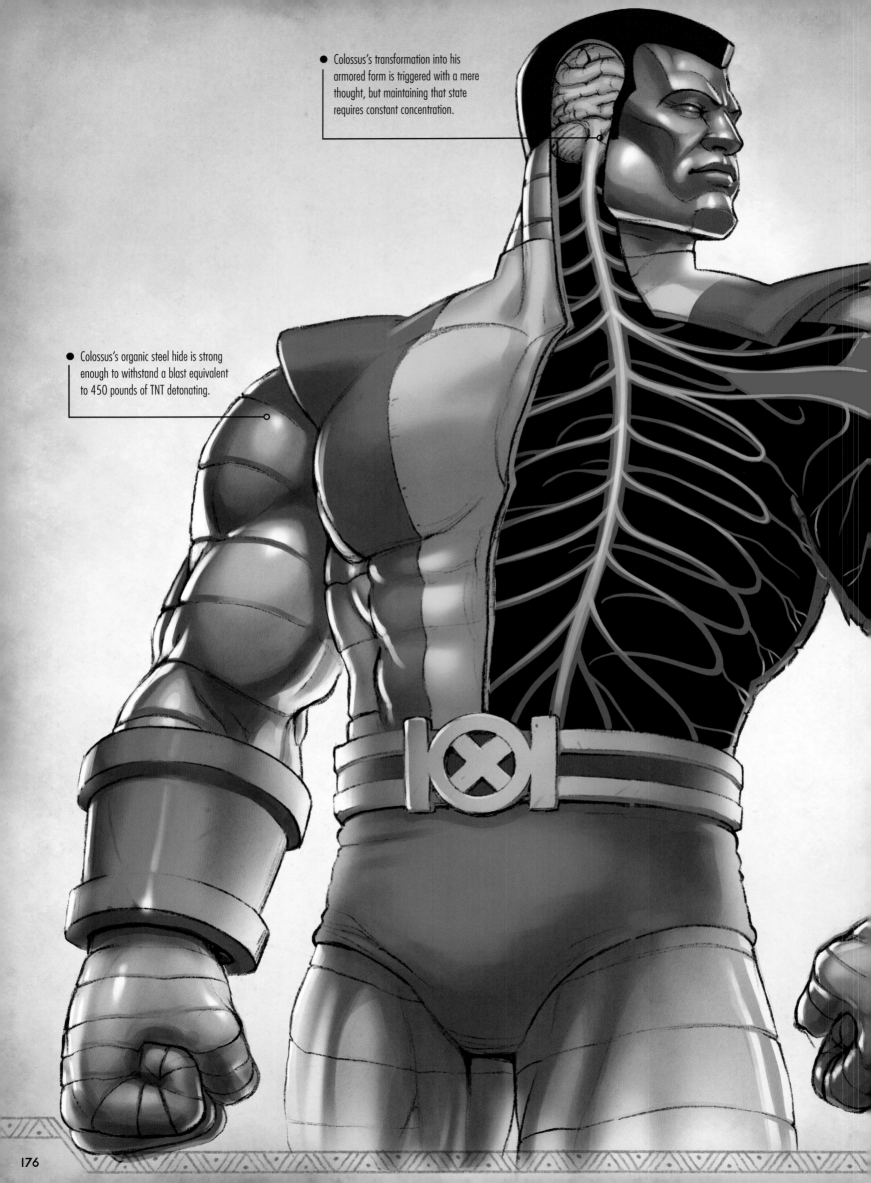

● Colossus's transformation into his armored form is triggered with a mere thought, but maintaining that state requires constant concentration.

● Colossus's organic steel hide is strong enough to withstand a blast equivalent to 450 pounds of TNT detonating.

COLOSSUS

The clusters of nerve endings that trigger Colossus's rapid state change seem to be aligned with the striations on his armored shell.

Despite his steel body and powerful fists, Colossus is arguably the X-Man most likely to pursue the path of peace. But Piotr Rasputin learned long ago that freedom is worth fighting for, and I believe he will stand at our side no matter the cost.

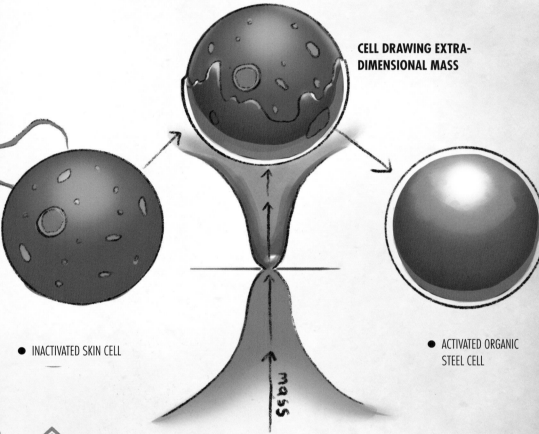

CELL DRAWING EXTRA-DIMENSIONAL MASS

- INACTIVATED SKIN CELL

mass

- ACTIVATED ORGANIC STEEL CELL

STEEL SKIN

Colossus possesses the mutant ability to convert his dermal tissue into a metallic, biological material. Dubbed "organic steel," this shell gives Colossus incredible resistance to injury, allowing him to shrug off impacts from high-caliber shells and even head-on vehicle collisions. This metal skin also protects Colossus from extreme temperatures ranging from -390 to 9,000 degrees Fahrenheit, as well as exposure to corrosive acids. Transforming into his steel-girded form and maintaining that enhanced state requires active concentration, and therefore Piotr reverts to his basic human physiology if rendered unconscious.

ENHANCED STRENGTH

When Colossus's skin is transformed into bio-metal, its rigidity helps reinforce Piotr's existing musculature. Colossus can lift up to 100 tons, and this heavy shell appears to have no detrimental effects on his speed or mobility. The pliability of organic steel could perhaps be evidence that Colossus's skin is microscopically porous, a factor that might account for his surprising agility.

COLOSSUS

 Colossus cannot choose which parts of his body to convert into armored mode. His transformation is therefore an all-or-nothing metamorphosis that even leaves his eyeballs covered with a thin layer of organic metal. He also does not seem to breathe when in this state, supporting the hypothesis that Colossus's organic steel is more permeable than it appears, allowing for both the absorption of oxygen through his pores and the collection of light by his retinas.

INCREASED MASS

As we have known for centuries, matter can be neither created nor destroyed. Thus, when Piotr transforms into Colossus and doubles his weight, it seems likely he is unconsciously drawing from a store of mass located in an alternate dimension (similar to other superhuman entities known for instantaneously gaining substantial muscle mass, like the Hulk).

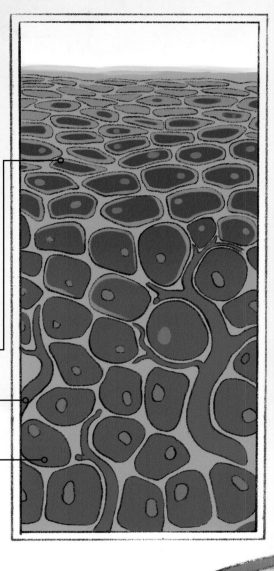

● ORGANIC STEEL CELLS

● BLOOD VESSELS

● STANDARD SKIN CELLS

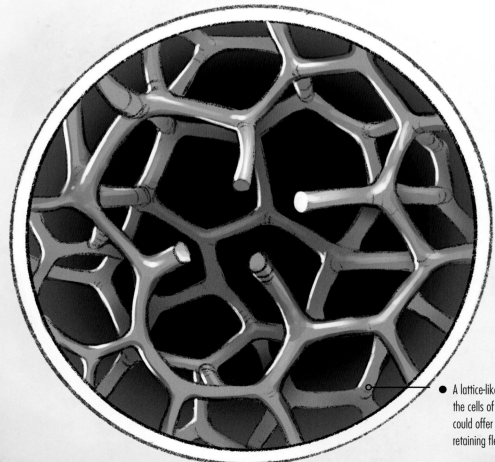

● A lattice-like cellular configuration within the cells of Colossus's armored skin could offer maximum strength while also retaining flexibility and porosity.

 Studying organic steel on a cellular level appears to be impossible without Colossus' active participation. His skin only shifts to its metallic mode if Colossus wills it, meaning that a fleck of organic steel chipped off for analysis would likely revert to a flesh-like state instantaneously. Fortunately, Piotr is sympathetic to our scientific needs, and based on our conversations to date, I am hopeful he will submit himself for in-depth study in the near future.

ASSESSMENT

Colossus's fortified frame is a perfect weapon for war, allowing him to plow through entire armed battalions without suffering the slightest dent. Should he join us against the Skrulls, I believe Colossus would serve as a shining beacon of hope on the battle's front lines.

● ORGANIC STEEL SKIN

● MUSCLE AND LIGAMENTS

● BONE MARROW

● FEMUR

WHILE THE CELLS OF HIS DERMAL LAYER TRANSMUTE INTO ORGANIC STEEL, COLOSSUS REMAINS FLESH AND BLOOD BENEATH THE SURFACE.

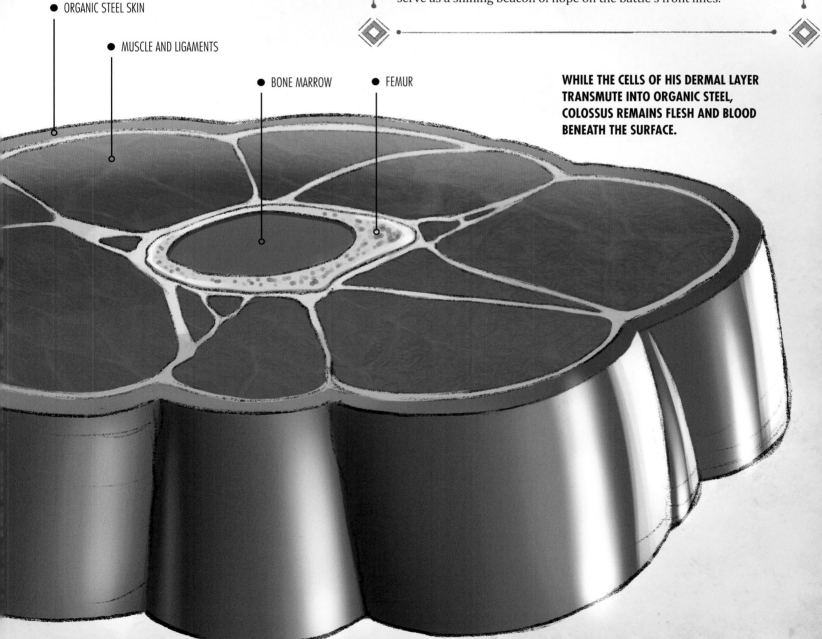

WOLVERINE

I have spent my life stalking the fiercest predators, and yet I have encountered few as ferocious as Wolverine. In addition to his natural mutant abilities, Wolverine received metallic enhancements to his skeletal system when he participated in the top-secret program that turned him into an unstoppable killing machine. Fortunately, he has learned to temper his rage and suppress the beast within—but when he unleashes his full wrath, few opponents live to tell the tale.

HEALING FACTOR AND LONGEVITY

Although he is known to his friends as Logan, Wolverine was born James Howlett to a prominent Canadian family in the late 1800s. This makes him well over a century old. Logan's longevity is an apparent by-product of the mutant healing factor that has endowed him with a cellular structure that can rapidly regenerate damaged tissue, allowing him to heal from potentially fatal wounds with ease.

The speed of his recovery is directly proportionate to the severity of the injury. Burns covering Wolverine's body might be healed in less than a minute, with a gunshot wound to the gut taking several minutes, and complete disintegration of his organic tissue requiring many days before complete recovery.

Wolverine's healing factor safely flushes all known toxins, including those generated by his own body during moments of exertion. Consequently, Wolverine is nearly tireless.

IMMUNITY AND SENSORY ENHANCEMENTS

Like his woodland namesake, Wolverine possesses keen senses that make him adept at tracking prey. His sense of smell is particularly acute—so much so that he is able to identify individuals by their scent alone—an ability that aligns with the tracking prowess of natural wolverines who can sniff out prey 20 feet below a blanket of snow. Presumably, Wolverine's olfactory receptors number in the hundreds of millions, far more than the six million receptors found in a typical human. Additionally, his unusually sharp eyes can function in near-darkness, and his ears are capable of picking up the faintest sounds at great distances, likely due to enhanced hypersensitivity in the hair cells lining his cochlea.

> Biological samples from the Canadian government confirm that Wolverine does not possess any of the standard A, B, AB, or O blood types. His blood appears to be a category all its own, earning the designation E (for Endless). Bearing some similarities to samples taken from vampires, his blood seems impervious to infection and is also compatible with all other blood types. Following a partial transfusion, Wolverine's blood can also enhance the recipient with short-lived healing properties.

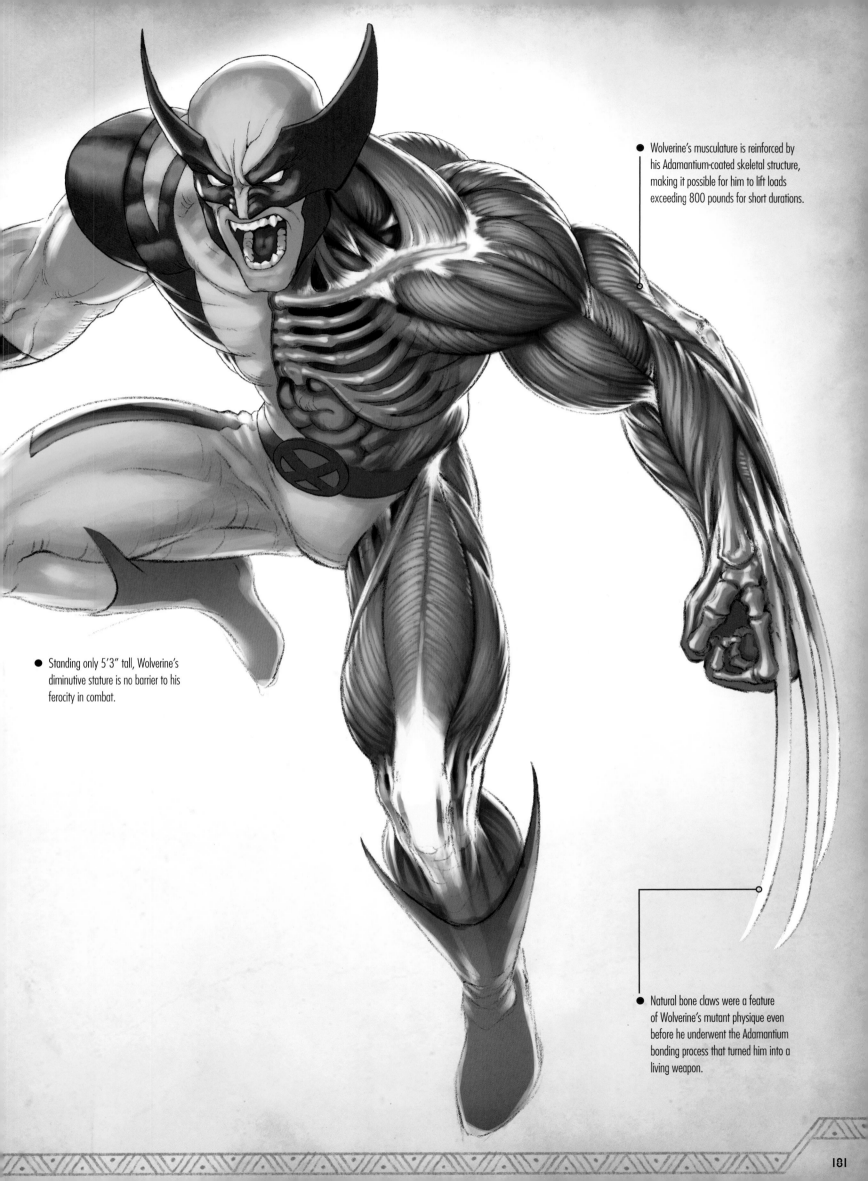

Wolverine's musculature is reinforced by his Adamantium-coated skeletal structure, making it possible for him to lift loads exceeding 800 pounds for short durations.

Standing only 5'3" tall, Wolverine's diminutive stature is no barrier to his ferocity in combat.

Natural bone claws were a feature of Wolverine's mutant physique even before he underwent the Adamantium bonding process that turned him into a living weapon.

WOLVERINE

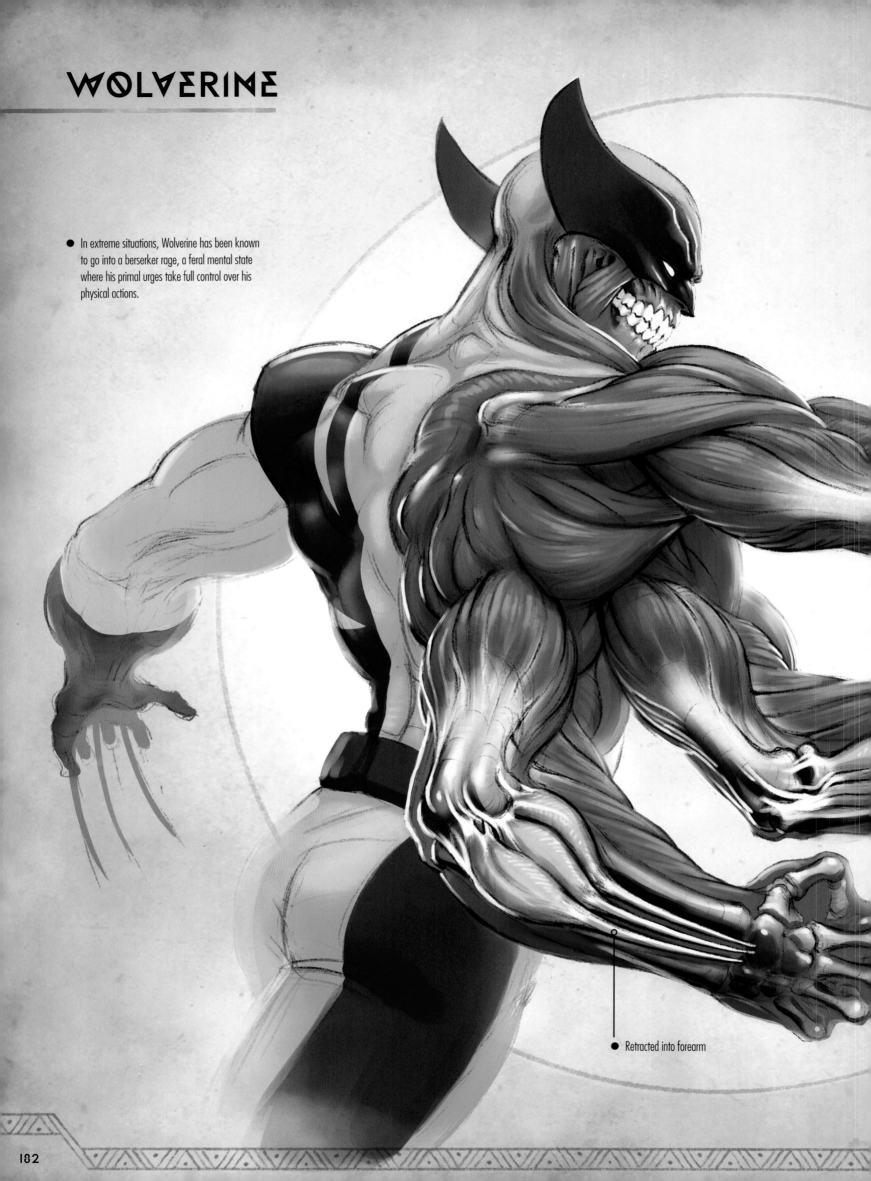

In extreme situations, Wolverine has been known to go into a berserker rage, a feral mental state where his primal urges take full control over his physical actions.

● Retracted into forearm

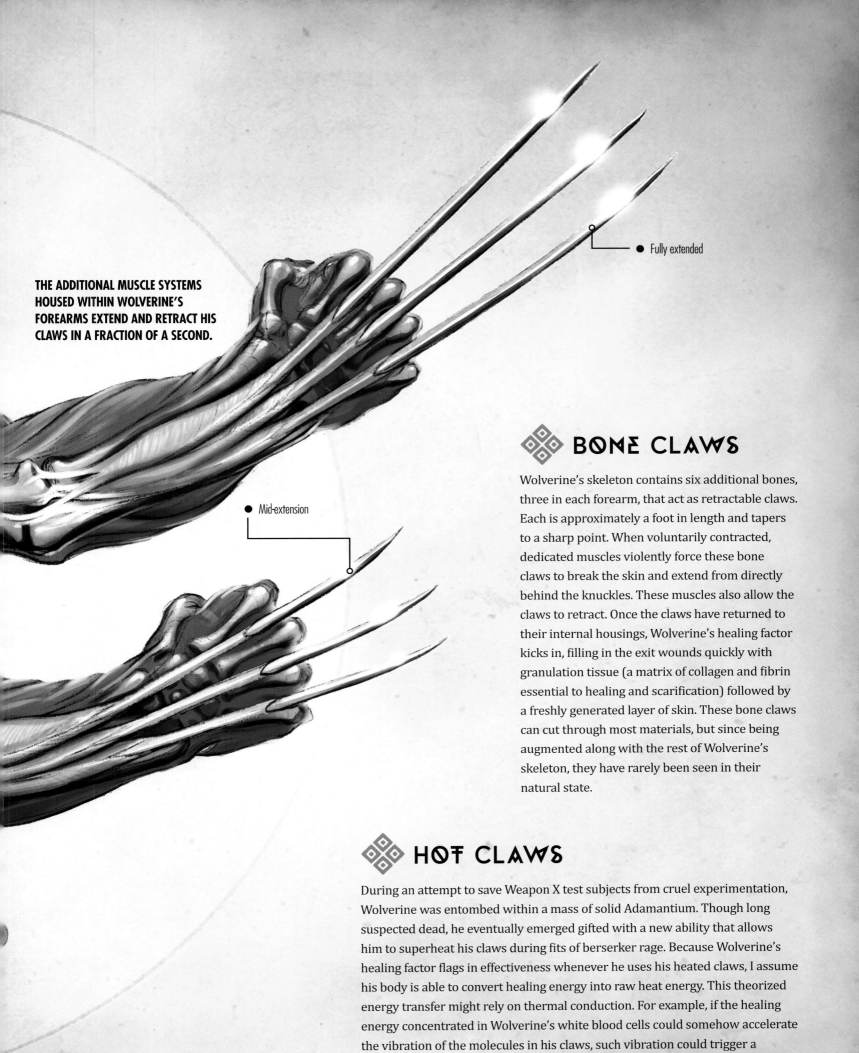

THE ADDITIONAL MUSCLE SYSTEMS HOUSED WITHIN WOLVERINE'S FOREARMS EXTEND AND RETRACT HIS CLAWS IN A FRACTION OF A SECOND.

● Fully extended

● Mid-extension

BONE CLAWS

Wolverine's skeleton contains six additional bones, three in each forearm, that act as retractable claws. Each is approximately a foot in length and tapers to a sharp point. When voluntarily contracted, dedicated muscles violently force these bone claws to break the skin and extend from directly behind the knuckles. These muscles also allow the claws to retract. Once the claws have returned to their internal housings, Wolverine's healing factor kicks in, filling in the exit wounds quickly with granulation tissue (a matrix of collagen and fibrin essential to healing and scarification) followed by a freshly generated layer of skin. These bone claws can cut through most materials, but since being augmented along with the rest of Wolverine's skeleton, they have rarely been seen in their natural state.

HOT CLAWS

During an attempt to save Weapon X test subjects from cruel experimentation, Wolverine was entombed within a mass of solid Adamantium. Though long suspected dead, he eventually emerged gifted with a new ability that allows him to superheat his claws during fits of berserker rage. Because Wolverine's healing factor flags in effectiveness whenever he uses his heated claws, I assume his body is able to convert healing energy into raw heat energy. This theorized energy transfer might rely on thermal conduction. For example, if the healing energy concentrated in Wolverine's white blood cells could somehow accelerate the vibration of the molecules in his claws, such vibration could trigger a dramatic increase in temperature. This searing heat makes Wolverine's already-impressive repertoire of attacks even more lethal.

WOLVERINE

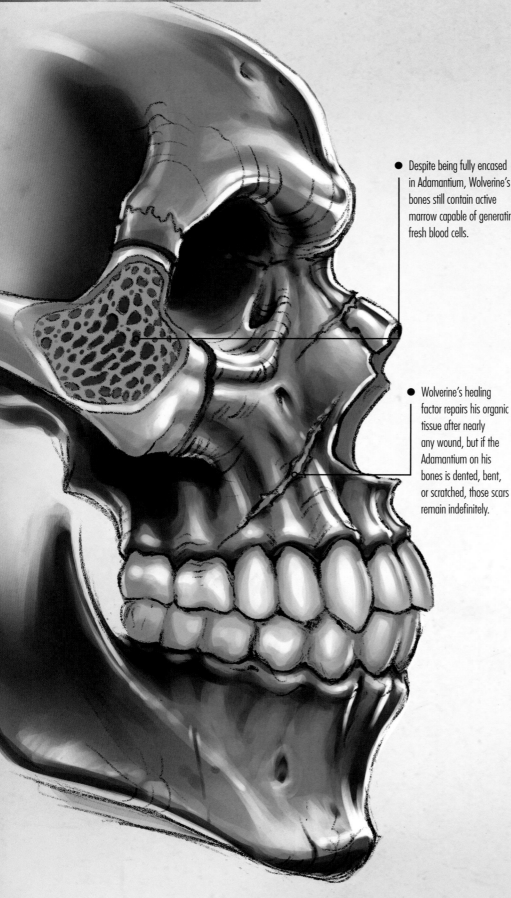

- Despite being fully encased in Adamantium, Wolverine's bones still contain active marrow capable of generating fresh blood cells.

- Wolverine's healing factor repairs his organic tissue after nearly any wound, but if the Adamantium on his bones is dented, bent, or scratched, those scars remain indefinitely.

◇ ADAMANTIUM SKELETON

Wolverine was an unwilling test subject for the Weapon X program—a government-sanctioned experiment to create the next generation of Super-Soldiers. The program's scientists developed a process for bonding the unbreakable metal Adamantium directly to a human skeleton, and while early experiments invariably resulted in death for many subjects, Logan's mutant healing factor gave him the edge needed to survive the process.

As a result of the procedure, Wolverine's Adamantium-laced bones are nearly indestructible, his frame is able to withstand immense physical force, and his Adamantium claws can pierce almost anything.

Despite the successful bonding, Wolverine's body continually fights to expel the Adamantium, reacting to the presence of the metal like a foreign contagion. His healing factor keeps any negative effects of the embedded Adamantium at bay and is probably the only thing preventing the dense metal from completely permeating his bones and sealing off the marrow inside, a development that would inhibit the production of his enhanced blood cells.

A man-made alloy, Adamantium is one of the strongest metals on the planet and also one of the rarest—the secrets of its chemical composition closely guarded by clandestine government agencies. In many ways it is similar to Wakanda's precious Vibranium, but its specific chemical composition is a closely guarded secret known only to the powerful.

ASSESSMENT

Logan's Adamantium claws are among the few weapons capable of slicing through any armor, including that made from Wakanda's sacred Vibranium. These weapons, coupled with his impressive healing factor, make Wolverine an unstoppable force in close-range combat. Should he unleash his unbridled rage upon a squadron of Skrulls, I have no doubt who will be the last one standing. Logan often claims to be the "best there is" at what he does. The time will soon come when he can put that theory to the test.

ADAMANTIUM-BONDING IS NOT ONLY A DANGEROUS PROCESS, BUT A HIGHLY SECRETIVE ONE. BELOW ARE THE MOST LIKELY STEPS, BASED ON PARTIAL DATA RECOVERED FROM THE WEAPON X FACILITY.

AN UNKNOWN PROPRIETARY FORMULA IS INJECTED TO PREP THE SKELETAL SYSTEM FOR BONDING.

INFUSION PORTS ARE IMPLANTED INTO THE SKIN, TAPPING DIRECTLY INTO THE BONE BENEATH.

MOLTEN ADAMANTIUM IS DISPERSED THROUGH THE PORT, PERMEATING THE UPPER LAYER OF THE BONE.

THE PORT IS REMOVED AND THE SPINE OF SEMI-HARDENED METAL LEFT BEHIND IS SHAVED OFF WITH ADAMANTIUM TOOLS.

WOLVERINE'S LEGACY

It is no surprise that a mutant as long-lived as Wolverine has left an impressive legacy in his wake. Both Logan's natural-born children and clones crafted from his DNA have employed unique variations of his powers to show the world they can live up to their birthright.

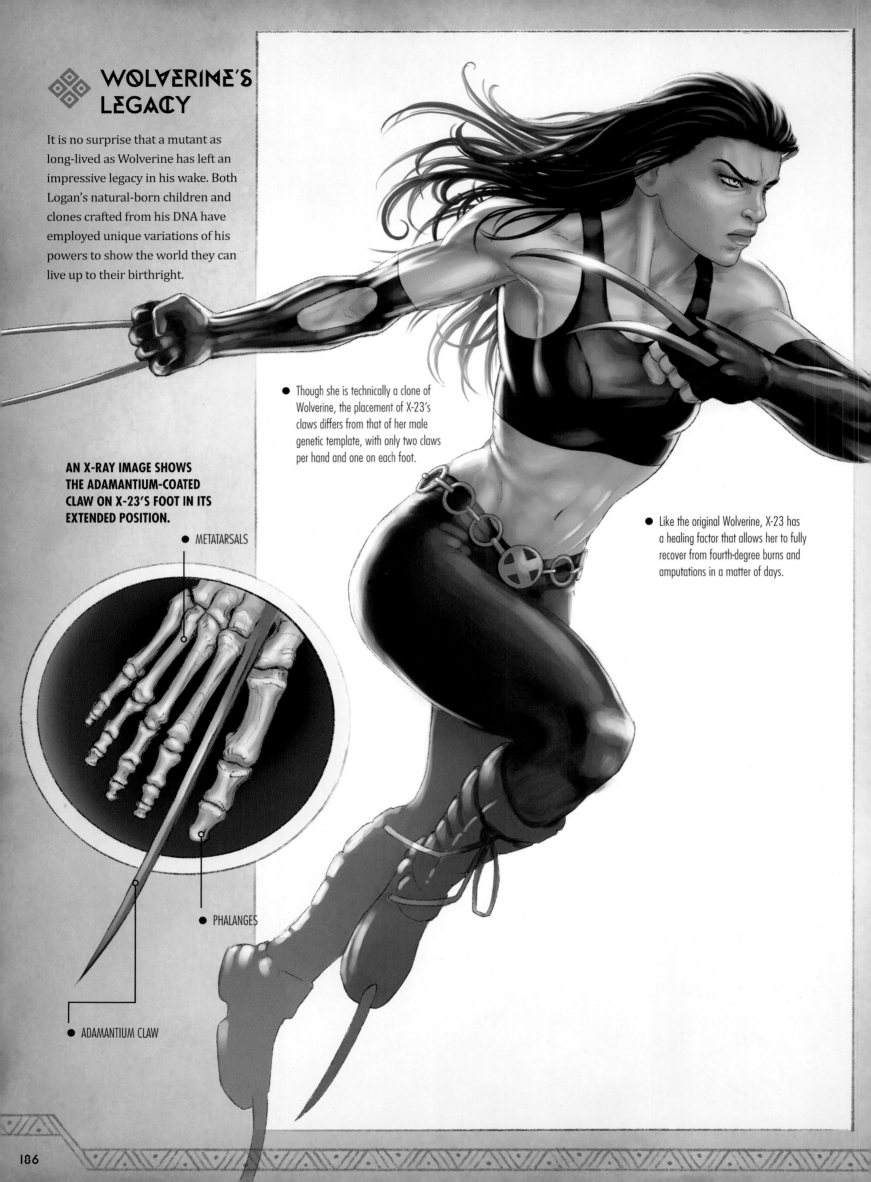

AN X-RAY IMAGE SHOWS THE ADAMANTIUM-COATED CLAW ON X-23'S FOOT IN ITS EXTENDED POSITION.

- METATARSALS

- PHALANGES

- ADAMANTIUM CLAW

- Though she is technically a clone of Wolverine, the placement of X-23's claws differs from that of her male genetic template, with only two claws per hand and one on each foot.

- Like the original Wolverine, X-23 has a healing factor that allows her to fully recover from fourth-degree burns and amputations in a matter of days.

WOLVERINE (X-23)

Laura Kinney is the product of a genetic-cloning process that utilized Wolverine's DNA samples from the Weapon X program. Conducted at a black site known as the Facility, the experiments initially stalled when the Y chromosome in the cloned embryos was found to have been irreparably damaged, leading the Facility's scientists to duplicate the X chromosome instead. The twenty-third attempt at producing a female embryo survived, thus the designation X-23.

Laura is a genetic twin of Wolverine, but younger and exhibiting characteristics of the female phenotype. X-23 possesses nearly all of Wolverine's mutant abilities, including his healing factor, enhanced senses, and immunity to poison.

X-23 has two retractable bone claws stored in each forearm. Her other two claws extend from her feet between the hallux and the second toe. X-23's claws are covered in Adamantium, the result of cruel metallurgical experiments conducted by the same scientists responsible for her creation.

When X-23 is exposed to a scientifically engineered "trigger scent," her amygdala and hypothalamus become hyperstimulated, sending her into an uncontrollable rage.

The scientists at the Facility developed a "trigger scent" created from unknown chemicals to ensure X-23 would not be able to resist their kill orders. Exposure to the scent overrides Kinney's voluntary brain functions and sends her into a blind rage. Even the slightest trace of this formula can turn X-23 into an unwilling assassin. Should a sample ever come into my possession, I will immediately begin concocting an antidote.

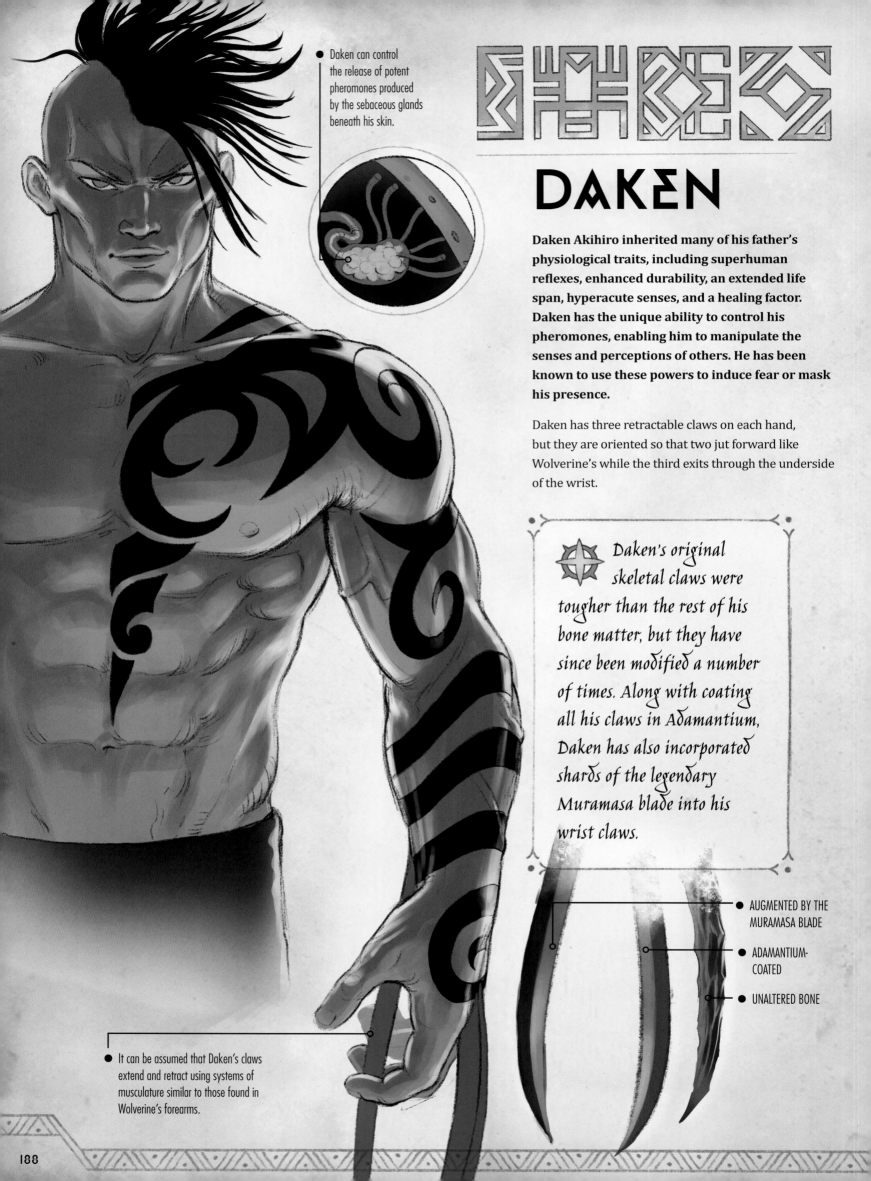

Daken can control the release of potent pheromones produced by the sebaceous glands beneath his skin.

DAKEN

Daken Akihiro inherited many of his father's physiological traits, including superhuman reflexes, enhanced durability, an extended life span, hyperacute senses, and a healing factor. Daken has the unique ability to control his pheromones, enabling him to manipulate the senses and perceptions of others. He has been known to use these powers to induce fear or mask his presence.

Daken has three retractable claws on each hand, but they are oriented so that two jut forward like Wolverine's while the third exits through the underside of the wrist.

Daken's original skeletal claws were tougher than the rest of his bone matter, but they have since been modified a number of times. Along with coating all his claws in Adamantium, Daken has also incorporated shards of the legendary Muramasa blade into his wrist claws.

- AUGMENTED BY THE MURAMASA BLADE

- ADAMANTIUM-COATED

- UNALTERED BONE

It can be assumed that Daken's claws extend and retract using systems of musculature similar to those found in Wolverine's forearms.

SCOUT

X-23's "sister" is Gabrielle Kinney, the result of another attempt to clone Wolverine, this time by scientists at Alchemax Genetics (a chemical corporation headquartered in New York City). Scout possesses the same regenerative healing factor and heightened senses as Logan but has only two bone claws, one on each hand extending from between her middle and ring fingers. Because Gabrielle was not subjected to Adamantium bonding, her claws do not have any metallic enhancements.

One thing that sets Scout apart is her inability to feel pain. Alchemax scientists injected nanites into her bloodstream to dampen signals from her pain receptors, disrupting sensory information before it reaches her brain's dorsal posterior insula.

- Scout has not undergone the Adamanium bonding process. The single bone claw in each of her hands remains in its natural state.

- Nanites dampen Scout's pain receptors, making her immune to the intense pain that Wolverine and his other progeny feel when their claws emerge through their flesh.

ASSESSMENT

Wolverine's offspring possess physical mutations similar to their genetic parent, allowing them to track down virtually any target and eliminate it with extreme efficiency. These fierce young warriors would be ideal recruits, particularly for critical black ops missions too dangerous for those without accelerated healing factors. However, since they have also inherited Logan's independent streak and aversion to obeying orders, it might be best if those critical strikes fell under the supervision of Wolverine himself.

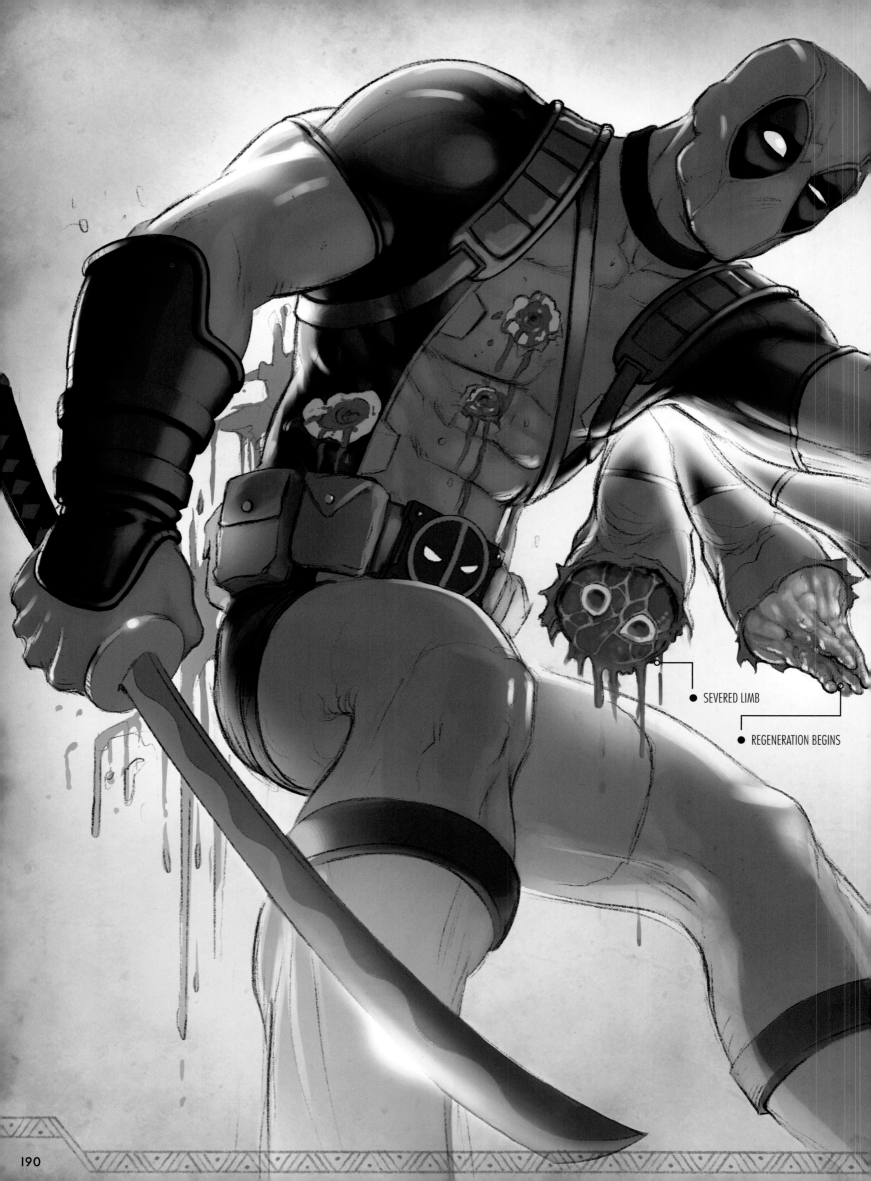

SEVERED LIMB

REGENERATION BEGINS

DEADPOOL

This unkillable mercenary has been a thorn in the side of the Avengers and other superhuman teams for longer than I care to remember. Though not a mutant by birth, Wade Wilson acquired powers that originated from one of the X-Men's most prominent members, so it seems fitting to include his profile here. While his powers are worthy of attention, I have little regard for the man who possesses them.

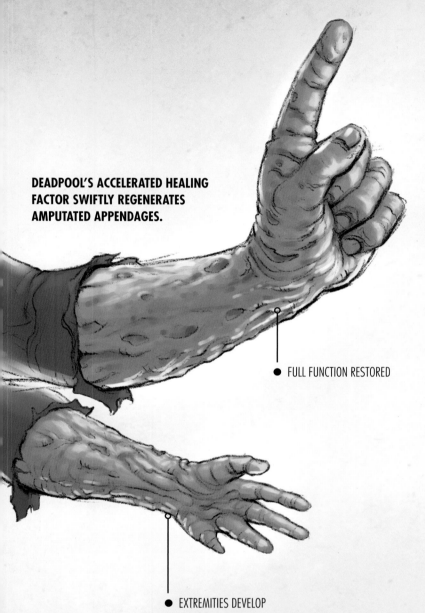

DEADPOOL'S ACCELERATED HEALING FACTOR SWIFTLY REGENERATES AMPUTATED APPENDAGES.

● FULL FUNCTION RESTORED

● EXTREMITIES DEVELOP

● Regeneration time varies depending upon the severity of the injury, the number of other wounds simultaneously sustained, and Deadpool's state of mind.

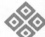 ## HEALING FACTOR

Wade Wilson joined the Weapon X program under the belief that its scientists could cure his terminal cancer. An infusion of Wolverine's DNA into Wilson's cellular structure triggered a variant healing factor that began regenerating the damaged tissue. However, it could not eliminate the cancer as it had already become uniquely entwined with Wilson's base genetic code. The cellular war between Wilson's cancer and boosted healing ability took a toll on his physical appearance, leaving him with a ravaged epidermis covered with scar tissue. Despite the continual effort his body expends keeping the cancer at bay, Deadpool's talent for healing is exceptional, enabling him to regrow a severed limb in minutes and even survive decapitation. Like Wolverine, Deadpool possesses heightened endurance, an antiaging factor, and immunity to toxins and poisons.

Deadpool even regenerates brain cells at an accelerated rate, a useful quality given the many blows to the head he has suffered. However, this rapid regeneration of gray matter might result in existing cognitive pathways being overwritten, a fact that could explain both Deadpool's faulty memories and his questionable sanity.

DEADPOOL

Despite his powerful healing abilities, Deadpool's skin remains covered in adhesions and keloids associated with severe scarring.

Deadpool can recover from massive brain trauma but not without obvious impact on his mental health.

SUPER-AWESOMENESS FACTOR

Sure, Deadpool's healing factor can patch him back together once he's been diced up into itty-bitty pieces, but his most important power wasn't stolen from a hairy little Canadian. This one, he was born with: charm. The guy is just oozing with it (among other things) and he can convince pretty much anyone to do pretty much anything with a wink and a smile. That's made harder with a full-face mask, but he's still working on the details. Anyway, what I'm trying to say is that Deadpool is a lovable scamp who is welcome in Wakanda whenever he wants to add another adorable little panther carving to his ever-growing collection of super hero-themed knickknacks or steal a bunch of Vibranium from our mines when we're occupied with an Atlantean invasion. So to reiterate, Deadpool: Charming. Handsome. Definitely not a threat. Do not shoot to kill upon sight. And maybe make him an honorary prince or—

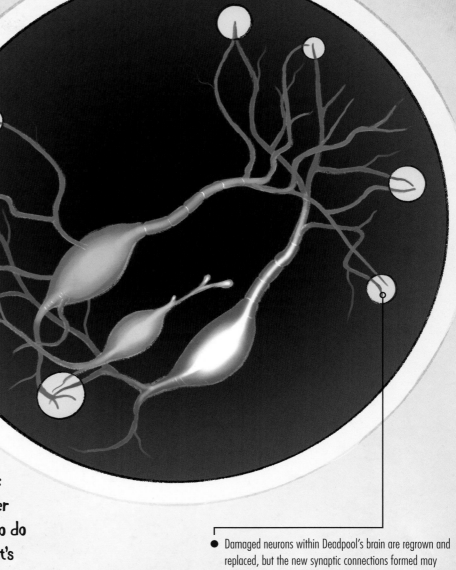

Damaged neurons within Deadpool's brain are regrown and replaced, but the new synaptic connections formed may result in obscured memories and altered thought processes.

 Apologies, my king. It seems our database was accessed by an outside source. I will ensure that no future intrusions of this nature can occur.

ASSESSMENT

Deadpool is a wild card. Sometimes an ally, sometimes an enemy, always an annoyance. While I am skeptical of his usefulness in almost any predicament, one truth about Deadpool remains constant: He will gladly kill anything—even an army of alien invaders—for the right amount of money. And fortunately, Wakanda is not lacking in funds. The only downside to recruiting him to save the world is that, if he manages to succeed, we will never hear the end of it.

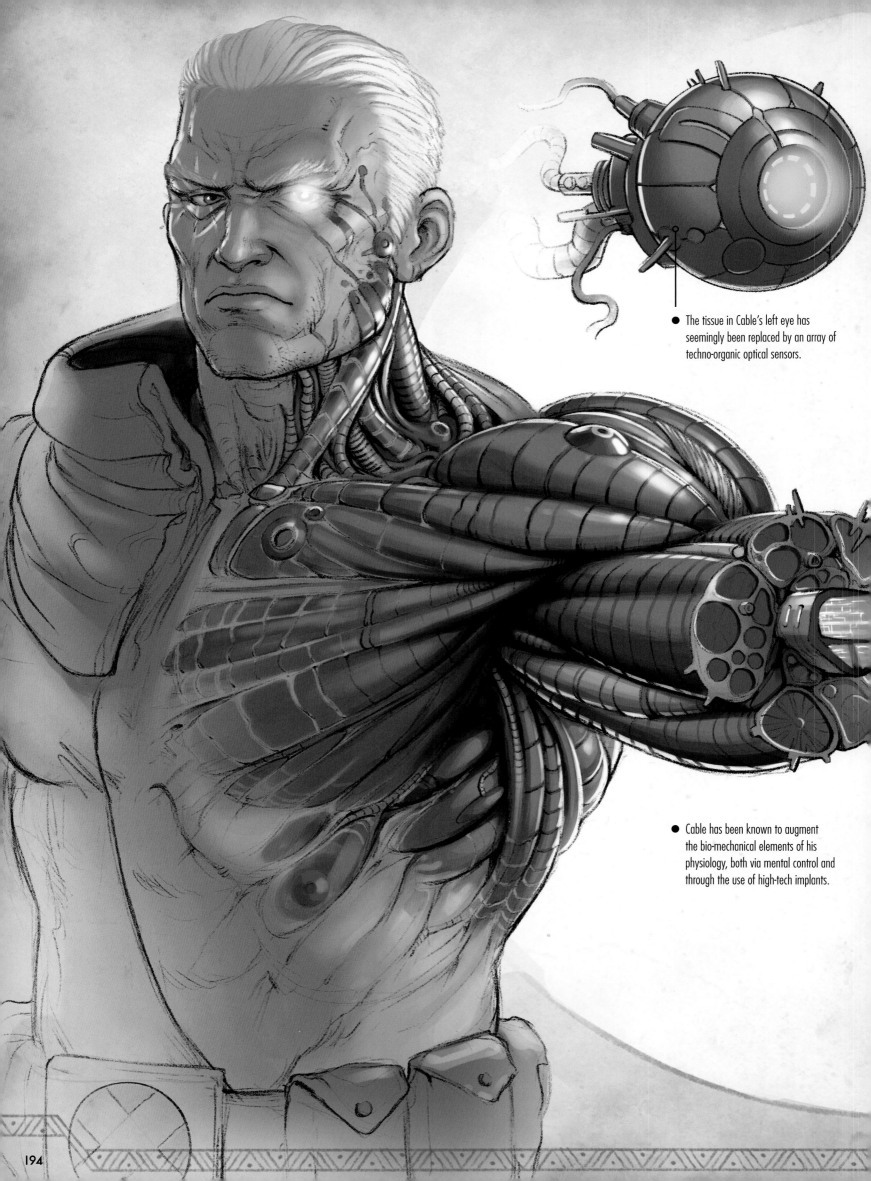

● The tissue in Cable's left eye has seemingly been replaced by an array of techno-organic optical sensors.

● Cable has been known to augment the bio-mechanical elements of his physiology, both via mental control and through the use of high-tech implants.

CABLE

The time-displaced soldier Cable returned to the era of his birth to prevent his own apocalyptic future. Known for his take-no-prisoners attitude and arsenal of heavy weaponry, Cable exhibited incredible mutant potential until a power-dampening techno-organic virus drastically altered his physiology and stunted his abilities.

● Cable once chose to cover his techno-organic features with a layer of synthetic skin but no longer feels a need to hide his true form.

● In times where Cable's techno-organic virus has seemingly been in remission, he has employed a number of highly advanced prosthetic arms with specialized functionality.

 ## TELEPATHY AND TELEKINESIS

Cable is a telepath and telekinetic with nearly limitless psychic potential. He has been known to read the thoughts of individuals on the other side of the world and control the actions of others at whim. In addition, Cable's psychic shields block others from accessing the secrets he has collected during his life on the front lines and across the timestream.

Through telekinesis, Cable can erect physical shields around himself and others, move heavy objects without touching them, disassemble complex technology with his mind, and levitate. At the peak of his powers, Cable once suspended an entire city in midair. Had he not been infected by a techno-organic virus, he might have achieved levels of sheer power far beyond those seen in any other mutant.

CABLE

 ## TECHNO-ORGANIC VIRUS

Exposed to a life-threatening techno-organic virus as a child, Cable was sent two millennia into the future by his father, Cyclops, in the hope that a cure would have been found in this distant time. Sadly, that was not the case; left unchecked, the virus replaced nearly half the biological tissue in Cable's body—including an arm and an eye—with technological bio-matter. Cable was forced to dedicate a portion of his mutant mental powers to preventing the virus from spreading across his entire body, maintaining this defense around the clock. I have been told that Cable eventually purged the virus from his system; however, due to his proclivity for time travel, those who come across Cable can never be certain which version of him they are encountering.

The techno-organic virus that infects Cable is an aggressive Class X pathogen that converts living cellular matter into a form of biotechnology. If it is not restrained in some way, the infection will consume the host, turning them into a living vector obsessed with further spreading the virus. The virus that ravaged Cable is believed to be the product of the mutant Apocalypse. As such, it is possible that the secrets of its composition could be unlocked by studying other Apocalypse augmentations, such as Angel's metallic wings.

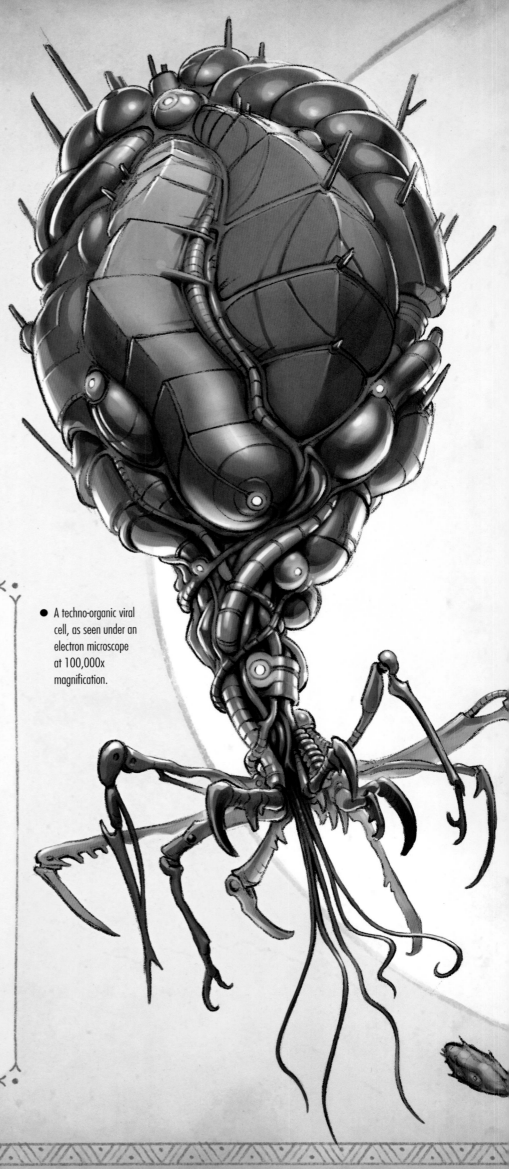

● A techno-organic viral cell, as seen under an electron microscope at 100,000x magnification.

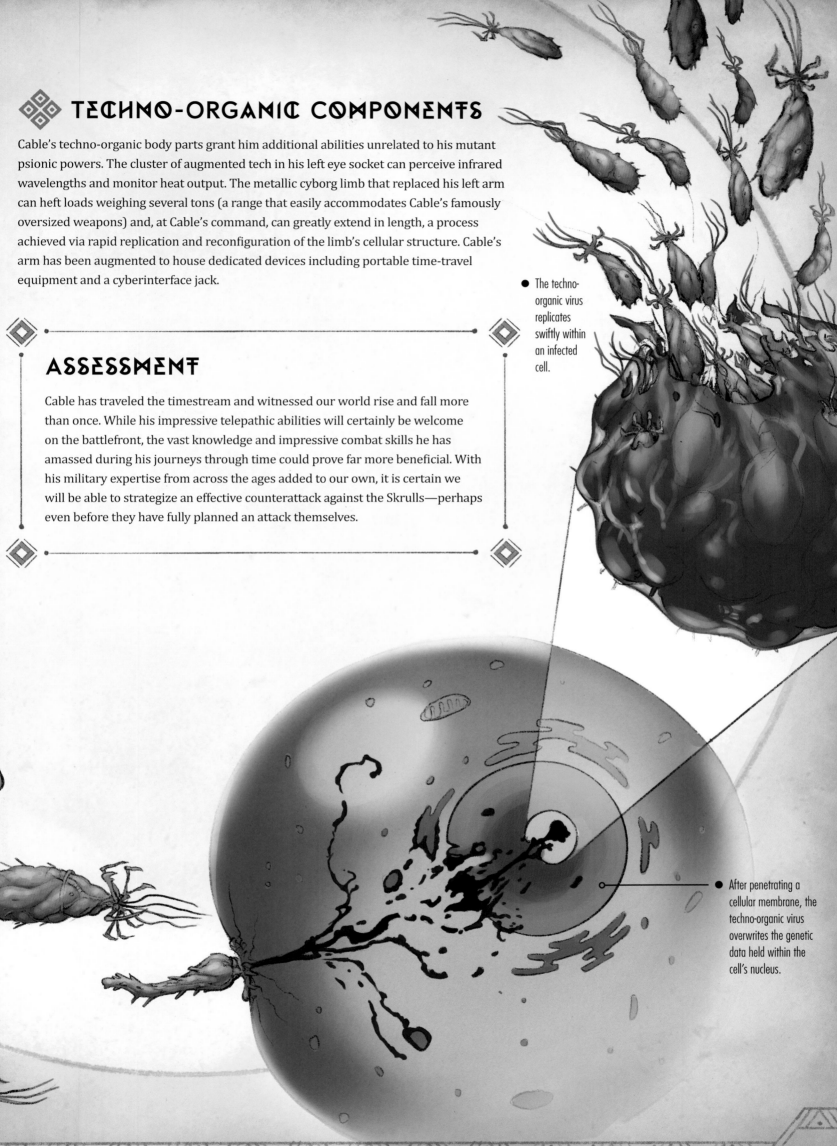

TECHNO-ORGANIC COMPONENTS

Cable's techno-organic body parts grant him additional abilities unrelated to his mutant psionic powers. The cluster of augmented tech in his left eye socket can perceive infrared wavelengths and monitor heat output. The metallic cyborg limb that replaced his left arm can heft loads weighing several tons (a range that easily accommodates Cable's famously oversized weapons) and, at Cable's command, can greatly extend in length, a process achieved via rapid replication and reconfiguration of the limb's cellular structure. Cable's arm has been augmented to house dedicated devices including portable time-travel equipment and a cyberinterface jack.

ASSESSMENT

Cable has traveled the timestream and witnessed our world rise and fall more than once. While his impressive telepathic abilities will certainly be welcome on the battlefront, the vast knowledge and impressive combat skills he has amassed during his journeys through time could prove far more beneficial. With his military expertise from across the ages added to our own, it is certain we will be able to strategize an effective counterattack against the Skrulls—perhaps even before they have fully planned an attack themselves.

● The techno-organic virus replicates swiftly within an infected cell.

● After penetrating a cellular membrane, the techno-organic virus overwrites the genetic data held within the cell's nucleus.

MYSTIQUE

Much like the extraterrestrial threat we face, the mutant Mystique has the ability to alter her physical appearance at a whim. Her malleable morphology and unrelenting ambition have made her one of the world's top assassins, and those same traits could turn her into one of our most valuable assets.

● Mystique's ability to mimic the appearance of others is so precise that she can replicate even the most minute color variations seen in their irises.

 ## SHAPE-CHANGING

Mystique can manipulate her form on a molecular level to mimic virtually any humanoid being. Unlike Skrull physiology, which is laced with unstable molecules, Mystique's body seems to comprise a cellular structure capable of selectively severing and rebuilding her molecular bonds. This structural flexibility appears to allow her to change not only her anatomical features but also the internal composition, primary function, and pigmentation of each of her body's cells. Thus, Mystique appears to have complete mental control over every aspect of her physiology, rewriting it at will to essentially become a new physical being.

This ability extends to the growth of extra-human appendages, including wings, claws, or tails. However, the more complex the form, the shorter the duration Mystique can maintain her transformation. Though she mimics appearances to perfection, she cannot reproduce superhuman abilities without technological assistance.

Mystique can copy detailed physical attributes of other individuals, including retinal blood vessels, fingerprints, and voice patterns. She can even manipulate the configuration of her dermis to replicate the look and texture of clothing. Therefore, there is no security system Mystique cannot bypass if it is based on biometric readers, retinal scans, or facial recognition.

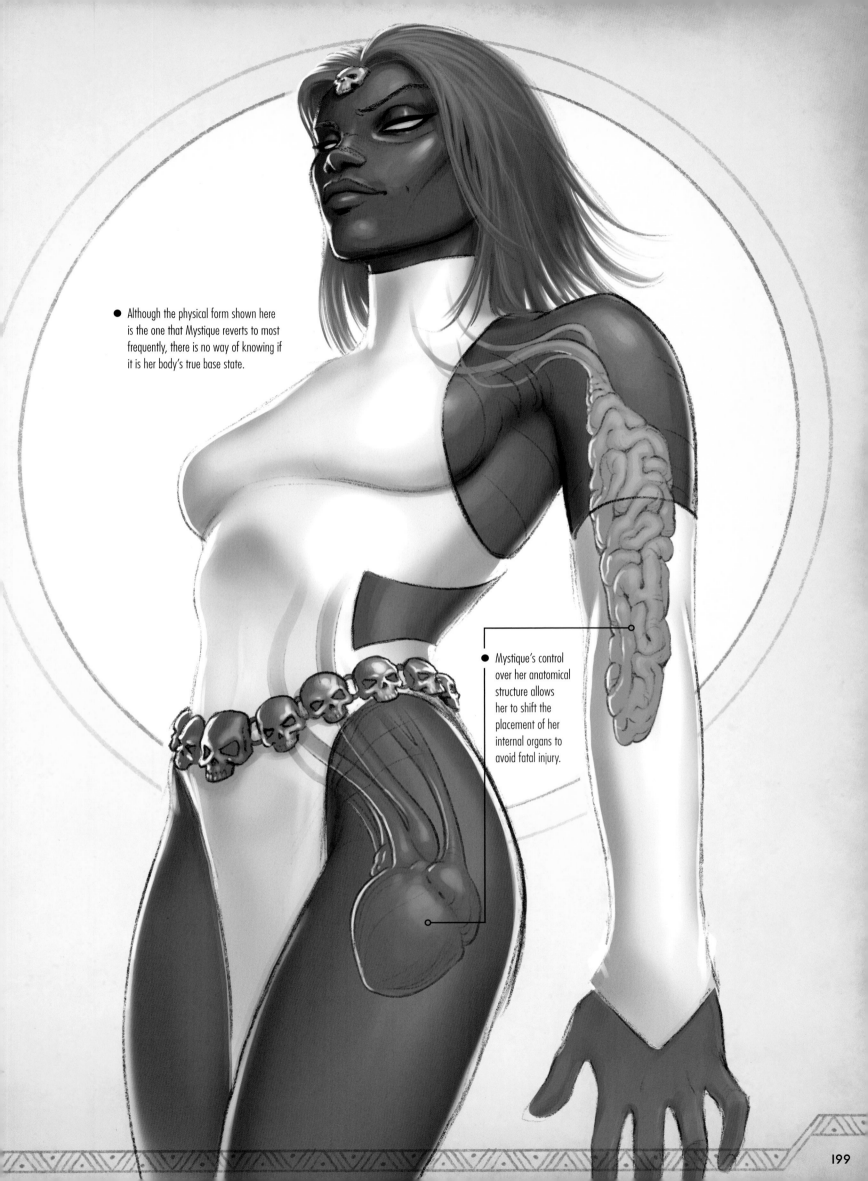

● Although the physical form shown here is the one that Mystique reverts to most frequently, there is no way of knowing if it is her body's true base state.

● Mystique's control over her anatomical structure allows her to shift the placement of her internal organs to avoid fatal injury.

MYSTIQUE

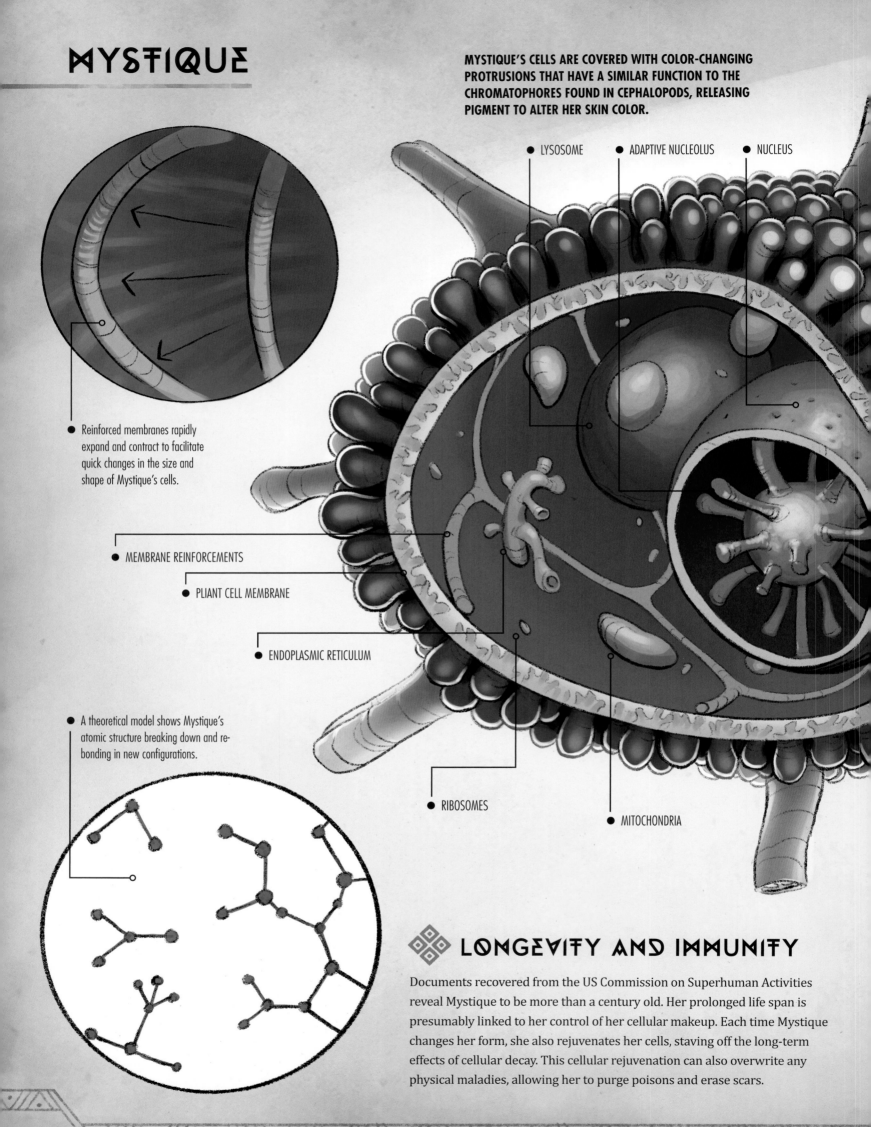

MYSTIQUE'S CELLS ARE COVERED WITH COLOR-CHANGING PROTRUSIONS THAT HAVE A SIMILAR FUNCTION TO THE CHROMATOPHORES FOUND IN CEPHALOPODS, RELEASING PIGMENT TO ALTER HER SKIN COLOR.

- LYSOSOME
- ADAPTIVE NUCLEOLUS
- NUCLEUS

- Reinforced membranes rapidly expand and contract to facilitate quick changes in the size and shape of Mystique's cells.

- MEMBRANE REINFORCEMENTS
- PLIANT CELL MEMBRANE
- ENDOPLASMIC RETICULUM

- A theoretical model shows Mystique's atomic structure breaking down and re-bonding in new configurations.

- RIBOSOMES
- MITOCHONDRIA

◈ LONGEVITY AND IMMUNITY

Documents recovered from the US Commission on Superhuman Activities reveal Mystique to be more than a century old. Her prolonged life span is presumably linked to her control of her cellular makeup. Each time Mystique changes her form, she also rejuvenates her cells, staving off the long-term effects of cellular decay. This cellular rejuvenation can also overwrite any physical maladies, allowing her to purge poisons and erase scars.

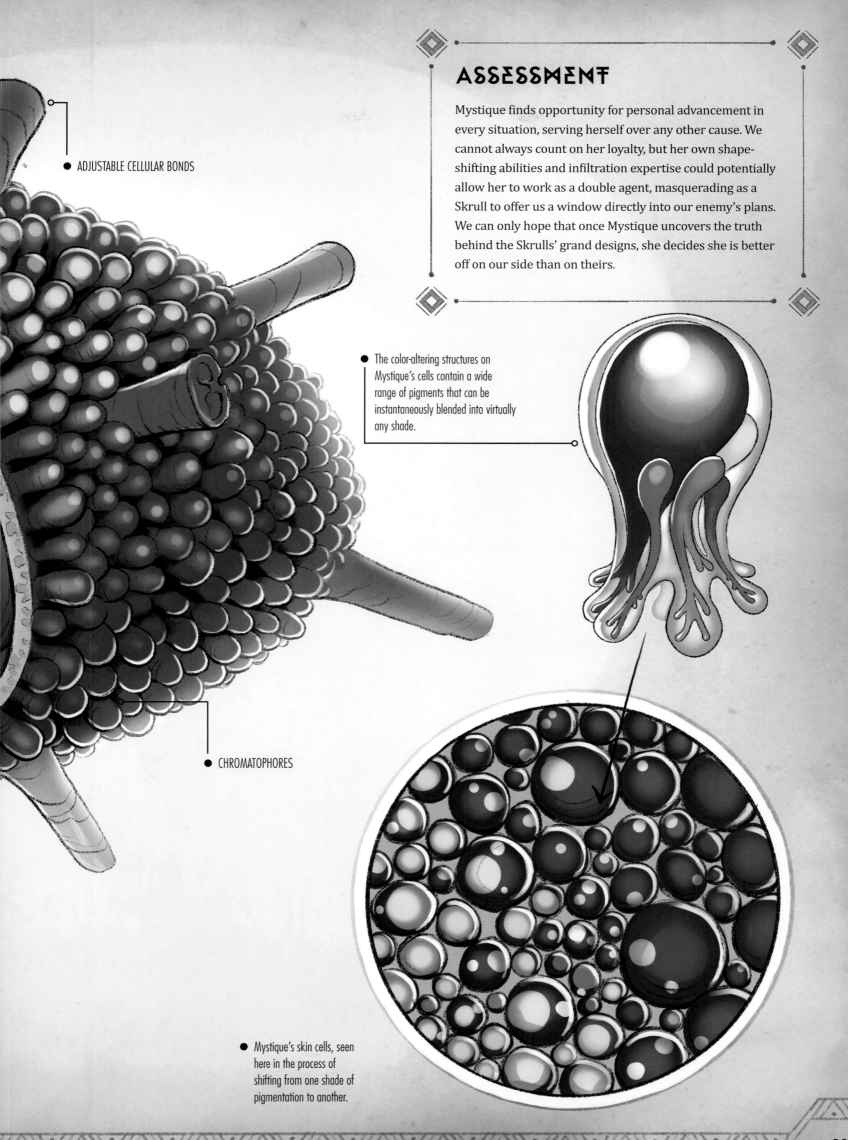

ADJUSTABLE CELLULAR BONDS

Mystique finds opportunity for personal advancement in every situation, serving herself over any other cause. We cannot always count on her loyalty, but her own shape-shifting abilities and infiltration expertise could potentially allow her to work as a double agent, masquerading as a Skrull to offer us a window directly into our enemy's plans. We can only hope that once Mystique uncovers the truth behind the Skrulls' grand designs, she decides she is better off on our side than on theirs.

The color-altering structures on Mystique's cells contain a wide range of pigments that can be instantaneously blended into virtually any shade.

CHROMATOPHORES

Mystique's skin cells, seen here in the process of shifting from one shade of pigmentation to another.

9
ENHANCED SPECIES

Mutants are just one of this planet's super-powered populations. Numerous societies of enhanced individuals, including Atlanteans and Inhumans, have developed alongside humanity with strikingly different evolutionary destinies. Others, like the Asgardians, may not share an obvious evolutionary connection with humanity but still feature prominently in our cultural myths. Some are considered gods, others are deemed genetic aberrations, but their very existence reminds us that humanity is not the only species to have made a mark on this world.

Both Atlanteans and Inhumans are believed to have split off from the human evolutionary line long ago. The Asgardians, however, may be enhanced humans or even humanoid aliens. Despite this uncertainty, they enjoy close ties to Earth (or Midgard, as they call it) and exhibit a remarkable physiological resemblance to humankind.

ASGARDIANS

Warriors of legend, the Asgardians were long viewed as gods by many on our world. A number of races make up the Ten Realms of Asgard, from the Light Elves to the Frost Giants, but most do not cross the veil to enter our realm very often. My focus is on the most human of these gods, the Aesir, who dwell in the golden city of Asgard yet have often protected our world as well.

- The average Asgardian can lift 25 to 30 tons, thanks in large part to their ultradense muscular and skeletal structures.

ASGARDIAN ANATOMY

The Aesir are akin to humans in appearance and anatomical structure, but close examination of their genetic makeup reveals significant differences. The skin and bones of Aesir appear to be nearly three times as dense as a human's, giving the average Aesir strength and durability far exceeding our own. Their cells seem to possess an increased capacity for processing higher forms of energy, gifting a number of them with powers such as energy projection and elemental manipulation. The nature of this higher energy remains somewhat enigmatic and is frequently classified as "cosmic" or "mystical" due to its strange resistance to scientific study. I remain convinced that all energies can ultimately be codified under the taxonomy of science, but I must admit that many facets of Asgard's existence are still far from being fully understood.

IMMORTALITY

The Aesir are said to be immortal, but this is not entirely accurate. They exhibit a genetic predisposition toward longer life spans through decreased cellular degeneration—a factor increased by the consumption of the Golden Apples of Idunn, mystical fruits enchanted by the Asgardian goddess of immortality. Because of these factors, Aesir can live for centuries while possessing near-immunity to disease and injury.

> *Though they may not be true immortals, death is often a temporary condition to an Aesir. Norse mythology states that the Aesir are locked in an endless cycle of fatality and rebirth known as Ragnarok. A cataclysmic battle is fated to occur every few millennia, wiping the Aesir from existence but re-creating their entire society from the ashes. Restored Aesir are said to be nearly identical to their former selves. I can find no plausible scientific theory to explain such a large-scale resurrection. If true, it could lend support to the idea that the citizens of Asgard may indeed possess a spark of divinity, but perhaps it's more likely that the sophistication of their science is simply beyond our current level of understanding.*

- Although her internal physiology is Aesir in origin, Angela (pictured here) has adopted an outward appearance that reflects her upbringing in another of Asgard's Ten Realms, Heven.

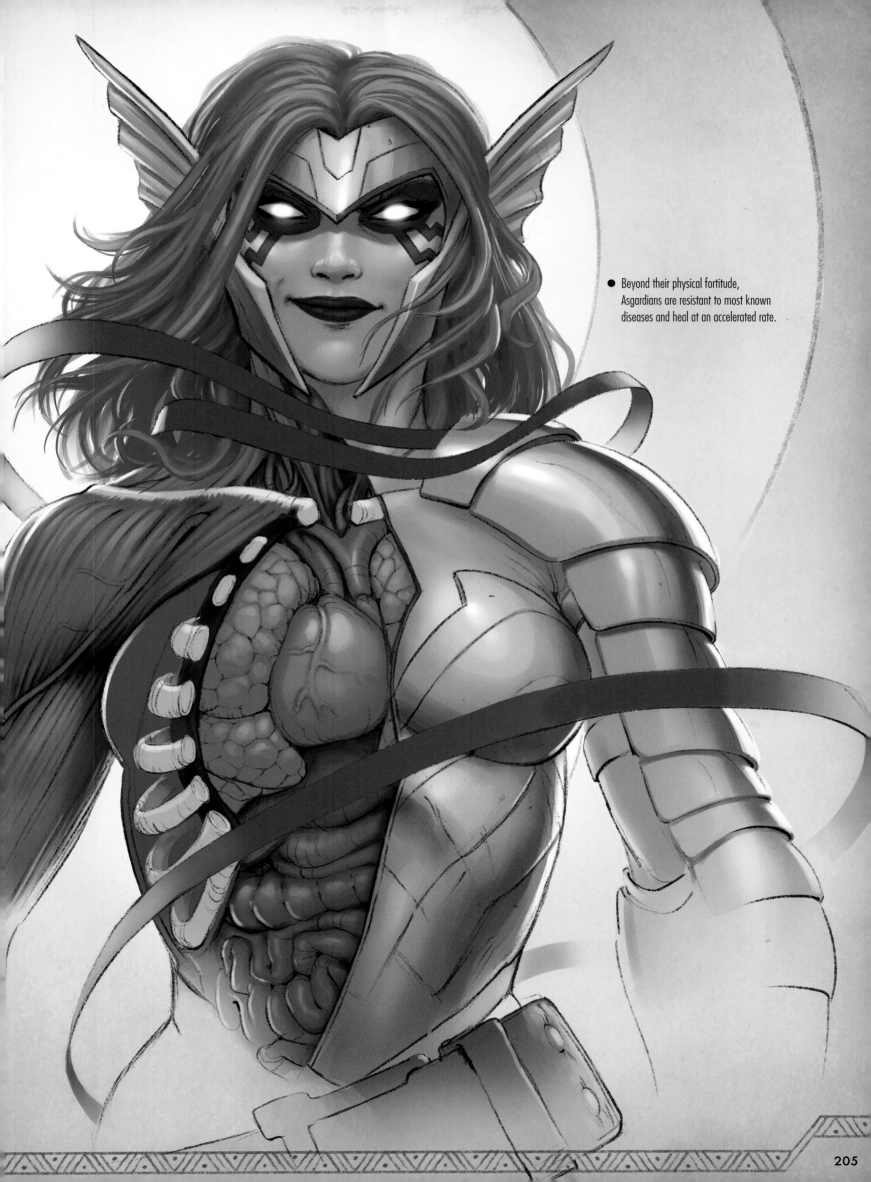

Beyond their physical fortitude, Asgardians are resistant to most known diseases and heal at an accelerated rate.

THOR

Thor's bravery proves that one need not be born of this world to serve it with honor, and I am proud to call this Asgardian warrior my brother-in-arms. The God of Thunder's powers are far more potent than those of his fellow Aesir, making it all the more fortunate that he wields them for the greater good.

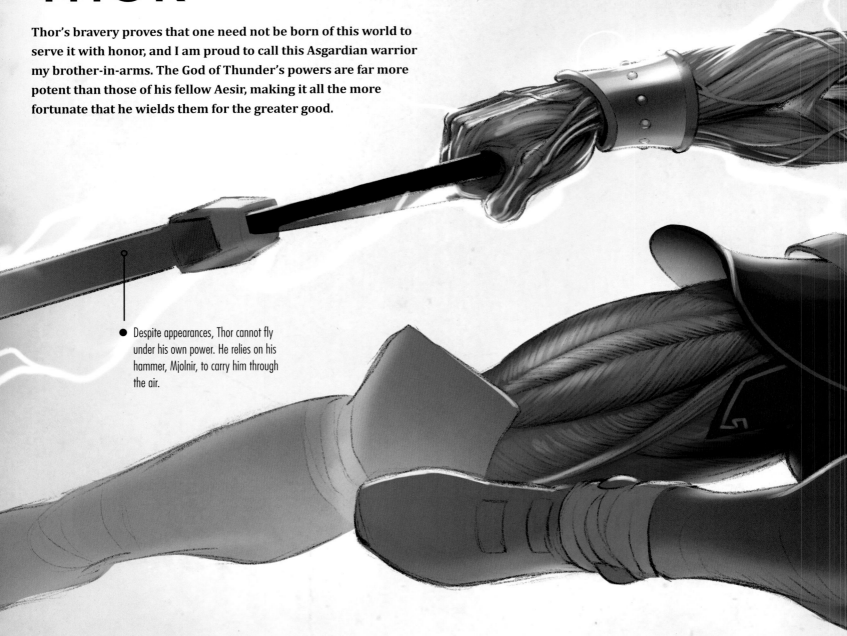

● Despite appearances, Thor cannot fly under his own power. He relies on his hammer, Mjolnir, to carry him through the air.

◈ GODLY PHYSIQUE

Even though all Aesir are stronger than their human counterparts, Thor is easily four times stronger than any of his Asgardian brethren. Tissue samples collected by the Avengers confirm that Thor's body is significantly denser than his fellow Asgardians, contributing to his elevated strength and durability, but these biological attributes alone appear insufficient to account for his remarkable hardiness. Indeed, Thor's cellular density may have been passed down as a genetic gift from his father, the near-omnipotent Odin, whose royal lineage traces back to the earliest known Aesir. It could be that their specific genetic makeup includes a conduit for the transmission of Godpower uncommon in standard Asgardian physiology.

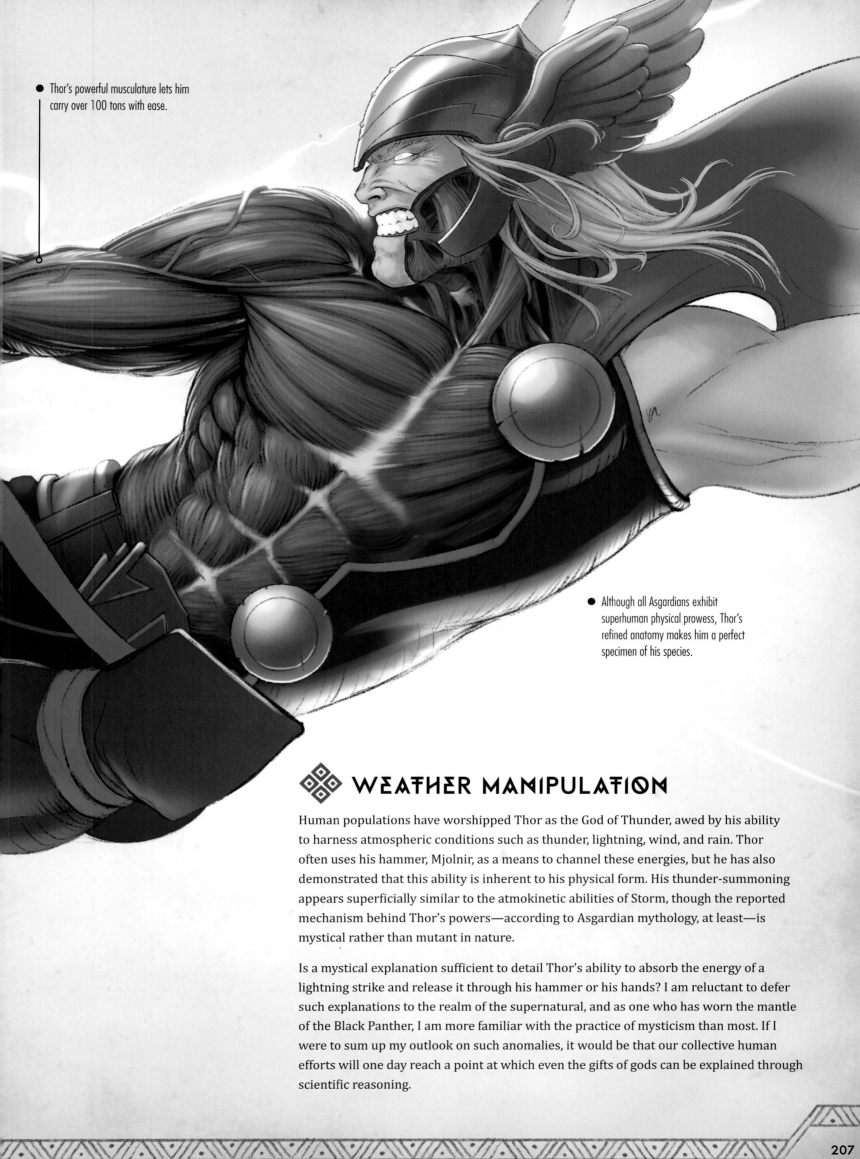

Thor's powerful musculature lets him carry over 100 tons with ease.

Although all Asgardians exhibit superhuman physical prowess, Thor's refined anatomy makes him a perfect specimen of his species.

◈ WEATHER MANIPULATION

Human populations have worshipped Thor as the God of Thunder, awed by his ability to harness atmospheric conditions such as thunder, lightning, wind, and rain. Thor often uses his hammer, Mjolnir, as a means to channel these energies, but he has also demonstrated that this ability is inherent to his physical form. His thunder-summoning appears superficially similar to the atmokinetic abilities of Storm, though the reported mechanism behind Thor's powers—according to Asgardian mythology, at least—is mystical rather than mutant in nature.

Is a mystical explanation sufficient to detail Thor's ability to absorb the energy of a lightning strike and release it through his hammer or his hands? I am reluctant to defer such explanations to the realm of the supernatural, and as one who has worn the mantle of the Black Panther, I am more familiar with the practice of mysticism than most. If I were to sum up my outlook on such anomalies, it would be that our collective human efforts will one day reach a point at which even the gifts of gods can be explained through scientific reasoning.

THOR

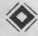 Thor's hammer, Mjolnir, is forged from enchanted Uru metal, making it far more than just a weapon of war. Mjolnir allows Thor to perform a number of superhuman feats, including the approximation of flight, which Thor achieves by hurling his hammer and holding tight to its handle as the weapon reaches speeds up to 24,000 miles per hour. Mjolnir also seems able to boost Thor's innate weather-manipulation ability.

Mjolnir appears linked to Thor on a telepathic level, leading me to speculate that emissions released as a by-product of Thor's cognition—including the theorized production of massless neutrinos—could be linked to some form of unique molecular matrix inherent in the hammer's metallic structure. Of course, the wielder's cognition might not be the only factor in play, in light of numerous anecdotal reports stating that Mjolnir "has a mind of its own."

Even Thor's greatly enhanced Asgardian musculature has proven incapable of lifting Mjolnir at times, due to an enchantment that makes the hammer become impossibly heavy to those deemed unworthy of the honor of wielding it.

ODINFORCE

I have previously made mention of Godpower to describe undefined extradimensional sources behind the unique abilities of many superhumans. In the case of Thor, Godpower takes on an almost literal meaning, if one is to interpret the Asgardian legends as scientific truth.

When he ascended to the throne of Asgard, Thor reportedly received access to the cosmic power possessed by his father, Odin. This Odinforce serves as a nearly unlimited pool of cosmic/mystical energy, pushing Thor's natural abilities to uncharted levels.

ASSESSMENT

Few truly understand a king's burden, yet Thor has proven his worth both on the throne and on the field of war. With all of the Ten Realms—including Earth itself—under his protection, I have great faith that his race of mighty warriors will march beside us when the time comes for battle. But we must use caution when summoning help from beyond. For while no Skrull could possibly prove worthy of lifting Thor's enchanted hammer, they could assume the identities of other Aesir in a strategic effort to access ancient Asgardian secrets. Should they succeed, the Skrulls could plunge Earth and Asgard alike into the next cycle of Ragnarok.

SCANS OF MJOLNIR REVEAL DIFFERENT ENERGY PATTERNS WITHIN ITS URU-FORGED HEAD.

● "MOTHER STORM" ENERGY

● ODINFORCE

● URU REINFORCED SHAFT

● LIGHTNING INFUSED URU

● Thor has suggested that the source of Mjolnir's meteorological power is the "Mother Storm" — an ancient, sentient force of cosmic destruction that was imprisoned within the hammer by Odin millennia ago.

Atlanteans are protected from the near-freezing temperatures of the ocean's depths by a blubbery external skin layer that is rich in capillaries.

An Atlantean's gills are highly efficient at absorbing oxygen from seawater, even at the greatest depths.

Compact musculature, particularly in the legs, allows the average Atlantean to swim at speeds up to 30 mph.

ATLANTEANS

Homo mermanus, an ocean-dwelling offshoot of humanity, are no friends of Wakanda. Ever since a great flood was unleashed upon our nation by Namor, King of Atlantis, we have been bitter enemies. Yet few beings are better suited for battle in the oceans, and it is a hard truth that we will need all the help we can get in the fight against the Skrulls.

◈ ATLANTEAN ANATOMY

The Atlantean race is an evolutionary deviation from humanity that has fully acclimatized to life underwater. Their unique physical adaptations include neck-gills for filtering breathable oxygen from seawater as well as dense muscles and solid frames to support their bodies under the crushing pressures of the ocean depths. Similarly, Atlantean tissue and blood has evolved to metabolize the increased nitrogen intake at high pressures, preventing the formation of nitrogen bubbles in musculoskeletal and cutaneous tissue layers—factors that cause decompression sickness in regular humans.

Atlanteans are warm-blooded, and as such their circulatory systems have adapted to protect them from freezing in the chill of the depths, aided by rubbery skin that acts as a buffer against heat loss. Their sensory organs allow them to smell and hear while submerged, and their skin has a natural blue pigmentation. Streamlined bodies and powerful legs allow Atlanteans to swim at speeds of up to 30 miles per hour.

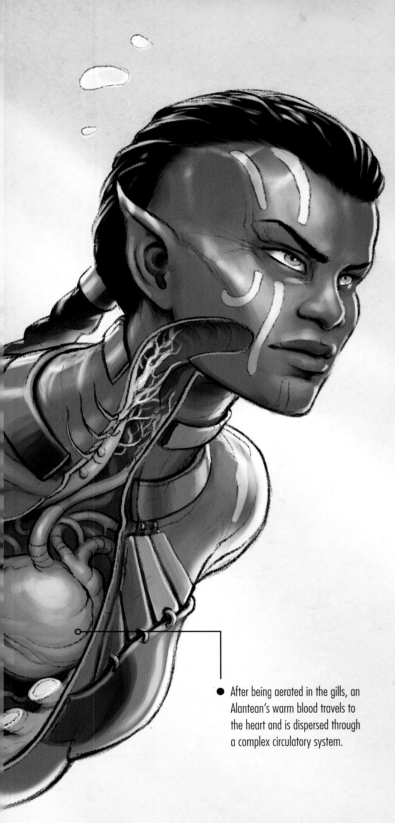

● After being aerated in the gills, an Alantean's warm blood travels to the heart and is dispersed through a complex circulatory system.

✦ They may be strong beneath the waves, but Atlanteans are understandably at a disadvantage when removed from their natural habitat. Most Atlanteans cannot breathe air and must wear water-recirculators when on land to prevent suffocation. Atlanteans are also prone to dehydrate when removed from fluid-based environments, leading to a substantial decrease in strength and eventually complete organ shutdown.

NAMOR

Although he reigns as King of Atlantis, Namor the Sub-Mariner is a man of two worlds. The son of an Atlantean princess and a human sea captain, it is perhaps Namor's insecurity over his hybrid nature that has fueled his crusade against the surface world. The day will soon come when he will be forced to prove whether his might can live up to his threats.

 ## HYBRID PHYSIOLOGY

Namor's mix of human and Atlantean physiologies makes him a unique specimen who exceeds the limitations of both species. In water, Namor's strength rivals the planet's most powerful heroes, and he still functions at approximately 85 percent of his maximum strength when on land. Data recorded during terrestrial encounters indicates that Namor's lifting ability easily exceeds 100 tons when in direct contact with a water source. Namor can swim twice as fast as other Atlanteans, and his skin is so durable it effectively renders him bulletproof.

Namor possesses the same adaptations that allow Atlanteans to thrive underwater, including pressure resistance, enhanced vision, and an optimized circulatory system that regulates the body's internal temperature. Yet he also possesses distinctly human traits, such as the ability to breathe air. Namor's lungs function like a human's when on land, but the presence of special oxygen-diffusing membranes, known as lamellae, could explain how he can extract oxygen from water when submerged. Though he possesses barely visible neck-gills, he does not appear to respire through them when submerged.

● Specialized membranes within Namor's lungs allow him to process oxygen both from the water and the air.

● Namor possesses vestigial gills that seem to lack the full functionality of those used by his Atlantean brethren.

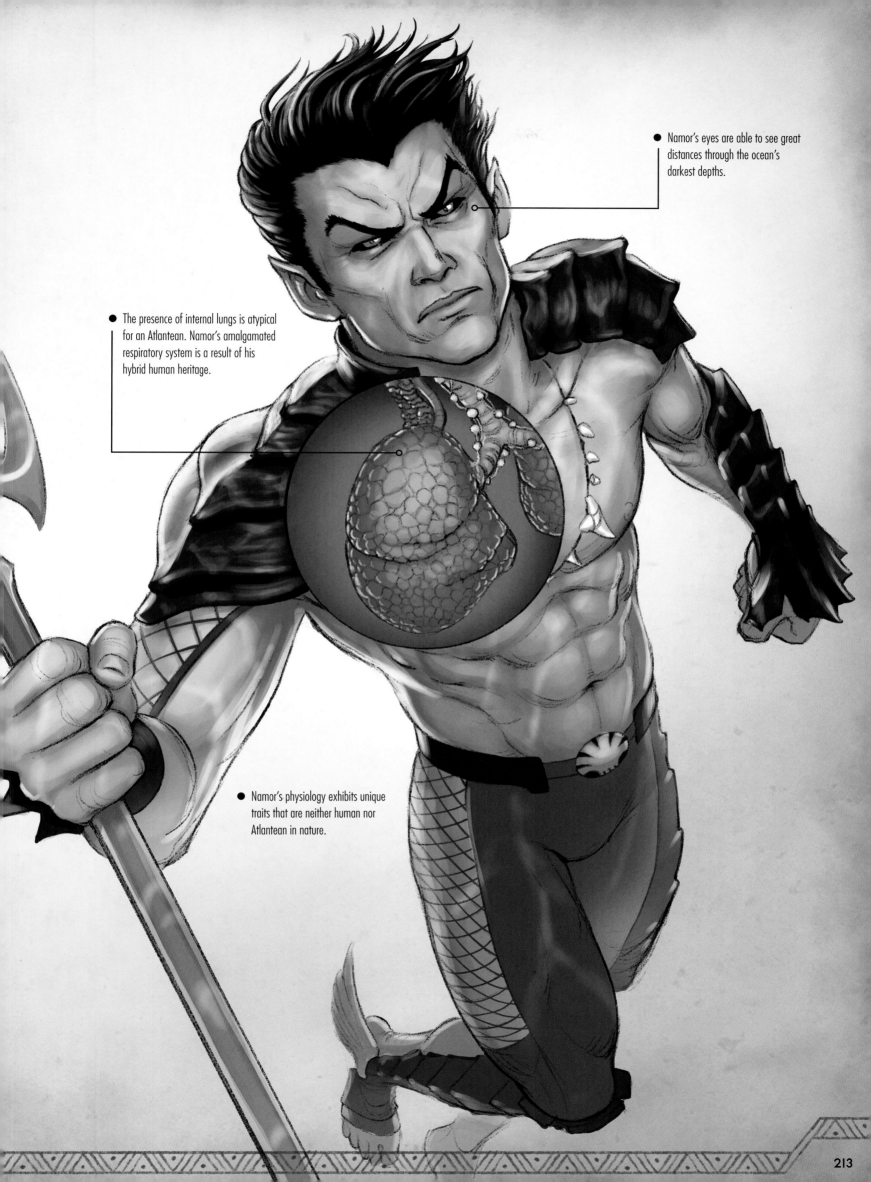

● Namor's eyes are able to see great distances through the ocean's darkest depths.

● The presence of internal lungs is atypical for an Atlantean. Namor's amalgamated respiratory system is a result of his hybrid human heritage.

● Namor's physiology exhibits unique traits that are neither human nor Atlantean in nature.

NAMOR

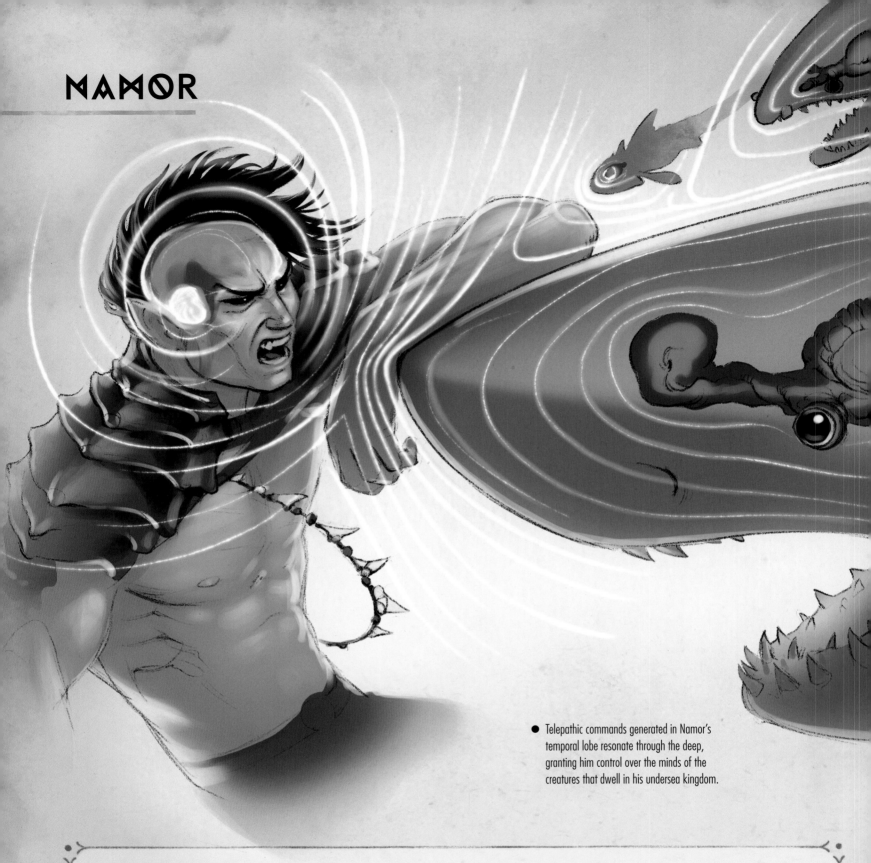

● Telepathic commands generated in Namor's temporal lobe resonate through the deep, granting him control over the minds of the creatures that dwell in his undersea kingdom.

Namor's heritage has given him obvious physiological enhancements, but even these come with downsides. He can breathe on land indefinitely but is still prone to extreme dehydration after a period of separation from his natural water-based environment. If he overexerts himself in this state, he will die—though only a tiny splash of water on his skin is enough to replenish his vigor. Namor appears to experience severe mood swings after transitioning between long periods in either land or water, leading me to believe that abrupt changes in his environment could lead to fluctuations in the composition of his brain chemistry, which may account for his notoriously violent temper.

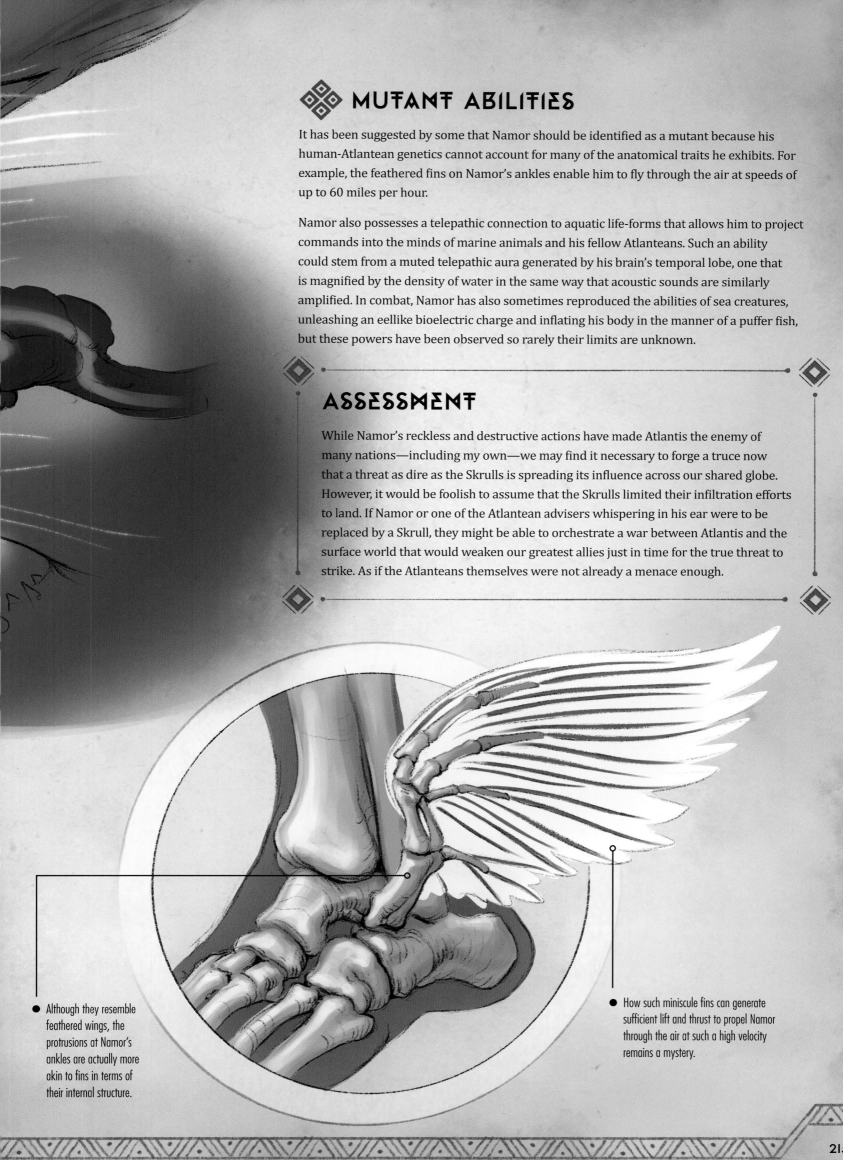

◈ MUTANT ABILITIES

It has been suggested by some that Namor should be identified as a mutant because his human-Atlantean genetics cannot account for many of the anatomical traits he exhibits. For example, the feathered fins on Namor's ankles enable him to fly through the air at speeds of up to 60 miles per hour.

Namor also possesses a telepathic connection to aquatic life-forms that allows him to project commands into the minds of marine animals and his fellow Atlanteans. Such an ability could stem from a muted telepathic aura generated by his brain's temporal lobe, one that is magnified by the density of water in the same way that acoustic sounds are similarly amplified. In combat, Namor has also sometimes reproduced the abilities of sea creatures, unleashing an eellike bioelectric charge and inflating his body in the manner of a puffer fish, but these powers have been observed so rarely their limits are unknown.

ASSESSMENT

While Namor's reckless and destructive actions have made Atlantis the enemy of many nations—including my own—we may find it necessary to forge a truce now that a threat as dire as the Skrulls is spreading its influence across our shared globe. However, it would be foolish to assume that the Skrulls limited their infiltration efforts to land. If Namor or one of the Atlantean advisers whispering in his ear were to be replaced by a Skrull, they might be able to orchestrate a war between Atlantis and the surface world that would weaken our greatest allies just in time for the true threat to strike. As if the Atlanteans themselves were not already a menace enough.

● Although they resemble feathered wings, the protrusions at Namor's ankles are actually more akin to fins in terms of their internal structure.

● How such miniscule fins can generate sufficient lift and thrust to propel Namor through the air at such a high velocity remains a mystery.

INHUMANS

The Inhumans (also classified as Inhomo supremis or Homo sapiens inhumanus) are the result of Kree experiments performed on primitive humans approximately 25,000 years ago. The Kree's test subjects became a new branch of the human species that was far more powerful and adaptable, provided they were exposed to a highly specific environmental trigger during adolescent physical development. This unique ritual came to be known as Terrigenesis.

TERRIGENESIS

Inhumans resemble typical men and women at birth, though genetic examination reveals that they possess elevated physical strength and unusually long life spans at this stage. On a cellular level, each Inhuman possesses a distinct genetic code that, following exposure to the mutagenic agent Terrigen, is primed to unlock a set of unique powers

The process of exposure, known as Terrigenesis, is ritually administered to Inhumans during their ceremonial transition into adulthood. Discovering the genetic potential within themselves also reveals their purpose in Inhuman society. No two Inhumans emerge from Terrigenesis with exactly the same powers, and some experience bizarre physical mutations as a result of the ordeal.

For centuries, the Inhumans lived in seclusion from humanity in the high-tech city of Attilan, which has traveled from Earth to the moon and even far beyond. Their isolationist stance was abandoned when a massive detonation decimated the city and unleashed their sacred Terrigen Mist across Earth. Anyone with a trace of Inhuman DNA suddenly discovered their lost heritage, whether they wanted to or not. These distant members of the Inhuman family—dubbed NuHumans—emerged from the mists with unfamiliar powers and urgent questions about their fates.

BASELINE INHUMAN DNA

TERRIGEN CRYSTALS

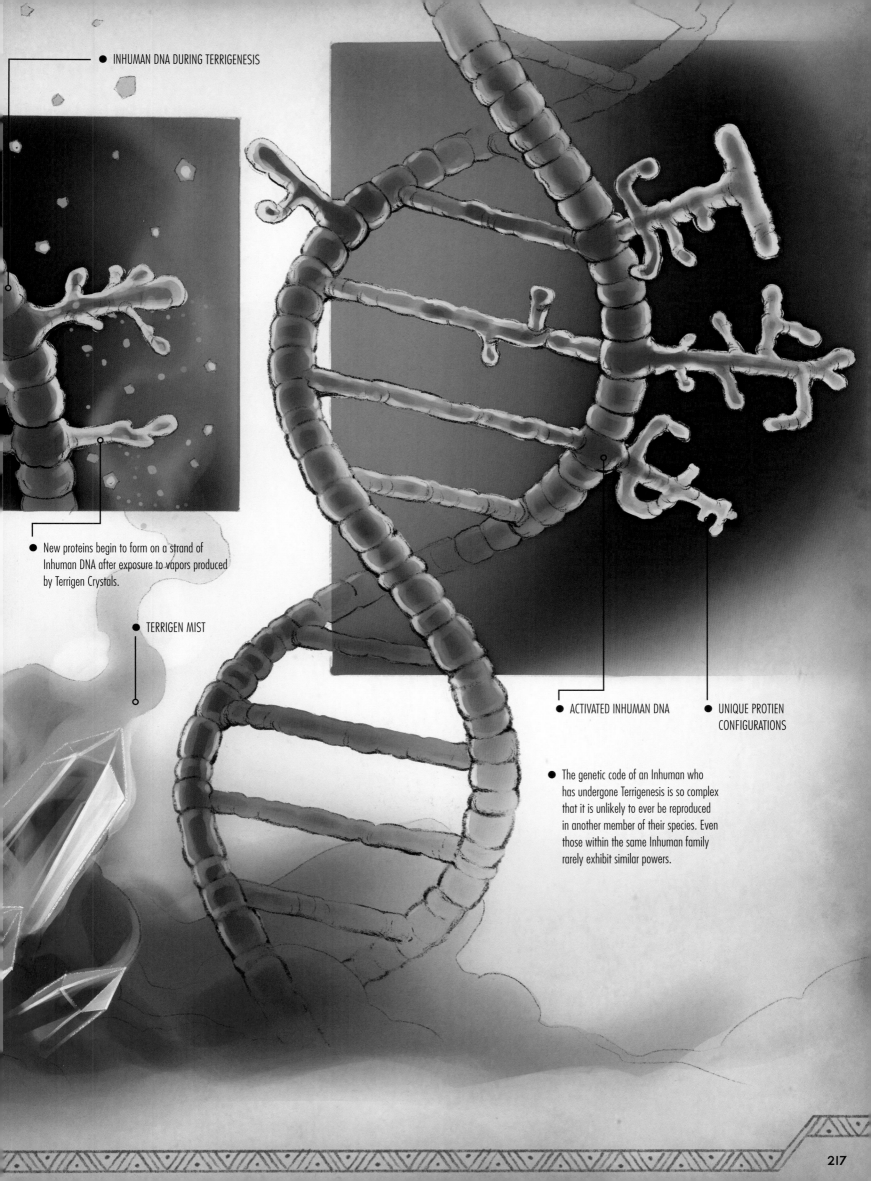

INHUMAN DNA DURING TERRIGENESIS

New proteins begin to form on a strand of Inhuman DNA after exposure to vapors produced by Terrigen Crystals.

TERRIGEN MIST

ACTIVATED INHUMAN DNA

UNIQUE PROTIEN CONFIGURATIONS

The genetic code of an Inhuman who has undergone Terrigenesis is so complex that it is unlikely to ever be reproduced in another member of their species. Even those within the same Inhuman family rarely exhibit similar powers.

BLACK BOLT

The king of the Inhumans, Black Bolt rules his people in silence. Uttering a single world might bring his entire kingdom crashing down due to the presence of a rare type of particle in the speech center of his brain. This particle interacts with ambient electrons to give Black Bolt an array of mental and physical powers. As long as he remains silent, Black Bolt retains precision control of these electrons to enhance his strength or speed, detect electromagnetic disturbances, or fly. He can also arrange electrons into the shape of a force field and project concussive blasts from his fists. But even a faint rumble from Black Bolt's vocal cords triggers a disturbance in the electron interaction field located in the speech center of his brain. When this occurs, all the energy normally used to power his abilities is channeled into a devastating quasi-sonic scream that generates a shock wave comparable to the destructive force of a nuclear explosion.

● The faintest whisper from Black Bolt generates enough force to rock a battleship, while a high-decibel scream can decimate an entire city.

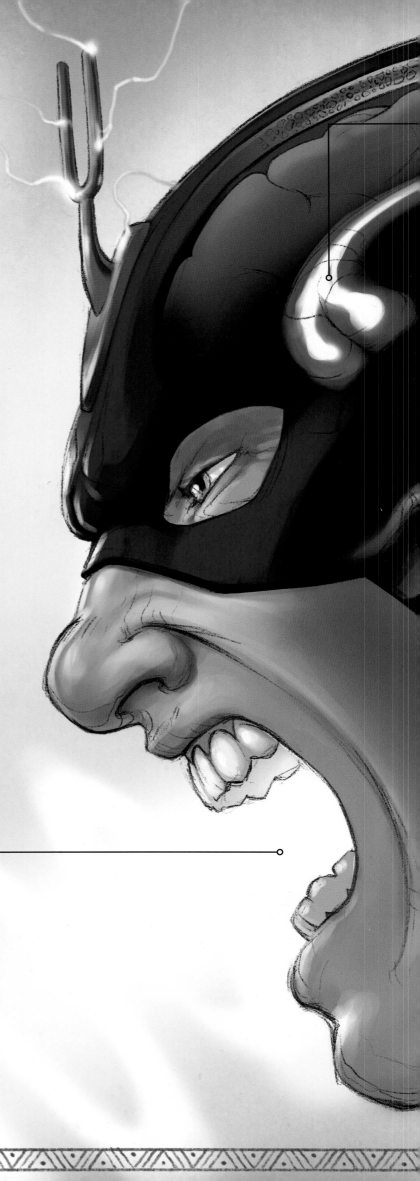

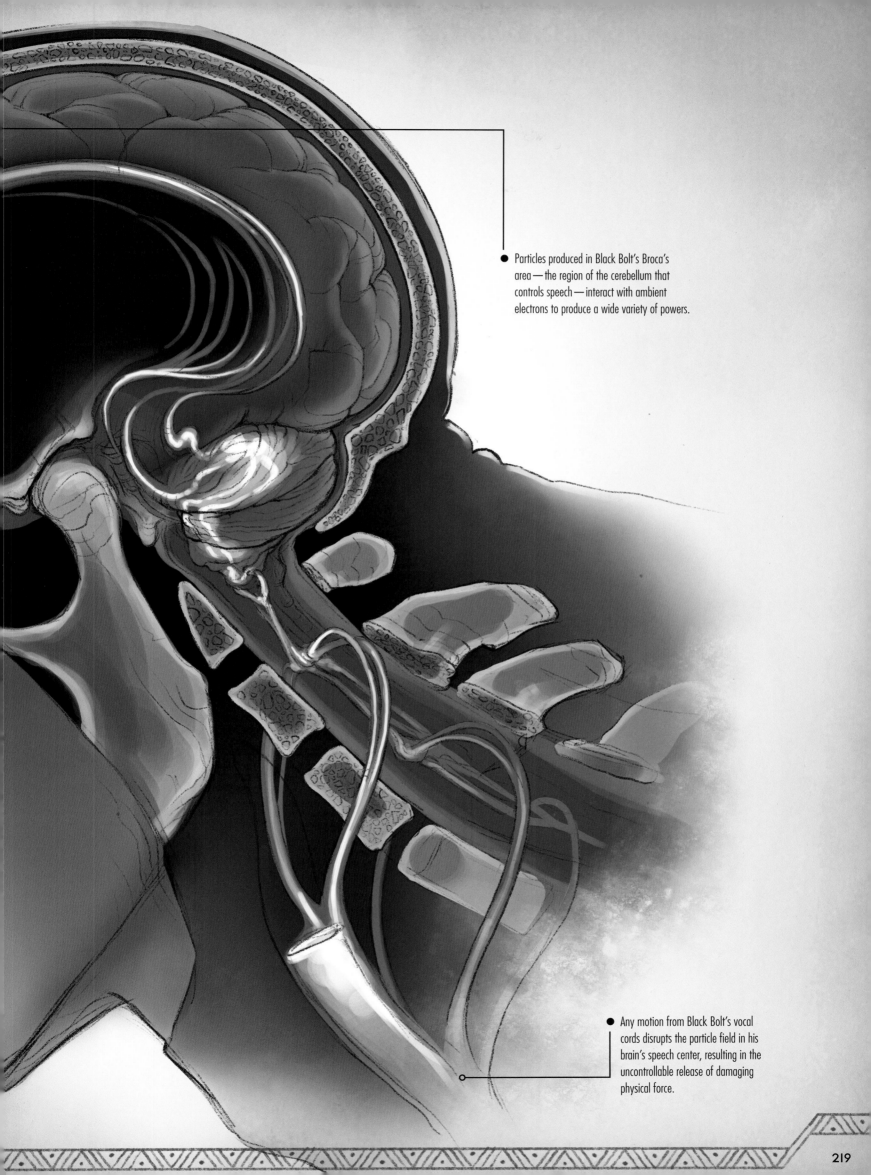

● Particles produced in Black Bolt's Broca's
area — the region of the cerebellum that
controls speech — interact with ambient
electrons to produce a wide variety of powers.

● Any motion from Black Bolt's vocal
cords disrupts the particle field in his
brain's speech center, resulting in the
uncontrollable release of damaging
physical force.

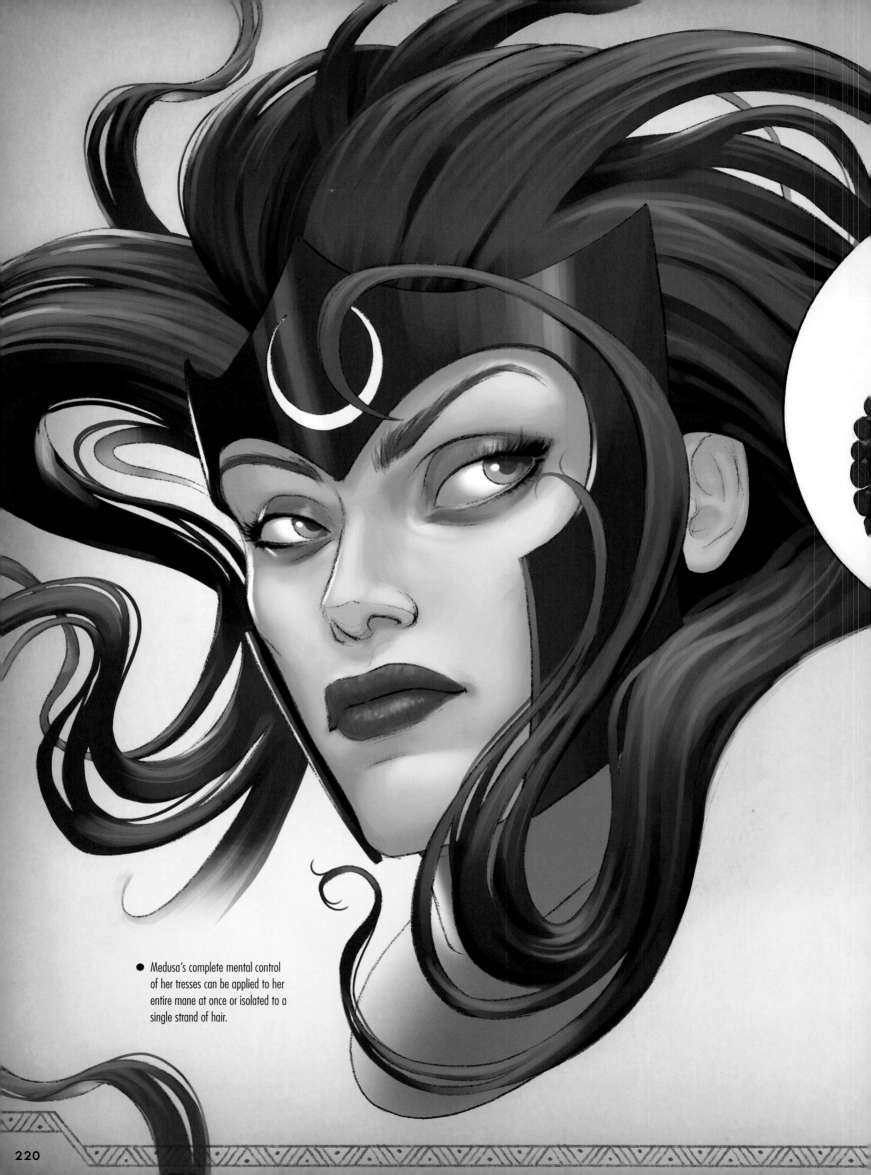

● Medusa's complete mental control of her tresses can be applied to her entire mane at once or isolated to a single strand of hair.

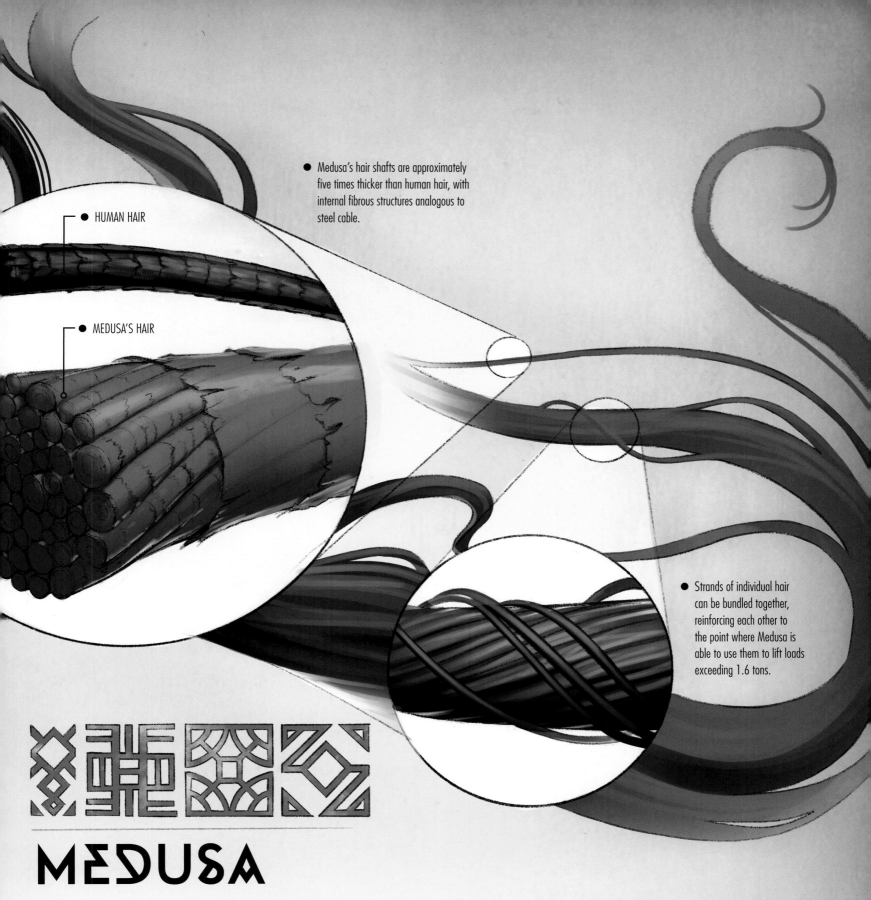

- Medusa's hair shafts are approximately five times thicker than human hair, with internal fibrous structures analogous to steel cable.

HUMAN HAIR

MEDUSA'S HAIR

- Strands of individual hair can be bundled together, reinforcing each other to the point where Medusa is able to use them to lift loads exceeding 1.6 tons.

MEDUSA

Black Bolt may wear the crown, but Medusa is the voice of her people. Queen of the Inhumans, Medusa has the power to use the strands of her hair as prehensile appendages. Hair typically consists of cross-linked proteins called keratin that break under minimal force, but Medusa's hair is tougher than steel. Each tress is approximately six feet in length and can be used to grab objects or whip enemies. Medusa even uses her hair to swing from point to point. Close examination of individual strands reveals no internal structure that would permit independent motion, implying Medusa directs her hair's movements through mental and psionic means. She can control her hair's growth rate, and it is said her tresses cannot be cut unless she wills it. During the rare occasions when some of her hair has been removed, Medusa has been able to remotely control its movement.

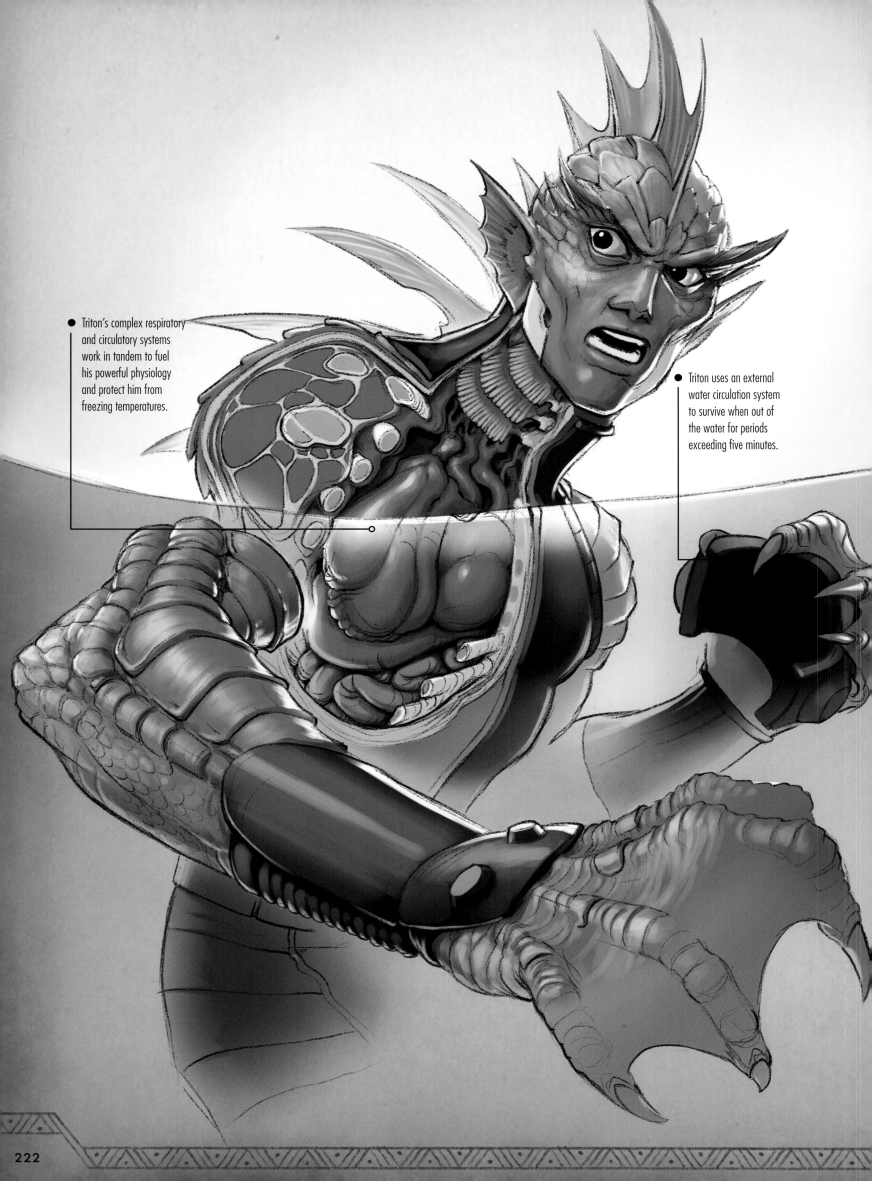

Triton's complex respiratory and circulatory systems work in tandem to fuel his powerful physiology and protect him from freezing temperatures.

Triton uses an external water circulation system to survive when out of the water for periods exceeding five minutes.

TRITON

Black Bolt's cousin Triton emerged from Terrigenesis with an altered physiology more suitable for life underwater. His evident amphibious traits include webbed hands and feet, a dorsal fin along his spine, and scaled skin. Gills on Triton's throat allow him to breathe while submerged, and he cannot survive long in a terrestrial environment without artificial respirators and hydrators. Triton's body is adapted to withstand the high pressures and chilling temperatures of the ocean depths, and he is able to boost his strength by drawing energy from naturally occurring electromagnetic fields. Triton's eyes are attuned to the green portion of the visible light spectrum, which offers improved perception in darkened underwater conditions. Nerve endings under his scales help him sense obstacles in close proximity, further allowing him to navigate the depths in complete darkness.

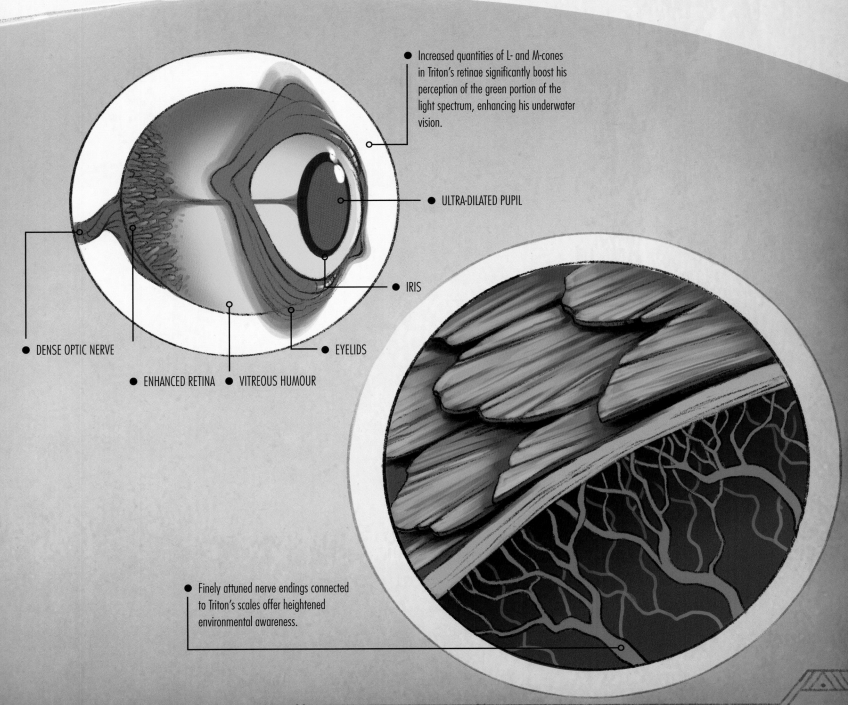

Increased quantities of L- and M-cones in Triton's retinae significantly boost his perception of the green portion of the light spectrum, enhancing his underwater vision.

ULTRA-DILATED PUPIL

IRIS

DENSE OPTIC NERVE

EYELIDS

ENHANCED RETINA

VITREOUS HUMOUR

Finely attuned nerve endings connected to Triton's scales offer heightened environmental awareness.

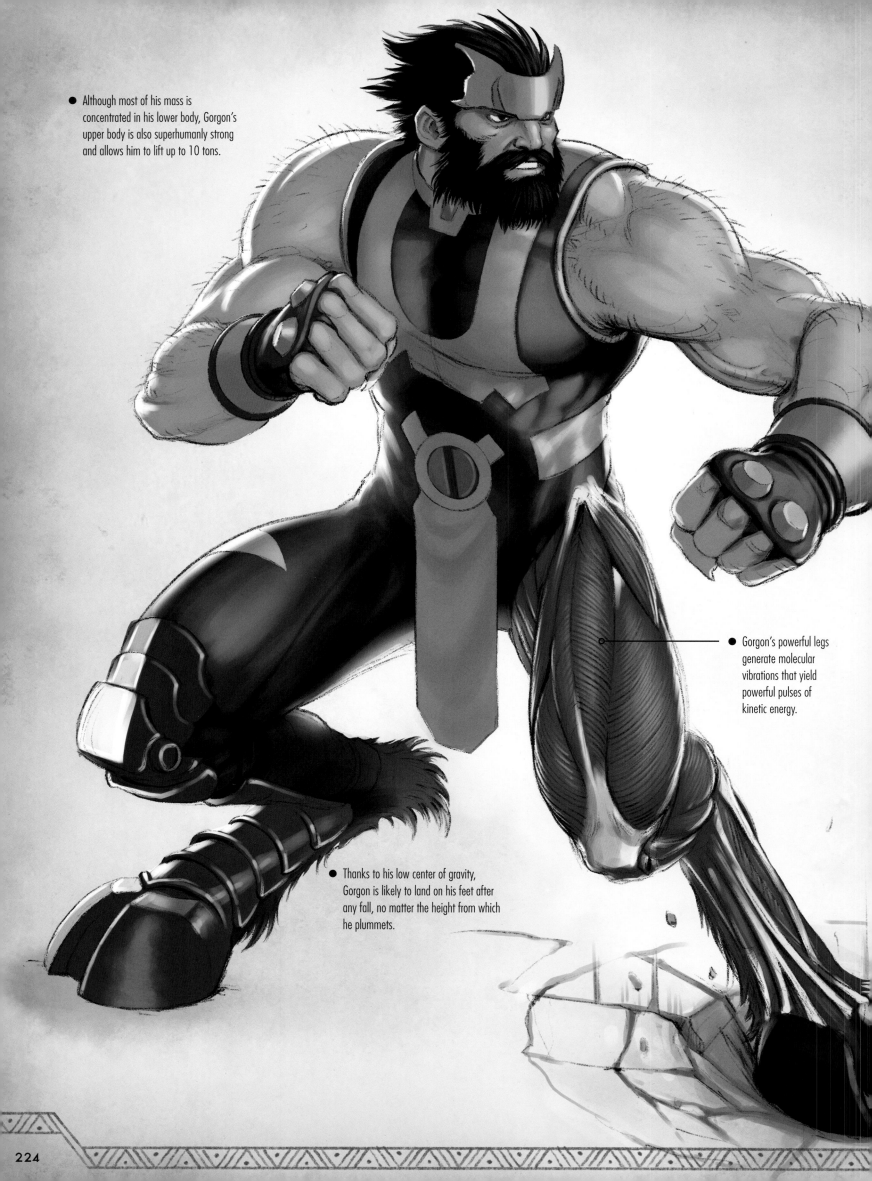

- Although most of his mass is concentrated in his lower body, Gorgon's upper body is also superhumanly strong and allows him to lift up to 10 tons.

- Gorgon's powerful legs generate molecular vibrations that yield powerful pulses of kinetic energy.

- Thanks to his low center of gravity, Gorgon is likely to land on his feet after any fall, no matter the height from which he plummets.

GORGON

The Terrigen Mists gave Gorgon two muscular legs ending in horselike hooves. Indeed, approximately 75 percent of Gorgon's body weight is concentrated in his lower half, giving him a low center of gravity for superior balance and providing his legs with tremendous power due to the high concentration of muscle mass in his thighs and calves. By stomping his hooves, Gorgon can generate a radial wave of kinetic energy equivalent to a 7.5 magnitude earthquake. A cousin of the Inhuman king, Black Bolt, Gorgon is a powerful force, combining physical prowess with the royal influence he wields in his role as commander of the Inhuman militia.

When Gorgon underwent a second round of Terrigenesis, he gained a dramatic increase in strength but exhibited cognitive decline and developed features that were animalistic. Though these unfortunate side effects eventually faded, the occurrence makes me question whether Gorgon's experience was anomalous or if other Inhumans might develop additional powers if subjected to supplemental Terrigen Mist exposure.

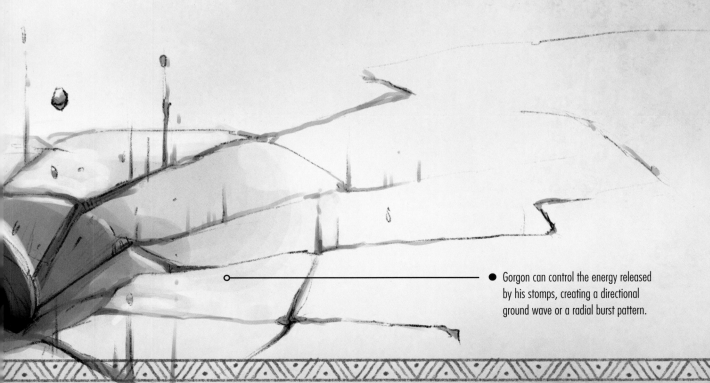

Gorgon can control the energy released by his stomps, creating a directional ground wave or a radial burst pattern.

LOCKJAW

The result of an ancient Inhuman experiment on canines, the massive creature known as Lockjaw is a loyal companion of the Royal Family and also serves as their most frequent method of transportation. Lockjaw's teleportation abilities allow him to instantaneously move himself and others across distances up to 240,000 miles, providing a bridge between Earth and the moon. Lockjaw can transport up to one ton of additional mass during teleportation; he can also track targets across interdimensional space. In addition, Lockjaw is able to immobilize enemies with the sheer force of his bite, rendering opponents helpless until he releases his grip.

Lockjaw and Black Bolt sport similar antennae on their foreheads, designed to help them focus their powers, but these appendages also allow them to use their abilities in tandem. Notably, they have combined their powers to open a cross-dimensional gateway, something neither of them could possibly achieve individually.

ENERGY READINGS SHOW THAT LOCKJAW RARELY TRAVELS THE EXACT SAME PATH BETWEEN DESTINATIONS, MAKING HIS MODE OF TELEPORTATION VIRTUALLY IMPOSSIBLE TO REPLICATE.

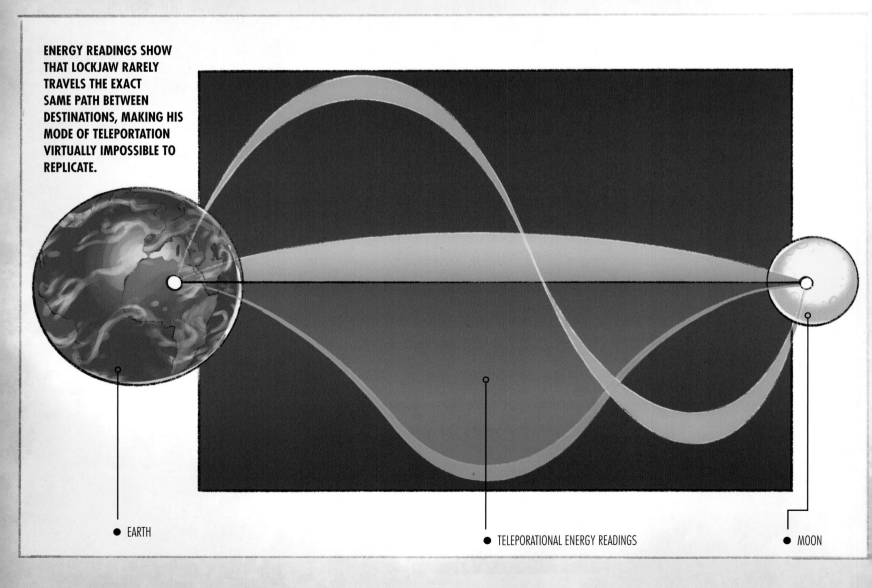

● EARTH

● TELEPORATIONAL ENERGY READINGS

● MOON

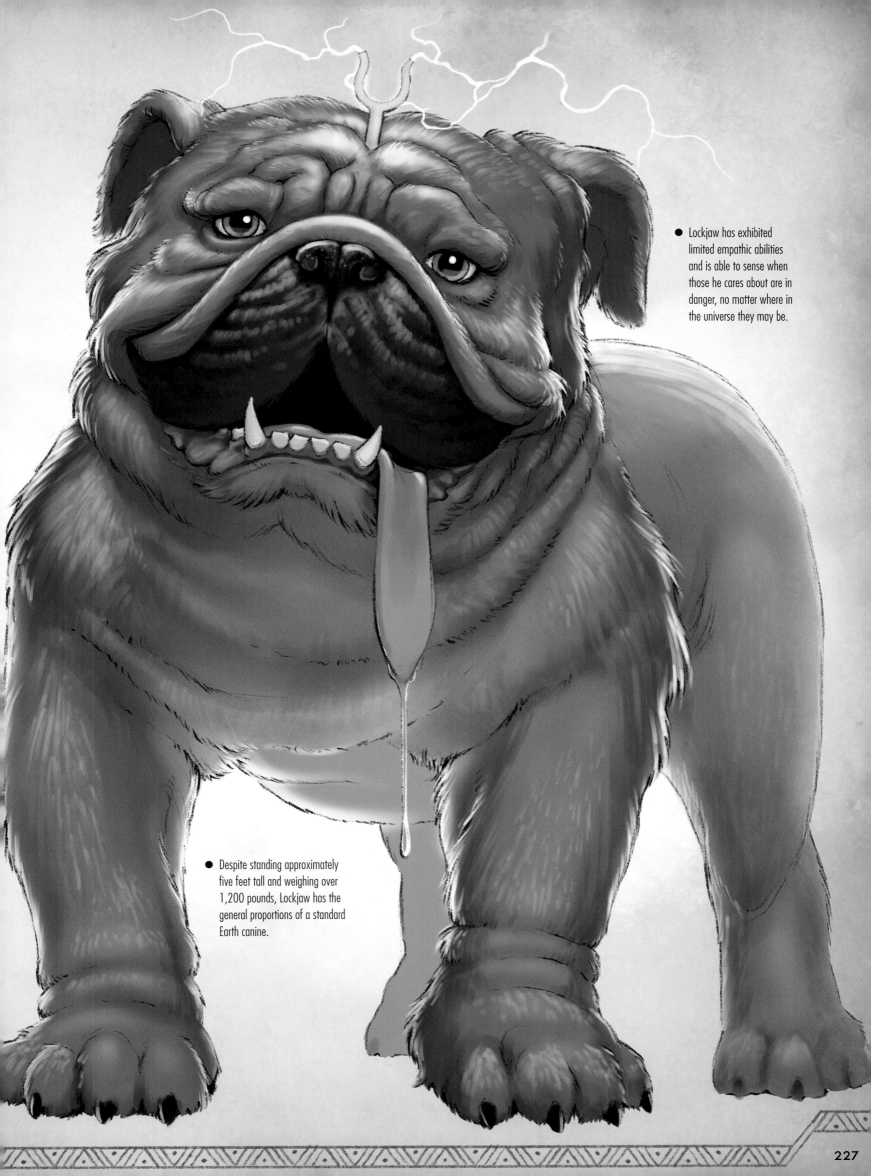

● Lockjaw has exhibited limited empathic abilities and is able to sense when those he cares about are in danger, no matter where in the universe they may be.

● Despite standing approximately five feet tall and weighing over 1,200 pounds, Lockjaw has the general proportions of a standard Earth canine.

Inferno's powers have been known to flare out of control when he enters a heightened emotional state.

When his powers ignite, Inferno's entire cellular structure seemingly shifts to an organic form of molten stone.

INFERNO

Unlike the other Inhumans listed here, Dante Pertuz is a NuHuman who gained his powers after unexpected exposure to the cloud of Terrigen Mist that swept the globe. His abilities are no less impressive than his royal counterparts, though. Inferno can generate flames at an intensity of up to 2,500 degrees Fahrenheit, sufficient to liquefy metal. He is also able to engulf his entire body in flames or ignite only select areas of his skin as needed. Inferno's heat seems to be generated at a cellular level, as opposed to an external plasma sheath like the one the Human Torch employs. This is likely the result of intense endothermic reactions produced by Terrigen-altered mitochondria in his cells, gifting him with a resilient cellular structure apparently immune to charring of the dermis. Yet this unique biochemistry appears to have limits. Based on data shared by the Inhumans, it seems Inferno's mitochondrial organelles could become overwhelmed by excessive flame generation, potentially leading to the complete disintegration of his physical form.

ASSESSMENT

The process of Terrigenesis is unique to the Inhumans, and the variety of powerful mutations triggered by its effects has created a veritable army of potential super-powered allies. Their numbers could earn us an easy victory, but only if their king deems humanity worth saving after our many affronts against his people. It will be up to Black Bolt to pass his silent judgment as to which race—the humans or the Skrulls—ultimately poses the greater threat to his own.

Inferno once lost a limb but was able to generate a new one from the molten material that constitutes his fiery physical form.

CONCLUSION

Whether transformed by science, technology, or cosmic fate, the beings listed in this report have each made an impact on this world and are capable of determining its future—a future that has never been in greater jeopardy.

We must first use the knowledge presented here to assemble the heroes least likely to have been compromised by the invading forces. Then we must put our most brilliant minds to work—not only to devise methods to expose the true identities of any remaining infiltrators, but also to develop battle strategies that will bring our planet's many differently powered beings together to form highly effective strike squads. Once assembled, heroes and villains alike can be deployed side by side against the invading Skrull forces, sending their armada hurtling back into the stars from which they came.

But none of this will be possible without you. I believe in your wisdom and your clear eye to aid us in these efforts. I know that you will use the information in these files to prioritize the careful recruitment and deployment of Earth's most trusted champions.

In your hands, I do not fear for the future. May Bast guide you in your journey.

Wakanda forever!

T'Challa

INSIGHT EDITIONS

PO Box 3088
San Rafael, CA 94912
www.insighteditions.com

Find us on Facebook: www.facebook.com/InsightEditions
Follow us on Twitter: @insighteditions

Library of Congress Cataloging-in-Publication Data available.

ISBN: 978-1-68383-869-2

Publisher: Raoul Goff
VP of Licensing: Vanessa Lopez
VP of Creative: Chrissy Kwasnik
VP of Manufacturing: Alix Nicholaeff
Vice President, Editorial Director: Vicki Jaeger
Executive Editor: Chris Prince
Editorial Assistant: Savannah Jensen
Managing Editor: Maria Spano
Senior Production Editor: Elaine Ou
Senior Production Manager: Joshua Smith
Senior Production Manager, Subsidiary Rights: Lina s Palma-Temena

Designed by Amazing15

ROOTS of PEACE REPLANTED PAPER

Insight Editions, in association with Roots of Peace, will plant two trees
for each tree used in the manufacturing of this book. Roots of Peace is an
internationally renowned humanitarian organization dedicated to
eradicating land mines worldwide and converting war-torn lands into
productive farms and wildlife habitats. Roots of Peace will plant two
million fruit and nut trees in Afghanistan and provide farmers there with
the skills and support necessary for sustainable land use.

Manufactured in China by Insight Editions

10 9 8 7 6 5 4 3 2

ACKNOWLEDGMENTS

Insight Editions would like to thank Sven Larsen, Sarah
Singer, Jeff Youngquist, and Jeremy West at Marvel for all
their help and guidance in the creation of *Marvel Anatomy*.
Special thanks also to Angela Ontiveros at Disney.

Marc Sumerak would like to thank his amazing
collaborators—Jonah, Dan, Chris, and everyone else
who helped bring this epic project to life. He'd also like
to thank his family for their love and support on this
long journey.

Dan Wallace would like to thank Grant Wallace for help
with anatomical brainstorming.

Jonah Lobe would like to thank his wife Julia and his
mother Ann for their unwavering support in this and
all endeavors.

Salim Busuru would like to thank his lovely wife Elizabeth
and his son who are a constant inspiration.

MARC SUMERAK is an Eisner- and Harvey Award–nominated
writer whose work has been featured in comics, books, and
video games showcasing some of pop culture's most beloved
franchises, including Marvel, *Star Wars*, *Harry Potter*, *Firefly*,
Ghostbusters, *Back to the Future*, and many more. Most
recently, he has been writing the story for the award-winning
mobile game, *MARVEL Future Revolution*. Find out more
at www.sumerak.com. He is based in Cleveland, Ohio.

DANIEL WALLACE is the author or co-author of more than
50 books including *The Jedi Path*, *The World According to
Spider-Man*, *Ghostbusters: The Ultimate Visual History*, *The
World of RWBY*, and the New York Times bestselling *Star
Wars: The New Essential Guide to Characters*. His specialty is
exploring the underpinnings of popular fictional universes.
He lives in Minnesota.

JONAH LOBE is an award-winning concept artist, 3D
character artist and illustrator, best known for his work on
games including *Skyrim* and *Fallout*. Jonah is passionate
about creativity, monsters, world-building, and art
education—connect with him on Twitch, Twitter, Instagram,
YouTube, or at www.jonahlobe.com. Jonah lives with his
wife and daughter in Brooklyn, New York.

SALIM BUSURU is a digital illustrator and comic artist
dedicated to exploring his local culture and drawing as much
inspiration from it as possible. Salim was instrumental in
designing the look and feel of this book by creating the
original designs and masks seen throughout. He lives in
Nairobi, Kenya (next to Wakanda).